Embodied Reckonings

Embodied Reckonings

"COMFORT WOMEN," PERFORMANCE, AND TRANSPACIFIC REDRESS

Elizabeth W. Son

UNIVERSITY OF MICHIGAN PRESS
ANN ARBOR

Published in the United States of America by the
University of Michigan Press
Manufactured in the United States of America
♾ Printed on acid-free paper

2021 2020 2019 2018 4 3 2 1

A CIP catalog record for this book is available from the British Library.

Library of Congress Cataloging-in-Publication data has been applied for.

ISBN: 978-0-472-13073-3 (hardcover : alk. paper)
ISBN: 978-0-472-03710-0 (paperback : alk. paper)
ISBN: 978-0-472-12364-3 (e-book)

All royalties earned from book sales will be donated to the Butterfly Fund,
which was started by survivors Kim Bok Dong and Gil Won Ok to help
female victims of sexual violence during armed conflicts. https://www.
womenandwar.net

Cover: (**top**) Survivor Kim Bok Dong at the Wednesday Demonstration on
September 10, 2014, in Seoul. She sits a few feet from a realistically
rendered bronze statue of an adolescent girl that was installed in 2011 to
commemorate the Wednesday Demonstrations and honor survivors. Credit:
© Yonhap via Newscom/ZUMA; (**bottom**) Survivors (left to right) Gil Won
Ok, Kim Soon-ok, Lee Yong Soo, Park Ok-sun, Yi Ok-seon, and Bae Chun-
hui at the Wednesday Demonstration on July 23, 2008 in Seoul. Photo by
Elizabeth W. Son.

For my mother, Eun Hie Paik, and father, Hun Bae Son

Acknowledgments

I have lived with this project for ten years. It has traveled with me from New Haven to Seoul, Tokyo, and countless cities across the United States. I could not have made it through this journey without so many people by my side.

First, I am indebted to the brave women whose stories are at the heart of this book. I feel so fortunate to have protested alongside Bae Chun-hui, Gil Won Ok, Kang Il-chul, Kim Bok Dong, Kim Soon-ok, Lee Mak Dal, Lee Soon-duck, Lee Yong Soo, Park Ok-sun, and Yi Ok-seon. Gil Won Ok, Kang Il-chul, Kim Gun-ja, Lee Mak Dal, Lee Yong Soo, and Yi Ok-seon welcomed me into their homes and generously shared their wisdom with me. I am so grateful to the activists, artists, and scholars who took the time to share their knowledge and passion for social justice. I am especially grateful to Yoon Mee Hyang, the admirable leader of the Korean Council for the Women Drafted for Military Sexual Slavery by Japan, for her support and time. I thank the wonderful staff members and affiliates of the Korean Council for their assistance: Kim Dong-Hee, Ahn Sun-Mi, Son Young-Me, Im Ji-Yeong, Yang Noja, Kang Joo-Hye, and Hanna Song. I thank artists Bang Eunmi, Peggy Choy, Ito Tari, Chungmi Kim, Kim Eun Sung, Kim Sam-Jin, and Kim Seo Kyung for taking the time to talk with me about their artistic work. I also thank Lee Na-Young, Cho Sihyun, Claire Sung, Ahn Shin Kwon, Kang Jisoo, Stephen Oh, Joseph Oh, Park Se Whan, and Yang Jinee for sharing their experiences with me. Sean Kim and Nam Seonu of the Seoul Arts Center and Llen Kim, Jang Nayong, and Yahng Yoon-Suhg of the Sejong Center for the Performing Arts shared materials relating to the theater productions discussed in the book. I am grateful to Mina Watanabe, and Fumiko Yamashita and Yumiko Saito of the Women's Active Museum on War and Peace for welcoming me to Tokyo and assisting with my research. Nakahara Michiko, Shiba Yoko, Takatsuka Banko, and Tsujii Miho also shared their stories. The Han family and Patricia Wilson helped make Seoul feel like home, and the de Boo family helped

make my stay in Tokyo memorable. Back in the States, I am grateful to Steven Cavallo, Roy Hong, Keun Hwang, Youngju Ji, Dong Chan Kim, Phyllis Kim, Michael Kodama, David Lee, Julie Jungsil Lee, Kathy Masaoka, Young H. Paek, Annabel Park, Chejin Park, Frank J. Quintero, Zareh Sinanyan, Joachim Youn, and countless others for sharing their activist work with me.

This project started in Yale University's American Studies Program under the guidance of my doctoral advisers Hazel Carby and Joseph Roach. Joe taught me to see the world anew through kinesthetic imagination, while Hazel helped me understand the power of cultural works to speak against silenced histories. Joe and Hazel are exemplars of the kind of scholar and teacher I aspire to become. I was also lucky to work with Alicia Schmidt Camacho and Lisa Lowe. Alicia has modeled how to bridge scholarship with a passion for social justice, and Lisa transformed my understanding of the stakes of studying histories of loss. All four of these scholars inspired my work on this project and my belief in the world-changing possibilities of academic inquiry.

I also benefited from the amazing teaching and mentorship of many others at Yale, among them Elizabeth Alexander, Wai Chee Dimock, Jonathan Holloway, Matthew Jacobson, Jill Lane, Mary Lui, Sanda Lwin, Christopher Miller, Diana Paulin, Robert Stepto, and Laura Wexler. Jill introduced me to the world of performance studies, and she and Alicia encouraged me to develop seminar papers into a dissertation. Mary carved out space at Yale for Asian American studies. My journey into American studies began at Wellesley College under the inspirational mentorship of William Cain and Lawrence Rosenwald, who helped me believe that it was possible to pursue a career in academia.

Northwestern University's Theatre Department brought Tracy Davis, Dassia Posner, and Harvey Young into my life. Their generous and astute advice, thoughtful engagement with my work, and friendship have made me a better scholar and teacher. I am also grateful for my colleagues in Theatre, Performance Studies, Asian American Studies, American Studies, and Radio/Television/Film who have engaged with my research or offered encouragement when I needed it the most: Shana Bernstein, Barbara Butts, Rives Collins, Marcela Fuentes, Henry Godinez, E. Patrick Johnson, D. Soyini Madison, Susan Manning, Sandra Marquez, Miriam Petty, Mary Poole, Ramón

Rivera-Servera, Anna Shapiro, Nitasha Sharma, Shayna Silverstein, Jessica Thebus, Will West, Ji-Yeon Yuh, Ivy Wilson, and especially Joshua Takano Chambers-Letson.

We are all lucky to have Dean Barbara O'Keefe at the helm of the School of Communication. I am so grateful to Dean O'Keefe for her support of my research and her unflagging advocacy for the arts.

As a scholar whose transnational research emerges from the worlds of both Asian and Asian American theater and performance studies, I am indebted to pathbreakers Suk-Young Kim, Dorinne Kondo, Esther Kim Lee, Josephine Lee, Daphne Lei, and Karen Shimakawa for showing us the way. In particular, Suk-Young Kim offered incisive comments and kindhearted encouragement; her mentorship during my Woodrow Wilson Career Enhancement Fellowship and her comments on a draft of the manuscript were invaluable. Catherine M. Cole provided critical feedback during my manuscript workshop. Suk-Young and Catherine model what it means to be fully committed to the study of performance and politics.

I am grateful to be part of the Korean Diaspora Working Group, which started in Evanston, with Anne Joh, Jinah Kim, and Ji-Yeon Yuh, who have shared their brilliance, *jeong*, and love of Korean food with me.

I thank Kaysha Corinealdi, Amina El-Annan, Kathy Foley, Melissa García, Anne Joh, Jinah Kim, Mary Lui, Uri McMillan, Christine Mok, Dassia Posner, Quan Tran, Charlie Veric, and Ji-Yeon Yuh for providing feedback on parts of earlier versions of this project. Patrick Anderson, Aimee Bahng, Herman Beavers, Robin Bernstein, Rhonda Blair, Jennifer DeVere Brody, Kimberly Juanita Brown, Kornel Chang, Tina Chen, Jasmine Nichole Cobb, Soyica Diggs Colbert, Brian Herrera, Jade Huell, Daniel Kim, Jisoo Kim, Jodi Kim, Ju Yon Kim, Tiffany Lopez, Michelle Massé, Paige McGinley, Yana Meerzon, Sean Metzger, Bonnie Oh, Joshua Pilzer, Janelle Reinelt, Freddie Rokem, David Román, C. Riley Snorton, Kim Solga, Al Tillery, Rima Touré-Tillery, and Sara Warner gave me advice, encouragement, and inspiration. Earlier chapter drafts greatly benefited from discussions at Yale University, Brown University, New York University, Northeastern University, Northwestern University, Washington University in St. Louis, George Washington University, the War and Women's Human Rights Museum in Seoul, the 2013 East of California/Association for Asian American Studies Junior Faculty Retreat, the Histories of Violence

Collective's 2013 Histories of Violence Symposium, the 2015 Woodrow Wilson Career Enhancement Fellowship Retreat, and the 2016 Northwestern Summer Institute in Performance Studies.

I have learned so much from my undergraduate and graduate students at Northwestern University. Alícia Hernàndez Grande, Dwayne Mann, Tova Markenson, Jae Noh, Grace Overbeke, Keary Watts, Elynne Whaley, and especially Hayana Kim provided not only invaluable research assistance but also illuminating conversation about my work and their own wonderful projects.

The amazing LeAnn Fields offered guidance and steadfast support, especially because she understood the heart of this book. I thank the anonymous readers of my manuscript who offered astute feedback that made this a richer book. I also thank Christopher Dreyer, Jenny Geyer, and the staff at the University of Michigan Press for their assistance. I thank Dassia Posner for the cover inspiration and Heidi Dailey for the cover design. The fabulous Kate Babbitt helped transform the manuscript during the final revision process. Different parts of the book have also benefited from the editorial eyes of Kelly Besecke, Deirdre Golash, Tisha Hooks, Roxanne Willis, and especially Ellen Goldlust and Jessica Hinds-Bond during the copyediting phase.

All translations from the Korean in the book are mine unless otherwise noted. Hayana Kim, Jae Noh, and Himnae Yoo assisted with many of these translations.

Research for the book was supported by the Yale Council on East Asian Studies; the Yale World Performance Project; the Yale Women, Religion, and Globalization Project; the American Society for Theatre Research; the Northwestern University Undergraduate Research Assistant Program; the Andrew W. Mellon Foundation; the American Council of Learned Societies; and the Woodrow Wilson National Fellowship Foundation. The Woodrow Wilson Career Enhancement Fellowship for Junior Faculty afforded me crucial time to complete this manuscript. I thank Caryl McFarlane and Ina Noble for their stewardship of this fellowship. The Women's Caucus for the Modern Languages awarded me the 2016 Florence Howe Award for Outstanding Feminist Scholarship (Foreign Language) for "Korean Trojan Women: Performing Wartime Sexual Violence" in *Asian Theatre Journal*: an award from this feminist organization means so much to me.

I am grateful to Cambridge University Press and University of Hawai'i Press for permission to use portions of chapters that ap-

peared in earlier versions: Elizabeth W. Son and Joshua Takano Chambers-Letson, "Performed Otherwise: The Political and Social Possibilities of Asian/American Performance," *Theatre Survey* 54, no. 1 (January 2013): 131–39; "Transpacific Acts of Memory: The Afterlives of *Hanako*," *Theatre Survey* 57, no. 2 (May 2016): 264–74; and "Korean Trojan Women: Performing Wartime Sexual Violence," *Asian Theatre Journal* 33, no. 2 (Fall 2016): 369–94.

This journey would have been far less meaningful and joyful without my friends. A special thanks to my colleagues who have been in conversation with me about my work since our days in New Haven and whose own work inspires me: Kathleen Belew; Kimberly Juanita Brown; La Marr Jurelle Bruce; Karilyn Crockett; Melissa García; Amanda Branson Gill; Tisha Hooks; Nicole Ivy; Simeon Man; Monica Martínez; Uri McMillan; Christine Mok; Quan Tran; Charlie Veric; Kaysha Corinealdi, my fellow writing warrior; and Amina El-Annan, who has walked by my side through it all. I am grateful for my friends at Grace Presbyterian Church, especially Diane and Max-Schanzenbach, Jane and Todd Shissler, Patty Oey and Jack Hsu, Alex Doty, Susan and Rob Lien, Allison and Marshall Brown, Caroline and Jason Little, and Doy and Greg Athnos, for loving us and making Chicagoland feel like home. Finally, I thank my best friends, Jenny Cha Lim, Katherine Jo, Dana Ahn Kim, and Eunmo Sung Jeon for standing by my side as my sisters and reminding me of who I am.

I would not be here today without my incredible parents, Hun Bae Son and Eun Hie Paik. My father began the journey from South Korea in 1964, when he sailed across the Pacific Ocean to pursue his studies on a full scholarship in the United States, eventually earning a doctorate. My mother made sure we crossed that ocean in the other direction during summer breaks so we would not forget our roots. I grew up watching my parents give tirelessly to their community: mentoring and hosting Korean graduate students at our home, taking members of our immigrant community to the hospital or to social welfare services, listening to their travails on the phone, and welcoming them with open arms to the weekly lunch feasts at our church in St. Louis. My parents model what it means to live a life of faith and deep commitment to one's family and community. I am so proud to be their daughter. My mother inspires me daily and strengthens me with her prayers, wisdom, and love. When I did not believe in myself, she lifted me up; my mother is truly the wind beneath my

wings. My mother and her sisters, S. H. Paik and M. H. Paik (1956–2013), also exemplify what it means to lead a community with perseverance and grace. I am proud to be in your lineage.

I thank my amazing older brothers, David Son and Key Son, whom I have looked up to my whole life, for their guidance, steadfast support, and love. I am proud to carry the Son name with both of you. I am grateful to have Kate Kimsey in my life as a fellow feminist and sister-in-law. I thank Zamin Yang, Mo Yang, Nancy Chang, and Aram Yang for their loving care and encouragement, and I especially thank my mother-in-law and father-in-law for their support of my research abroad. My nephews and niece, David Son Jr., Nate Son, Oakley Son, Alex Yang, and Zoe Yang, enrich my life; I feel so lucky to be your aunt and will always be here to cheer you on. I am grateful to be part of an amazing extended family of Paiks, Chois, Seos, Yangs, and Sons. I will always be indebted to Misun Oh, Kap Yon Kim, Sue Nam Ahn, Seon Kim, Emily Fung, Emily Na, Amanda Mischevich, and the other wonderful people who have helped to take care of my children over the years.

My best friend and partner, Halla Yang, has lived with this project from the beginning and lifted me up with his gentle encouragement, humor, and love. He celebrated every milestone with me and carefully read parts of this book in its early stages. His devotion to our family and championing of my work helped enable me to pursue my dreams. I could not have done any of this without him. Finally, to my sunshine, Sofia and Isaac, thank you for being you and for bringing so much happiness into our lives. You inspire your *eomma* with your inquisitive way of looking at the world around you, your creativity, your kindness toward others, and your joie de vivre. This book is also for you and your generation, the promise and keepers of a better world.

Contents

xv A Note on Transliteration and the Order of Names

PROLOGUE
xvii Beginnings

INTRODUCTION
1 Reckoning with Histories of Violence and Erasure

27 CHAPTER 1
Embodying Claims for Redress: The Wednesday
Demonstrations

65 CHAPTER 2
Staging Justice: The Women's International War
Crimes Tribunal

103 CHAPTER 3
Redressive Theater: Histories of
"Comfort Women" on the Stage

147 CHAPTER 4
Performances of Care: Memorial Building
in the Korean Diaspora

177 EPILOGUE
Until the End

185 Notes

237 Bibliography

259 Index

A Note on Transliteration
and the Order of Names

For transcribing Korean words into English, I use the Revised Romanization of Korean, the official romanization system endorsed by the Ministry of Culture and Tourism in South Korea. The only exceptions are proper names and surnames well known by other romanization styles.

Following Korean and Japanese convention, surnames precede given names. For example, *Lee* is the last name for *Lee Mak Dal*, and her given name is *Mak Dal*. I follow this practice in the body of the chapters but use given name followed by surname in reference citations for clarity. For subjects who do not live in Korea or Japan, I follow the convention of given names followed by surnames.

Prologue: Beginnings

On October 16, 2007, in a Yale University lecture hall packed with more than two hundred students and faculty, Lee Mak Dal gave her testimony in Korean.[1] I was her interpreter. "I didn't want to go. I wanted to see my mother," she said. Seventeen-year-old Lee, the youngest of three daughters, left her home in Busan in 1940 to follow a Japanese man and a Korean woman who had promised her a job in a factory to support her poor family. Instead, she was abducted and forced into sexual slavery for the Imperial Japanese Army. I busily took notes, grappling with the best way to convey the inflections of her Korean words to the audience. "But they kept on hitting me, and I told them I didn't want to go. And I have these scars," said Lee, describing how her handlers forced her onto a ship bound for Taiwan. Lee touched her cheek below her left eye with her index finger, marking these scars as corporeal evidence of the violence she had endured. "They pushed me and dragged me up the stairs" to the ship. Her voice quivered. I slowed down; my voice became softer as I shared her description of the vessel that transported her to Taiwan. She wiped her eyes as she recalled serving soldiers in makeshift "comfort stations." "They took us somewhere deep in the woods. They would set up tents and put down wooden boards." Lee went on to describe the sexual, physical, and verbal abuse she endured and the atrocities she witnessed during her five years of enslavement.

Japanese military sexual slavery forever transformed the lives of an estimated two hundred thousand girls and young women.[2] The Imperial Japanese Army and Navy forced mostly Asian and Dutch women—euphemistically called "comfort women"—into service for its troops before and during World War II. Like Lee

Mak Dal, these women endured unspeakable violence and anguish during their captivity in what were really just rape camps. These "comfort stations" were constructed in Japan, China, Taiwan, the Philippines, and throughout Japan's occupied territories in Southeast Asia and the Pacific Islands.[3] For almost fifty years, survivors hid their experiences of wartime sexual slavery from the public. Since the early 1990s, however, these women and thousands of their supporters have been advocating for reparative measures.[4]

Activists have pursued political and legal redress that has centered on the Japanese government's acknowledgment of Japanese military sexual slavery, an official apology, and reparations. The Japanese government continues to deny survivors these reparative measures, but redress is not just governed by the state or the courts; it is also reimagined and enacted by ordinary people through embodied forms of expression.[5] At the center of this activism are Lee and other women who have traveled all over the world, giving their public testimony at protests, in courts, at congressional hearings, at conferences, and at universities. This book thus highlights the work of select Korean survivors—Lee Mak Dal, Lee Yong Soo, Gil Won Ok, Kim Bok Dong, and Yi Ok-seon—who have chosen public roles in the social movement and have participated in their own recuperative acts.

The same week that Lee spoke at Yale, I saw *The Trojan Women: An Asian Story* at the Alexander Kasser Theater in New Jersey. I felt a disconnect between the intimate experience of listening to Lee's testimony and the highly stylized and aesthetic representations of life in "comfort stations" in *The Trojan Women*, a theatrical interweaving of Euripides's tragedy with the history of Korean "comfort women." Lee Mak Dal's testimony in the United States demonstrated the courageous and active role survivors have taken in challenging state denials and fighting for justice. More than her trauma formed Lee's subjectivity: her time in the "comfort stations" did not define her as a woman or as a mother to her adopted son. While *The Trojan Women* offered a limited representation of the women's subjectivities, it was a striking rendering of the violence of Japanese military sexual slavery within the long history of wartime sexual violence. Many do not get the opportunity to listen to survivors tell their own stories and encounter these histories through artistic forms such as theater.

Experiencing these performances in the same week made me wonder about the power of embodied practice—how it moves between acts of testimony and artistic expression and how it seeks to express this history of violence through the body. This book puts into conversation various performances that took place in venues from the street to the stage to explore how live embodied forms of expression can alter the ways we imagine and practice a more expansive view of redress. The volume looks at how individuals and local communities inspired by these women have found ways to join the survivors in creating a transnational social movement, raising awareness of institutionalized sexual violence against women, rewriting historical narratives, educating new generations, and building communities.

During her testimony, the edges of Lee Mak Dal's history brushed against my own.[6] To see my own skin next to her soft, wrinkled hand was to witness what could have been in a different time, in a different place, and in different circumstances. Her testimony could have been my grandmother's words, my mother's words, my words. While no one in my family experienced Japanese military sexual slavery, it is a part of my history as a Korean diasporic subject born in the United States. My parents grew up during Japan's colonization of Korea. I heard stories of my maternal grandfather preaching to his congregation as Japanese officials threatened his life. I did not realize until I was a young adult that my Korean was sprinkled with Japanese words such as *tsume-kiri* [nail clipper] and *tamanegi* [onion].

Lee and most of the Korean military sex slaves were taken from Gyongsangnamdo, a province in southeastern Korea full of verdant rice fields nestled between mountains. Lee hailed from Busan, a port city from which handlers could easily transport women across the Japanese Pacific empire. I spent many childhood summers in that city, where my mother grew up. My familiarity with the southern dialect of this region helped me understand and interpret for Lee. Though I have no experiential connection to this history of sexual violence, I feel a strong bond with these women and a sense of responsibility to do something. Many activists, artists, and supporters across the Korean diaspora also share this sentiment.

During Lee's 2007 testimony, I barely held myself together under the weight of her utterances. I scribbled down my translation notes as fast as I could, hoping that what I rearticulated would be a fair ap-

proximation of her courageous words. After her testimony, we sat quietly next to each other as the young activist who accompanied Lee explained the work of her organization to the audience. I do not know how Lee felt after her testimony, but I felt self-conscious and vulnerable. I reached for Lee Halmeoni's hand under the table, and we held on to each other tightly.[7] Nearly a decade later, as I remember that moment, I want to thank her and all the other survivors who have shared their stories with me—Lee Mak Dal, Lee Yong Soo, Gil Won Ok, Kim Bok Dong, and Yi Ok-seon. You all are an inspiration to the world.

Introduction: Reckoning with Histories of Violence and Erasure

"Why is the government making us suffer over and over again by calling this the 'final settlement?'" Lee Yong Soo asked the crowd on December 30, 2015, after taking the stage at a Wednesday Demonstration. "I will keep fighting until the end, until the end!"[1] The crowd responded with thunderous cheers. The faces of supporters peered over the tops of large photographs of survivors who had passed away. Protesters sat facing Lee and another survivor, Gil Won Ok, who were bundled up on a frigid day to attend the last Wednesday Demonstration of the year. Every Wednesday since 1992, survivors and their supporters have gathered across from the Japanese Embassy in Seoul to demand reparative measures from the Japanese government. On this day, the crowd was larger than usual—around one thousand, according to organizers[2]—because they had come together to remember the nine survivors who died that year and to protest the recent agreement between Japan and South Korea to "resolve" the "comfort women" issue.

Earlier that week, the governments of South Korea and Japan had announced that they had reached a "landmark agreement . . . to resolve their dispute over Korean women who were forced to serve as sex slaves for Japan's Imperial Army."[3] The announcement about the agreement by the foreign ministers of Japan and the Republic of Korea included an apologetic statement from Prime Minister Shinzo Abe and a pledge of $8.3 million to create a government foundation to provide "support for the former comfort women."[4] The Korean government also acknowledged the Japanese government's concerns

about a realistically rendered bronze statue of an adolescent girl commemorating the "comfort women" that had been installed across the street from the Japanese Embassy in Seoul and agreed to ask the organization responsible for the statue to consider its removal. The agreement stated that the issue of "comfort women" was "resolved finally and irreversibly."[5] But can such a history of violence ever be resolved "finally and irreversibly"? What could possibly atone for the women's pain and loss?

The agreement demonstrates how the Japanese state narrowly defines redress: it offered monetary reparations and the barest trappings of an apologetic statement. Korean survivors and their supporters responded with disbelief and anger toward both governments, stating that neither the survivors nor their advocacy group had been invited to the negotiating table and that the apology was insufficient. The main Korean organization that supports survivors, Hanguk Jeongsindae Munje Daechaek Hyeobuihoe [The Korean Council for the Women Drafted for Military Sexual Slavery by Japan], released an official statement declaring its reasons for rejecting the agreement.[6] It pointed out that while the prime minister had expressed his apologies through a diplomatic representative, the sincerity of it was questioned. The agreement did not broach the state's responsibility for sexual slavery, only mentioning "an involvement of the Japanese military authorities at that time."[7] "Do you think we've been struggling like this for such a long time out of greed for that 1 billion won?" asked survivor Kim Bok Dong. "What we are demanding is legal reparation. It means that Japan must admit that it committed crimes as a criminal state."[8] In October 2016 Kim and some other survivors publicly rejected the Korean government's attempts to contact them to begin the payments from the Japanese government.[9] Survivors want the Japanese government to take full legal responsibility by acknowledging that the "colonial government and its military had committed a systematic crimze" and that it "actively initiated the activities which were criminal and illegal."[10] They also note that the agreement did not include "preventative initiatives such as truth seeking and history education" and that the removal of the statue cannot be a precondition for the agreement, since it is "public property and a historic symbol representing the peaceful spirit of the Wednesday Demonstrations."[11] One of the most disturbing aspects of the agreement is the push to shut down public discus-

sion of sexual slavery and to impose silence and forgetting. Even as they advocate for state redress, the women and their supporters point to the necessity of public accountability and acknowledgment, education about the history of "comfort women," community building, and memorialization. They call for an expansive view of redress that is legal, political, social, cultural, and epistemological.

All of the remaining survivors are now in their late eighties or nineties and, at some point in the relatively near future, their activism will come to an end. This moment is thus critical for them, and questions concerning redress, representation, and the transmission of memory become more urgent. How are histories of gender-based violence negotiated across cultures and generations? How can one imagine and enact restitution for grievously unspeakable violence outside state parameters? What role does performance play in this process? What are the stakes when we move from the participation of survivors in the social movement to cultural representations of these women? What is the relationship between art and activism? This is the first book to examine the political and cultural aspects of performances—or embodied practices—that address the history of girls and young women who were subjected to sexual enslavement by the Imperial Japanese military.

Performance plays a central role in how diverse actors—survivors, activists, and artists—grapple with and work to redress histories of sexual violence and the erasures of such experiences. The history of Japanese military sexual slavery, a history that centered on the violation of women's bodies, calls for re-presenting, mobilizing, and reinvesting those bodies with meaning through *redressive acts*. I define redressive acts as embodied practices that involve multiple audiences in actively reengaging with traumatic pasts to work toward social, political, cultural, and epistemological change. These visions of justice include the performance of a multifaceted subjectivity for survivors and restoration of their social status, affirmation of ownership over self-narratives, production of knowledge, community formation, and commemoration of the women's history.

This is a process-oriented conception of redress in which change comes to survivors and their supporters not only at the end of the procedure (or *as* the end of the procedure) but also during enactments of redress at live public events. The embodied nature of performance makes it particularly suitable for intergenerational and transpacific

reckonings on street corners, on theater stages, and in public parks. These performances constitute a transpacific redressive repertoire that reflects both the politicization of the "comfort women" cause and the production of redress. This book illuminates how the official erasure of wartime sexual crimes, in which Japan and the United States participated after the war, and Japanese state denials of official redress inadvertently nurtured a transnational movement of activism and artistic intervention that performs restitution through acknowledgment and memorialization. The book uses case studies from South Korea, Japan, and the United States to examine the cultural and political life that has emerged from a history of violence and silence.

The varied sites of redressive performances do not distract attention from claims for more conventional justice. In fact, the public, communal dimensions of such performances have emboldened supporters to push forward the demand for state accountability and broaden how they define what constitutes redress. While insisting on the importance of state accountability, these performances—protests, tribunals, theater productions, and the building of memorials—also point to the limitations of political and legal redress in attending to the social, psychological, and cultural needs of survivors of sexual violence and their communities. Military sexual slavery involved organized mass rape and physical torture on an unprecedented scale. Survivors have contended with the traumatic ramifications of living with this past for more than half a century: a sense of shame, a loss of dignity, a fear of intimacy, and abandonment by family members and communities. Through education initiatives, health and wellbeing activities, and memorialization projects, activists and survivors point the way toward a more expansive view of repair. This book follows survivors, activists, and artists who draw attention to the sociocultural dimensions of redress made possible through protests, tribunals, theater, and memorial building.

Japanese Military Sexual Slavery, 1932–1945

Now it's all in the past, but if I try to speak about the pain we went through, my heart feels like it could burst. They lied to us, said we could earn a lot of money at the factory, "We're go-

ing to make you rich by teaching you skills." But they lied to us, took us when we didn't even know what a factory was, took us to a small room—no, not even a room, not even an attic, just one bed. They pushed us onto one bed and the men lined up. They lined up, so even before you wiped off your bottom the next one came in. That's what they did to those young ones. That became a disease. Now I say this in passing, but what I felt when that was happening to me, I cannot speak of it in words.

—Gil Won Ok[12]

Gil Won Ok, born in Pyongyang in 1928, was just thirteen years old when she boarded a train with a group of girls. Gil, who hoped to support her family, thought they were headed to work in a Japanese factory. Instead, the girls were taken to a "comfort station" in China and repeatedly raped by soldiers. After the teenager contracted syphilis and developed tumors, a Japanese military doctor performed a hysterectomy on her.[13] Although she was unable to bear children, she eventually adopted a son.[14] Gil came forward publicly in 1998 and has since been active in the social movement. A constant presence at the Wednesday Demonstrations, Gil has also traveled the world to give her testimony. In 2014, at the age of eighty-seven, Gil delivered more than a million signatures to the secretariat of the UN Human Rights Council, calling on the organization to advocate for the "comfort women" survivors.[15]

The "comfort station" in which Gil was held captive was part of a larger state-sponsored system of sexual slavery that grew out of increased Japanese militarism and colonial expansion in the Asia-Pacific region between 1931 and 1945.[16] The Japanese army opened hostilities in northeastern China (the Manchurian Incident) in 1931 and in Shanghai (the First Shanghai Incident) in 1932. Also in 1932, the Imperial Japanese Navy and Army established the first "comfort stations" to prevent the raping of local women and limit the spread of venereal disease.[17] After Japan began its full-scale war against China in 1937, the number of "comfort stations" grew exponentially in response to outrage against the sexual crimes Japanese soldiers committed against local women. The growth of "comfort stations" became more systematized when orders started to come from the top ranks in the military and government.[18] In 1942, after the United

States entered the war and the conflict intensified, "comfort stations" spread throughout Southeast Asia and the Pacific Islands. Soldiers and officers treated women like supplies, moving them wherever the military was stationed.

What distinguished the "comfort system" from other militarized sexual violence at the time was its institutionalized, systematic nature and the number and ethnic diversity of the victims.[19] Girls and young women who worked in these "comfort stations" came from Japan, from Japan's colonies, and from its occupied territories in Korea, China, Taiwan, the Philippines, Vietnam, Burma (now Myanmar), and the Dutch East Indies (now Indonesia and East Timor).[20] The majority of these women came from Korea, a colony of Japan.[21] The Korean women ranged in age from eleven to twenty-eight, though the majority were between fourteen and nineteen.[22] Most of the young women came from poor families, lived in rural areas, and were searching for work in factories and hospitals. Instead, the Japanese military and its operatives such as local police and local procurers inveigled or forced the young women into working in "comfort stations." These stations were housed in existing buildings or structures built solely for the purpose of providing a place where soldiers could obtain sexual services. Like Lee Mak Dal, some women were forced to follow troops to the front lines and sexually serve them in the mountains.[23] Both the military and civilian operators managed "comfort stations."[24]

The girls and young women served anywhere from ten to forty men a day under dire conditions.[25] The sexual abuse was relentless. "Doing it night and day, is that life? That's death," shared Lee Mak Dal. "I didn't know if my lower parts were still there, still alive or dead."[26] Confined to their living quarters, "comfort women" were also subjected to beatings, mutilation, starvation, invasive medical checkups and procedures, and forced abortions.[27] "And after we went through all that suffering," Lee explained, "they beat us up for not doing well, we were almost dying. They didn't know whether we would all die today or tomorrow, so they had no mercy."[28]

As the end of World War II approached, Japanese military officers ordered the destruction of documents of their potential wartime criminality.[29] As troops retreated, they sometimes killed the women or abandoned them on battlefields.[30] In Micronesia, the army killed seventy women in one night because "they felt the women would be

an encumbrance or an embarrassment were they to be captured by the advancing American troops," explained UN special rapporteur Radhika Coomaraswamy who authored the first UN report on the "comfort women" in 1996.[31] Some of the women committed suicide. Others remained where they were. Many, like Lee Mak Dal, managed to return to their home countries. "My mother didn't sleep for days and nights and just prayed. 'Please just come back alive.' She prayed every day," explained Lee. "My mother saw me and fainted. She fell to the ground because she was shocked."[32] Lee did not tell me whether she shared her experiences in the "comfort stations" with her mother. Upon their return, many women were too ashamed to share their secret with their kin, and many families and neighbors ostracized returning women. At the state level, an official forgetting of the "comfort women" started to set in. During the International Military Tribunal for the Far East (known more familiarly as the Tokyo War Crimes Trials), US-led Allied officials glossed over crimes of sexual violence, focusing instead on atrocities inflicted on Allied nationals.[33] As Japan rebuilt itself as a pacifist nation and became a Cold War ally of the West, there was little discussion of its wartime culpability.

For almost five decades, public and personal silence shrouded this history of sexual violence.[34] In the 1990s, however, survivors began coming forward, galvanizing the social movement for redress that was forming in South Korea.[35] The combination of post–Cold War political change, democratic reform in South Korea, and feminist organizing around the issue of sex tourism in Korea and Japan led to growing awareness of and interest in Japanese military sexual slavery.[36] During the 1987 International Sex Tourism Seminar on Jejudo (Jeju Island, South Korea), Professor Yoon Jeong-Ok, who later became cochair of the Korean Council for the Women Drafted for Military Sexual Slavery by Japan, gave the first presentation on the "comfort system" to Koreans. The next year, she gave her presentation to an international audience at the Women and Sex Tourism Culture Symposium on Jeju Island.[37] She brought the history of wartime sexual slavery to the attention of Korean and Japanese participants, helping them "see the underlying connection between the issues of the 'comfort women' in colonial Korea and the kisaeng [sex] tourism in contemporary Korea," anthropologist C. Sarah Soh explains.[38] During South Korean President Roh Tae-woo's official visit

to Japan, activists urged the Korean government to request that the Japanese government investigate Japanese military sexual slavery.[39] The activists also issued a list of demands to the Japanese government, but the Japanese government refused to investigate the issue, asserting that the "comfort system" was a private enterprise.[40]

Women—particularly those from Christian, academic, and feminist backgrounds—responded to Japan's denials by organizing a campaign for redress. On November 16, 1990, they established the Korean Council for the Women Drafted for Military Sexual Slavery by Japan, an umbrella organization for thirty-seven women's groups.[41] The first survivor to testify in public was Kim Hak-soon, who came forward at a press conference on August 14, 1991.[42] Soon after, more survivors came forward in Korea. These women have become the center of what is now a transnational social movement spearheaded by the Korean Council. Over the past twenty-five years, 238 former "comfort women" have come forward in South Korea and officially registered with the government.[43] As of October 2016, only forty of these women were still alive.[44] The Korean Council has organized protests, petition drives, and domestic and international campaigns to inform the public about the history of the "comfort women" and to ask for official redress from the Japanese government. They have also led seminars and educational projects in schools, opened the War and Women's Human Rights Museum in Seoul in 2012, and provided survivors with welfare services such as counseling, medical support, and home visits.[45]

Because of the activism of survivors and the growth of alliances among nongovernmental organizations, the social movement has become global. Activists maintain transnational ties through conferences, solidarity protests, and political initiatives. Korean Council members have networked with activists from around the world—especially Japan, the Philippines, Taiwan, and the United States—in campaigns for formal redress from Japan. For example, Filipina activists from Liga ng mga Lolang Pilipina [League of Filipino Grandmothers] and Taiwanese activists from the Taipei Women's Rescue Foundation have collected oral testimony and provided welfare services for survivors in their respective countries.[46] These organizations as well as others from Indonesia, China, Timor-Leste, Hong Kong, and the Netherlands meet each year at the Asian Solidarity Conference. They have also organized joint events, such as the Women's Interna-

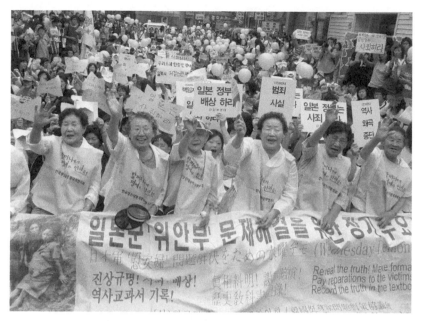

Fig. 1. Survivors (*left to right*) Lee Mak Dal, Gil Won Ok, Lee Soon-duk, Lee Yong Soo, Jang Jeom Dol, and Park Ok-sun at the Wednesday Demonstration on August 15, 2007, in Seoul. Photo by Lee Jin-man. Courtesy of the Associated Press.

tional War Crimes Tribunal on Japan's Military Sexual Slavery (2000). Many activists from outside Korea attend the Wednesday Demonstrations and coordinate solidarity protests in their home countries. Activists with the Korean Council also travel with survivors to international events and use international platforms, such as the UN Commission on Human Rights, to advocate for state redress from the Japanese government. "My body being crippled," explained Lee Mak Dal, "I can't let go, can't let go, can't let go. Those, those sons of bitches, I have not avenged what happened to me."[47] For Lee Mak Dal and other survivors, the past remains an open wound, and the desire for justice is fierce.

Two of the central demands of the survivors and activists are an official apology in the form of a resolution from the Japanese Diet and legal reparations. For the survivors, legal reparations means that the funds come from the government and that the compensation is coupled with an unequivocal statement taking responsibility for systematic criminal and legal violence. These demands are

part of a larger call for Japan to take moral and legal responsibility for its system of military sexual slavery. The Korean Council has put forth seven demands to the Japanese government: "1. Acknowledge the war crime; 2. Reveal the truth in its entirety about the crimes of military sexual slavery; 3. Make an official apology; 4. Make legal reparations; 5. Punish those responsible for the war crime; 6. Accurately record the crime in history textbooks; 7. Erect a memorial for the victims of the military sexual slavery and establish a historical museum."[48]

The two central demands fit what legal scholar Roy Brooks formulates as the "atonement model."[49] "Reparations are essential to atonement, because they make apologies believable," explains Brooks. "They turn the rhetoric of apology into a meaningful, material reality and, thus, help to repair the damage caused by the atrocity and ensure that the atrocity will not be repeated."[50] As material expressions of redress, reparations make the apology believable. Many survivors and activists do not find apologetic statements from the Japanese government believable; they feel that such statements are undercut by acts such as the prime minister's visits to Yasukuni Shrine, which honors the war dead, including a number of war criminals.

Survivors and activists would like the Japanese state to meet all seven demands, although this may never happen. Activists and survivors presumably know this, yet they continue to push for state recompense because of a belief that representatives of the perpetrators should take responsibility for the violence. At the same time, Korean Council activists, survivors, and their supporters are meeting some of these demands for redress through an investigation of the "comfort system" and a symbolic indictment of perpetrators at the Women's International War Crimes Tribunal on Japan's Military Sexual Slavery, education at seminars and at the War and Women Human Rights Museum, and commemoration through the bronze girl statue. They powerfully demonstrate that the Japanese government does not have the sole power to make change. Furthermore, they express an elastic view of redress that goes beyond state and legal parameters.

Survivors emphasize different parts of the multivalent call for redress. "Our youth won't come back even if they recompense; our bodies aren't going to be revived," explained Gil Won Ok. "I don't

know how many years I have left, but even if it's just a little, I want to live like a real person, so we want redress and the apology to resolve our *han*"—the Korean concept for the knotted feelings of resentment, sorrow, indignation, and injustice that build over years of hardship and oppression.[51] Gil added, "To raise our country. That's why we want an apology. We want to make Korea a strong country, a real peaceful country."[52] Gil articulates the impossibility of complete redress for her loss; she can never have her youth or her young body back. Gil thus sees redress from the Japanese government as providing her with dignity—that is, the ability to "live like a real person."

In describing what she and other survivors want from the Japanese government, Gil uses the Korean word *baesang*, which translates as "redress," "reparation," "recompense," or "remedy." It has a more capacious meaning than the Korean word *bosang* (compensation in the monetary sense), including the idea of making up for the loss of something. This redress is not simply for her; it would enable the entire Korean nation to become stronger and more peaceful. Though her sentiments may contain articulations of patriotism, Gil is primarily conveying that redress is not simply personal but rather is about larger, collective change. Invoking the nation becomes a way for her to articulate her private injury as a public grievance. Most important, she positions herself and other survivors as the co-agents of change for peace. For Gil, peace means a world without wars where women are vulnerable to sexual violence. "If this world wants peace, if one wants a country without war, if one doesn't want the painful things that happened to us to repeat," she explained, "the Japanese need to repent, for peace, whatever it takes."[53]

To this day, the Japanese government refuses to take full responsibility for the institutionalized, state-sponsored system of sexual slavery its military created. Not until 1992, when Japanese historian Yoshimi Yoshiaki unearthed incriminating evidence at the Defense Agency library in Tokyo, did the Japanese government stop denying the existence of the "comfort system." Some Japanese government officials have subsequently acknowledged the existence of the "comfort stations" but have obfuscated the government's role in their operation.[54] In 1993, Chief Cabinet Secretary Yohei Kono acknowledged the existence of "comfort stations," admitted that many women had been recruited against their will, and offered an apology on behalf of

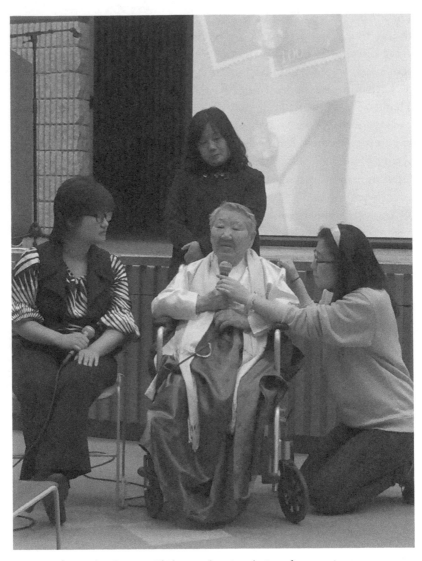

Fig. 2. Survivor Gil Won Ok (*seated, center*) gives her testimony at George Mason University on March 16, 2016. The event was organized by Elly Park/Nabi USA–Washington D.C. (*to Gil's left*). Elizabeth Cho (*to Gil's right*) interpreted for Gil, with assistance from Yoon Mee Hyang of the Korean Council for the Women Drafted for Military Sexual Slavery by Japan (*behind Gil*). The event was part of Gil's US tour to meet with UN Secretary-General Ban Ki moon and Korean American communities in New York and Virginia. She gave her public testimony at George Mason University and American University. Photo by Elizabeth W. Son.

the Japanese government. His remarks have become known as the Kono Statement, and many politicians have stood by it. Many survivors, however, refused the statement because the Japanese Diet did not officially approve it. The statement was also worded to obfuscate the government's role in the system and to shield the Japanese government from legal responsibility for the war crime. After the Kono Statement, the Japanese government established the controversial Asian Women's Fund (1995–2007) to express its remorse and moral responsibility.[55] However, many survivors and the Korean Council adamantly rejected the fund because most of the money came from donations rather than from the Japanese government. In addition, the Japanese government remained unwilling to accept legal responsibility for the state's direct involvement in military sexual slavery.[56] In 2007, Prime Minister Shinzo Abe stated that he adhered to the 1993 Kono Statement but then "undercut [his words] by asserting that there was no evidence showing the military's role in forcing women into sexual slavery."[57]

Survivors and activists say apologetic gestures by the Japanese government are further undermined by the prime minister's visits to Yasukuni Shrine and other official acts. In addition, the government selectively censors narratives of Japanese war crimes in secondary school textbooks.[58] When pushed into a corner about reparations, Japanese politicians claim that when South Korea signed the 1965 Treaty on Basic Relations between Japan and the Republic of Korea, it forfeited Korean citizens' right to demand financial reparations from Japan for World War II–related crimes.[59] However, activists and the Korean government argue that the treaty does not fully address Japan's responsibilities for its actions during the war, primarily because it does not "officially dea[l]" with military sexual slavery.[60]

While leading the continuing challenge to the Japanese government's evasion of responsibility for what happened to the "comfort women," the Korean Council faces criticism. Some opponents characterize it as a nationalistic group or a left-wing organization with "close ties to North Korea" that is trying to incite anti-Japanese sentiment with its propaganda; others say the council is a major impediment to reconciliation in the region.[61] Detractors represent the survivors not as activists but as passive "grandmothers" who are misinformed or even manipulated by their supporters.[62] This book emphatically pushes back against these gross misrepresenta-

tions and illuminates the complex work of the activism in support of survivors.

Embodied Reckonings

This book's title, *Embodied Reckonings*, captures the way I understand how survivors, activists, and artists contend with the history of the "comfort women." In this book, I challenge the centrality of logos-centric expressions of the pain of the "comfort women" survivors. As Asian studies scholar Chungmoo Choi argues, the "women's corporeal experience lies at the core of the comfort women issue" because their "pain has registered on their bodies and memories."[63] Words alone fail to communicate the traumatic ramifications of this kind of past. Understanding the work of survivors and their supporters to reckon with that trauma requires attending to their embodied acts. My use of the word *reckoning* draws on definitions from the *Oxford English Dictionary*: "the action or an act of giving or being required to give an account of something"; "a time when the consequences of an action must be faced." Reckoning invokes the settling of accounts or wrongs and expands to a more capacious sense of "grappling with" or "coming to terms." This continual process of reckoning on the part of survivors and their supporters happens through the body. The multiple performances for and as redress constitute a reckoning.

This book builds on the literature on performance, human rights, and justice as exemplified by the work of performance scholars Diana Taylor and Catherine Cole.[64] The volume looks at how age functions as a vehicle for introducing different notions of embodiment to narratives of sexual trauma. In their elderly bodies, the women offer survival, resilience, and remembrance. Grandmotherhood helps structure social relations and the exchange of memory between survivors and their supporters. In her analysis of the *madres* [mothers] and *abuelas* [grandmothers] of the "disappeared" in the Plaza de Mayo in Buenos Aires, Taylor illustrates the limitations of performing gendered roles in public spaces when the state and patriarchal society overdetermine notions of motherhood and femininity.[65]

In Korea, however, the age of the survivors has worked in the opposite direction. The aging female body confounds Korean cul-

tural tropes. For example, the aged female body does not easily fit into a narrative that analogizes the colonial-era violation of young female bodies as national injury. Instead of being limited by their gender, the survivors have found freedom to communicate new messages.

In response to Cole's point that scholars in the field of theater and performance studies need to more fully analyze the "public, performed dimensions" of scenes of transitional justice such as South Africa's Truth and Reconciliation Commission,[66] I examine the verbal and the nonverbal, the embodied facets of testifying in different sites where meaning manifests in attempts to walk, the touching of scars, or the wiping of tears. Close attention to embodied performances of testimony illuminates the ways survivors use their aged, scarred bodies to push against the frameworks of the Women's International War Crimes Tribunal on Japan's Military Sexual Slavery, for example. Their performances at the tribunal provide new insight into how we understand the relationship between gender, evidentiary proof, and embodiment.

Moving beyond nation-bound negotiations of violent pasts, this book examines how subjects inspired by the "comfort women" cause have grappled with the personal, communal, national, transnational, and institutional politics of memory as they imagine redress through activism and artistic works. The volume joins a growing body of scholarship on Asian performance and politics spearheaded by performance studies scholar Suk-Young Kim.[67] Like Kim, I examine how state politics manifests in and is contested in the everyday performances of ordinary citizens.

This book builds on the work of transnational Asian American studies scholars Lisa Yoneyama and Cathy J. Schlund-Vials in extending cultural theorist Lisa Lowe's framework of the "tireless reckoning" with America's imperial past to transpacific cultural practices of memory and justice.[68] In the case of the "comfort women" history, this reckoning has to contend with what Yoneyama calls the "transpacific arrangement of Cold War justice."[69] Japanese state denials of the "comfort women" history tell only part of the story of the multinational silencing of Japanese wartime criminality. The United States is implicated in official postwar erasures of sexual war crimes during the Tokyo War Crimes Trials (1946–48), inadequate postwar settlements for Japanese war crimes, and involvement in the "after-

life" of militarized sexual labor and violence in Japan and South Korea (1945 to the present).[70]

Through their embodied engagements with the "comfort women" cause, survivors, activists, and artists imagine and enact recompense for loss imposed by war and the official silence surrounding the system of institutionalized sexual violence.[71] My analysis of their work is influenced by Schlund-Vials's description of Cambodian American memory as a "generational impulse to constantly remember the forgetting as an alternative means to justice, reclamation, and reparation."[72] By focusing on live, public enactments and interactions between performers and audiences, I probe more deeply into the embodied aspects of remembrance and how the everyday of activism *and* artistic work can become a site of vibrant change that also confronts the amnesia of transnational politics. In doing so, this book makes an important contribution to the rich body of scholarly work on Japanese military sexual slavery.

Few scholars have examined the interplay between political activism and artistic expression in relation to the "comfort women" history. The literature on the "comfort women" has primarily focused on the history of the "comfort system," on the activism that developed with and around survivors, on questions regarding state redress, on gender politics, on the politics of memory, and on cultural representations of the "comfort women" history in literature and the visual arts.[73] Performances about military sexual slavery have been an underexamined site of cultural production. The work of ethnomusicologist Joshua Pilzer is one exception to this generalization: his study of songs in the lives of three survivors showcases how they articulate their selfhood and build relationships through singing.[74] This book takes a closer look at how survivors have taken active roles in rescripting their legacy and advocating for justice. These victims of sexual violence are not helpless or passive; they bring their full humanity and agency to their own recuperative acts. Through their corporeal presence and action, survivors and their supporters embody their dreams for and practices of justice.

"Comfort Women": Nomenclature and Identity

Lee Yong Soo told me, "I am not a 'comfort woman.' I always tell people that I am Lee Yong Soo, a name my mother and father created

for me."[75] She rejects the label "comfort woman" as an identity category, insisting that people know her name. The Korean Council officially uses *ilbongun wianbu* [Japanese military's "comfort women"] for what the women were called and *ilbongun seongnoei* [military sexual slavery by Japan] to describe the women's experiences.[76] During a July 2012 briefing on the Japanese occupation of Korea, US Secretary of State Hillary Clinton corrected a State Department official who referred to "comfort women" and said that they should be referred to as "enforced sex slaves."[77] *Sex slave* may be a more accurate term to describe the women's wartime condition, but some survivors have objected to its explicitly demeaning quality.[78]

I use the term "comfort women" because it is the most legible to an international audience as a historical term, but it is always in quotation marks to convey my unease about using the euphemism. Many Korean survivors choose to be called *halmeoni* [grandmother]. In the book, I often use *survivor* to refer to the women to emphasize their postwar and contemporary status as women who have lived through Japanese military sexual slavery. The book demonstrates how the category of survivor is just one facet of the multilayered experiences and identities these women use to hold perpetrators accountable and to draw attention to sexual violence worldwide.

At the core of the development of the "comfort women" activism and the expansion of what constitutes redress is the survivors' active involvement in staging their reparative demands. They perform many different identities: victim, survivor, living witness, *halmeoni*, history teacher, and peace protester.[79] These categories create many ways for the public to support them and their cause.[80] Although the public often views former "comfort women" as living embodiments of the history of Japanese military sexual slavery, doing so risks constructing a limited subjectivity for the women that does not see them as independent of their wartime experiences. It is important to remember that these women were for decades denied their claim to victimhood.[81] Occupying the position of victim in the social movement became an empowering act of agency for these women.[82] It was also a political necessity: to make redressive claims against the Japanese state, the women needed to claim their status as victims. From that position, the survivors reclaim their wartime experiences and rewrite history. In the face of denials—such as the contention of Prime Minister Shinzo Abe and other conservative Japanese politi-

cians that the military was not involved in coercing women into sexual slavery—claiming victimhood became the reclamation of history. In drawing attention to their wartime victimization, the women claimed their agency to bear witness. Such actions led to the formation of communities of remembrance that continue to challenge this silenced history.

The "comfort women" history and cause are always at risk of co-optation by other interests. It is a precarious narrative that could too easily dissolve into a nationalistic narrative of woman as nation, personal injury as national injury. The people who attend testimonial events, protests, and stage productions come for many reasons. Some harbor anti-Japanese sentiment, some advocate for women's rights, but most come out of sympathy and support for the survivors. Nationalism also does not define the work of activists from the Korean Council and other organizations, who genuinely care for the survivors and tirelessly advocate on their behalf. In fact, as sociologist Na-Young Lee points out, "Korean Council activists have long raised questions about ethnic nationalism, militaristic sexual culture, colonial legacy, and sexual violence."[83]

Survivors and Korean Council activists invoke an elastic conceptualization of victimhood in which the women claim ownership of their pasts and channel their wartime victimization into speaking against other injustices. Kim Bok Dong and Gil Won Ok started the Nabigigeum [Butterfly Fund] in 2012 to help female victims of sexual violence during armed conflicts.[84] They have promised that if they receive reparations from the Japanese government, they will donate the money to other victims of sexual violence. During protests and on trips abroad to give their testimony, they encourage supporters to make donations to the Butterfly Fund, and supportive organizations hold fund-raising events. In 2013, Kim and Gil donated the money they had raised to rape victims in the Congo and to the Vietnamese survivors of sexual violence committed by Korean soldiers during the Vietnam War.[85] They also called on the Korean government to make reparations to the families of civilians who were massacred and to the victims of sexual violence its troops committed between September 1964 and March 1973.[86] The activist survivors of Japanese military sexual violence have crafted new identities for themselves as advocates for other women who have been traumatized by sexual violence.

Performing Redressive Acts

Through their bodily presence and their actions, survivors and their supporters embody their visions for justice through redressive acts. Concepts like justice and redress depend on performance for their actualization or fulfillment.[87] My conception of redressive acts is influenced by critic E. Tammy Kim, who writes that "many survivors ask for more in the way of symbolic, prospective reparations, pointing to a thick, holistic model of reparative action that encompasses official/ritualized apology, material restitution, public memorialization, and accurate historical education."[88] Kim sees "dialogic performances" as taking place between Japan and the women, between "aggressor and victim."[89] I situate these performances between multiple performers and audiences as a way of displacing the state as the main arbiter of redress. My framework focuses more on the process of redress, of remedial actions. Collective participation and involvement in the process bring about possibilities for redress.[90]

Re-dress—as in the continual dressing of or attending to a wound—is a repetition of a remedial gesture. Repetition is at the heart of performance. Performance studies scholar Richard Schechner points out that "performance means: never for the first time. It means: for the second to the nth time."[91] The potential for redressive measures lies in the continual iteration of actions. However, redress is always already an incomplete project; failure is inherent in the project of redress because of the irreparability of the wound.[92] Looking at both redress and performance brings to mind the work of anthropologist Victor Turner, who argues that "social dramas" have four phases of action: a breach of established norms or social relations, a crisis, redressive action, and reintegration.[93] However, I do not see a linear progression in redressive acts. A sense of complete restoration is continually stalled. In fact, it may never happen. Yet the desire for repair drives efforts to obtain redress to the "nth time."[94] The incompleteness, the seeming failure, of state redress efforts helps to generate other possibilities for change.

I approach the body as both a living "crucible of experience and an expressive instrument," as dance scholar Mark Franco puts it.[95] Focus on the lived body is not about mere physicality; it is also about looking at the body as it moves through the world. It is about what the body experiences, expresses, and remembers. A performance-

oriented lens also focuses attention on questions of audience participation and the mise-en-scène. Redressive acts effect redress because of live, embodied encounters between Self and Other. They engage multiple audiences, giving both individuals and communities material ways to join in the process of contending with traumatic pasts.

Transpacific Redress, Politics of Memory, and Communities of Remembrance

This book examines the sites of redressive acts that cross national, political, and cultural borders. The transpacific framework I use identifies the political, social, and cultural spaces carved out by the Asia-Pacific war(s), the geography of "comfort stations," the social movement for redress, and the cultural productions that traverse the Pacific.[96] Influenced by comparative literature scholars Françoise Lionnet and Shu-mei Shih's framework of transnationalism, I look at "minor cultural articulations in productive relationship with the major (in all its possible shapes, forms, and kinds), as well as minor-to-minor networks that circumvent the major altogether."[97] My focus on "minor-to-minor" networks of activism and artistic collaboration in multiple places allows me to concentrate on *transpacific redress* in the embodied performances of survivors, activists, and artists in South Korea, Japan, and the United States. These subjects work against militarization—an "extension of colonialism and its gendered and racialized processes" and "a structuring force that connects the histories of the Japanese and US empires across the regions of Asia and the Pacific Islands," as cultural studies scholars Setsu Shigematsu and Keith L. Camacho elucidate.[98] Transpacific redress consists of political, social, and cultural formations that emerge from redressive acts that germinate and accrue over time and space.

While I also look at the work of Japanese and non-Asian subjects, I primarily focus on Korean and Korean American subjects. I do not wish to imply that the experiences of Korean survivors are representative of the experiences of all women affected by Japanese military sexual slavery or that Korean activists and survivors should dictate the terms of redress for survivors in other countries. However, concentrating on Korean and Korean American subjects allows me to

map the personal, collective, and national politics and desires driving people to engage in activism and artistic practice.

The public embodiment of memory and its relation to community formation are important to this study. "Dealing with memories entails paying attention to remembrance and forgetting, to narrative and acts, to silences and gestures," writes sociologist Elizabeth Jelin.[99] Looking at the co-constitutive nature of memory and forgetting requires attending to a broader range of expressions that includes acts and gestures.[100] A transpacific genealogy of redressive acts illuminates how different subjects grapple with remembrance and forgetting. "Genealogies of performance also attend to 'counter-memories,' or the disparities between history as it is discursively transmitted and memory as it is publicly enacted by the bodies that bear its consequences," writes theater and performance studies scholar Joseph Roach.[101] Bearing the consequences of memory, survivors share what Roach calls *epochal memory*, which is "specially marked by the limits of generational recollection."[102] For survivors, "to perform an act of remembrance and to possess a means of memorialization become equivalent to demonstrating power and autonomy," as Yoneyama articulates.[103] The women's acts of remembrance are central to their public activism.

Communities of remembrance are sustained and nurtured by the involvement of nonstate actors in activism, theater, and memorial building. These varied pursuits are the sites of collective reckonings necessitated by histories of violence like Japanese military sexual slavery. As literary scholar Viet Thanh Nguyen writes, "Given the scale of so many historical traumas, it can only be the case that for many survivors, witnesses, and inheritors, the past can only be worked through together, in collectivity and community, in struggle and solidarity."[104] Nguyen draws attention to the necessity of a transgenerational accounting of historical traumas for "many survivors, witnesses, and inheritors." Communities of remembrance may be disparate in their identification, politics, and strategies—yet they are connected by the actions of remembrance in the pursuit of justice.

* * *

From June 2007 to March 2016, I conducted archival research and periods of ethnographic fieldwork that involved longitudinal connec-

tions with multiple communities. I attended Wednesday Demonstrations in Seoul and visited with survivors at Our House in Seoul and the House of Sharing in Gwangju City. I examined digital and print archives at the Korean Council for the Women Drafted for Military Sexual Slavery by Japan in Seoul and the Women's Active Museum on War and Peace in Tokyo. I attended productions of *Nabi* and *Bongseonhwa* in Seoul and Chicago, respectively, and *The Trojan Women: An Asian Story* in Montclair, New Jersey, among other productions. I participated in survivors' testimonial events in Seoul, Los Angeles, New Haven, Chicago, and Fairfax; solidarity protests in Chicago; and memorial dedication ceremonies in Palisades Park, Hackensack, and Glendale. My research also included interviews with survivors, activists, directors, choreographers, and community members in South Korea, Japan, and the United States.

Merging cultural studies and performance theory with a transnational and feminist analysis, this book offers ways of reconceptualizing predominantly legal and political understandings of redress that tend to concentrate on institutionalized state forms of remediation. It refocuses attention on the actions of ordinary people—particularly women who identify as survivors, activists, or artists—who have taken reparative measures into their own hands. In my research on the topic of the "comfort women," I have striven to practice what theater scholars Jill Dolan and David Román model—critical generosity—an attention to the "context and ambition of the performances under discussion," as Román puts it.[105] Writing about AIDS performance, Román notes the "sensitive critical dance" between "honoring the intentions of progressive cultural work and pointing out its limitations or failures."[106] For me, the "critical dance" triangulates three activities: honoring the aspirations and intentions of my subjects, analyzing the weaknesses and failures of their progressive movement with a critical eye, and working to understand the complexity of their efforts. The greatest challenge of generous criticism on this topic is to keep the focus on the survivors, the women at the center of it all.

The first two chapters illustrate how activists, survivors, and their supporters use performative strategies to advocate for official reparative measures. These activities broaden our concept of what constitutes redress to include the performance of a multifaceted subjectivity, the reclamation of personal narratives, the production

of historical knowledge, and the formation of communities of remembrance. Performances such as the Wednesday Demonstrations and the Women's Tribunal reflect and play significant roles in the growth of the social movement. The second part of the book shifts the focus to stage productions and memorials, considering aesthetic reinterpretations of survivors' experiences. Throughout the book, I consider how different subjects reflect on and perform different senses of redress—governmental, legal, symbolic, epistemological, cultural, and social. The volume provides a critical framework for understanding how actions designed to bring about redress move from the political and legal notions of this concept to its cultural and social possibilities.

Chapter 1, "Embodying Claims for Redress: The Wednesday Demonstrations," introduces the Wednesday Demonstrations and how these protest performances allow survivors to embody historical and redressive claims in a public arena. The Wednesday Demonstrations are one of the longest-running street protests in the world. These protests have been the main vehicle through which the "comfort women" social movement has garnered both domestic and international support. Drawing on archival documentation of protest material and photographs at the Korean Council; print and online news articles; interviews with activists, survivors, and protesters; and my own participation in the rallies in 2007, 2008, and 2013, I show how the Wednesday Demonstrations function as performances for and as redress for survivors. These weekly protests have transformed the public space in front of the Japanese Embassy into a redressive arena, where protesters imagine and practice social redress through education on the street about history and the cultivation of reparative communities through intergenerational and transnational coalition building.

In Chapter 2, "Staging Justice: The Women's International War Crimes Tribunal," I turn to another site of redressive action, the Women's International War Crimes Tribunal on Japan's Military Sexual Slavery, which was held on December 8–12, 2000, in Tokyo. While the Wednesday Demonstrations helped reframe private injury as public grievance in South Korea, the Women's Tribunal brought transformation to a global stage. The Women's Tribunal brought together an unprecedented number of survivors from a range of countries, illustrating the widespread, systematic nature of Japanese mili-

tary sexual slavery, and presented a comprehensive legal (albeit symbolic) case against the Japanese government. Sixty-four survivors testified to their experiences, demonstrating their solidarity with each other and with women affected by current sexual crimes. Drawing on tribunal documents, interviews, and archival footage of the tribunal, I show how a performance-oriented lens illuminates the centrality of performative methods to the Women's Tribunal and to the critical work survivors accomplished in their challenges to legal protocol and their assertions of their subjectivity.

Artists have grappled with the "comfort women" history in a range of media, including literature, visual art, documentary film, dance, and theater.[107] The cultural phenomenon of the growing number of theatrical productions about the "comfort women" history since the 2000s speaks to the desires of artists to hold on to the rapidly decreasing numbers of elderly survivors, reembodying their presence and transmitting their history through the live medium of stage productions. Theater also uncovers that which is often unspoken during protests and legal proceedings—the affective negotiations of living with trauma for survivors and their families.

Chapter 3, "Redressive Theater: Histories of 'Comfort Women' on the Stage," discusses the work of theater to reckon with Japanese military sexual slavery and its legacy. I look closely at four theatrical works—Korean American playwright Chungmi Kim's *Comfort Women* (2004); the Korean translation of Kim's play, *Nabi* (2005–9); Aida Karic's *The Trojan Women: An Asian Story* (2007); and Korean playwright Yoon Jung-mo's *Bongseonhwa* (2013, 2014). In productions of *Comfort Women/Nabi*, Korean history itself migrates as the plays depict the transpacific journeys of immigrants and "comfort women" survivors who have traveled the world to give their public testimony. *The Trojan Women*, an international collaboration between a Bosnian-born director and a Korean choreographer, composer, and theater troupe, merges testimony with shamanic ritual movement. It premiered in Austria and then toured the United States and South Korea. *Bongseonhwa* focuses on a multigenerational conflict over remembering a matriarch's past as a "comfort woman." It was first staged in Seoul in 2013 and then toured to Washington, D.C.; Glendale, California; and Chicago in 2014, shadowing memorial-building efforts in these cities. In performing "comfort women" histories, the artists involved in these

productions foster a space for narrating forgotten histories and critiquing structures that enable such amnesia. The interventions these works accomplish lie not just in what they represent and render onstage, but also in how they help constitute a transpacific cultural remembrance of sexual slavery under the Japanese military and its lasting social and cultural impact.

In the final chapter, "Performances of Care: Memorial Building in the Korean Diaspora," I discuss memorial building by Koreans and Korean Americans in Seoul; Palisades Park, New Jersey; and Glendale, California. As fewer survivors are able to participate in the Wednesday Demonstrations, supporters are putting more energy into memorialization projects. Seoul is home to the original bronze girl statue, the most well-known "comfort women" memorial. Palisades Park is the site of the first "comfort women" memorial in the United States, and Glendale is home to the first bronze girl statue outside Korea. My analysis is based on ethnographic fieldwork in 2010 and 2013 at protests and dedication ceremonies in these three cities; interviews with artists, politicians, and community members; and news articles, ceremony programs, and pamphlets. I am particularly interested in how these memorials invite performances of care, embodied acts that materialize concern and interest through providing for the needs of or looking after what one is caring for—in this case, memorials. People come by and dress the bronze girl statue in warm clothes during the winter in Seoul and carefully tend to the landscaping around memorials in the United States. An examination of the life of these memorials in their respective communities brings to light a nexus of individual, collective, and national desires over the commemoration of the "comfort women" history and activism.

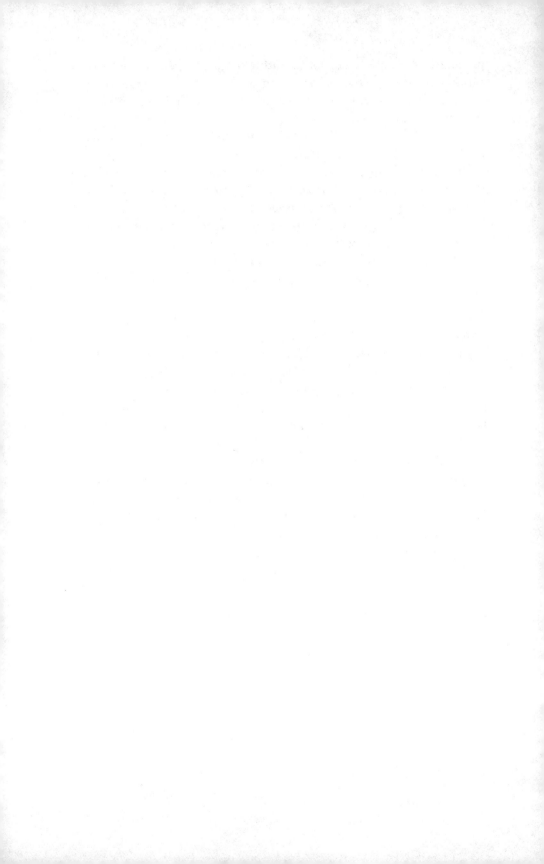

Embodying Claims for Redress: The Wednesday Demonstrations

"Listen, you bastards!" Lee Yong Soo shouted into the microphone as she gathered with others in protest across from the Japanese Embassy in Seoul on March 15, 2006. Turning her body toward the building, Lee continued, "We're here again. This is our 700th time out here. I can't die until the *han* of the shame and dishonor inside of me from having suffered at the hands of you bastards when I was just sixteen years old is released."[1]

Lee was translating her memories of sexual violence and her sixty-year grievance into *han*, the Korean concept for the knotted feelings of resentment, sorrow, indignation, and injustice that build over years of hardship and oppression. Born in 1928 to a poor family, Lee was just a teenager when she was inveigled into sexual enslavement as a "comfort woman."[2] She left behind her parents and five brothers, four of whom she looked after while her mother worked as a wet nurse for a wealthy local family.[3] Taken to Taiwan, Lee endured repeated rapes, electric shocks, and beatings in "comfort stations," some of them merely tents set up in fields between bombing raids.[4] When the still-teenaged Lee returned from the war, her mother called her a ghost and fainted.[5] "This didn't just happen to me," she told me during our first interview. "It killed my mother and father. So how much *han* do you think I must have?"[6] After giving her first public testimony in 1992 and joining the Wednesday Demonstrations, Lee traveled extensively, visiting Japan, the United States, China, Taiwan, and the Philippines to raise public awareness of the "comfort women" cause.[7]

Refusing to be passive at the March 2006 protest, Lee was defiantly demanding that the "bastards" who had wronged her and so many other women be held accountable. Lee, the handful of other octogenarian survivors, and their supporters were all returning for the seven hundredth time to this site. They were participating in the longest-running political demonstration in South Korea and one of the longest ongoing protests in the world, the Wednesday Demonstrations (*suyo siwi*).[8] These weekly rallies give survivors an opportunity to express their visceral feelings of *han* and to join others in calling for justice. This chapter examines what happens when survivors and thousands of their supporters repeatedly gather to perform demands for redress.

When Lee testified at the seven hundredth Wednesday Demonstration, the "comfort women" activist movement had become internationally recognized for giving voice to the victims, and the movement was bringing supporters of all ages and nationalities to the weekly protests in Seoul. This had not always been the case. After World War II, a confluence of social, cultural, and political factors in South Korea kept the Japanese military's wartime sexual enslavement of women out of public view. Many Koreans, including survivors, wanted to forget this history of colonial subjugation and violence. The survivors of Japanese military sexual slavery were brought to the public's attention in 1991, when Kim Hak-soon became the first woman to testify publicly about her ordeal.[9] Discussions of Japanese military sexual slavery subsequently began circulating in the Korean media. The first Wednesday Demonstration was held on January 8, 1992, before a state visit by Japanese Prime Minister Kiichi Miyazawa. A small handful of middle-aged activists fiercely protested the Japanese government's denial of the existence of "comfort women" and called for public acknowledgment of the "comfort system," an official apology, and legal reparations.

In the first years of the Wednesday Demonstrations, only a few survivors participated. The protests had a more somber tone, and survivors wore neutral-colored protest garb and blended in with their mostly female supporters. By the first decade of the new century, the height of survivor participation, an average of ten survivors in bright yellow vests constituted the focal point of festive weekly gatherings of fifty to seventy-five protesters. Hundreds of supporters joined for larger rallies, such as the seven hundredth and the one thousandth

Wednesday Demonstrations. Since 2011, the number of participating survivors has declined as women have died and others have experienced poor health. But the number of supporters continues to grow. What began as a protest by a handful of middle-aged female activists has grown into a vibrant weekly congregation of people of all ages and genders.[10]

The activists of the Korean Council for the Women Drafted for Military Sexual Slavery by Japan organize the rallies, which are sponsored each week by a different women's, civic, religious, or educational organization from South Korea, Japan, or elsewhere. The council's website explains that the "Wednesday Demonstrations have turned into a place for solidarity between citizens and the victims, a living site for history education, a platform for peace and women's human rights, bringing people together in solidarity beyond gender, age, borders, and ideologies."[11] The area where the protests take place has also become a stage for multiple performances— cultural performances by supporters, memorial services for the survivors, and press conferences with activists. Activities related to the Wednesday Demonstrations are not confined to South Korea. As part of what has become a transnational social movement, solidarity protests occur around the world, with "thousands of people in 60 cities in 23 different countries," according to the Korean Council, including Osaka, Tokyo, Manila, Taipei, Melbourne, Berlin, Paris, Chicago, and Washington, D.C.[12] What role has performance played in the transformation of the Wednesday Demonstrations into a site for multiple expressions of memorialization, demands for reparations, solidarity, and education?

Before noon on July 25, 2007, during my first summer of participating in the protests, survivors arrived in two vans. One came from Nanumaejip [House of Sharing], a Buddhist-run shelter for survivors an hour outside Seoul, while the other came from Urijip [Our House], a rest home for survivors in Seoul run by the Korean Council.[13] Young female supporters helped Lee Mak Dal, Lee Soon-duk, and Gil Won Ok, who came from Our House, out of their car to plastic chairs on the sidewalk.[14] Survivors from the House of Sharing, including Bae Chun-hui, Park Ok-sun, and Yi Ok-seon, soon joined them. Volunteers helped each survivor put on a yellow vest.

Elementary school children, uniformed high school students, university students, nuns, foreign tourists, Japanese activists, jour-

nalists, and local Koreans gathered around the seated survivors.[15] Some waved colorful placards with slogans such as "Legal Reparations" and "Formal Apology"; others were busy taking photos. The atmosphere was convivial. The street, which measured approximately thirty feet wide, separated the entrance to the Japanese Embassy from the twelve-foot-wide sidewalk on which protesters and survivors assembled. At the start of the protests, supporters stood on the sidewalk behind the survivors. Their bodies mirrored the rows of Korean riot police standing guard in front of the embassy—mostly Korean men in their early twenties who were serving their two-year compulsory national service in the Korean National Police force instead of in the military.[16] Protesters expressed their grievances with collective shouting and physical gestures directed at the embassy. As the crowd grew, people flowed into the street and faced the survivors, expanding the area of the protests and changing the configuration of the performance so the survivors were the main audience.[17] The general script for the hour-long protest included a brief introduction by the emcee (usually a member of the Korean Council staff or of the sponsoring organization); a lively singing of "Like a Rock";[18] a report by the Korean Council on current news; a call for solidarity and the chanting of slogans; a speech by the sponsoring group, which often gave a cultural performance; the reading of the weekly statement; the introduction of the survivors and any special visitors; and a final rallying call.

These weekly protests are the most important vehicle through which the leaders of the Korean Council, survivors, and their supporters have created a visible platform for the victims of sexual slavery and achieved public support for the women. What changed the public's view of these survivors from prostitutes and "tainted" women to revered celebrity-like figures? What kind of tactics did Korean Council activists utilize?

In the 1990s, these activists were concerned with educating a larger public about the historical and political claims of the survivors and were looking for a way to make these women's private injuries into a public grievance. One of the central issues was how best to represent the women's victimization. From 1992 to 2000, activists used the framework of mourning loss to articulate their demands for redress from the Japanese government.[19] As the movement grew, the activists' concerns expanded to include coalition building and mem-

ory production. In making these shifts, the women invoked various discourses regarding human rights, intergenerational community building, and peacemaking to broaden the historical, geographical, and political relevance of the "comfort women" movement. By the end of the twentieth century, activists had developed the Wednesday Demonstrations' signature style of sonic, visual, and physical presentations to work toward these objectives.[20]

During this second phase of the protests (2000–present), the Wednesday Demonstrations broadened their domestic and international support and strengthened ties with the various participating groups. Drawing on archival documentation of protest material and photographs at the Korean Council; print and online news articles; interviews with activists, survivors, and protesters; and my periodic participation in the rallies in 2007, 2008, and 2013, I focus on the second wave of the Wednesday Demonstrations to explore the intersections between performance, activism, and memory in relation to the aging bodies of survivors. I am particularly interested in how survivors navigated this political and cultural landscape and became the engine for the ways the Wednesday Demonstrations function as performances for *and* as redress for survivors.

The City as Performance Space

"The Japanese people must come out to that place, get on their knees, and apologize," Gil Won Ok declared in a 2007 interview during my first research trip to South Korea.[21] Gil, an active participant in the weekly rallies, was articulating her desire for a material expression of a sincere apology, the act of getting on one's knees. She also articulated the significance of "that place"—the space of the Wednesday Demonstrations—as a public platform for the movement and an arena for publicizing private grievances. "Performance space is never empty," writes novelist and literary theorist Ngũgĩ wa Thiong'o, for "it is always the site of physical, social, and psychic forces in society."[22] If a performance space embodies all these different forces, how do protesters transform the space through their weekly performances?

When I asked my taxi driver to take me to the Japanese Embassy, he headed down Sejongdaero (Sejong Boulevard, named for the king

who developed the Korean alphabet) toward the US Embassy and took a right turn onto a side road. He then had to ask a pedestrian for further directions. Sejongdaero is the largest boulevard in central Seoul: it is the address of such notable buildings as City Hall, the Sejong Center for the Performing Arts, and the US Embassy before splitting in front of Gyeongbokgung [Gyeongbok Palace]. Because of the boulevard's size and proximity to government buildings, public areas along Sejongdaero have been the sites of countless demonstrations, among them labor union rallies and anti-American protests. The Japanese Embassy is approximately five minutes away by foot from Gyeongbokgung, which was built in 1392 as the main royal palace during the Joseon Dynasty. It was partially destroyed during the Japanese colonial period (1910–45), and the Japanese colonial government built its main administrative building, the Government-General Building, on the ruins. The obscure location of the Japanese Embassy off the main boulevard is a physical and symbolic decentering of a Japanese colonial past.

As in the rest of Seoul, new buildings and the bustle of pedestrians and cars have paved over conspicuous reminders of the Japanese colonial past. Public expressions of "postcolonial" forgetting manifest in projects such as the state-sponsored restoration of Gyeongbokgung starting in the 1960s and the demolition of the Government-General Building in 1996.[23] Conspicuous nationalistic landmarks such as the statues of Admiral Yi Sun Sin, who defeated the Japanese in a sixteenth-century naval battle, and King Sejong mark the nearby landscape. These two statues of patriarchal pride are prominently situated in Gwanghwamun Square, a park built in 2009 in the middle of Sejongdaero, so cars now travel along lanes bordering each side of the park.[24]

The domestic politics of memory regarding Japanese colonialism are also intertwined with the history of US military and political involvement. The "tenacity of colonialism," as Asian American studies scholar Elaine H. Kim and Asian studies scholar Chungmoo Choi aptly put it, has persisted in twentieth-century and twenty-first-century Korea. As Kim and Choi explain, "a palimpsest of multiple layers of Japanese colonialism and neo-imperial domination, especially by U.S. hegemony . . . superimposed its systems on the political and social infrastructures of Japanese colonial rule."[25] The cityscape near the embassy materializes this "palimpsest of

multiple layers." In contrast to the Japanese Embassy, the location of the US Embassy on the main boulevard and within view of Gyeongbokgung signals the history of the US neocolonial presence on the peninsula after World War II and the continuing importance of US military, economic, and political interests in South Korea. The two embassies and the restored palace form a triangle, a symbol of the three countries' entanglement and a visual and material invocation of wartime memories.

It is possible to walk by the Japanese Embassy today without thinking much about the history of the area. The only conspicuous reminder of a bygone colonial era is the Japanese flag flying on the embassy building of crimson brick, which was built in 1976, an unimpressive five-story structure eclipsed by neighboring high-rise buildings with glass exteriors.[26] "What memories," Thiong'o asks, "does the space carry and what longings might it generate?"[27] It is not simply a question of what memories the space carries. To rephrase Thiong'o's question, what memories do the bodies in this space carry, and what longings do they bring to the space they occupy? "Space," philosopher Michel de Certeau reminds us, "is a practiced place," and he points to the embodied aspect of transforming a public space into a performance space.[28] When protesting bodies perform in front of the Japanese Embassy on Wednesdays, they alter the space, reminding others that the *post* in *postcolonial recovery* remains elusive and that the work of decolonization is moving at a glacial pace when crimes against "comfort women" remain unresolved.

As the symbol and site of Japanese diplomacy, the embassy stands as a surrogate for the nation of Japan. Theater and performance studies scholar Joseph Roach calls such public sites "vortices of behavior."[29] "Their function," explains Roach, "is to canalize specified needs, desires, and habits in order to reproduce them."[30] Activists and survivors recognized the embassy as a strategic vortex; it is where they direct their claims against the Japanese government.[31] In the case of the Japanese Embassy, the building and its occupants are the symbols of potential restitution.

These agents join the multiple audiences for the protests: embassy workers, riot police, pedestrians, journalists, and survivors. The protesters initially face the embassy, directing their petitions for official address to the Japanese government through the embassy. As

protesters spill into the street and behind the emcee, a circle of bodies forms. In this moment, one can see the embodied workings of the protests as redress. The emcee, the speaker, and the visiting groups have their backs to the embassy, performing for the survivors and the participants, thus positioning them as the main audience. In this moment of gestural interpellation, protesters move from passive audience members or spectators into action.

A Discourse of National Shame

For almost five decades, silence shrouded the historical experiences of "comfort women" in Korean public discourse.[32] "Why do you have to focus on the shameful parts of Korean history?" a relative asked after I explained my research project to her. She reminded me that older generations of Koreans, particularly those who were born or grew up during the Japanese colonial period and the Korean War (1950–53), equate the sexual violation of survivors with national violation, using a language of shame.[33] Legal scholar Hyunah Yang and others point out that public discourse channeled the "comfort women" issue into a nationalist narrative of colonial injury through sexual slavery.[34] As archival research and survivor testimonies made Japan's role in the "comfort system" more apparent, Koreans—particularly men—reframed the issue using a language of "hurt" national pride.[35] Meshing a sense of damaged national pride with general anti-Japanese sentiment,[36] Koreans such as my relative viewed "comfort women" survivors as an unpleasant reminder of a country that was unable to protect its people and was consequently feminized as "weak" under Japanese colonial rule.

To garner public support, the movement has tapped into the nationalist discourse that invokes sexual victimhood as national injury.[37] However, it would be inaccurate to say that nationalism is the primary motive of the activists and their supporters. The people who make their way out to the Wednesday Demonstrations come for many reasons: some are antiwar advocates, some believe in women's rights as human rights, and most come out of respect, sympathy, and support for the survivors. In addition, nationalism is not adequate to describe the admirable work of activists from organizations such as the Korean Council, who genuinely care for the welfare of survivors

and tirelessly advocate on their behalf. Nevertheless, the framework of national victimhood has been necessary to petition for official redress and has been effective in drawing support for the movement in South Korea.

The absence of public discourse about the experiences of "comfort women" also contributed to many survivors' decisions not to come forward publicly. As Yang rightfully points out, it is important to understand this public silence "not just in relation to Japanese government actions and international politics, but also in relation to South Korean society itself."[38] Sometimes families chose to send their daughters off to what they thought were decent job opportunities. In addition to the Japanese "recruiters" who deceived and kidnapped women into the "comfort system," Koreans worked as procurers and members of the Japanese colonial police force that helped facilitate the rounding up of women for the system of sexual slavery.[39] As sociologist C. Sarah Soh points out, these women were victims not merely of the Japanese military but also of the political economy and culture of Korea: "the abuse and maltreatment of daughters and wives in the patriarchal system, with its long-standing masculinist sexual culture, contributed as much as did the colonial political economy to the ready commodification of these women's sexual labor."[40] After the war, many survivors chose to guard their pasts in a patriarchal society with Confucian roots that valorized women's chastity. Many did so out of a sense of ignominy, guilt, and the fear of losing familial and communal ties. In light of the social and cultural stigma surrounding sexual slavery, how did activists mobilize public support for the survivors?

Changing Colors and a Changing Mise-en-Scène

On January 25, 1994, Lee Yong Soo and two other survivors made a dramatic gesture of protest against the Japanese government. Wearing Korean mourning dresses, the three women attempted to commit suicide by stabbing themselves at one of the Wednesday Demonstrations. Frustrated with the Japanese government's inaction and dismissal of their claims, they believed that only such an act in such a prominent place—in front of the Japanese Embassy—would get the attention of the Japanese government. Lee remembers pulling out a

knife before she fainted. The survivors were taken to the hospital with no serious injuries. "I thought if we died," explained Lee, "the Japanese would do for the other *halmeonidul* what we wanted, so let's die for them."[41]

Lee's memory of one of the most dramatic gestures at the Wednesday Demonstrations points to the more subdued milieu of the "comfort women" movement in the early 1990s, when public support was scant. Through their dress and actions, Lee and the other women survivors sought to convey the gravity of their claims and the depth of their sense of loss. Protesters have used various accoutrements—vests, signs, and banners—to shape the stage and the visual theme of the Wednesday Demonstrations. These items, designed and made by activists at the Korean Council, are a visual manifestation of the different frames survivors have used to make their cause legible. In the first wave of the Wednesday Demonstrations, activists conveyed their loss through, for example, a framework of mourning. During the second wave, the loss was named as the loss of sexual and moral innocence. However, the women refused to be defined by this loss, proudly wearing yellow vests and calling themselves reborn and liberated butterflies. In this section, I focus on how a rhetoric of loss was made tangible by what protesters wore and held in their hands. For survivors, this loss involved social, emotional, psychological, and physical devastation after sexual violence.

The primary protest dress for the Wednesday Demonstrations was a vest that has undergone significant changes in color, material, and style since 1992. The shifts in the design of the vests reflect the changing views of "comfort women" by both the activists and wider society. The donning of vests during the Wednesday Demonstrations followed a common practice in Korean political demonstrations, where protesters wear vests in the style traditionally worn by factory workers in the color of their organization.[42] The protest vests are sleeveless tops with a front zipper or button opening. Sometimes they also have side openings, like a smock, with ties so they can be easily thrown over clothes. The fronts and backs of the vests—which reach down to wearers' waists—are usually marked with slogans and the name of the protesting organization.

Because few people knew or talked about the history of the "comfort women," the Wednesday Demonstrations of the early 1990s publicly demonstrated the women's pain, their victimization, and their

demands to the Japanese government. As the Korean Council's Secretary-General Yoon Mee Hyang explained, "The Wednesday Demonstrations started with a simple objective: to let the Japanese government know of our demands."[43] These demands included that the Japanese government acknowledge the crimes its military had committed; that it admit the historical truth of the women's claims; that it make an official apology; that it provide legal reparations for survivors through legal channels; that it punish those responsible for the crimes; that it accurately record the crimes in Japanese history books; and that it build a memorial for victims of military sexual slavery and a museum to educate the public about the history.[44]

At the first Wednesday Demonstration, most of the protesters wore white vests as they stood in front of the embassy gate, facing the street. Later that year, some protesters started wearing vests made of hemp. One side of the vest featured a block print of an archival photograph of four "comfort women" above the name of the Korean Council. The other side had two phrases in large diagonal print: "Jeongsindae Manhaeng" [Brutality Against Jeongsindae] in red on top and "Sasir Injeong" [Acknowledge the Truth] in black below.[45] Other slogans on the vests included "Jeongsindae Huisaengja" [Jeongsindae Victim] and "Baesanghara" [Pay Reparations]. The printed slogans spoke to the initial goals of the activists: establishing the historical truth of the violence and claiming the women's status as victims to make claims for state reparations. Activists' choice of the word *huisaengja* instead of *pihaeja* (which also means victim) emphasizes the fact that the women were sacrificed for their country and for the safety of other women. *Huisaeng* means sacrifice, whereas *pihae* connotes damage or harm. The artistic rendering of an archival photograph on the vest provided visual evidence of this history.

The Wednesday Demonstrations became the site for the politicization of mourning, a place where survivors and their supporters called for the reclamation of what had been stolen from them: youth, family, honor, and dignity, just to name a few. Between the first protest in 1992 and 2000, activists and survivors wore two kinds of vests, one made of white cotton and one made of yellowish-ivory hemp, both of which evoke Korean mourning clothes. Wearing hemp or white clothes was the public manifestation of an inward sense of loss.[46] It is no surprise that Lee Yong Soo and the two other women

Fig. 3. Protesters stand in front of the Japanese Embassy at the first Wednesday Demonstration, January 8, 1992, in Seoul. Two of the women in the front wear vests with the slogans (*left to right*) "Sasir injeong" [Acknowledge the Truth] and "Gonggaesagwa" [Public Apology], and one wears a vest with a print of an archival photograph of four "comfort women" in Burma. Credit: © Yonhap via Newscom/ZUMA.

who attempted to stab themselves wore *sobok*, a traditional Korean hemp dress worn during funerals, to convey their state of mourning.

Yoon pointed out that the women chose these fabrics to "show our wounds. . . . Hemp, like the hemp that our ancestors used to wear, shows that our *minjok* are hurting and have lots of wounds," she explained. "No one knew that, so it was necessary to show that through clothing."[47] *Minjok*, which translates as "people," ambiguously refers to ancestors, survivors, activists, and other members of society. Yoon purposefully includes "comfort women" survivors in the *minjok*, because Korean society has historically ostracized these women for their wartime victimization. Her use of the word *our* to qualify *minjok* also conveys how the activists feel a collective empathetic pain for the women's victimization and their postwar experiences of trauma and silencing. Ultimately, Yoon's invocation of *minjok* illustrates activists' desire that all Koreans feel the pain of the "comfort women." Her use of *minjok* relocates the sense of wound-

ing from a nationalistic context (it is usually used to refer to "one race/one nation") to a context in which Korean society comes to terms with a terrible loss.

Beginning in 2000, the visual presentation of the Wednesday Demonstrations dramatically shifted. All the participating survivors began to wear yellow vests, and protesters held more vibrantly colored signs. While I do not want to suggest that the milieu of the Wednesday Demonstrations changed overnight from somber to jovial, the alteration in the color scheme was noticeable. As both national and international support for the survivors began to expand, a growing number of people—particularly students—began attending the protests. Activists sought to make the protest experience more memorable and enjoyable, and they viewed the use of brighter colors as an important way of reshaping the ambience. Through the strategic use of bright yellow vests, activists sought to foster a "sense of hope and solidarity."[48] The color yellow evokes light and vitality, and the survivors' use of the color symbolized regeneration and a new life.[49] "We wanted to make it so you had fun, you were happy, it changed your mood for the better," explained Yoon.[50] Activists and survivors also viewed their participation in the Wednesday Demonstrations as a way to instill both the movement and themselves with new life, literally making the mourning fabrics more vibrant with color.

The first time protesters wore the bright yellow vests during the Wednesday Demonstrations, the vests bore the slogan "2000 nyeon Ilbongun Seongnoejeonbeom Gukjebeopjeong" [The 2000 International Tribunal of Japanese Sex Slavery Criminals]. The year was significant because of the historic Women's International War Crimes Tribunal on Japan's Military Sexual Slavery, a defining moment for what was becoming a transnational social movement. The tribunal, which I discuss in the next chapter, represented the culmination of nearly a decade of international coalition building involving members of the United Nations and prominent women's rights organizations. A broad array of feminist, human rights, and legal activists and scholars assembled in support of survivors and their cause. Wearing the words *International Tribunal of Japanese Sex Slavery Criminals* was a way to name the crime as sex slavery and to pronounce the culpability of the Japanese government as a common foundational concept on which all protesters were basing their petitions. It also helped rebrand the movement as focused on more than just Korea.

The message of the yellow vests underwent two more changes. In 2005, the front of the vest read, "Halmeonie Myeongyeoewa Ing-woneul!" [Honor and Justice for the *Halmeoni*!], and the back read "Sanggyumyeong Sajoe Baesang" [Truth, Apology, and Reparations]. Having the redressive goals of the movement on the vest created a sense of uniformity among the group. The name of the Korean Council was also always on the vests, making the protesters' affiliation clear. Another vest I first observed in 2013 had a purple butterfly and the name of the Korean Council in Korean on the front and, on the back, the bilingual slogan, "Ilbongun 'Wianbu' Pihaejaege Jeon-guireul! Justice for the Survivors of Japanese Military Sexual Slavery!" In 2016, the vest bore the words "Justice for the Survivors of Japanese Military Sexual Slavery" in English on the front. The display of slogans on the vests enabled the survivors to express the movement's demands without tiring their voices. Most important, the demands of the movement, whether written on the vests, banners, and placards or expressed through collective shouting, created the appearance of collective unity.

Toward the end of the first decade of the twenty-first century, the impact of the protests changed significantly. The Wednesday Demonstrations had become much larger than they had been a decade earlier, and a global community had become interested in the movement. In addition, the protest participants began to see their roles differently. "Now I think the purpose is not just targeting the Japanese government but for ourselves," explained Yoon in 2008. She saw the protests "as a space where we can teach living history to students, and through that, learning ourselves, teaching ourselves a peace of mind, a sense of respect toward human rights."[51] She articulates the protesters' significant shift from simply calling for redress from the Japanese government to enacting redress as they defined it. This included teaching young students "living history," finding "peace of mind," and cultivating "a sense of respect toward human rights." These were new forms of redress that put power back in the hands of ordinary people. These new goals converted the actions designed to address the violence done to "comfort women" into actions that also promoted broader social change in the world.

The signs conveyed this expansion of the movement's goals. In the 1990s, the protesters' signs communicated demands such as "Il-bonjeongbuneun Jeongsindae Huisaengja Ginyeombireul Geolli-

hara!" [Japanese Government: Establish a Memorial for the Victims of the Jeongsindae!] (1992) and "Gun Wianbu Gaebyeol Bosanghara!" [Compensate Military Comfort Women Separately!] (1994). In the 2000s, activists increasingly invoked antiwar, peace, and human rights rhetoric to situate the experiences of "comfort women" within a larger historical and political context. In 2005, for example, protesters held a sign that read "Yeoseongui Ingwon Chimhae. Eonjekkkaji Chimmokal Geosinga!" [The Human Rights Violation of Women. How Long Will You Stay Silent!]. In 2008, one sign read "Yeoseongpongnyeokjungdan. Gongsiksajoe. Jeonguireul. Jeonjaeng. No! Pyeonghwa. Yes!" [Stop Violence against Women. Official Apology. Justice. No to War! Yes to Peace!].

Activists reframed the "comfort women" issue in the context of antiwar rhetoric and rhetoric that protested violence against women so it would have a more universal resonance. As feminist scholars Inderpal Grewal, Julietta Hua, Laura Hyun Yi Kang, and Leti Volpp remind us, it is important to problematize the universalistic discourse on violence against women; for example, situating a specific cause within more universal, global discourses can take away from local demands for redress and subsume multiple meanings and memories under the banner of women's human rights.[52] While I agree with this illuminating critique of invocations of a women's human rights discourse, the social movement's framing of the "comfort women" violence as a women's human rights cause also shows its relevance outside particular geographic and historical parameters and conveys its systemic nature and connection to other acts of violence against women. While the movement since 2000 has spoken increasingly with the language of human rights, many survivors still refer to Korea as a "weak country" that was unable to protect them and equate personal redress with national redress. For survivors, invoking the nation in gendered terms becomes a way to express a deeply personal sense of injury as a collective grievance. Even as signs and some of the protest rhetoric gesture toward more universal, global themes, the yellow vests help bring the focus back to the survivors and their protest message.

The vests draw the eye's attention to the women's aged bodies.[53] The presence of the survivors has been central to the possibility that the weekly demonstrations will generate redress. Even when the crowds grow larger and people start moving into the street, one can

still spot the survivors because of their vests and the fact that they are sitting down. The seating is most likely provided to enable these elderly women to participate without exhausting themselves. But it also spotlights the women's physical condition, their frailty, and any health complications that might have resulted from their time in "comfort stations."[54] Highlighting their poor health as bodily evidence of wartime violations gives weight to their claims.[55]

Performing Innocence

The aging of the bodies of the victimized women has also complicated symbolic invocations of young women's bodies as a way of constructing national identity and history.[56] If young bodies stand in for the violated nation, what happens when these women age? Representations of aging bodies have been juxtaposed against material and symbolic manifestations of youth at the Wednesday Demonstrations in another important protest accoutrement: banners. From 1992 to the present, activists and survivors have held countless banners. Staff members and volunteers at the Korean Council design and make the banners.[57] After the survivors are seated, they often collectively hold them. The other protesters sometimes hold their own banners. Two banners used between 2001 and 2007 feature images of youth: one shows a painting by survivor Kang Duk-Kyung, while the other displays an archival photograph of "comfort women."[58] These two banners illustrate the movement's approach to another dimension of the discourse of loss—the theft of the women's youth and sexual and moral innocence.

The symbolic and material manifestations of youth, which include the rhetoric of innocence and actual young protesters, illuminate the multiple registers of the interplay between youth and old age at the Wednesday Demonstrations. On the one hand, as ethnomusicologist Joshua D. Pilzer rightly points out, the young girl and *halmeoni* are central to the symbology of the movement and to South Korean public culture because they promote a narrative of Korean victimization and Japanese culpability.[59] "As nationalist victimology has simplified issues of responsibility," he writes, "it has taken an interest in reducing the 'comfort woman grandmothers' to an archetypal 'comfort woman grandmother,' whose story has a single narra-

tive: abduction or coercion out of poverty, the traumas of sustained sexual violence, and a post-war life of misery and illness."[60] Although nationalist victimology does not define the work of activists from the Korean Council, they have used the framework of victimhood as the basis for petitions for official redress and as a way of drawing support for the movement in South Korea and abroad.

Invoking this framework of victimhood also helped disassociate the "comfort women" from women involved in militarized prostitution in so-called camptowns near US military bases in South Korea.[61] Koreans labeled these women *yang galbo* [Western whore] and later *yang gongju* [Western princess] and *yang saeksi* [Western bride].[62] Associations of "comfort women" with camptown prostitution contributed to the Korean public's sense of national shame regarding "comfort women." The rhetoric of innocence that was used to differentiate the history of "comfort women" potentially vilified camptown sex workers, pitting them as *willing* prostitutes against the virtuous girls and women *forced* into sexual slavery as "comfort women."[63] This kind of problematic thinking among the Korean public was based on a simplistic understanding of camptown sex work that failed to take into account the similarities between these two different histories of sexual exploitation and the complexity of what leads women into camptown sex work and the harsh conditions they endure.[64] I do not mean to imply that the Korean Council activists purposefully sought to vilify camptown women, but I do think they were aware of how this differentiation regarding the question of consent could help draw public support for the "comfort women" during the 1990s. Beginning in 2000, the Korean Council has organized local seminars with women who work on issues of militarism, gender, and human rights violations during conflicts and strategized with local Korean women's organizations that work on behalf of camptown sex workers since 2008.[65]

The two banners I analyze here illustrate how invoking the sexual and moral innocence of the survivors simultaneously emphasizes their victimization and obscures connections with other histories of militarized sexual violence such as camptown sex work. The first banner, which appeared in 2001, was approximately eight feet long and two feet wide.[66] It was used during a controversial time, when a Japanese government–approved Japanese history textbook omitted any mention of "comfort women." The Korean Council argued that

this "dangerous" textbook "idealizes the Japanese Imperial government's invasions in the Pacific area and omits the part describing the 'comfort women' issues."[67] The demand that the Japanese government "Rectify Distorted Information in History Books," which was printed in English, Korean, and Japanese, took up most of the banner. To the left of the text was an image of Kang's painting and its title, *Purity Lost Forever*.[68] In this painting, Kang illustrated her memories of being raped for the first time by a Japanese soldier.[69] The painting depicts a naked woman lying under a cherry tree. A Japanese soldier's body forms the trunk of the tree; his right hand extends in the direction of the naked woman, who is lying with her head resting on a root. Cherry blossoms cover her feet. Hiding her face with her hands, the woman expresses her sense of shame and loss. The image shows the period right after her violation. Kang's ironic evocation of the *sakura* [cherry blossoms] symbolically reclaims honor for the "comfort woman."

The painting's dominant imagery of flowers also resonates with a frequently chanted slogan during the protests, "Government of Japan, make an official apology and pay for our 'bloom of youth.'"[70] This was a moment when activists actually alluded to the act of sexual violation. However, they filtered the injury through the language of lost youth, emphasizing the chastity of the young women forced into sexual slavery. Even survivors used the rhetoric of innocence. "Japanese Embassy, listen to me, redress my lost youth," shouted Lee Yong Soo at the protest on July 23, 2008. "Redress! Redress! Redress!" responded protesters. Lee's invocation conveyed her desire to publicly proclaim her blamelessness for her past and her status as a victim, to voice the public grievance of an individual.

By transforming "comfort women"—whom Confucian-influenced Korean society viewed as "tainted"—into young, "virginal victims," the Korean Council moved to displace the shame surrounding the issue. As helpless "victims" who were chaste before they were forced or deceived into sexual slavery, these women, like the figure in Kang's painting, could not be blamed for their past.[71] Activists redirected this shame to the Japanese government for its past enslavement of these women and its ongoing refusal to take responsibility for this exploitation. Perhaps this explains why the designer of the banner juxtaposed the image of "stolen innocence" with the demand that the Japanese government claim responsibility for the

acts of its military. If the activists could place the "blame" solely on the shoulders of the Japanese government, Koreans would be freed from any sense of national guilt, thereby inviting increased public support for the women. The preserved chastity of the women would also allow their history to become part of national discourse, so that redressing military sexual slavery would become part of redressing the nation.[72]

From 2001 to 2007, the Wednesday Demonstrations featured another popular banner, sometimes held alongside the previous one, that bore two images: an archival photograph of four "comfort women" in Burma on the left (the same photo used on the protesters' original vests) and Kang Duk-Kyung's painting, *Punish Those Responsible*, on the right.[73] The banner juxtaposes images of youth (photography) and of the elderly (painting). The banner was approximately ten feet long and two feet wide. The banner bore slogans in Korean, English, and Chinese: "Reveal the Truth," "Make Formal Apologies," "Pay Reparations to the Victims," and "Record the Truth in the Textbooks." The multilingual banner shows the activists' awareness of the international crowd participating in the protests and the international audience viewing the protests on the news.

The painting depicts a blindfolded Japanese soldier tied to a tree. The background is in carmine, reminiscent of the Japanese flag. The wrinkled hands of three survivors hold guns directed at the soldier. Four doves fly toward the tree. The tree is eerily similar to the one in *Purity Lost Forever* because the man's legs become part of the trunk. The militant image of grandmothers holding guns expresses the survivors' rage and rancor and their desire for the perpetrators of this crime to be punished. Most important, the elderly survivors claim the agency of retribution. This image contrasts sharply with the protests, which are mostly nonconfrontational. The photograph, taken on September 3, 1944, in contrast, shows young women who served in "comfort stations." The image shows a smiling soldier sitting next to four women leaning against a rocky incline. They are identified as "prisoners of war" caught in Burma. Two women have turned their faces to the side, one woman stares blankly into the camera, and a visibly pregnant woman looks down at her feet.[74] This iconic photograph was used on Korean Council brochures and prominently displayed at the Women's Tribunal (see chapter 2).

The grainy black-and-white photograph of young "comfort

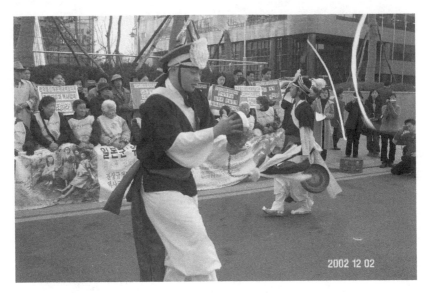

2002 12 02

Fig. 4. Musicians perform *pungmullori*, a form of traditional Korean drumming and movement, for the survivors at the December 2, 2002, Wednesday Demonstration. Survivors hold a banner with an archival image of four "comfort women" in Burma (*left*) and Kang Duk-Kyung's painting, *Punish Those Responsible* (*right*). Photo courtesy of the Korean Council for the Women Drafted for Military Sexual Slavery by Japan/War and Women's Human Rights Museum.

women" reminds the public of the history of Japanese military sexual slavery and how survivors are living proof of this history. The desolate backdrop accentuates the starkness of their condition, and the women with their soiled clothes look desperate. The pregnant woman is the "punctum," to use the words of literary theorist and philosopher Roland Barthes, of the photograph, poignantly reminding the viewer that these women sacrificed more than their youth in being robbed of the joy of motherhood.[75] In holding the banner and letting it rest on their laps and against their legs, the survivors seem to bring the photograph to life and provide a different take on the embodiment of the dyad of youth and old age. The contours of their legs reshape the image printed on the fabric, making the viewer more aware of the living, elderly body. Against the photographic image of shamed women averting their eyes from the camera's gaze, the living survivor sits defiantly, publicly claiming her past and demanding jus-

tice. The past and present are "laminated," to echo the words of performance studies scholar Rebecca Schneider, in this layering of the photograph over the bodies.[76] This beautifully illustrates the more flexible, dynamic sense of temporality survivors bring to what it means to fight for change. The women's claims not only are about amending wrongs of the past but also are about restoring dignity in the present to prevent the repetition of this history.

The Korean Council also draws on images of schoolchildren and nuns, who often attend the protests, to circulate the concept of innocence. More important, these images of youth convey the future-oriented nature of the movement. As part of a 2008 campaign to increase pressure on the Japanese government, the Korean Council designed a postcard for supporters to sign and mail to the Korean government.[77] The front of the postcard shows a photograph of five survivors in their protest vests at a Wednesday Demonstration. Above the image are the phrases "Korean government, lead the restoration of justice for the Japanese military 'comfort woman' victim," and "Korean government, actively work toward redress from Japan for the Japanese military 'comfort woman' victim." The survivors are holding the banner with the photograph of the four "comfort women" in Burma; the top portion of the photograph is visible. On the postcard, a group of elementary schoolchildren and nuns stand directly behind the survivors. The placement of children right behind the grandmothers communicates a sense of futurity about attending to the victims of Japanese military sexual slavery—the notion that attending to the past will ensure a more just future. The protests have become a place where these intergenerational bonds are nurtured. The other critical side of the dyad of the young girl and *halmeoni*: grandmotherhood helps structure social relations on the street and foster intergenerational coalition building.

The changing accoutrements—the vests, banners, and signs—of the Wednesday Demonstrations illustrate the different ways activists have framed the demands and needs of "comfort women" survivors over the decades. Activists have used an elastic framework of loss to garner national support for their cause, using symbols including vests that evoke mourning clothes and visual images of youth. These symbols have attracted thousands of supporters to the Wednesday Demonstrations. "In the 1990s, everything was gray. We were in so much pain," explained Yoon in 2014. "Now the women are viewed

as activists building historical justice. I can see the changes in the women's expressions and language."[78] The remainder of the chapter explores the repertoire of the rallies—somatic disruptions, performed testimonies and apologies, and cultural performances—to show how survivors as activists have inspired the next generation. Through these performances, protesters reimagine ways of treating others with dignity, honoring the memories of those who have suffered, and being in community with survivors.

Somatic Disruptions

The Wednesday Demonstrations have transformed the front of the Japanese Embassy into an arena of redress for survivors. This section examines the kinds of physical interference and signals that protesting bodies create through *somatic disruptions*. Protesters create such disruptions as part of their repertoire of calling for official redress and of practicing community. Somatic disruptions capture attention and raise awareness through the repositioning of the bodies of bystanders and passersby. These repositionings include the physical turning of a head as a person suddenly becomes aware of protesters. To create this movement, protesters use sonic techniques (such as singing) and physical strategies (such as occupying space and making collective gestures). Through somatic disruptions, protesters seek to communicate their demands for redress from the Japanese government and stir citizens out of complacency. Somatic disruptions such as shouting demands in unison give protesters physical ways to coalesce as a community. Somatic disruptions in the vortex of embassy space are simultaneously claims for state restitution and redressive moves in and of themselves.

I turn to dance studies scholars such as Susan Leigh Foster and SanSan Kwan to become more attuned to kinesthesia—how bodies navigate space and come into contact with objects and other people. In her analysis of the 1960s lunch counter sit-ins, the 1980s AIDS die-ins, and the 1999 WTO protests in the United States, Foster argues that the "physical interference" of bodies at protests in public places "makes a crucial difference," demonstrating "the central role that physicality plays in constructing both individual agency and sociality."[79] Kwan focuses on choreography, or "the conscious design-

ing of bodily movement through space and time," in her study of how aesthetic movement helps Chinese and Chinese diasporic people bring together their kinesthetic experiences of urban centers and their negotiation of Chinese identity.[80]

Through the use of sound (songs, chants, and speeches), protesters make their physical presence known and change the flow of everyday activity around the embassy. These sounds are amplified through speakers to reach beyond the physical space of the protests. Every protest begins with the singing of "Like a Rock," which has become an anthem for the activists. With its upbeat melody, the song communicates the protesters' desire to persevere through adversity or "stormy weather," hoping to attain the "paradise that will come." For survivors and their supporters, this paradise is free of violence. The loud singing also alerts embassy employees headed out for lunch and local pedestrians that the protests have started.

Though the protests may appear to have little impact on the embassy, somatic disruptions affect daily life in the area. These small disruptions are the first steps toward waking people out of apathy and into awareness. Every Wednesday around noon, those who work close to the embassy must choose whether to pass by the protesters. Employees leave the embassy through a side entrance around 12:30 p.m. for lunch, which means that they do not encounter the protesters unless they make a special effort to do so. Some employees turn their heads in the direction of the protesters, but most go in the opposite direction for lunch. Similar to people who maneuvered around the lunch counter protesters in the 1960s, embassy workers and pedestrians have to, in Foster's words, "scrutinize their own behavior," and they often change their walking route in response to the protesters. The protesters thus "exer[t] a subtle control" over pedestrians' actions.[81] These somatic disruptions of the actions of embassy employees and pedestrians fit with the protesters' goal of stirring people out of apathy.

In August 2008, after unsuccessfully trying to ask Japanese Embassy employees a few questions about their opinions of the protests, I spoke with two Korean women who worked in the embassy on their way to lunch. "We feel the same way as other Koreans," one woman said. "We feel bad and our hearts ache. We feel the same way, even more strongly."[82] When I asked whether working in the Japanese Embassy strengthens these feelings, she told me that many Koreans be-

come more patriotic after working at the embassy. Although this woman could not show overt support for the protesters because of her affiliation with the embassy, she used a language of sympathy that metamorphosed into an implicit yet strong critique of the Japanese government. Working in the Japanese Embassy activated feelings of loyalty to Korea among people who might not have been particularly patriotic when they began their embassy jobs.

Sound also gives the protesters a physical way to grow closer as a community. Since a feeling of belonging to a community does not come automatically, supporters cultivate this feeling through collective actions. Scholarship on the participatory nature of community building illustrates the centrality of performance to a sense of collective belonging. Pointing out the limitations of political scientist Benedict Anderson's focus on print culture in the formation of an "imagined political community" (print culture is available only to the literate), gender and sexuality studies scholar Anne McClintock argues: "In our time, national collectivity is experienced preeminently through spectacle."[83] Cultural studies scholar May Joseph concurs that "citizenship is not organic but must be acquired through public and psychic participation."[84] Like the ancient dialectic between the chorus and the soloist, the collective shouting of protesters augments the solo voice of the emcee. "Japanese government, apologize now," yells the emcee. The protesters respond, "Apologize now! Apologize now! Apologize now!" As protesters direct their voices toward the embassy, they raise their right fists. A survivor who has felt isolated or a lone activist from another country momentarily experiences a sense of community through joint physical gestures and the sound of one's voice blending with others. In addition to singing and chanting, the protesters also shout together as they turn and look up at the embassy. They yell "Yah!" at the top of their lungs, stopping only when they run out of breath. Words cannot communicate the pain, frustration, and anger survivors express through this single cry. As they make noise together, protesters experience a collective—albeit fleeting—moment of release and rejuvenation.

Occupying the physical space around the Japanese Embassy constitutes more than "interference created by people's physical bodies," to use political scientist Gene Sharp's language.[85] Even when protesters do not come into bodily contact with authority figures, their occupation of embassy space expresses demands for redress.

When protesters claim a public space, they are inserting themselves into national politics, public dialogue, and collective memory. During large demonstrations, such as the seven hundredth Wednesday Demonstration on March 15, 2006, hundreds of protesters occupied the road in front of the embassy, stalling both vehicle and pedestrian traffic. The protesters isolated the embassy, a statement of their refusal to accept Japan's rejection of moral and legal responsibility. They did not face the embassy directly, instead turning their sides to it and focusing their attention on the emcee, the speakers, and the performers in the front of the protest group. They stood with the embassy on their left. By physically occupying this public space, the protesters show their desire for a place in Japanese-Korean politics. Yet in turning their bodies away from the embassy, they redirect the agency of change from the state to the people.

The protesters' physical presence creates somatic disruptions in the everyday movements of passersby. Although the street in front of the embassy is not often busy, the road sees heavy foot traffic around noon. Protesters take over the sidewalk behind the survivors, and passersby frequently slow down when they see the protesters and then clumsily maneuver around them.[86] Some protesters will move to make room for pedestrians. In the summer of 2008, as I stood among the protesters, I became part of this bodily expression of dissent. We were disrupting the linear movement of pedestrians through this space. As they zigzagged through the crowd, the passersby stopped, adjusted, and realigned their movements. By pausing and repositioning their bodies, pedestrians acknowledge the protesters, hear their demands, and (for a brief moment) become part of the protest.

Intergenerational Communities of Remembrance

Young people ranging in age from elementary schoolchildren to university students now form the largest constituency among protesters.[87] Some students come with their teachers or participate as part of a school assignment. Others come to simply show their support and respect for the *halmeonidul* (plural form of *halmeoni*). In identifying as *halmeoni*, survivors transform a once-obliterated subjectivity, gesture toward the infertility many survivors suffered because of

their wartime trauma, and express their desire for social bonds with their supporters. This moniker establishes a familial order that transcends a one-dimensional notion of victimhood.[88] As *halmeonidul*, these women are bearers of wartime memories and figures of postwar resilience, as evidenced through their physical and verbal testimonies. They also draw on their positions as grandmothers to reclaim the dignity, respect, and social bonds they were denied during their wartime and postwar experiences.[89] Many survivors could not bear children and became estranged from or lost touch with their families.

"I can't go door to door and show my face, so I have to go to the Wednesday Demonstrations to present myself, so people can say, 'Ah, there is a living witness of history,'" Lee Yong Soo told me. "Whether they read about it in books or see it somewhere else, they're interested in knowing, 'Oh, these *halmeonidul* exist.'"[90] Survivors such as Lee view themselves as living evidence of this history who can provide firsthand accounts of what happened. The Wednesday Demonstrations offer a large, public outlet for survivors to give testimony to their existence. Their presence and the testimony their bodies offer counteract official erasures and forgetting, including the postwar destruction of incriminating wartime documents, the Japanese government's denials, and the dismissal of oral testimony as a legitimate source of historical knowledge. Sharing traumatic memories is also imperative to the well-being of the survivors. Psychoanalyst Dori Laub argues that after a trauma has occurred, it is important for the victim to "*re-externaliz[e] the event,*" to "literally transfer [the story] to another outside oneself and then take it back again, inside."[91]

Lee, who has been participating in the protests since the early 1990s, expressed the shame she harbored when she initially came out to protest. But her feelings gradually changed. In 2007, she told me, "So when I raised my fists and shouted 'Apologize! Compensate us!' sitting there, whether it rained or snowed, I was embarrassed at first, but I'm not any more. I need to be a living witness to the world."[92] Through her activism, Lee has reclaimed her past and found meaning in teaching others. Her presence as a testifying body constitutes both a powerful reclaiming of her experiences and an assertion of her agency after being viewed as a passive victim her entire adult life. "That's the woman I am," proudly explained Lee, "a living witness of history, going to the

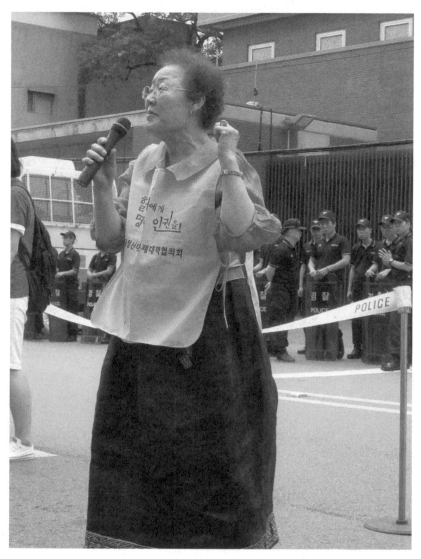

Fig. 5. Wearing a yellow protest vest, survivor Lee Yong Soo gives her testimony at the July 29, 2008, Wednesday Demonstration in Seoul. Riot police who guard the entrance to the Japanese Embassy are visible behind her. Photo by Elizabeth W. Son.

demonstrations and shouting that I exist. I am here fighting Japan, to spread awareness, while people are watching."[93] To bear witness of wartime victimization is to testify to the continual present work of survival, not just to the past.

Survivors also use the space of the Wednesday Demonstrations as a public platform for addressing an array of topics such as the war in Iraq, critiques of the Korean government, and support for the Japanese people during national tragedies like major natural disasters. For example, at the May 12, 2004, Wednesday Demonstration, survivors vocally condemned the war in Iraq and disapproved of the Korean government's plan to send troops to the region. Before participating in the protest, survivor Yun-shim Kim spoke at a press conference in front of the US Embassy in Seoul: "I was taken away when I was 14. We gather together every Wednesday in front of the Japanese Embassy to protest the Japanese imperialist war crimes, but you didn't seem to care, and now you're sending Korean babies off to war again?"[94] Kim critiques the Korean government for failing to heed the lessons of war and for putting innocent lives in harm's way. Kim's embodied experience of war cultivated her own pacifism and empathy for those sent into war. In a different kind of intergenerational connection, many decades after her own experience of war, Kim remains in touch with what it feels like to be a very young person caught between geopolitical conflicts.

The Wednesday Demonstrations provide survivors with a public space for sharing their thoughts and experiences with their supporters. A vital exchange of knowledge, respect, and care happens among students and the *halmeonidul*. The Wednesday Demonstrations provide what theater and performance studies scholar David Román describes as the "space necessary to attempt to reperform the bonds of kinship that enable the possibility of community."[95] In noting how the protests give "us a lot of strength," Lee explained that she reconnects with other survivors and activists on Wednesdays. She especially connects with protesting students who refer to her as *halmeoni*. Calling the survivors *halmeoni* sets up a familial structure, placing survivors in the position of teachers. "I'd like to hear from the grandmothers in person about their sad history at the time of the Japanese colonial period and tell others about it," said Jeon Sol, a seventeen-year-old Korean high school student, at the March 17, 2004, protest.[96] Wanting to write about this issue in her school news-

paper, Jeon attended the protests with her teacher and ten friends. Attending the protests has also changed the way the protesters view survivors. Kang Ji Soo, an eighteen-year-old high school student, regularly attended the protests during her school break. "Before I met them, I just thought of them as victims, victims of sexual violence. I felt bad for them," shared Kang at the October 30, 2013, Wednesday Demonstration. "After meeting them in person and seeing them boldly shout and call for an apology and redress, my perception of them has changed. First, I felt pity for them, now I have so much respect for them."[97]

Survivors imagine themselves as part of a makeshift kinship structure with their young supporters, referring to them as *husondeul* [descendants]. "If [the Japanese government] does not do what they should in my generation," added Lee, "my descendants will continue."[98] Lee, who was married briefly in her sixties, does not have biological children.[99] She views young supporters as her chosen offspring, her "descendants" who will continue her quest for justice. Gil Won Ok similarly referred to supporters as *husondeul*. Gil, who also had no biological children, said that although the Japanese government thinks "that all of this will disappear after we die, but absolutely not, we have our descendants." She continued, "Even after I die, the next generation will for sure with one heart, one mind, one cause, raise up this country, and when our country becomes strong, those people [the Japanese] will not look down on us."[100] Gil's gendered language targets a "weakened" country as the reason for Japan's disregard, and she sees national redress as personal redress. She believes that the "descendants," the young people who come out to the Wednesday Demonstrations, will ensure that redress is extracted from the Japanese government.

Most important, she expresses the social bond she feels with these young supporters. Her love for them is obvious. "Sometimes when elementary schoolchildren come, they go, '*Halmeoni, halmeoni*, cheer up and have strength! We're here. Cheer up,'" Gil told me. "And something inside just suddenly opens up."[101] Gil feels rejuvenated and cleansed by that opening up. Her young supporters embolden her with a sense of hope. The bond between survivors and the younger generations allows activists such as Lee and Gil to envision a multigenerational horizon for redress, as they are asking not simply for the amending of past wrongs but also for the assurance of a more

just future. In doing this, survivors move themselves outside the role of passive victim to the more active role of enabler of justice.

Performances of Cultural Redress

A sharp clanging pierced the air, followed by steady drumbeats, which grew more intense and urgent. Colorfully clad in black jackets with loose sleeves adorned in blue, yellow, and red stripes, elementary schoolchildren sat on the street in a semicircle. The rumbling beats of their double-headed hourglass-shaped drums (*janggu*) and double-headed shallow barrel drums (*buk*) echoed in the air, punctuated by the sharpness of two gongs, the *kkwaenggwari* and *jing*. On October 25, 2005, thirteen children from Durae School smiled and drummed harder as they looked ahead at the *halmeonidul*, the main audience. Some of the *halmeonidul* clapped along, and most smiled as they watched the children's performance. The children from Durae School joined the long line of student groups, citizen organizations, and individuals who have performed *pungmullori*, a mix of traditional Korean drumming, dancing, and acrobatics, at the Wednesday Demonstrations.[102] The students offered their performances as gifts of respect and solidarity. These and other performers invoke the power of healing for the survivors, celebrate the community, express anti-Japanese sentiment, and politicize the protests in a uniquely Korean style. *Pungmul* performances near the Japanese Embassy resonate strongly because Japanese authorities repressed such performances during the colonization of Korea.

Pungmullori, which has roots in shamanic rituals, was often performed at harvest festivals to encourage healing, good fortune, and celebration. Performers dance and interact with audiences as they play their instruments. The deep *janggu* and the *buk* produce loud, thunderous beats that can be heard far away. Bodies are drawn to the noise; hearts pound faster as people approach and then join the others who are swaying, clapping, and dancing to the lively beats. During the Japanese colonial period, *pungmul* was banned because of its power to rally communities. It was also denigrated as farmers' music (*nongak*), a bygone peasant ritual. The *pungmul* performances place the Wednesday Demonstrations in a long genealogy of political protests in South Korea and illuminate the intergenerational nature of

the movement. In the late 1970s and 1980s, a resurgence of cultural nationalism led to the revival of *pungmul*, mostly by student protesters at demonstrations. It is now used as a regular part of Korean political protests to express both dissent and pride.

The Wednesday Demonstrations have also attracted large numbers of international supporters, mostly from Japan and the United States.[103] For example, the members of the Weekly Wednesday Troupe, a group of Japanese citizens from Takarazuka, were inspired by the Wednesday Demonstrations to travel around Japan performing the testimonies of survivors.[104] They also sometimes participate in the protests in Seoul, singing and performing skits for the survivors as material signs of support. "You are connected to the past as well as to the future," explained the Japanese woman performing the role of Gil Won Ok. Two other Japanese women playing the roles of Korean survivors Lee Yong Soo and Yi Ok-seon appeared on the makeshift stage in the middle of the street. On July 23, 2008, members of the Weekly Wednesday Troupe performed a short skit and dance routine for eight elderly survivors and their supporters at the 823rd Wednesday Demonstration. Korean students, middle-aged activists, and a handful of reporters surrounded the performers and the survivors as riot police guarding the embassy kept watch. Anticipation and excitement were in the air. In colorful *hanboks* [traditional Korean dresses], the performers' chests featured headshots of the women they were playing, and they spoke halting Korean, since their lines were written phonetically in Japanese. Through their performance, the Weekly Wednesday Troupe demonstrates their admiration for survivors and their support for the cause. The survivors' age and photos remind viewers of the urgency of the transmission of this epochal memory.

Performances of apology sometimes take place on Wednesdays during the rallies. Followed by a group of fellow *zainichi* [ethnic Koreans who live in Japan] holding a banner with Japanese and Korean on it, one woman walked before the grandmothers and tentatively reached for the microphone at the August 1, 2007, Wednesday Demonstration. She spoke in Japanese, intermittently stopping to suppress her tears, and through a translator offered an apology. The grandmothers responded by waving their butterfly-shaped placards. Many other groups from Japan have visited the Wednesday Demonstrations to apologize in person to the grandmothers. These apologies

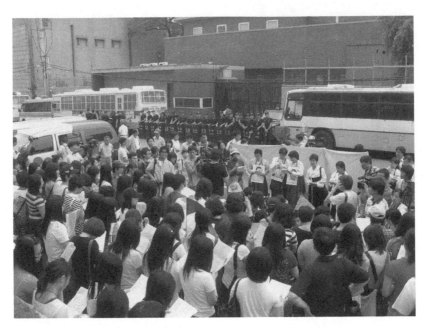

Fig. 6. Members of the Weekly Wednesday Troupe, a group of Japanese citizens from Takarazuka, perform a skit at the July 23, 2008, Wednesday Demonstration in Seoul. Performers playing Lee Yong Soo, Yi Ok-seon, and Gil Won Ok, who were present, wear headshots of the survivors. Riot police stand guard in front of the Japanese Embassy. Photo by Elizabeth W. Son.

do not constitute mere words but are coupled with the act of standing in solidarity with the grandmothers. Countless student and civic groups have performed at the Wednesday Demonstrations, playing traditional Korean instruments, acting in short skits, singing songs, and offering personal apologies. These performances are calls and responses between survivors and supporters in a live process of redressive acts.

Transpacific Restagings of Protest

Women's, civic, and human rights organizations in Japan, Taiwan, the Philippines, Australia, Canada, England, France, Germany, and the United States have organized solidarity protests with the Korean Council. Individuals from the organizations meet at conferences, tes-

timonial events, and the Wednesday Demonstrations, staying in touch through social media. The Korean Council coordinates with interested organizations to hold events in solidarity with protests on symbolic dates: August 15 (in commemoration of the surrender of Japan, the end of World War II, and Independence Day in many former Japanese colonies); March 8 (International Women's Day); and large-scale Wednesday Demonstrations, such as the one thousandth demonstration on December 14, 2011. Most significantly, when survivors are not able to participate, supporters convey the presence of survivors with photographs.

Kang Il-chul was dressed in white and lifted her right fist as she joined members of local Korean American organizations, including churches, groups for the elderly, veterans' organizations, and sports organizations in Washington, D.C., on a sunny March 22, 2005.[105] The Korean American Association of the Washington Metropolitan Area, Washington Coalition for Comfort Women Issues, and Korean Veterans Association of Washington, D.C., were the main organizations behind the protest.[106] Women holding photographs of survivors of military sexual slavery flanked Kang on both sides. The mix of first- and second-generation Korean Americans around her waved small Korean flags and held up signs that said in Korean and English, "No apology, no reparation, no admittance to UN Security Council," "Give me back my youth," "Japan Stop History Distortion," and "Dokdo Islet is Korean Territory."[107] These slogans, which reflect different political agendas, suggest that a broad coalition was coalescing around the "comfort women" issue.[108] Some were protesting Japan's bid for a nonpermanent seat on the UN Security Council; others were raising nationalist issues, such as the conflict over the Dokdo Islets and the revisions in Japanese history textbooks. This group had gathered the morning before an appeal hearing on behalf of "comfort women" survivors at the D.C. Circuit Court of Appeals.[109] The protesters occupied the plaza leading to the courthouse, which borders Constitution Avenue and sits one block west of the US Capitol. As the protesters at the Wednesday Demonstrations do, these protesters strategically chose nationally marked space. By geographically staging the protest within this nexus of power, protesters were asking for official redress and placing the US nation-state in the position of arbiter of justice. Facing Constitution Avenue, their bodies formed an arc, with Kang and the photographs of survivors at the

center. Like their counterparts in Korea, the Washington, D.C., protesters stood physically and symbolically behind survivors and their claims for reparations.

As the protesters directed their claims toward US courts and politicians and the American public, they also addressed the local Korean immigrant community and the Korean public abroad with their use of Korean signs and chanting of Korean slogans. On this day, the emcee shouted into the megaphone in Korean, "Make reparations to military 'comfort women.'" "Make reparations, make reparations, make reparations," those in the crowd shouted back, shaking their right fists in the air. Their calls for redress resonate with those at the Wednesday Demonstrations, connecting these seemingly disparate performances through an embodied hand gesture of solidarity. "Dokdo Islet is Korean territory," continued the emcee. "Territory, territory, territory!" While survivors of military sexual slavery were supposed to be the center of this gathering, protesters expressed two other grievances against the Japanese state: the distortion of Japanese history textbooks and Japan's claim to the Dokdo Islets. This event was not just an embodied expression of solidarity with protesters and survivors in Korea but was also a platform for other political agendas, entwining local US citizenship claims with Korean nationalist pride.

As citizens, protesters called on the US government to oppose Japan's bid for a nonpermanent seat on the UN Security Council. They cited Japan's history of military sexual slavery and the country's refusal to admit wrongdoing as evidence of its insincere commitment to peace. At the same time, the protest offered an outlet for Korean diasporic political concerns and nationalist pride. After shouting their demands, protesters sang the Korean national anthem and a rendition of "Arirang," a popular Korean folk song. At this event, the issue of military sexual slavery became subsumed into a nationalist framework, locating redress for survivors as redress for the Korean nation after a colonial history of wrongdoing and positioning the US nation-state as the arbiter of justice. This exemplifies what transnational Asian studies scholar Lisa Yoneyama calls the risk of political misappropriations of the memories of Japanese military sexual slavery through seeking justice for survivors of Japanese war crimes in US courts.[110]

Despite the fact that this demonstration was problematic from the perspective of the issues important to the survivors, Kang and

photographs of other survivors were the visual focus of the protest. Activists use the photographs of former sex slaves as surrogates for living survivors who cannot attend and as a way of recognizing survivors who have passed away. For a majority of solidarity protests around the world, survivors have been present in only visual images. Kang's presence at the Washington protest reanimated the photographs and reminded observers that the estimated two hundred thousand women taken into military sexual slavery were and are real, living individuals.

Conclusion

This chapter looks at the perennial questions that arise when talking about protests: How effective are they? What changes do they bring? What role does performance play in bringing about that change? Answering these questions requires a more elastic definition of change and sense of time. The changes the protesters have enacted go deeper than formal diplomatic forms of redress. Through the act of participating in the protests, survivors have come to think differently about themselves and their relationship to the world. Furthermore, they have educated generations of Koreans and motivated people who encounter the demonstrations to think about broader questions surrounding the ramifications of wartime violence against women, education about historical events, memorialization, and social justice. These changes go much deeper than apologies and monetary reparations. These are shifts in consciousness. They are political awakenings. Survivors and their supporters have also developed social bonds with each other, formed transnational networks with other activists, and brought international visibility to their cause. These changes—the social and cultural forms of redress—did not happen overnight; they took years and decades and may reverberate for generations. The weekly performances of the Wednesday Demonstrations brought forth these changes in the survivors and in the protesters who stand alongside.

The weekly Wednesday Demonstrations give survivors a public space for remembering and performing as victims, survivors, living witnesses, *halmeonidul*, history teachers, and peace protesters. Protesting is an act of defiant re-membering, a coming together of bodies

and the memories they enact and politicize. With the "materiality of their own bodies," in the words of theater studies scholar Sandra L. Richards, these women fill the void left by the deceased or by survivors who have chosen to avoid the limelight.[111] In a space paved over by "postcolonial forgetting," the survivors perform memories of wartime violence through their physical and verbal testimonies.

Román argues that people with AIDS at public protest events "exploit[ed] the space of performance to challenge its horizon of expectation." Their presence "unsettled the traditional representational iconography of AIDS in the dominant media." The way people with AIDS presented themselves at events such as candlelight vigils changed how people thought about the disease and the social and political issues associated with it. Román concludes that "once people are gathered in the space of performance, the possibility of intervention proliferates."[112] The presence of survivors at the Wednesday Demonstrations serve a similar function. In performing a multifaceted identity at the Wednesday Demonstrations, they challenge the expectation that elderly victims of sexual violence might be passive and meek. The dynamic repertoire of the protests enables survivors to boldly embody individual and communal petitions for redress.

By framing the Wednesday Demonstrations as performances, I call attention to the signifying power of the body, the interaction of the body with other bodies or audiences, and the agency of these subjects in a particular space during a distinct period of time. Understanding the Wednesday Demonstrations as performances illuminates the strategic work of activists and survivors in using space, sartorial choices, and physical movement to elicit affective responses from both participants and viewers. Furthermore, viewing these weekly gatherings as purposeful embodied acts shows how former "comfort women" have broadened our understanding of the work of victims of sexual violence in public spaces.

Protesters both affirm the need for reparative measures from a national body and broaden the demand for redress to include social and cultural transformation, and the participation of survivors enables the Wednesday Demonstrations to have this dual purpose. Through their corporeal presence, survivors *embody*—or materialize or make tangible—both their historical experiences and demands for redress.[113] Framing survivors as living embodiments of the history of sexual slavery has required an invocation of both youth and old age.

Using rhetoric and images that portray youth as a time of sexual and moral innocence differentiates the violence done to "comfort women" from other histories of sexual violence, while drawing attention to the aging body adds credence to demands for redress. Moreover, the survivors use their status as elderly women to occupy the position of *halmeonidul*. Claiming grandmotherhood opens up familial frameworks that help structure social relations on the street so that protesters become part of a makeshift kinship configuration.

However, in positioning survivors as living embodiments of history, the protests run the risk of constructing a limited subjectivity for these women in which they cannot be seen apart from their wartime experiences as "comfort women." This cuts to the central tension of the Wednesday Demonstrations: how to balance the burden of claiming victimhood while mobilizing that experience into a teachable and reparative gesture. The elderly women use the protests as an opportunity to reclaim their experiences of sexual violence as part of their multifaceted and interrelated identities as victims, survivors, living witnesses, *halmeonidul*, history teachers, and peace protesters.[114]

As a result, the women's presence provides powerful testimony that inspires a range of performances during the Wednesday Demonstrations. These include somatic disruptions, or bodily interferences with the movement of passersby through public space; testimonies and apologies; and cultural performances, including short skits and Korean drumming. Through the performance of the Wednesday Demonstrations and the many performances within the protests, survivors and their supporters work to transfer the agency to make reparations from the state to the public by creating a redressive arena. They reimagine and practice social restitution outside official parameters. The survivors elevate the significance of the act of remembering history through education on the street and cultivate communities of remembrance through intergenerational and transnational coalition building.

The Wednesday Demonstrations resonate in striking ways with the weekly protest performances of the *madres* [mothers] and *abuelas* [grandmothers] of the "disappeared" in the Plaza de Mayo in Buenos Aires.[115] Like the Wednesday Demonstrations, the protest marches in Argentina have strategically used public space, gendered roles, garment choices, and ritualistic movement.[116] While

the *madres* made visible the disappearance of their children, the transformative possibilities of their performances of motherhood, as performance studies scholar Diana Taylor argues, were limited. Even as they attempted to redefine motherhood and utilize it as a collective identity, the *madres* were often "trapped in a bad script," reinscribing essentialist notions of motherhood and femininity that have been overdetermined by the state and patriarchal society.[117] The Korean protesters' invocations of the gendered role of *halmeoni* does not work in quite the same way. The ambiguity of the aged body does not easily fit into nationalist narratives. The central role of aging survivors at the Wednesday Demonstrations calls for new focus on the interrelationships among aging, embodiment, and social change in political protests.[118]

So do the survivors think the Wednesday Demonstrations are effective?[119] Lee Yong Soo adamantly insists that the protests have been effective because they have attracted supporters and given people an opportunity to see a "living witness of history."[120] On the surface, the ritual that has been repeated every Wednesday since 1992 seems to suggest that the protests have failed as an arena of official redress. However, the Wednesday Demonstrations bring to light the inherent tension of redressive acts, which are always incomplete projects. They offer material albeit fleeting moments of reparation in the sharing of memories, the teaching of history, and the community building that takes place during these protests. A skeptic may question how much change can occur during one hour on a Wednesday. Nonetheless, redressive moments build on each other over time. Theater director Augusto Boal has proposed a model for considering the participation of the audience. He articulates the transformative possibilities of performances as a "rehearsal of revolution," so that audiences are being called to action and putting into practice the revolution.[121] The Wednesday Demonstrations are both the revolution and the rehearsal—a final performance that enacts reparative change on the street and a rehearsal that calls for future acts of redress beyond the official parameters of state apologies and legal reparations.

Staging Justice: The Women's International War Crimes Tribunal

"This is how I walk after they rape me," explained Marta Abu Bore, an elderly woman from East Timor.[1] Bore joined sixty-three other survivors of sexual violence at the hands of the Japanese military during World War II at the historic Women's International War Crimes Tribunal on Japan's Military Sexual Slavery. The women had come from nine countries—North and South Korea, China, Taiwan, the Philippines, Indonesia, East Timor, Malaysia, and the Netherlands—to testify as plaintiffs in the tribunal held in Tokyo on December 8–12, 2000.[2] Bore slowly rose out of her chair and took a few steps. A table in front of her blocked her path—she turned from one side to the other to get around it, but a woman sitting behind her gently touched her arm to coax her to sit back down. Bore was trying to articulate the trauma of rape in the "comfort stations" and the physical ramifications of the violence on her aged body. Words failed to capture the pain of her violation, so she attempted to show what perpetrators did to her. But as she tried to express her memories, a gentle arm held her back. The legal counsel had pointedly asked her whether she could walk after the rapes, almost inviting her to dwell on this detail, but she was discouraged from giving full expression to the physical trauma of her violation. Bore's performance illustrates both the performative aspects of the tribunal and its limitations.

The Women's Tribunal notified the Japanese prime minister of the proceedings and invited him to participate, but the government did not respond.[3] In fact, the Japanese government has never tried Japanese war criminals or initiated official forums such as a truth commission. The

tribunal nonetheless requested an amicus curiae [friend of the court] brief to present the anticipated arguments of the Japanese government and considered both these arguments and the potential arguments of accused individuals.[4] For the three days of the tribunal, prosecution teams from the nine participating nations presented the legal case against the Japanese state. The next day, Chief Judge Gabrielle Kirk McDonald ordered a recess, and organizers held the Public Hearing on Crimes against Women in Recent Wars and Conflicts. During this hearing, organized by the Women's Caucus for Gender Justice, women from thirteen areas of current and past armed conflicts testified to their painful experiences of rape and other forms of violence. On the final day of the tribunal, the judges presented their preliminary verdict, pronouncing Emperor Hirohito and other Japanese officials guilty.

The Women's Tribunal afforded Bore and other survivors an unprecedented public platform for testifying about their experiences. This was the first time East Timorean survivors had come forward.[5] Yet Bore was prevented from fully testifying in the way she wanted to—through embodied movement. The tribunal's legal protocol and spatial limitations got in her way. Bore's experience highlights the Women's Tribunal's dual role in efforts to redress the violence inflicted on "comfort women." Most obviously, it drew attention to the call for formal, legal redress. In addition, both despite and because of its limitations, the tribunal forged a path to redressive measures that centered on performance. This chapter captures the multiple ways organizers and participants used performative strategies during the Women's Tribunal: to make possible collective participation in a legal event, to display or demonstrate ideas of justice, and to promote social and political change.

Bore and other tribunal participants may not have intentionally challenged legal frameworks when they sought to use their bodies to give testimony. Nevertheless, their embodied tactics implicitly questioned the given frame of international adjudication handed down by postwar tribunals and their inattention to gender-based crimes. In staging what philosopher Jacques Rancière calls "scenes of dissensus," the Women's Tribunal allowed for the emergence of new political subjects.[6] "A dissensus," writes Rancière, "is not a conflict of interests, opinions, or values; it is a division put in the 'common sense': a dispute about what is given, about the frame within which we see something as given."[7] In other words, dissen-

sus is about "putting two worlds in one and the same world."[8] While Rancière did not explicitly discuss performativity, it is central to the embodied enactment of staging scenes of dissensus that make political subjecthood possible.[9] Staging scenes of dissensus requires people who put their bodies on the line to make differences visible and felt. Rancière provides a useful framework for understanding how the Women's Tribunal intervened in the process of justice: the tribunal opened up space for dissensus, and in this space participants used embodied action to question the "given" frame of international adjudication in general and legal formal protocol in particular. Their performances illuminated the gaps between protocol and what truth telling means to the survivors.

Through a juxtaposition of two worlds—the long-standing framework of international human rights adjudication and a vision of an alternative process—the Women's Tribunal critiqued the inattention that past juridical protocol had given to gendered human rights violations such as military sexual slavery. Survivors were crucial to illustrating these limitations, not only as representative embodiments of a historical moment and its aftermath but also because their testimonial performances broke the "script" of legal protocol for taking an oath and giving testimony. Their enactments showed the fissures in the law's preference for a logos-centric testimony and opened up space for more expansive articulations of what constitutes justice.

The tribunal's organizers started by establishing Japan's legal responsibility for making reparations and symbolically indicting those responsible. This redefinition facilitated other performances of justice that together produced a more complete picture of Japanese military sexual slavery and what it meant to try to restore survivors' political and social status and dignity. The tribunal also brought together participants as members of transpacific communities of remembrance committed to holding perpetrators morally accountable for wartime sexual violence against women. By situating the public hearing as a central part of the Women's Tribunal, organizers also sought to frame the struggles of "comfort women" survivors as a global call to action to attend to past and current women's human rights violations. In other words, the Women's Tribunal and public hearing set a precedent for desired future behavior: impeding a culture of impunity by calling for the public accountability of people who commit sexual violence against women during armed conflicts.

While the Women's Tribunal attempted to be a court of justice, albeit a symbolic one, it also created a site of transitional justice as an alternative to traditional jurisprudence.[10] Bore's interrupted performance illuminates a central tension at the Women's Tribunal: how to honor victims and their needs while judging guilt via traditional court processes that are not always friendly to victims. Unlike a truth commission, which can have separate victim-centered hearings and conventional court-like proceedings, the Women's Tribunal attempted to combine both into one event.[11] The Women's Tribunal combined different modes of adjudication used in postconflict societies such as international war crimes tribunals, people's tribunals, and truth commissions.[12] While the Women's Tribunal sought to strike a balance between serving as a tribunal and serving as a truth commission, it was closer to a traditional court of law than a truth commission.

Like officially sanctioned tribunals, the Women's Tribunal sought to establish the legal basis for war crimes and to call on an international community to serve as the arbiter of justice.[13] However, a number of crucial differences existed between officially sanctioned tribunals and the Women's Tribunal.[14] The Women's Tribunal focused solely on sexual slavery and other acts of sexual violence against women. It also structured legal proceedings differently and more like truth commissions: "victimized" countries served as prosecutors, and survivors were key witnesses.[15] Further, the Women's Tribunal had a dual legal and pedagogical purpose, unlike traditional courts of law and more like truth commissions: it was designed to both make a legal case against Japan and produce a more complete history of Japanese military sexual slavery. Noting these differences is crucial to understanding how the Women's Tribunal produced and then used dissensus to highlight both the need for and the limitations of international adjudication and its juridical protocol. Analyzing the tribunal as a live, embodied performance shows how the Women's Tribunal worked toward its goals.

Performance and the Law

Critical legal studies scholars have long noted the limits of a text-centered analysis of law and legal practices and emphasized the need

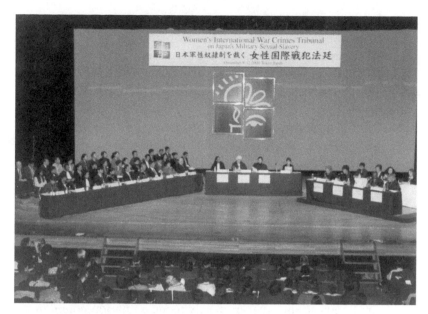

Fig. 7. The Women's International War Crimes Tribunal on Japan's Military Sexual Slavery took place in Tokyo on December 8–12, 2000. On the last day of the tribunal, legal counsel from nine countries sat on the right of the stage with the co-chief prosecutors and the registrar sitting in the center as they listened to the judges' (*seated on the left of the stage*) concluding remarks and verdict. Photo courtesy of the Korean Council for the Women Drafted for Military Sexual Slavery by Japan/ War and Women's Human Rights Museum.

to understand their theatrical dimensions.[16] "Law is both a consumer and a producer of images and performances," writes legal scholar Austin Sarat. "Law is visual and theatrical, using and depending on what people show, do, and dramatize."[17] The law and its practices rely on different aspects of performance, from restored behavior to liveness, for production, interpretation, and fulfillment.[18] In addition, the changing landscape of international law and human rights with the rise of truth commissions requires further inquiry into the methods used to produce these alternative sites of justice.[19]

In her groundbreaking book on the South African Truth and Reconciliation Commission (TRC, 1996–98), theater and performance studies scholar Catherine Cole asks scholars to give critical attention to the "public, performed dimensions" of scenes of transitional justice.[20] Following Cole's example, this chapter examines closely the

verbal and the nonverbal, the embodied facets of testifying. Cole demonstrates how the "TRC embraced performance—that is, embodied enactment before an audience—as a central feature of its operations" while probing the "consequences of this decision."[21] Close attention to embodied testimonial performances illuminates the ways survivors negotiated the precarious site of the Women's Tribunal and pushed against its frameworks. Cole shows how looking at the convergence of the archive and repertoire in the political trials of the 1950s and 1960s and during the TRC can be analytically fruitful. In a similar fashion, the Women's Tribunal's demand that survivors perform as living evidence provides new insight into how we understand the relationship between evidentiary proof and embodiment.

The scholarship on law and aesthetic practices is growing.[22] This chapter builds on that literature by looking anew at the interrelationships among performance, law, and human rights through close attention to questions about aged, scarred bodies and transnationalism. Unlike previous studies that primarily focus on nation-bound negotiations of violent pasts, this chapter focuses on what it looks like for a transnational collective to grapple with personal, communal, national, and institutional politics of memory in reimagining justice. I also ask questions about gender and women's bodies in exploring what happens when survivors and activists call out the failures of international adjudication and reconceive the contours and duration of redress. As was the case for the weekly protests in South Korea, redress was not simply an end goal of the Women's Tribunal; rather, reparative memories and gestures were materialized *during* the procedure. A process-oriented conception of justice that began at the tribunal continues today.

The extant literature on the Women's Tribunal from the fields of legal studies, history, Asian studies, and gender studies addresses the historical context of the tribunal; key moments from the tribunal from an experiential standpoint; the way it demonstrated military sexual slavery to be a violation of international law; and the global network that organized the tribunal.[23] However, none of this literature looks at the proceedings through a performance-oriented lens, even though the Women's Tribunal was clearly designed as a public event for an audience. What comes to light when we attend to the live, performed elements of the Women's Tribunal? To what extent do the tribunal's limitations negate its positive contributions of provid-

ing space for silenced memories, making a legal case against the Japanese state, and galvanizing a transpacific community of witnesses? How was the Women's Tribunal both a rehearsal for a future legal performance that will probably never happen and a public enactment of justice? What techniques did it use to accomplish both goals? How did survivors participate in staging justice? Performative strategies were central to the vision, legitimacy, and operation of the Women's Tribunal; a performance-oriented lens allows one to see how victims of sexual violence were central to challenging legal protocol.

Genealogies of and Visions for the Women's Tribunal

Neither an officially sanctioned tribunal nor a mock trial, the Women's Tribunal was a unique court-like body and public event. The Korean Council for the Women Drafted for Military Sexual Slavery by Japan describes it as a "symbolic international human rights tribunal."[24] Modeled after people's tribunals such as the Russell Tribunal (1966–67), the Women's Tribunal sought to exercise the moral authority of a community of responsible citizens who were not afraid to hold states accountable for war crimes.[25] Based on the premise that "law is an instrument of civil society," people's tribunals step in where "states fail to exercise their obligations to ensure justice."[26] As a people's court, the Women's Tribunal was specifically "established as a result of the failure of states to discharge their responsibility to ensure justice."[27]

Scholars and activists have traced the genealogy of the Women's Tribunal, like other international justice systems, to the 1945–46 International Military Tribunal at Nuremberg (the Nuremberg Trials) and the 1946–48 International Military Tribunal for the Far East (the Tokyo War Crimes Trials).[28] These two institutions constituted the first trials at which nations gathered in a collective effort to hold other states accountable for war crimes and played an important role in beginning to articulate the contours of a body of international human rights law. For example, as historian Yuma Totani writes, "the Charter of the Nuremberg Tribunal was the first to give ['the concept of crimes against humanity'] clear codified expression."[29] After securing the unconditional surrender of Japan at the end of World War II, US-led Allied forces occupied Japan and orchestrated the country's

transition into a demilitarized and democratic state. "Started as the Allied occupation of Japan at the end of World War II," writes sociologist Mire Koikari, "the occupation was almost from the very beginning exclusively controlled by the United States, which evaded interference from other Allied powers such as Britain, the Soviet Union, China, and Australia."[30]

Between 1946 and 1948, a team of judges and prosecutors from eleven countries envisioned and set up the Tokyo War Crimes Trials as a central component of this transition.[31] Totani explains that like the Nuremberg Trials, which tried German leaders who "waged aggressive war and committed large-scale atrocities," the Tokyo War Crimes Trials heard cases involving twenty-eight Japanese political and military leaders accused of the "planning and execution of aggressive war in the Asia-Pacific region" and of involvement in "atrocities committed by the Japanese armed forces against millions of civilians and prisoners of war in various theaters of war."[32]

The Women's Tribunal was established to "do what the Tokyo Tribunal and the international community has failed to do."[33] Organizers of the Women's Tribunal consciously designed it to be a "reopening or continuation" of, not a replacement for, the Tokyo War Crimes Trials.[34] Organizers asserted that the Allied powers were responsible for failing to prosecute despite "ample evidence of rape and sexual slavery in the 'comfort system.'"[35] Though the prosecution of crimes against peace ("the top priority for the U.S. government," in Totani's words) "took center stage" at the Tokyo War Crimes Trials, prosecutors also charged defendants with war crimes and crimes against humanity, which were defined as "restricted to wartime civilian-targeted atrocities."[36] Totani shows that although prosecutors at the Tokyo War Crimes Trials did present evidence of military sexual slavery or "forced prostitution" (as it was known at the time) of Chinese, Dutch, Indonesian, and Timorean women, these individual cases of rape were not seen as "another commonly patterned war crime" or part of an institutionalized system of sexual slavery, most likely because of insufficient evidence of "high-level governmental involvement."[37] Prosecutors embedded these crimes of sexual violence within larger cases of Japanese aggression toward civilians, and because the presentations took the form of synopses, these crimes went unnoticed by observers and researchers.[38] Ultimately, crimes against women were not a

priority for prosecutors, who focused energy on atrocities inflicted on Allied nationals.[39]

Though the Tokyo War Crimes Trials were multinational legal proceedings, they were led by US and Allied prosecutors "interested primarily in establishing the responsibility of wartime Japanese leaders for atrocities targeted at Allied nationals."[40] "The U.S. military knew about comfort stations," writes activist and journalist Matsui Yayori, "because it captured comfort women on various battlefields, including Burma and Okinawa."[41] But at that time the US military and its allies did not see the "comfort system" as a violation of international law. These men likely viewed the "comfort system" as another form of the military-monitored sex work that was an inevitable part of military life during World War II.[42]

The US government was responsible for many of the major shortcomings of the Tokyo War Crimes Trials. While the Japanese right wing called the Tokyo War Crimes Trials a "revenge trial," scholars and lawyers have found three main faults: "it gave the emperor impunity, it overlooked the devastating effects of colonialism, and it neglected the issue of sexual violence, such as military sexual slavery."[43] For ideological and political reasons, the United States, as historian John W. Dower puts it, "exonerat[ed] the emperor of all war responsibility, even of moral responsibility for allowing the atrocious war to be waged in his name."[44] Though the feeling was not explicitly stated at the Women's Tribunal, many observers blame the United States for failing to prosecute Emperor Hirohito and for how "U.S. national interests ended up denying justice for all people victimized by the war."[45] Japan's recuperation, first as a demilitarized and democratic country and then as a Cold War ally in Asia, was a greater priority for the US government and its vision of a Pax Americana than was addressing Japan's wartime criminality.[46] This vision became manifest in the San Francisco Peace Treaty (1951), which led to the end of the occupation the following year and prevented former colonized individuals from seeking reparations. Some dismissals of court cases filed by former "comfort women" pointed to this treaty as one of the main reasons why individuals and countries could not seek reparations from the Japanese government.[47]

Since the early 1990s, survivors have sought legal justice in Japanese, US, and Korean courts.[48] Three Korean survivors and members of the Association of Korean Victims filed a 1991 lawsuit in the To-

kyo District Court. The court rejected the women's demands for an official apology, monetary reparations, an investigation, the revision of history textbooks, and the construction of a memorial museum. While the presiding judge "ruled out compensating individual South Koreans for wartime damage stating that the redress issue was settled by a 1965 bilateral agreement between Japan and South Korea which normalized their relations," activists and the Korean government argued that the treaty did not fully absolve Japan, primarily because it did not address or "officially dea[l]" with military sexual slavery.[49] In September 2000, an unprecedented transnational group that included six survivors from Korea, four from China, one from the Philippines, and four from Taiwan filed a class-action lawsuit against the Japanese government in the US District Court for the District of Columbia under the Alien Tort Claims Act, which was "originally designed to address damages caused by piracy and provides foreign citizens the right to sue other foreign citizens and entities for abuses of international law."[50] Lower courts dismissed the case, but the US Supreme Court eventually granted certiorari and sent it back for reconsideration.[51] Protesters gathered holding photographs of Korean survivors before a 2005 appeal hearing in Washington, D.C. (see chapter 1). The D.C. Circuit Court of Appeals dismissed the case in 2005 because "the issue involved international relations and the courts are not authorized to hear the claims," and the Supreme Court denied cert and closed the case in 2006.[52] Two 2007 rulings by Japan's highest court rejected compensation claims by former sex slaves and forced laborers from China, although the Supreme Court of Japan "acknowledged that [the women] had been coerced by the Japanese military or industry," wrote journalist Norimitsu Onishi.[53] As of 2010, ten lawsuits had been filed in Japanese courts, and all had been dismissed by the Supreme Court without any legal gains for the petitioners. In 2015, a class-action suit filed by two Korean survivors against the Japanese government and major corporations for "conspiring to force Korean women into sexual slavery during World War II" was permanently dismissed.[54] The failure of these cases points to the continued elusiveness of legal redress from the courts.

"Most of the victims are aged and now believe that there is no hope for their cause in these courts," wrote Women's Tribunal organizers Matsui Yayori, Yoon Jeong-Ok, and Indai Sajor in 2000. "A

number of them have already passed away and those that remain wonder if the Japanese state is simply waiting for them to die, hoping for the problem to die with them. We cannot allow this impunity to go unchallenged."[55] Faced with legal dead ends and state apathy and denials, Matsui, a member of the Japan-based Violence Against Women in War Network (VAWW-NET); Yoon, a member of the Korean Council; and Sajor, a member of the Philippines-based Asian Centre for Women's Human Rights (ASCENT), felt the need "to give the women survivors who are all of an advanced age a sense of what constitutes justice."[56] Women from these organizations coordinated the tribunal and raised funds to pay for the rental of the auditorium and travel costs of and housing for the plaintiffs. Countless volunteers attended to the survivors and helped run the event.[57]

The Women's Tribunal was designed to be the "survivors' truest day in court."[58] The Women's Tribunal had three general objectives: (1) to address and amend the failures of national and international judicial systems to adjudicate the issue; (2) to gather evidence on the nature of sexual slavery in different countries and to establish the legal basis for Japan's responsibility; and (3) to bring together an international community to enforce the judgment and work to impede the cycle of impunity for wartime sexual violence against women.[59] One of the Women's Tribunal's central concerns was to establish its own legitimacy and authority.

Legitimacy and Cross-Legal Memories

The Women's Tribunal sought to legitimize itself by performing cross-legal memory, which it accomplished by invoking previous tribunals and reenacting juridical protocol.[60] The concept of "cross-legal," as developed by literature and trauma studies scholar Shoshana Felman on the "model of cross-cultural," refers to a "trial's reference to another trial, of which it recapitulates the memory, the themes, the legal questions or the arguments, and whose legal structure it repeats or reenacts—unwittingly or by deliberate design."[61] What Felman calls "cross-legal memory" persists in the restored behavior of previous trials and accumulates in what theater and performance studies scholar Joseph Roach calls "genealogies of performance."[62] Here, I examine the embodied nature of cross-legal memory, which,

in the case of the Women's Tribunal, continued not just in legal structures but also in bodies that consciously invoked and reperformed the legal memory of the Tokyo War Crimes Trials.

Performance studies scholar Branislav Jakovljević's invocation of Felman's framework of cross-legality in his analysis of the political performances of Slobodan Milošević prompts special consideration of the Women's Tribunal's multiple temporal orientations.[63] Jakovljević explains that "what is significant for the Milošević trial is that its cross-legal references extend both to the past and to the future, bringing together legal memories and hopes."[64] As with all performances, legal memories are reenacted with key differences from the original proceeding. In the Women's Tribunal, these differences were designed to amend and address the failings of existing international law and human rights protocol as well as to articulate a vision for future performances of justice. This critical alteration—embodied repetition with a difference and with an eye toward both the past and the future—was the linchpin that enabled the worlding of dissensus at the Women's Tribunal.

The Women's Tribunal used a repetition of legal protocol to enact cross-legal memories of the Tokyo War Crimes Trials during both the planning process and the proceedings. The most striking difference between the Women's Tribunal and the Tokyo War Crimes Trials and other officially sanctioned tribunals was that organizers did not establish the Women's Tribunal by law or conduct it under the auspices of a state or international body such as the United Nations. As historian Kim Puja asks, "When the state is an agent of crime, who is in a position to judge the state?"[65] The Women's Tribunal's unequivocal answer is that civil society belongs in this position.

The Women's Tribunal represented the culmination of collaborative efforts across national boundaries. The multinational planning effort significantly departed from its postwar predecessor. Although countries with victimized populations, such as China, the Philippines, and the Netherlands, participated in the Tokyo War Crimes Trials, Allied legal experts, particularly from the United States, directed the prosecution's strategy, and the concerns of the victor nations dominated.

The Women's Tribunal disrupted this power discrepancy by having a diverse panel of judges and by focusing on victimized countries and survivors. The history of colonial victimization included Japan's

colonization of Korea and Formosa (now Taiwan) and occupation of territories in China, the Philippines, East Timor, Malaysia, and the Dutch East Indies (now Indonesia). For example, Japanese occupiers in the Dutch East Indies (1942–45) interned Dutch citizens in camps and forced Dutch women into sexual slavery. "In order to reduce the high VD rates among their men," writes historian Yuki Tanaka, "senior Japanese military officers sought to procure young, unmarried women free of sexual disease for military prostitution."[66] Jan Ruff O'Herne, a Dutch survivor, testified at the Women's Tribunal. Survivors, activists, and prosecutors from these victimized countries were the key participants in the Women's Tribunal: they served as organizers, as drafters of the charter, and as witnesses.

Unlike the Tokyo War Crimes Trials, Japanese women from the perpetrator nation and organizers and survivors from victimized countries worked together on the Women's Tribunal.[67] As co-convenor Matsui explained, "a group of Japanese women who felt responsible for the crimes their own country committed against women" proposed the idea of the Women's Tribunal.[68] Women from VAWW-NET, which organizes efforts in Japan on behalf of survivors, presented the plan at the Fifth Asian Solidarity Conference on "Comfort Women," held in Seoul in 1998.[69] The Asian Solidarity Conference is an annual meeting for a network of organizations from South Korea, Japan, Taiwan, and the Philippines, among other countries, whose members work on behalf of survivors. The planning of the tribunal was led by Matsui, Yoon, and Sajor. Participants from civil, women's, and human rights organizations from Japan and from victimized countries planned the tribunal for two and a half years, meeting in Geneva, Seoul, Tokyo, Shanghai, Jakarta, Manila, Taipei, and The Hague.[70] They came from such organizations as the Committee on Measures for Compensation to the Former Comfort Women for Japanese Army and Pacific War Victims (North Korea), the Shanghai Research Center on Comfort Women (China), the Taipei Women's Rescue Foundation (Taiwan), and the Indonesian Women's Coalition for Justice and Democracy.[71]

Their incredible collaborative efforts, as Kim Puja points out, offer "one model for a form of feminism that transcends national borders," a model of "feminism without borders," to echo feminist scholar Chandra Talpade Mohanty, that works through, across, and with multiple borders.[72] Shared histories of sexual oppression and

visions for social change among the survivors and participants in the Women's Tribunal were "political rather than biological or cultural bases for alliance."[73] The participants in the Women's Tribunal were united not by the fact of their gender, race, or ethnicity but by their belief in justice for former "comfort women" and their commitment to fighting against ongoing gender-based and sexual violence.

As at the Tokyo War Crimes Trials, a panel of international judges presided at the Women's Tribunal, but with a critical difference: they were diverse in gender, legal background, and nationality.[74] The Women's Tribunal obtained its authority from the people who came together to form it: scholars, activists from affected countries, UN-recognized legal experts, and survivors. Though the Women's Tribunal was not an official UN body, all the judges and chief prosecutors were recognized legal experts in international law and human rights, and two were directly involved in UN legal bodies. Chief Judge Gabrielle Kirk McDonald was the former president of the International Criminal Tribunal for the Former Yugoslavia (ICTY), and co-chief prosecutor Patricia Viseur-Sellers was the legal adviser on gender-related crimes in the Office of the Prosecutor for ICTY and the International Criminal Tribunal for Rwanda (ICTR).

The participation of legal experts such as McDonald and Viseur-Sellers strengthened the credibility of the Women's Tribunal. Moreover, their direct involvement in the ICTY and the ICTR illustrated the connections between adjudicating on Japanese military sexual slavery and impeding contemporary and future wartime sexual violence against women.[75] "The ICTY was the first war crimes court created by the UN and the first international war crimes tribunal since the Nuremberg and Tokyo tribunals," according to the tribunal's official website.[76] Both the ICTY and the ICTR had "convicted several defendants of rape as a crime against humanity."[77] For example, the accused in *Prosecutor v. Kunarac* (ICTY) were charged with both rape and enslavement as crimes against humanity. According to Carmen Argibay, one of the judges at the Women's Tribunal, this "laid a sound foundation for the subsequent prosecution of the crimes of sexual slavery."[78]

In cross-legal reference to the Tokyo War Crimes Trials, the Women's Tribunal took place in central Tokyo. The Allies had chosen to host the post–World War II tribunal in Japan's capital so that the country's public "could have easy access to this historic trial and

appreciate its fact-finding mission." The choice of a former military academy at Ichigaya as the site, explains Totani, "had the benefit of impressing the Japanese public with the fact of defeat and putting a symbolic end to the unquestioned authority of the Japanese military establishment."[79] The site of the Women's Tribunal proceedings, Kudan Kaikan, was also a former military building, an ironic choice for the public indictment of the Japanese military. Kudan Kaikan is in the Chiyoda ward of central Tokyo, which is also the site of the National Diet Building, the prime minister's residence, and the Supreme Court. By situating the Women's Tribunal within this geographic nexus of power, organizers attempted to symbolically disrupt traditional political and juridical control of redressive action. According to VAWW-NET member and scholar-activist Nakahara Michiko, organizers also thought it was important to locate the tribunal in Japan to make an appeal to the Japanese public about the justice claims of the witnesses.[80]

The presence and participation of activists, supporters, and survivors as agents of memory work in this space directly confronted Japan's national forgetting of wartime criminality. Kudan Kaikan is at the foot of a long hill leading to the Yasukuni Shrine, where nearly 2.5 million war dead have been enshrined since 1869.[81] Those enshrined include 1,068 convicted war criminals, including 14 Class A war criminals.[82] The first gate of the park where the Yasukuni Shrine is located is just a few minutes' walk from Kudan Kaikan. When I visited on a rainy day in May 2010, a steady trickle of people ranging in age and gender (but mostly men) were paying their respects at the shrine. In a ritualistic performance, one after another stepped up to the entrance of the wooden temple, tossed a coin into a large rectangular collection box, bowed twice, clapped their hands twice, bowed again, and left. Many of these people are "show[ing] their appreciation and respect to those who died to protect their mother country, Japan."[83] This surprising level of activity illustrates the importance of war memory to many Japanese citizens and the country's sensitivity regarding issues that might gesture toward Japanese wartime criminality.

The Yasukuni Shrine has become a symbol of Japanese militarism and a contested site for the politics of war memory in Japan and throughout Asia. Visits of former prime ministers to Yasukuni have been a "diplomatic sore point" with former Asian colonies and

Fig. 8. Tokyo's Kudan Kaikan, where the Women's International War Crimes Tribunal on Japan's Military Sexual Slavery was held on December 8–12, 2000. Photo by Elizabeth W. Son.

occupied areas such as Korea and China.[84] Activists and survivors assert that the prime ministers' visits to the shrine undercut Japan's gestures toward apologies. As a counterperformance to the rituals of wartime glorification by conservative politicians and citizens, the Women's Tribunal challenged this way of remembering Japan's colonial past. The Women's Tribunal's alternative memory making faced resistance from a group of neoconservative right-wing Japanese who protested outside Kudan Kaikan. On the second day of the Women's Tribunal, organizers warned participants to avoid going outside because of the protesters and suggested that Japanese participants take off their ID tags before exiting the building.[85]

Only one-third of the more than three hundred media representatives who attended the Women's Tribunal were from Japan.[86] Japan's national educational television channel agreed to devote one program to the Women's Tribunal in its four-part series on war responsibility, promising complete cooperation with VAWW-NET. What eventually aired in January 2001 was completely different from the

original agreement: omitted were the testimony of a Chinese survivor, the testimony of former soldiers, and the guilty verdict against the emperor. Instead, the program included a lengthy interview with a historian who was critical of the Women's Tribunal. According to Japanese studies scholar Norma Field, VAWW-NET sued the broadcasters, "charging them with having violated [the organization's] trust in making fundamental alterations to the program without prior explanation in response to right-wing pressures."[87] During the legal battle, which lasted close to seven years, it emerged that the program's chief producer had changed the program because of pressure from two politicians, including Shinzo Abe, who later became prime minister and in 2007 denied that the military had coerced women into the "comfort system."[88] In 2007, the Tokyo High Court ruled in favor of VAWW-NET, and the broadcaster immediately appealed the ruling; in 2008, the Supreme Court reversed the ruling and dismissed the lawsuit. The controversy over the program illuminates the continued sensitivity in Japanese public discourse about the nation's history of wartime criminality.

"All Rise": Opening Statements

"All rise, the court is now in session," announced Rowena Guanzon, the court registrar from the Philippines. "The Honorable Gabrielle Kirk McDonald presiding."[89] The audience rose to its feet as the four presiding judges, dressed in long black robes with blue sashes, entered the stage and found their seats. The court was set up on a stage in a large auditorium in Kudan Kaikan.[90] The four judges sat at a long table stage left, while the two chief prosecutors and the registrar sat center stage. The prosecutors and witnesses from the different countries sat across from the judges. The witnesses' and prosecutors' tables and the judges' table formed a trapezoidal configuration that opened out onto the large auditorium.

Approximately one thousand people, including around six hundred Japanese, attended the tribunal each day.[91] Two large video projection screens displaying testimony and the prosecution's presentation of evidence framed the sides of the stage outside the proscenium arch, creating fluidity between the stage and the auditorium.[92] This heightened the sense that the audience members were not merely

watching but were part of the proceedings as witnesses who would share the responsibility of arbitration.

Guanzon stated the case against Emperor Hirohito and other high-ranking Japanese government and military officials and presented the summary of the common indictment, which included charges of sexual slavery and rape as a crime against humanity, and which related to the mass rapes that took place in the Philippine village of Mapanique.[93] Chief Judge McDonald then called for appearances for counsel. Patricia Viseur-Sellers and Ustinia Dolgopol, co-chief prosecutors on behalf of the peoples of the Asia-Pacific region, introduced themselves, followed by prosecutors for North and South Korea, China, the Philippines, Malaysia, the Netherlands, Indonesia, East Timor, Taiwan, and Japan.[94] The international organizing committee made some opening remarks, and then the chief prosecutors read the indictment. McDonald announced that the judges accepted that this was not a tribunal established according to law by a state or international body but a people's tribunal established by civil, women's, and human rights organizations.

"Might I preface my remarks by saying, your Honors, that we are after simply two things: the application of the law as it existed at the time period that the crimes were committed. We ask no favor from the current development of law concerning slavery or rape," stated Viseur-Sellers in her opening remarks. "We therefore formally would ask you to re-open the proceedings of the Tokyo War Crimes Trials, because we believe that we have crucial evidence that your Honors should have listened to, should have accepted. Now, that evidence was available during the time period, but it was not sought out."[95]

This statement is fascinating because it collapses the temporal distance between the Tokyo War Crimes Trials and the Women's Tribunal. As a performative act, the utterance created continuity between the latter and the former. The Women's Tribunal sought to "apply the law as it existed at the time the acts were committed," a statement that was an explicit invocation of legal memory from the Tokyo War Crimes Trials.[96] "We will remain within the context of your findings," continued Viseur-Sellers, "and merely submit more evidence to substantiate what you have already based previous convictions of war crimes upon."[97] However, a crucial difference opened a space for dissensus that highlighted the limitations of the Tokyo War Crimes Trials. While the prosecutors from the Tokyo War

Crimes Trials chose to proceed on war crimes and not on crimes against humanity, the prosecutors of the Women's Tribunal, Viseur-Sellers explained, "have exercised a very vital decision and that is to proceed on crimes against humanity."[98]

Prosecution teams from North and South Korea, China, the Philippines, Taiwan, Malaysia, the Netherlands, Indonesia, and East Timor described how the system of military sexual slavery impacted the women from their respective countries and identified the individual military officials responsible for the operation of "comfort stations." The prosecutors corroborated video and live testimony by survivors with archival documentation and tied personal experiences of violence to the larger system of military sexual slavery throughout the Japanese empire. A joint North and South Korean team presented its case on the first day, followed by China, Taiwan, and the Philippines on the second day.[99] Malaysia, the Netherlands, Indonesia, and East Timor presented on the third day. Whereas the Tokyo War Crimes Trials only touched on sexual violence in China, the Philippines, and the Netherlands, the Women's Tribunal presented the widespread nature and recurring patterns of the sexual slavery system across Japan's former colonies and occupied territories.

In redressing the omissions of the Tokyo War Crimes Trials, the Women's Tribunal performed two key aspects of the legal proceedings differently: the question of Emperor Hirohito's responsibility and the gendered nature of the crime. Others blamed the United States for exonerating the emperor from any responsibility for wartime criminality.[100] The immunity granted to the emperor could have strengthened what is known as the Chrysanthemum Taboo. "In simplest terms," explains historian Alexis Dudden, "this taboo is a social prohibition against publicly raising the question of the emperor's involvement in the war, as well as all the histories that hang in *that* history's balance."[101] The emperor's death in 1989 lifted this taboo, and the Women's Tribunal examined his responsibility for war crimes. The Japanese team led the presentation on the establishment of state responsibility and the emperor's liability. Akira Yamada, a Japanese historian from Meiji University, gave expert testimony that the emperor was not simply a puppet but knew about Japanese atrocities and did not take any action to correct the situation.[102]

The Women's Tribunal was also attentive to the gendered nature of the crime and recognized that international law had not

given detailed attention to the particularities of wartime sexual violence. The Tokyo War Crimes Trials prosecuted those who oversaw and implemented the Japanese slave labor system but, as Argibay points out, it did not consider "its gender analogue, the comfort women system."[103] The Women's Tribunal took into consideration international law on slavery that existed at the time of the crime and found the most common indications of sexual slavery in the "comfort system": "1) involuntary procurement, 2) treatment as disposable property, 3) restriction of fundamental rights and basic liberties, 4) absence of consent or of conditions under which consent is possible, 5) forced labor, and 6) discriminatory treatment."[104] Because the Women's Tribunal was held decades after the end of the system of military sexual slavery, the tribunal also addressed the social and psychological ramifications of the "comfort system" for survivors. Lepa Mladjenovic, a Serbian feminist and director of Belgrade's Autonomous Women's Center against Sexual Violence, presented on posttraumatic stress disorder. The Koreans and other prosecution teams examined the social ramifications of psychological trauma, particularly addressing women's inability to have children or get married.[105] The Women's Tribunal attempted to address the long duration of trauma for survivors and the social and psychological ramifications of what the women endured during the war. However, although the tribunal brought these issues to light, the amount of therapeutic healing it offered remains unclear. Hence, manifold sites of redressive action outside political and legal mechanisms are needed to attend to the multiple wounds women sustained from this violence.

Proceedings I: Disrupting Juridical Rituals

The Women's Tribunal reflected the influence of truth commissions in its focus on survivors' participation and its effort to create a space where the women could testify before a supportive audience.[106] The testimony of the thirty-three witnesses the Women's Tribunal permitted was arguably the most important evidence against the Japanese military. The witnesses included four women from North and South Korea, three from Taiwan, three from China, fifteen from the Philippines, two from the Netherlands, four from Indonesia, and two

from East Timor.[107] Thirty other survivors, including Lee Yong Soo and Kim Bok Dong, attended but did not testify.

"Seeking neither vengeance nor a summary condemnation of the Japanese people," writes Dudden, "the tribunal sought simply to affirm—for the sake of the victims themselves—that the women had been wronged. The women would be thus able to claim a history that had been taken from them by the perpetrators of the crimes of sexual slavery and the postwar Japanese governments who have called the women liars."[108] Survivors who had never had the chance to tell their stories in a formal case against perpetrators received public affirmation, recognition of their claims, and ownership of a history that had been continuously denied. "The Tribunal," writes Japanese studies scholar Rumi Sakamoto, "provided an authoritative setting, where the victims' stories were validated in the context of an international court case and used as evidence to prove the legal responsibility of the Japanese State."[109] Testifying was more than a legal act. In valuing these women's testimony as historical accounts of Japanese military sexual slavery and showing respect to the women themselves, the tribunal also became a space for expressing the women's dignity. In this way, the Women's Tribunal was akin to a truth commission and, in Dudden's words, "took on the energy of an oral history sit-in."[110] Through sharing their testimony, the thirty-three witnesses and the hundreds who heard them performed a defiant act of protest.

Attention to the embodied, performed elements of the testimony (physical movement, facial expressions, gestures, tears, and so forth) illuminates the different ways survivors testified and challenged the typical framework of legal adjudication.[111] The testimony of survivors exceeded the protocol for juridical acts such as taking the oath and giving testimony.[112] Cole stresses the importance of "illuminat[ing] the ways that embodiment—such as intonation, gesture, cadence, and eye contact—forms a crucial part of narrative/personal truth in public testimony."[113] Embodiment was critical to how survivors at the Women's Tribunal articulated their truth. In this space of dissensus, survivors emerged as political subjects who were creators of multiple truths about the past and who played a part in the restoration of their dignity. However, as a legal setting that focused on the women's wartime victimization, the Women's Tribunal risked reifying their former "comfort women" status as their subject position. Unlike the Wednesday Demonstrations, the Women's Tri-

bunal did not allow the women to perform a multifaceted identity. Nevertheless, despite the limitations of the tribunal, it made a significant contribution, allowing most of the women their first opportunity to publicly claim victimhood and to give that testimony within a retributive framework.

One of the most common court rituals is taking the oath. During the Women's Tribunal, asking survivors to affirm their testimony turned out to be a complicated ordeal. Four Korean survivor witnesses—Ahn Bok Sung, Mun Pil Gi, Kim Yong Sook, and Ha Sang Suk—took their seats at the witness table. After viewing a video of Ha's testimony and listening to her testify onstage, the prosecutor asked Ha a few questions about her experience and then provided evidence, such as the memoir of a Japanese commander of the Eleventh Army, to verify that Ha and other women worked in the Chinese "comfort stations" mentioned in the documents. After the prosecutor's interrogation of Ha, Chief Judge McDonald stated that the tribunal's charter required an affirmation of the correctness of the testimony. The prosecutor asked Ha, "Do you affirm to the effect that the testimony is truthful in front of the judges?" "Are you asking us . . . whether what I told you about the Japanese soldiers is correct?" Ha asked as she wiped tears from her eyes. "Of course, they took me." Again the prosecutor asked, "Can you affirm that what you told in front of this [sic] judges is truthful?" "[The] Japanese people who took me here, they have to be the ones who take me back home and they have to give me my money back, give me fare to go back home, and apologize," Ha insisted. The judge explained that she was not implying that Ha had been untruthful and that the affirmation was simply a requirement of the charter. Calling Ha *halmeoni*, the prosecutor again asked her whether she acknowledged the truthfulness of her words. Ha nodded. McDonald then stated that the registrar would like witnesses to take an oath before beginning their testimony, ending her statement with an audible sigh.[114]

Ha perceived the oath as a questioning of the veracity of her story and became upset. The second time Ha was questioned, she disregarded the question and stated what she wanted to result from her testimony. She agreed to acknowledge the truthfulness of her words only when the prosecutor pleaded with her in a culturally sensitive, respectful manner—calling her *halmeoni*—and focused on her as the agent who would decide the truthfulness of her state-

ments. Hearing the word *halmeoni* might have helped Ha feel like she was being respected and acknowledged. Though I do not think a sense of kinship formed in the brief encounter between Ha and the prosecutor, I would surmise that Ha felt a sense of (superficial) cultural closeness to the prosecutor.

The Korean prosecutor also called the next survivor, Kim Yong Sook, *halmeoni*, but the translator addressed her as Mrs. Kim Yong Sook, asking "Do you acknowledge and affirm that you will only tell the truth?" She nodded her head and said yes. The registrar talked to the prosecutor before asking again, "Kim Yong Sook *halmeoni*, do you affirm the fact that you will only testify the truth and nothing but the truth?" "Yes, I do." She nodded twice.[115] The court insisted that witnesses operate within the parameters of juridical protocol, in this case conforming to the oath commonly used in American courts: "Do you swear to tell the truth, the whole truth, and nothing but the truth, so help you God?" At the end of her testimony, the registrar again asked Kim, "Do you swear that everything you stated here is true?" The prosecutor translated the question into Korean, a Korean woman behind Kim reminded her that she had talked about her scars, another woman behind her told her to just say it was true, and Kim nodded.[116]

Such moments illuminate anxiety about the legitimacy of the tribunal and the tension around testimony as truth telling. The interaction between Kim and the two Korean women sitting behind her shows that Kim found the repeated questioning of the truth of her testimony confusing and perhaps hurtful, just as Ha clearly did. Although the Women's Tribunal was a different kind of judicial proceeding, the officials—the judges and the registrar—sought to follow juridical protocol as closely as possible. This protocol dictates that all testimony by court witnesses begin with an oath that verifies the truthfulness of what is about to be said.

The Women's Tribunal represented the first time that many of the survivors testified in public. Allowing them to give testimony in a space of validation put into practice one of the central tenets of the Women's Tribunal: restoring the dignity of survivors. "To respect someone's dignity by treating them with dignity requires that one *shows* them respect, either positively, by acting toward them in a way that gives expression to one's respect," explains philosopher Michael Rosen, "or, at least, negatively, by refraining from behavior

that would show disrespect."[117] The Women's Tribunal provided the space for people to show or perform respect for the women.

The testimony given by Chinese witnesses Wan Ai-hua, Yuan Zhu-lin, and Yang Ming-zhen was particularly emotional. The three survivors were barely able to testify as they fought back tears or wept as they spoke. With her upper body rocking back and forth, Wan tearfully stated that she was fourteen years old when she was taken away into sexual slavery. After being raped for the first time, Wan ran away but was recaptured, a pattern repeated on two other occasions. She raised her arms as she explained how she had been tied to a tree and had hung from it as soldiers hit and raped her. Wan stood up, explained that she had been about five feet, four inches tall but was now shorter because of her injuries, and then sat down again. Asked by the prosecutor what she would like to request, Wan explained that the perpetrators had done terrible things to her and that the Japanese government must take responsibility: "My body is injured so badly, and I am angry about it. I have a very strong anger toward Japan." As the prosecutor continued with her presentation, Wan struggled out of her seat even though a woman behind her attempted to hold her back. Wan stood facing the judges and reached her left arm out toward them as she pounded on her chest with her right fist. She seemed to be saying something, but the translation did not come through. Suddenly, in one of the most dramatic moments of the tribunal, she fainted and fell back into the arms of the woman behind her, who was there to comfort her. Members of the prosecution team and medical experts rushed to help Wan. Chief Judge McDonald called for a recess while paramedics took her to a hospital.[118]

Wan's fainting illustrates the ongoing trauma of living with this memory and the difficulty of sharing it. Words failed to express her pain, leaving her to turn to gestures of rising and falling. What do we make of this moment when the performance of the court was interrupted? Felman writes of a similar moment when a witness fainted during Adolf Eichmann's trial:

> The fainting that cuts through the witness's speech and petrifies his body interrupts the legal process and creates a moment that is legally traumatic not just for the witness, but chiefly for the court and for the audience of the trial. . . . But it is through this breakdown of the legal framework that history emerges in the courtroom and, in the legal

body of the witness, exhibits its own inadvertently dramatic (nondiscursive) rules of evidence. It is precisely through this breach of consciousness of law that history unwittingly and mutely yet quite resonantly, memorably speaks.[119]

Wan's interruption of the legal process calls attention to the intimate human scale of mass systematic sexual slavery and the individual who bears this history.

After a fourteen-minute recess, the court resumed, and the judges reentered the stage. Before the Chinese team proceeded, Chief Judge McDonald said slowly,

> May I say that the judges understand the difficulty that the women have coming here to testify. It is necessary for them to testify so that we hear their stories and understand what has happened to them. But we understand also that it's very, very difficult. I want them to understand, as well as the other women who will come and testify, that we want them to be as comfortable as possible . . . and understand that we appreciate your being here and we want to hear your stories. And if, at any time, you need additional time to gather yourself . . . if you wish water, if you wish to be excused for a moment to gather yourself, we will freely grant you permission to do that.

Looking straight at the prosecutor from the Chinese team, she continued, "And, Counsel, I'm sure you understand how difficult it is for them, and I'm sure that you will take that into consideration as you question them."[120] This moment, as Dudden also points out, was a "palpable expression" of the Women's Tribunal's effort to restore the dignity of survivors.[121] The court recognized the difficulty of giving testimony and called on those present to respect and attend to the needs of people reliving difficult memories.

While survivors were given the space to testify, they were often asked to focus on certain narratives, particularly the story of the first rape. After a viewing of her video testimony, the prosecutor for the Taiwanese team pressed Iyang-Apay (Chinese: Lin Shen-chung) for details of her experience of sexual slavery when she was seventeen years old. "How did they force you to become [a] 'comfort woman'?" the prosecutor asked. When there was no immediate response because of difficulties with the microphones, he asked the question again. She began to explain that the local police chief had told her

mother that she would be sent to become a performer. Seemingly frustrated that she was not getting to the story of the rape, the prosecutor asked again, "How did they force you to work as a 'comfort woman'?" Lin said she had first worked as a seamstress and launderer. A Japanese officer later took her to a cave in the mountains, where she was raped.[122]

The prosecutor insisted on arriving at the story of initial violation, dismissing the narrative speed and style at which the survivor chose to tell her story. The prosecutor's repeated questioning brought to light the juridical focus on the story of the crime. For Lin, the deception and false hopes of a job opportunity initiated her story of becoming a "comfort woman." Although what was probably at work was the desire of rape victims to avoid the most violent and direct descriptions of their violation, Lin also was asserting her political subjecthood. She chose the narrative arc of how she was forced to become a "comfort woman."

While the Women's Tribunal provided a public space for survivors to testify, not all witnesses received equal space and time. During Japan's presentation, two former Japanese soldiers, Kaneko Yasuji and Suzuki Yoshio, testified.[123] Their testimony provided crucial evidence that corroborated previous testimony. What transpired was one of the most disturbing moments of the Women's Tribunal, as Suzuki recounted with great detail his rape of a Chinese woman. Unlike every other witness, he was not cross-examined by the prosecutor; nevertheless, he took a few minutes to recount, without interruption, details from the design of the hem on the woman's dress, which aroused him, to how the woman trembled and turned white. "She obeyed me totally," he concluded, as he explained that on the battlefield people were "irresistible" and soldiers were "forcibly raping and sometimes killing." When the prosecutor asked why he had decided to come and give his testimony, Suzuki responded, "We have to pass on the true nature of the war, so even though I feel very shameful, I am making this [testimony]." The audience applauded.[124] Perhaps Suzuki's testimony was uninterrupted because he was a man and told a narrative that fit within the legal argument and juridical protocol. "Their evidence," stated Dolgopol, the co-chief prosecutor, "tells us that rape went unpunished in the Japanese military, and in fact, their evidence tells us that rape and atrocities were actually encouraged by the Japanese military."[125]

Operation II: Performing Scars

The Women's Tribunal was not simply a trial; it was also a site of knowledge production. As the chief judge, McDonald, mentioned at the start of the tribunal, "By considering the evidence which is admitted, the judges will develop an historical record which will document the experiences of the 'comfort women' who have so far been excluded from history."[126] The registrar was under pressure to produce a testimony-based historical record amid contestation by deniers of that history, and this pressure may have motivated the registrar to repeatedly ask Kim to affirm the truthfulness of her testimony. By the time the third witness, Mun Pil Gi, took the stand, the script of the oath for the tribunal was set; the registrar asked her to affirm her testimony once.

As do truth commissions, the Women's Tribunal sought to provide a space for survivors to give testimony that would contribute to the production of historical knowledge about their experiences and provide evidence of Japanese military sexual slavery that would implicate the Japanese state. In her study of how testimony was used in the social movement that led to the uprising against the Mexican state of Oaxaca in 2006, anthropologist Lynn Stephen describes a person who testifies before a truth commission as an "active social agent engaged in a personal and collective performative act that can potentially broaden the meaning of truth to advance alternative and contested understandings of history."[127] Those who testified at the Women's Tribunal were actively advancing not only "alternative and contested understandings" of the wartime history of Japanese military sexual slavery but also—and arguably most important—its lasting mark on their lives.

The Women's Tribunal admitted three types of evidence: written and visual documentation, written or oral (and video) testimony from survivors and experts, and material and physical evidence.[128] Survivors' evidence was divided into testimony and physical and material evidence. This separation of the verbal from the physical implicitly minimizes the importance of the embodied elements of testifying—especially the showing of survivors' scarred bodies and the way in which the women refer to their scars to mark the long impact of trauma.

During Kim's testimony, the prosecutor drew her attention to the

picture of her scars on the auditorium screen and asked how she had received these scars. Kim described the soldier who had raped her and cut her with his sword. Ha, who sat next to her, nodded her head and wiped her eyes as she listened to Kim's testimony. Kim explained that another soldier had called her names for being a Korean woman and told her that unless she learned to worship and serve the emperor and Japanese soldiers, she needed to be punished. He had stripped her naked and marked her body. Kim brought her right thumb and index finger together as a pointer, then brought both hands to her left breast and then motioned behind her right shoulder with her left hand. She energetically pointed to different parts of her lower body as she mimicked the movements of a sword. "If you see my body, I'm full of scars," she said. "I hate Japanese soldiers. I could never forgive them. I'm over seventy now. But I could never fully forget or forgive."[129] In drawing attention to her scarred body, Kim suggested that her verbal testimony would be incomplete without showing the physical imprint of the trauma on her body. As she drew attention to her scars, her words indicated that she continues to live in pain.

Physical marks such as Kim's scars allow for powerful performances that rescript the meaning of violence, as performance studies scholar E. Patrick Johnson explains in his analysis of his grandmother Mary Rhyne's embodied retelling of her experience as a domestic laborer, during which she points to scars on her hands. "The past labor site permanently claims, marks, and disfigures the body," writes Johnson. "Simultaneously, Mary's public display of the scars speaks against, or defiles, the domestic site." Johnson points out that through this performance, "the performer rewrites her body—she assigns it new or additional meanings."[130] In her verbal and physical testimony, Kim remarked on her scars to speak against the crime of military sexual slavery. In doing so, she assigned her body new meanings and repositioned herself as a survivor.

As Kim's testimony suggests, survivors conceive of their bodies as archives. Performance studies scholar Diana Taylor argues that although written material has problematically been privileged as "more valid" than other forms of knowledge, the repertoire of "embodied and performed acts generate, record, and transmit knowledge."[131] Taylor describes how the women protesting in the Plaza de Mayo in Buenos Aires "turned their bodies into archives, preserving and displaying" photographs of their children who "disappeared"

during the "Dirty War" in Argentina. They "staged the archive in/on the body, affirming that embodied performance could make visible that which had been purged from the archive." The children of the disappeared, writes Taylor, "like the Madres, have become the paradoxical living archive, the embodied home of the 'remains.'"[132] While Taylor's assertion that performances like Kim's testimony have epistemological power is an important intervention, Taylor does not fully attend to the gray space that exists between the archive and the repertoire, particularly when bodies themselves are archives. Taylor mentions the "paradoxical living archive" and describes how it interacts with conventional archival traces such as photographs, but she does not interrogate how one accounts for the physical body itself as archival proof of a contested history, not simply the "conduit of memory," as it is in the Argentinian case.[133] At the tribunal, the archive and repertoire collapsed into each other as the performing witness, without any props, embodied what was absent from or had been erased from the archives.

The archive and repertoire collided during Park Yong Shim's testimony. There were moments when written, visual, and embodied forms of evidence overlapped. In her video testimony, Park described having been inveigled into the system in 1938, when she was seventeen, and transported from Nampo to Pyongyang via China; Singapore; Rangoon; and Lashio, Burma (now Myanmar). She shared her Japanese names, Udomaru and Wakaharu, and the names of Japanese soldiers she had encountered. In the middle of her testimony, the man interviewing her in the video showed her the September 3, 1944, photo of a soldier standing next to four "comfort women"—the same photograph used on banners during the Wednesday Demonstrations. "Can you identify yourself in the photo?" he asked Park. She identified herself as the pregnant woman. The camera moved to a close-up shot of the photograph and then to Park. "I can recognize this as myself," she explained. "I was pregnant before I was taken as a hostage to the Allies."[134]

Park's testimony became a different kind of presentation when the prosecution introduced another element. After showing her video testimony, the prosecutor announced that Park was in the audience. She rose and bowed to the members of the audience, who applauded as Park wiped away tears. The prosecutor corroborated details from Park's testimony with other evidence, such as the testimony of Japa-

nese operators of "comfort stations," who verified the route on which Park had been taken, and a November 30, 1944, news article written for US soldiers that described the capture of four Japanese "comfort girls."[135] When the court resumed after a lunch recess, Chief Judge McDonald asked for affirmation that the woman in the audience was indeed the same person in the video. The prosecutor then asked Park to come toward the stage and confirm that this was her video testimony; she did so.

What is fascinating here are the different ways that the court demands the embodied presence of witnesses.[136] Park's physical presence in the hall did more than simply validate her testimony: it reflected and emphasized the intervention that the video, her participation, and the participation of other survivors were making in the historical abstraction of the estimated two hundred thousand women taken into sexual slavery. Like the use of the photograph on the banners of the Wednesday Demonstrations, this moment illustrated how survivors such as Park have been called on to embody archival claims as living evidence of the history of Japanese military sexual slavery. The presence of Park and the other survivors helped materialize a history of loss and assert that military sex slaves were real women with real names.

The Public Hearing: Making Connections

After three days, the Women's Tribunal recessed and held the Public Hearing on Crimes against Women in Recent Wars and Conflicts. While the Women's Tribunal focused exclusively on Japanese culpability, the public hearing demonstrated the connections between Japanese military sexual slavery and contemporary violence against women as well as the importance of accountability for crimes past and present.[137] The public hearing is often overlooked in the literature on the Women's Tribunal, but it staged a critical intervention by placing Japanese military sexual slavery within a larger context of ongoing sexual violence toward women in times of conflict. Both the Women's Tribunal and the public hearing embodied a transpacific community of remembrance, a women's collective that serves as the keeper of war memories and a practitioner of alternative forms of justice.

The Women's Caucus for Gender Justice and an international advisory committee from the Philippines, Canada, the United States, Australia, Argentina, Algeria, the former Yugoslavia, and India coordinated the hearing.[138] The Violence Against Women in War Network and the Asian Centre for Women's Human Rights, the main organizers of the Women's Tribunal, cosponsored the hearing. Women from thirteen areas of current and past armed conflicts—Vietnam, Burma, Guatemala, Burundi, East Timor, Okinawa, Colombia, Algeria, Mexico, Afghanistan, Kosovo, Sierra Leone, and Palestine—testified to their painful experiences of rape and other forms of gendered violence.

The hearing was held on the same stage as the Women's Tribunal. Survivors spoke from a podium located center stage between a screened booth and the facilitators' table. Those who desired to remain anonymous sat in a three-sided booth covered in brown cloth stage right; a white sheet of paper with the name of the survivor's country was taped to the front of the booth. The cloth gave the survivor privacy as she gave her testimony. Three survivors spoke from the screened booth. The facilitators—Vaheeta Naina and Charlotte Bunch from the Women's Caucus and Suzuyo Takazato of Okinawa Women Act against Military Violence—sat at a table stage left. Bunch provided a short historical introduction to the situation in each woman's country before turning the microphone over to the survivors. After the morning and afternoon testimony, guest commentators highlighted common themes and discussed initiatives that had been taken in each locale to demand justice. Radhika Coomaraswamy, the UN special rapporteur on violence against women, also addressed the audience. The hearing concluded with a short traditional Okinawan dance performance; Filipina actress Monique Wilson's performance of "My Vagina Was My Village" from Eve Ensler's *The Vagina Monologues*; and a gathering of survivors of Japanese military sexual slavery and the women who testified.[139]

As Naina said during her introduction, survivors of military sexual slavery have "inspired and encouraged" many women to come forward with their stories of violation. She credited survivors of Japanese military sexual slavery with illuminating the "links, the patterns between crimes committed against women fifty-five years ago and those that are committed today" and with influencing the signatories of the statute of the International Criminal

Court to recognize sexual slavery as a war crime and a crime against humanity.[140] This public hearing was also "an occasion to show how the lack of accountability for crimes already committed causes the continuation of commission of such crimes unabated," in which "innocent civilians, women and children continue to pay the price for the refusal of world powers to learn lessons from the horrendous experiences of war."[141] The hearing and the tribunal articulated how adjudication of past crimes in the present is intrinsically entangled with a sense of futurity: the goal is to prevent such acts from taking place in the future.

One testimony stood out: that of a young Okinawan woman who had been raped by US military men in 1984. She sat behind the screen to protect her identity. When she was a junior in high school, she was sexually assaulted by three US military personnel in a park but did not report the rape to the police because she did not want to face their harassment and further humiliation. She explained that rape had been rampant in her neighborhood because of its proximity to the US Air Force's Kadena Air Base. After high school, she moved to mainland Japan. "I wanted to escape Okinawa, where everything reminded me of the rape," she said.[142] While the young woman's body was not visible, her presence on the stage and her verbal testimony powerfully communicated the devastating impact of militarized sexual violence.

The hearing highlighted US military bases in Asia as places where sexual violation by the military is likely to occur and thus illuminated the "afterlife" of Japanese military sexual slavery. As the woman powerfully stated, many Okinawans were forced to become "comfort women."[143] Explained Bunch, military bases cause the "flourishing" of sex work districts and an increase in the crime of trafficking in women and children.[144] Just as Japan disguised the "shock of its policy of enslaving women into sexual slavery by calling them 'comfort women,'" sexual slavery and military sex work near military bases takes place under the "guise of voluntary and paid" work.[145] The public hearing made an important intervention that the Women's Tribunal did not when it established the relationship between the "comfort stations" of World War II and the proliferation of sex-work districts as the US military expanded its neocolonial presence in Asia thereafter.[146]

The US role in using Asian women for military sex work during the occupation of Japan may have made its representatives unwilling to look at the issue of militarized sexual violence. According to journalist Eric Talmadge, "After its surrender—with tacit approval from the U.S. occupation authorities—Japan set up a similar 'comfort women' system for American GIs." He continues, "An Associated Press review of historical documents and records—some never before translated into English—shows American authorities permitted the official brothel system to operate despite internal reports that women were being coerced into prostitution."[147] In an effort to protect "respectable" Japanese women from American troops, the Japanese government set up the Recreation and Amusement Association, a government-sponsored brothel system.[148] While many of the women recruited into this system were already sex workers, some were deceived or trapped into sex work, and many faced physical hardships similar to what the victims of Japanese military sexual slavery endured.[149] Some were even former "comfort women."[150] As the United States expanded its military presence throughout Asia, sites of military sex work proliferated, particularly in South Korea and the Philippines. "Occupied" nations are also complicit in promoting the use of women's bodies around military bases. For example, for the South Korean government, military sex workers were "an indispensable asset, as 'personal ambassadors,' in its adaptation to the changing security policies of the United States in the early 1970s," as political scientist Katharine H. S. Moon points out.[151]

Although the Women's Tribunal had the potential to more explicitly expose US responsibility for the multinational silencing of the history of Japanese military sexual slavery, it missed the opportunity to do so.[152] Instead, the public hearing explicitly addressed US responsibility for the afterlife of military sexual slavery and other acts of violence in Vietnam and Guatemala.[153] Perhaps this failure is not surprising, considering that doing so in the framework of a tribunal would have alienated the US government, a potential ally in the struggle for official redress. The United States did become an ally with survivors in July 2007, when the US House of Representatives passed a resolution that encouraged the Japanese government to take responsibility for the crime of Japanese military sexual slavery (see chapter 3).

Conclusion

On the last day of the tribunal, the proceedings moved to Nippon Seinenkan, a larger venue than Kudan Kaikan. The layout of the stage resembled the court of the previous few days, except that all the prosecutors sat together at a long table. Flanked on all sides by the other judges, Chief Judge McDonald read the preliminary verdict that "the Tribunal finds the accused Emperor Hirohito guilty of responsibility for rape and sexual slavery as a crime against humanity, and the judges determine that the government of Japan has incurred state responsibility for its establishment and maintenance of the comfort system."[154] She looked up as applause slowly filled the auditorium, reaching a crescendo as people cheered and whistled. The judges' usually stoic faces broke into big smiles. The audience members rose to their feet as some of the survivors lifted their hands into the air. After the verdict and a two-hour reading of the summary of the findings, survivors gathered on the stage to thank the judges and to stand together in celebration of a long-awaited decision.

The "peoples of the Asia-Pacific region have invested this tribunal with the power to uphold the human rights of the women taken into military sexual slavery by Japan," stated Dolgopol, the co-chief prosecutor. The tribunal, she continued, had promoted the alternative vision "that when governments fail, people have the right to take action and to seek vindication."[155] Although a people's tribunal cannot provide the guarantees of due process that an officially sanctioned court can and cannot enforce a sentence or order reparations, as legal scholar Christine M. Chinkin points out, "it can make recommendations backed by the weight of its legal findings and its moral force."[156] McDonald presented the full official judgment at a special ceremony in The Hague on December 4, 2001.[157]

The verdict at the Women's Tribunal represented the culmination of a long process of taking redressive matters into the hands of civil society. The judgment was delivered to Japan's minister of foreign affairs in 2002, but the government did not follow up on the tribunal's recommendations.[158] Through its performance of the cross-legal memory of the Tokyo War Crimes Trials, the Women's Tribunal practiced and made visible the justice that survivors had waited so long to receive. Felman writes that "the legal function of the court, in other words, is in its very *moral essence* a *dramatic*

function: not only that of 'doing justice' but that of *making justice seen'* in a larger moral and historically unique sense."[159] The Women's Tribunal not only put on a display of justice as manifested in the legal proceedings and the guilty verdict but also helped bring about a transpacific community of remembrance that included activists, legal experts, survivors, journalists, and ordinary citizens. This community extended from the people in the space of the court to an imagined community of responsible citizens who were not afraid to call on states to be accountable for their crimes against humanity. Despite its limitations, the Women's Tribunal can be a model for other activists and survivors of gender-based violence in attempting to merge a court of law with a truth commission and affirming the importance of providing survivors with public space in which to make their case.

The Women's Tribunal constituted a major accomplishment for the social movement for redress, as Secretary-General Yoon Mee Hyang of the Korean Council told me.[160] It reaffirmed the value of redressive measures outside state parameters such as ownership of testimony and public recognition of survivors' experiences and claims. While the Women's Tribunal relied on a legal framework, it illuminated the shortcomings of juridical protocol and the need for an expansion of public spaces where survivors can give testimony and receive public acknowledgment.

In situating itself as an extension of the Tokyo War Crimes Trials, the Women's Tribunal underscored the failure of the postwar international community to prosecute crimes of sexual slavery against women and the ongoing problem of the fact that sexual crimes against women are often addendums to mechanisms of accountability. This was the case in South Africa during the TRC.[161] It is also the case for the ICTY and the ICC, despite the fact that they "have put sexual violence against women in contexts of conflict squarely on the map of international criminal law in the past decade. Acts of sexual violence can now be charged as genocide, crimes against humanity, war crimes, and grave breaches of humanitarian standards," writes philosopher Margaret Urban Walker.[162] However, a "2004 Human Rights Watch report reveals that neither the ICTR, local courts, nor the recently launched traditional gacaca hearings are dealing adequately with sexual violence."[163] The Women's Tribunal demonstrates the importance of creating and supporting sites of transitional

justice dedicated solely to crimes of sexual and gender-based violence so that it is not merely an addendum but a central part of adjudication. The 2010 Tribunal of Conscience for Women Survivors of Sexual Violence during the Armed Conflict in Guatemala (1960–96), which was directly inspired by the Women's Tribunal, is an example of a gender-focused site of justice.[164] The Women's Tribunal also reminds us that redressive acts cannot be isolated events, that we must have multiple reckonings in different sites—protests, tribunals, theaters, parks, and museums.

One of the most concrete legacies of the Women's Tribunal has been the establishment of the Women's Active Museum on War and Peace, which opened on the sixtieth anniversary of the end of World War II in 2005. It is the only museum in Japan devoted to the history of Japanese military sexual slavery. Matsui, who proposed the idea of the Women's Tribunal, conceived of the museum as "a means of continuing the Tribunal's legacy."[165] According to a museum brochure, "WAM will keep the spirit of the tribunal alive, making efforts to bring justice to survivors, and to end the cycle of impunity for wartime sexual violence."[166] As the WAM's Secretary-General, Mina Watanabe, explained in 2010, the museum was the best way to share the tribunal's findings and the history of Japanese military sexual slavery with the Japanese public, particularly the next generation, since few textbooks include references to the "comfort women" issue. "It's also a kind of realization of the tribunal judgement," said Watanabe.[167]

Watanabe describes WAM as not simply a site of memorialization but also a "center for action" where the public can learn ways of supporting survivors who are still fighting for official justice.[168] Funded solely by private donations and by Matsui, who passed away in 2002, WAM houses the archival material for the Women's Tribunal—films and survivors' testimony—and holds seminars and special exhibitions on topics ranging from testimony by former Japanese soldiers to the paintings of Korean survivors.[169] When I was doing research at WAM in May 2010, visitors to the museum included an elderly Japanese woman and a group of middle school students from outside Tokyo. Though the museum is small, it is a space for people to learn more about the history of Japanese military sexual slavery and to participate in the community of remembrance. However, the work of the museum comes with potential right-wing threats directed at its

employees and volunteers, who name the perpetrators responsible for the sexual crimes committed during the war. WAM is housed in a building owned by a Christian organization, where the people at WAM feel secure because there are like-minded people in the building who are conscious of human rights.[170]

Performance is central to the Women's Tribunal and to the critical work of survivors in challenging legal protocol and asserting their personhood. The Women's Tribunal, like the Wednesday Demonstrations, was a site of knowledge production and community formation. Both sites of redressive action provided survivors with public acknowledgment of their wartime experiences. Like the Wednesday Demonstrations' international restagings of solidarity, the Women's Tribunal reflects and extends the growing transnational scope of the movement. Alongside the work of activists and survivors, artists have grappled with how to represent the experiences of women who endured military sexual slavery.[171] The remainder of this book looks more closely at artistic work and its connection to activism, focusing on the proliferation of cultural production surrounding the ongoing negotiation of this history in theater and memorial-building projects in South Korea, Austria, and the United States.

Redressive Theater: Histories of "Comfort Women" on the Stage

The first two chapters illustrate how activists, survivors, and their supporters have used performative strategies to advocate for official reparative measures and open up the question of what constitutes redress. Their acts range from reclaiming personal narratives and producing historical knowledge to forming communities of remembrance. In this chapter, I extend the social and epistemological aspects of redress to the aesthetic realm of theatrical production. What is the relationship between theater and activism? What is at stake when we move from the actual survivor to the survivor in representation onstage? How does one deal with the question of authenticity in representations of "comfort women"? What can theater tell us about the transpacific politics of memory surrounding those formerly known as "comfort women"? How do theatrical works expand or limit the public's understanding and awareness of gender-based violence, survival, and redress?

This chapter examines four theatrical works—Korean American Chungmi Kim's *Comfort Women* (2004); the Korean translation of Kim's play, *Nabi* (2005–9); Bosnian director Aida Karic's *The Trojan Women: An Asian Story* (2007); and Korean playwright Yoon Jung-mo's *Bongseonhwa* (2013, 2014). I draw on close readings of performance texts, analysis of productions, and ethnographic interviews with some of the artists and audience members. These works dramatize the narratives of Korean survivors and depict different models of reckoning using a range of motifs and artistic styles and techniques. They address varied approaches to performing the history of "com-

fort women"—dramatizations of the intergenerational transmission of memory and the central role of survivor testimony in *Comfort Women, Nabi,* and *Bongseonhwa;* the directorial vision of and activist politics behind *Nabi, The Trojan Women,* and *Bongseonhwa;* and the enactment of violence and memory in all the productions. The various theatrical approaches in these productions allow for different kinds of redressive work: critique, remembrance, and the invitation to engage.

These theatrical works not only address transpacific themes but also circulate between different countries. *Comfort Women* and *Nabi* depict the worldwide travels of immigrants and "comfort women" survivors to give their public testimony. *Comfort Women* traveled across the Pacific to South Korea in its first international restaging as *Nabi* in 2005. *Nabi* toured South Korea in theaters, schools, churches, and the streets from 2005 to 2009 and toured Canada in 2008.[1] *The Trojan Women,* an international collaboration between a Bosnian-born director and a Korean choreographer, composer, and theater troupe, merges testimony with shamanic ritual movement. It premiered in Austria and then toured the United States and South Korea. *Bongseonhwa,* which was first staged in Seoul in 2013, was presented in Washington, D.C.; Glendale, California; and Chicago in 2014, shadowing memorial-building efforts in these cities.

In performing "comfort women" histories, the artists involved in these productions create a space where forgotten histories can be narrated and the structures that enable such amnesia can be critiqued.[2] These artists help expose a gendered politics of silencing in Korean and Korean American society that extends beyond the state to communities and families. This kind of redressive theater may cultivate a critical social consciousness through *introspection,* an inward examination of and reflection on the self's relation to the subject matter, and *extrospection,* an outward scrutiny and observation of communities and other histories outside one's immediate experience of the subject matter at hand. In moving between the two, artists and audiences may bear witness to the history of "comfort women."[3] These theatrical interventions, however, carry risks associated with creating art from trauma: in this process, it is important to avoid sensationalizing violence, taking traumatic events out of their historical context, and perpetuating complacency. Nevertheless, theat-

rical works play an important role in the larger context of transpacific redressive acts: they have the potential to become vehicles for fostering communities of remembrance. The intervention these works accomplish lies not just in what they represent and render onstage but also in how they help constitute a transpacific cultural memory of sexual slavery under the Japanese military and the lasting social and cultural impact of that history.

Transpacific Acts of Memory: *Comfort Women* (2004)

"Your generation is our hope," Soonja Park tells Jina in Chungmi Kim's *Comfort Women* (2004).[4] In this play, Park, an elderly survivor, is visiting New York to attend a protest in front of the United Nations that coincides with a visit by the prime minister of Japan. Twenty-one-year-old Jina, a Korean American university student, invites Park and Bokhi Lee, another survivor, to meet her grandmother. As the play develops, the audience learns that Jina's grandmother has been repressing her own memories of enslavement as a "comfort woman." In *Comfort Women*, which is a revised version of Kim's play *Hanako* (1999), Kim explores cross-cultural and intergenerational reckoning with the legacy of sexual slavery under the Japanese military. Kim's play joins a growing number of stage productions about the "comfort women" that delve into areas that are often not spoken of during activist public events—the intimate negotiations survivors and their families must make as they live with trauma.[5]

The realist drama of *Comfort Women* and *Nabi* takes place in the living quarters of an elderly Korean woman who lives with her family in Queens, New York, and has dreams and flashbacks of her life before, during, and after World War II. Jina's arrival with the two survivors interrupts her grandmother's private reveries, and the elderly woman is reserved and dismissive of these survivors and their activist work. In response, one of the survivors passionately defends their cause and shares her wartime experience. Frustrated with her grandmother's rudeness, Jina storms out of the room and thus is not present when the tension between the grandmother and the survivors reaches a climactic moment. One of the visiting survivors glimpses the name *Hanako* tattooed in Japanese on the grandmother's back, confirming that she is a former "comfort woman." While the survi-

vor recalls Jina's grandmother as a young woman, the grandmother becomes visibly upset, adamantly denying that she was Hanako, a name bestowed by a Japanese officer while she was a "comfort woman." After Jina takes the two survivors to a rally to protest a speech by the Japanese prime minister at the United Nations, a series of reenactments of the past that the script refers to as "memory scenes" takes place on an upstage platform behind a scrim. After remembering painful scenes from her time in the "comfort stations" and from her postwar life, the grandmother tells the ghost of her mother that she was Hanako and that she and her mother need to accept her past. The other two survivors tell Jina about her grandmother's secret past, and she returns to comfort the elderly woman, reassuring her that she is still loved. The two of them declare that they will share her story with others.

Comfort Women does not dwell on narratives of Japanese culpability and state politics. Instead, this play focuses on personal and familial conflicts over memory and thus encourages dialogue about a potentially divisive history across ethnic and national boundaries. The play fosters compassion for the survivors while giving space to the audience to engage in introspection. It allows them to identify with the granddaughter figure, who is a witness to the women's survival and activism. Though the play is overly didactic at times, it stages and offers a redressive critique of dominant narratives surrounding sexual slavery at the hands of the Japanese military: for example, the ideas that the "comfort women" issue is strictly an Asian concern, that the history of silencing belongs to one particular nation, and that an official apology and reparations are the primary redressive goals. Understanding the cultural significance of *Comfort Women* requires consideration of its longer Korean production life as *Nabi* and how the two plays together treat remembrance and witnessing as possibilities enacted through the gathering of communities at productions in the United States, South Korea, and Canada.

Kim first wrote a one-act play inspired by the testimony of survivors, *The Comfort Women* (1995).[6] Reading a book of survivor testimony "shocked and enraged" the playwright, compelling her to examine, as journalist Diane Haithman puts it, the "emotional scars of women who had survived 50 years of shame."[7] "I wanted to honor all the 'comfort women'; those who broke the silence and those who have not," explained Kim. "And I wanted to give them a voice with

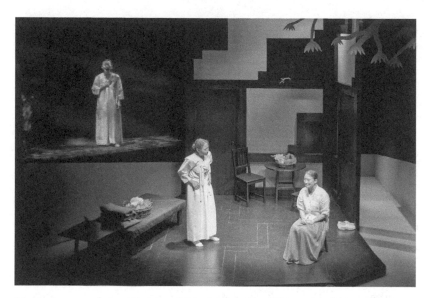

Fig. 9. A scene from Chungmi Kim's *Comfort Women* at Urban Stages, New York, 2004. In this scene in the home of Jina's grandmother, Jina's grandmother talks with one of the visiting survivors. Incidents from Jina's grandmother's past are performed on an elevated platform (*stage right*). Directed by Frances Hill, set and lighting design by Roman Tatarowicz. Photo by Roman Tatarowicz.

dignity in hopes that the world would listen to them and do something to prevent the recurrence of such horrific human-rights violations."[8] Though she problematically invokes the desire, commonly expressed by artists, to "give voice" to these women (as if survivors lacked the capacity or opportunity to express themselves), Kim articulates the redressive possibilities that are inherent in artistic treatments of the history of "comfort women" that afford access to the women and their experiences by a larger audience. She seeks to show that the history of "comfort women" is "not just the story of the past" but connected to contemporary "injustice and violence against [the] fundamental human rights" of women and children.[9] Kim approaches the issue of making the history of "comfort women" relevant to the present by focusing on the relationships among elderly survivors and a Korean American university student. After meeting survivors in South Korea, Kim developed her one-act play into the full-length *Hanako*, which the East West Players (EWP) premiered in 1999 at Los Angeles's David

Henry Hwang Theater, where it was directed by Tzi Ma.[10] "Instead of recounting the horrors of war," wrote Haithman, *Hanako* focuses on "a fictional meeting between some aged comfort women and a very traditional Korean grandmother of their generation who meets them when she emigrates to New York."[11]

The production of *Hanako* was part of the EWP's effort to broaden its repertory and expand its subscription base, previously mostly Japanese American, to include more Korean American audiences. "The EWP," writes theater scholar Esther Kim Lee, "have had the longest history of producing plays written by Korean or Korean American writers."[12] Early in its history, in 1967 and 1970, the EWP produced three plays by cofounder Soon-Tek Oh, but it did not stage another play by a Korean American playwright until Sung Rno's *Cleveland Raining* (1995) and *Hanako*.[13] "Korean American plays," notes Lee, "were rarely produced during the 1970s and 1980s, when plays presented under the category of 'Asian American theater' were mostly about the Chinese and Japanese American experiences."[14]

Tim Dang, the EWP's artistic director, hoped that *Hanako* would foster dialogue between the Japanese American and Korean American communities.[15] A play such as *Hanako* could appeal both to first- and second-generation Korean Americans and to Japanese American audiences learning about the history of "comfort women" for the first time. According to Mary Omoto, who saw the EWP production, "Before I saw the play, I didn't know something like this had happened. For the Japanese not to offer an apology is appalling."[16] Reviewer Sam Chu Lin wrote, "Many in the audience were visibly moved by what they had seen," adding that "fears that the presentation might split Los Angeles' Korean and Japanese communities proved unfounded."[17]

Directed by Frances Hill, *Comfort Women* premiered at Off-Broadway's Urban Stages on October 23–November 28, 2004 after playing at public libraries in the five boroughs of New York City as part of the theater's On Tour series.[18] "What attracted me to the play was that it was not a documentary of comfort women, but a heartfelt story that was based in New York with the young girl a student attending NYU fascinated by the horror of the comfort women's situation," writes Hill. "The play had the poetic elements that Ms. Kim was so skilled at writing."[19] The play did not attract large Korean audiences to the theater but nevertheless brought the

history of "comfort women" to a public that was not familiar with those stories.[20] The production received mostly positive reviews. Critic Lindsey Wilson described it as a "play of enormous emotion and prominent social awareness." She continued, "The cruel and inhumane treatment these girls were subjected to is horrific and graphic in its description, but it is a description that needs to be broadcast to the world. *Comfort Women* is here to not only declare 'this happened,' but 'this happened to me.'" She concluded that the play's personalization of history, which enabled audiences to connect with individuals, is a "very powerful way to learn, but it's also a very emotionally draining method of learning."[21] Some reviewers pointed to the play's weaknesses: critic Jenny Sandman considered it an "overdue and . . . timely examination of war atrocities" and a "compelling story" that became "a little harried" toward the end: "The yelling, singing and the many brutal stories leave no time for the audience to rest or reflect."[22] Theater scholar and critic Dan Bacalzo felt that "the script suffers from a tendency toward melodrama and convenient coincidences to move the story forward" and that "the play is most effective when Soonja Park and Bokhi Lee relate their horrifying stories of abuse; the details are almost unimaginable yet based upon historical fact."[23]

Urban Stages mounted the production during a politically contentious year, with violence in Iraq at a peak and a presidential election just around the corner.[24] On the New York theater scene, the issue of past and contemporary victimization in wartime and responsibility for such acts was on people's minds; one of the most critically acclaimed theater productions about the "war on terror," Victoria Brittain and Gillian Slovo's *Guantanamo: "Honor Bound to Defend Freedom,"* which was staged at the Culture Project in October 2004, focused on first-person accounts of released detainees and their families.[25] That fall also saw the Kaye Playhouse stage two plays about Japanese involvement in World War II: *Kazuki: This Is My Earth*, written and directed by Yoshimasa Shinagawa, centered on the story of a Japanese painter who was a prisoner of war in a Siberian labor camp, while Koichi Hiraishi's *Senpo Sugihara: The Japanese Schindler* told the heroic story of Chiune Sugihara, "who, as Japanese consul to Lithuania in 1940, rescued thousands of Jews by giving them transit visas to Japan."[26] These plays, which one critic described as the "flip side of Japanese guilt: Japanese wartime suffering

and virtue," point to the complicated politics of remembering Japanese responsibility for crimes related to the war.[27]

Japanese invocations of victimization during World War II have come at the cost of suppressing the country's history of atrocities. Protesters have pointed to the government's failure to take responsibility for military sexual slavery as an indication that Japan is not qualified to be a global leader promoting peace. During its 2004–5 bid for a nonpermanent seat on the UN Security Council, protesters gathered from Seoul to Washington, D.C. (see chapter 1) to urge the global community to reject Japan's bid.[28] Other protests have targeted government-approved textbooks' whitewashing of wartime criminal acts by Japanese soldiers, visits by the prime minister to the Yasukuni Shrine, and territorial disputes between Japan and Korea. These issues made occasional appearances in major US newspapers such as the *New York Times* during the production of *Comfort Women*, but the issue of sexual slavery under the Japanese military remained relatively unknown in the United States until the 2007 campaign for a US House of Representatives resolution (H.R. 121) in support of survivors. In 2007, Korean American and other Asian American grassroots organizations in Los Angeles, Miami, Washington, D.C., and New York worked to raise awareness of the issue among their respective communities and to lobby government officials to take an interest in the campaign. These issues provide some context for what was at stake in the struggle over the history of "comfort women."

The playwright's decision to locate the story of the encounter between the grandmother and the other two survivors in the United States demonstrates the transnational contours of the social movement for redress for "comfort women." This made it easier for an American audience to identify with the characters. Critic Don Shirley suggests that Kim may have been "trying to demonstrate just how far the bitterness engendered by the Japanese actions can travel. Perhaps she also was trying to lure Americans into the story by making it more immediate." However, he finds the setting "arbitrarily distant" from the location where the violence first took place.[29] In contrast, however, I view the setting of the narrative in the United States as strategic: locating it across the Pacific from where the trauma took place was necessary for the play's larger cultural work of making it relevant to US audiences.

The grandmother's immigration to the United States has enabled her to "forget" her past as a military sex slave.[30] She instead channels her memories of the past into mourning the loss of her brother, who was conscripted into the Japanese Imperial Army, was stationed at Hiroshima and badly wounded during the US bombing of the city, and died from his injuries after returning to Korea.[31] The action of the play unfolds as the grandmother is preparing for her brother's *jesa*, a Korean memorial ritual in which food and prayers are offered to the spirit of the deceased on the anniversary of his or her death or on a holiday. Jina brings the survivors home with her because she thinks they will help her grandmother seek reparations on behalf of her brother.

In bringing these two histories into conversation—the conscription of Korean colonial subjects into the Japanese Imperial Army and the American bombings of Japan during World War II—Kim points to the complicated transpacific politics of remembering World War II–era atrocities. One of the visiting survivors encourages Jina's grandmother to report her brother's death to a Japanese organization that is collecting data as it prepares to pressure Japan to make reparations to its colonial conscripts. The possibility of pursuing reparative measures from the United States with regard to the Hiroshima bombing is not even mentioned. In fact, in its focus on the brother's victimization as a Japanese colonial subject, the play enacts a forgetting of US culpability. While national politics of memory are not the focal point of *Comfort Women*, the play raises the important question of who is responsible for remembering and atoning for these wartime atrocities.

Though immigration to the United States allows the grandmother to repress certain traumatic memories from the homeland, the United States also becomes a site for remembering for second-generation Asian Americans, who have what I call a *transpacific affinity* with the cause of "comfort women." Korean American artists have gravitated toward this history because most of the sex slaves were Korean and their struggle for redress has become the most widely known in the United States. A sense of "shared ethnic and/or gender identity," in the words of gender and sexuality studies scholar Laura Hyun Yi Kang, has been part of the motivation for presenting this history as a redressive act. However, as Kang points out, "Rather than attributing a shared ethnic and/or gender identity as the secure origin or compelling

cause of their representational impulse, [these claims of identification] bring 'Korean Americans' and 'Korean American women' into legibility as distinctly *American* subjects of representation and knowledge production, consequently troubling rather than affirming any neat alignment of identity-knowledge-justice."[32]

Situating *Comfort Women* in the United States allows us to consider the participation of Asian Americans, particularly those of Korean descent, in the transnational social movement. Asian American students and activists have organized fund-raising events and supported appearances by survivors to provide testimony at universities, court hearings, and protests. Through the character of Jina, the play illuminates how many second-generation Korean Americans have been drawn to the cause of the survivors through the combination of a desire for closer ties to their cultural heritage and an espousal of human rights and social justice values. The granddaughter, who is characterized as idealistic, passionate, and caring, is politically involved in the cause of "comfort women": she studies their history, attends rallies that raise awareness, and gathers signatures for a petition asking the Japanese government to provide redress for survivors. Jina, who immigrated to the United States when she was ten years old, explains the persistence of her childhood experiences of racism and her grandmother's advice to "value [her] Korean heritage and do something worthwhile."[33] She views her involvement with survivors as stemming from pride in her Korean heritage and her commitment to a worthwhile cause. She explains that this is not just a concern for Korean Americans and that other Asian Americans who support human rights and justice will be attending the UN rally.[34]

In depicting the family life of a survivor, *Comfort Women* begins to explore how survivors' lives were not defined by their wartime experience. *Comfort Women* also imagines the range of ways survivors might have lived their lives, from a grandmother who has kept her past a secret from her family to survivor-activists who travel the world to tell their stories. The play opens the space for the audience to consider communal and familial responsibility for silencing this history and intensifying the suffering of survivors. While critic Edward Rothstein argues that *Comfort Women* "falters when it becomes purely pedagogical in its attempts to emphasize the deeds of the Japanese,"[35] it extends responsibility for cultural amnesia to individuals and communities.

The grandmother represents the thousands of women who chose not to come forward. Only 238 former sex slaves officially registered with the South Korean government so they could receive support for housing, living, and medical expenses.[36] As of October 2016, only forty of these women were still alive.[37] Thousands of other women did not identify themselves to the government and most likely have kept their past secret from their families and communities. In a patriarchal society such as Korea that valorizes a woman's chastity, survivors have faced immense social stigma and ostracism from their own families and communities.[38] Jina's great-grandmother made her daughter feel ashamed and insisted that she forget her past so that she could reintegrate into society. Having adopted this attitude of shame, the grandmother attempted to pass it on to Jina: "Those women—are not the kind of people Koreans are proud of," she says. "They are shaming our country." The grandmother's shame encompasses not only past victimization by Japanese colonial powers but also other survivors' exhumation of the past. Jina's mother thus describes the survivors as not "even worth discussing" and tells Jina "to stay away from 'those comfort women.'" Her grandmother says, "You see, it will embarrass your mother and father if you get involved with them." Jina interprets her mother's and grandmother's hesitations as concerns about *chemyon*, or "keeping up [a] good image"; her mother and grandmother are concerned that associating with survivors who are misunderstood to be prostitutes or sullied women might damage Jina's reputation. Later, Soonja Park shares that some of the survivors feel misunderstood by Korean society. "Because of damned ignorant people, we've been condemned and ignored in our own country. For so long, we lived in shame, in silence, as if we were guilty. Guilty of what? But no more. We will bring justice!"[39]

The misunderstanding to which Soonja Park refers is indicative of the mid-1990s, when the play is set. At the time, the historical facts remained contentious, and even Koreans were unsure whether the women were prostitutes or sex slaves. As Park explains, "We were not whores! We were innocent girls—abducted by the Japs. Forced to become sex slaves. We were marked as military supplies and transported from one station to another in the battlefields."[40] The rhetoric of innocence used in the play contrasts the virtuous girls and women who were enslaved as "comfort women" from the sex workers of

military camptowns. While emphasizing the sexual and moral innocence of former military sex slaves has helped differentiate their history from that of camptown sex workers, this has perpetuated a simplified understanding of sex work in camptowns. It does not take into account the resonances between the two histories of exploitation and ignores both the factors that led women into such sex work and the difficult conditions they endured.

The play challenges a discourse of shame and represents survivors as dignified and as integral to the social movement. *Comfort Women* shows that many Americans have learned about this history through the international travels of survivors who have participated in court hearings, protests, and testimonial events organized by student groups and feminist, ethnic, civic, and social organizations in the United States. In the play, a women's group has invited Park and Lee to talk about "military comfort women," and the two survivors' participation in the UN protest highlights the international reach of demands for state redress.[41] The United Nations has been an important ally of activists and survivors and has played a major role in raising international awareness about the issue.

In the play, Kim juxtaposes the public space of the UN protest with the private space of the home to illustrate the possibilities of reparative action outside the parameters of officially sanctioned acts. The grandmother's living quarters become an alternative redressive space, and the state is thus decentered as the sole provider of justice. In *Comfort Women*, the women appeal to one another and particularly to the Korean American grandmother, who embodies the reluctance of many Koreans to join the cause. Restitution involves more than apologies and reparations from the state; it also includes the personal sharing of memory. In the space of the home, a different script about military sexual slavery emerges. Private testifying allows survivors to depart from scripted public testimony and thus assert ownership over their own narratives.[42] In the play, Jina's grandmother talks about her family, while Park and Lee share details of their ailments and frustrations.

At the same time, the play invokes rhetoric commonly heard at protests and in public testimony. Because of the debate in Japanese public discourse about the validity of survivor testimony, it is not surprising that Park passionately defends her account of the past and her cause. In a heated moment, Jina's grandmother disapprovingly

asks why the women are "stir[ring] up the past now" and suggests that they "should forgive and forget." Park angrily replies, "So that the past will not repeat itself!" She adds, "For nine years I was a sex slave! I will never forgive!" The stage direction mentions that Park "speaks with such passion as if testifying before the public."[43] Her words echo those of actual survivors such as Lee Yong Soo.

The survivors view Jina and her generation as mediators of reparative action. "We were political hostages—sacrificed out of human greed and injustice. Yet, in our homeland, we were the outcasts hidden away. The faceless faces, the voiceless voices for over fifty years—(Beat.) Who can give us back our youth?" asks Bokhi Lee as she turns to Jina. "Your generation is our hope," Park tells Jina.[44] Similar to the demand that the Japanese government "pay for our 'bloom of youth'" that is heard at the Wednesday Demonstrations, Lee invokes the moral and sexual innocence of survivors and connects it to the youth of Jina's generation. Like survivors who participate in the Wednesday Demonstrations, the survivors in the play consider younger generations of supporters to be the torchbearers of the struggle. The grandmothers in the streets and the grandmother onstage set up a familial relationship between survivors and younger generations. This framework allows survivors such as Lee Yong Soo and Gil Won Ok to envision a multigenerational horizon for redress at the Wednesday Demonstrations.

Comfort Women dramatizes the complex interplay of remembering and forgetting through the staging of flashbacks. One of the central dramatic actions in the play is the Korean American grandmother's remembering and eventual acceptance of her wartime past. These flashbacks and fragments indicate that the Korean grandmother shows signs of posttraumatic stress disorder. Psychiatrist Judith Herman writes, "The traumatic moment becomes encoded in an abnormal form of memory, which breaks spontaneously into consciousness, both as flashbacks during waking states and as traumatic nightmares during sleep."[45] The grandmother also struggles with the trauma of her return and her life of self-silencing—what literary scholar Cathy Caruth calls the "enigma of survival," the very "act of survival" that is itself a form of trauma.[46] In the play, all three survivors work through this trauma in their own ways.

The climactic memory sequence occurs after Lee identifies Jina's grandmother as Hanako. The grandmother hides under her comforter

as reenactments unfold behind the scrim. She hears her husband calling her a "dirty Jap soldiers' whore" and telling her to "get the hell out of my sight," the sound of a baby crying, and her mother saying, "I told you never tell anyone."[47] The sequence also includes scenes showing impending violence with a Japanese officer (though no explicit scenes of rape) and encounters with a girl who is killed for trying to escape. In one memory scene, Hanako, played by the same actress who plays Jina, is pushed on the ground by a Japanese officer. Running his sword over her body, he tells her, "I name you—Hanako. A woman as beautiful as a flower . . . Soon to be deflowered!"[48] He then cuts her skirt with his sword. By having the same actress play both Jina and Hanako, Chungmi Kim poignantly illustrates survivors' desires that future generations avoid a similar fate.[49] The play concludes with the grandmother admitting to her mother and herself that she is Hanako.[50]

Though Jina is not present when the survivors confront each other, she is eager to hear their testimony. Jina returns to her grandmother's room after learning about her past and comforts the elderly woman, who admits, "Fifteen I was—The Japs—they first cropped my hair ruthlessly and stripped my Korean dress off of me. I wanted to die then. But I was so young and afraid." Jina offers to help her grandmother share her memories with her family and the rest of the world. "I'll help you," Jina tells her grandmother. "You'll help me with your stories—the truth."[51] In a symbolic gesture, Jina opens a window, letting in sunshine for the first time. Though the narrative arc of the play enacts an easy closure to the conflicts over memory, the play touches on a number of important issues in the social and cultural negotiation of this history for Korean and Korean American subjects.

Theater as Transpacific Protest: *Nabi* (2005–2009)

Comfort Women continued to resonate with audiences in South Korea in its new incarnation as *Nabi* [Butterfly]. Translated into Korean with minimal revisions, *Nabi* premiered on May 4, 2005, at the Seoul Theater Festival and toured nationally in 2006.[52] Bang Eunmi, the director of *Nabi* and the founder of the Nabi Theatre Company, continued to direct and produce the play in theaters,

middle and high schools, churches, prisons, and on the streets for the next four years, and in 2008, she took the play to Canada.[53] In contrast to the US productions, the Korean productions of *Nabi* were an explicit form of arts-based activism.[54] Productions of *Nabi* have been acts of transpacific protest, raising awareness about the historical facts of military sexual slavery while honoring the women at the center of this history.

In 2005, Bang wanted to direct a play in connection with the six-tieth anniversary of Korea's liberation from Japanese colonial rule. "As a woman," she said, "I also wanted to tell a story about women." Bang understood that liberation from Japanese colonial rule was not a universally joyous event because so many communities were devastated, particularly the women who had been forced into military sexual servitude. Survivors faced an uncertain future of social ostracism and psychological and health issues. Bang read a Korean newspaper article about the New York production of *Comfort Women* and felt compelled to share the play, so she contacted Chungmi Kim, and the two women collaborated on the new production.[55]

Delving deeper into the story behind *Nabi* also brings to light how a transpacific politics of memory animates interest in the cause of "comfort women." Bang continued to work on productions of *Nabi* after 2005 because of "Yoko's story," the US controversy regarding Yoko Kawashima Watkins's *So Far from the Bamboo Grove* (1986).[56] Bang apparently believed that Watkins distorted history and did a disservice to survivors of sexual slavery under the Japanese military. The semiautobiographical novel, based on Watkins's childhood, is about an eleven-year-old Japanese girl whose family flees Korea at the end of Japanese colonial rule. In 2006, some Korean American parents in Massachusetts complained about the inclusion of Watkins's book in the sixth-grade curriculum on the grounds that the book lacked historical context and was "racist and sexually explicit" (it included rapes, all of them committed by Korean men).[57] "Korean-American parents complain that she paints the Koreans as rapists and murderers," writes journalist Lisa Kocian, "without discussing the decades of atrocities committed by the Japanese during a brutal occupation that included forcing young women into sexual slavery and torturing Koreans to death."[58] As historian Carter Eckert puts it, teaching the book without historicizing it "might be compared to teaching a sympathetic novel about the escape of a German

official's family from the Netherlands in 1945 without alluding to the nature of the Nazi occupation or the specter of Anne Frank."[59] Korean American parent groups and the Korean consulate in Washington, D.C. led national campaigns to remove the book from middle school curriculums, succeeding in several states on the East Coast.[60] As the principal of a Korean immersion school in San Mateo County, California, said, "the controversy over Watkins' novel has more to do with anger at the Japanese government's refusal to apologize for its wartime actions."[61] Sociologist Grace M. Cho suggests that in the 1990s, the publicity regarding sexual slavery under the Japanese military "unleashed the traumatic effects of colonization and war that had been accumulating in the Korean diasporic unconscious for fifty years."[62] Kim's *Comfort Women* and *Nabi* are products of the sense that it is important to seek justice for Korean subjects who suffered under Japanese colonialism. *Comfort Women* may have resonated with Bang and with Korean audiences because it internationalized the cause of survivors for Koreans across the diaspora.

Understanding the cultural work of *Nabi* requires learning more about the director of the Korean productions. Though she is slim and petite, Bang has a loud, almost shrill voice that I could not help but hear during the Wednesday Demonstrations in Seoul in 2007, when we stood across from the Japanese Embassy and called out for an official apology and legal reparations. After the protests, I noticed the director energetically greeting the survivors. When Bang agreed to an interview the following summer, she asked that I meet her at a protest not too far from the Japanese Embassy, this time for a completely different cause. In the summer of 2008, protesters in groups as small as a handful and as large as several thousand demonstrated daily in front of government buildings, along the streets, and in open plazas against the importation of US beef in particular and against the conservative Lee Myung-bak presidency in general. I met with Bang in a small clearing by a street near the city center where she had gathered with other parishioners from her diocese. A few riot police stood next to the group. Bang and I sat on a stone platform between the police and the protesters. After the group dispersed, Bang asked that we find a quiet place to talk. We began our interview in a hole-in-the wall restaurant specializing in beef soup and *soju*, a rice-based alcoholic drink. Then we wandered through the streets of central Seoul, eventually ending up in front of a bookstore. What I found interesting

about our walking interview was Bang's need to be on the move and close to passersby. She did not want to be sequestered; she wanted to be immersed in the daily activities of the city's residents. This desire for connection with local communities is evident in Bang's work in *Nabi* and in her presentations of the production in nontraditional performance spaces in the hope of enacting social change.

Bang's changes to the script were geared toward making the play more palatable to a Korean audience and less emotionally draining. Bang felt that *Comfort Women* was clearly written for an American audience and came across as didactic, particularly with its barrage of accounts of women's wartime experiences. Because the history of sexual slavery at the hands of the Japanese military is more widely known in Korea, Bang explained that the play "should not be for educational purposes only, but [should] also develop an impression and move toward catharsis."[63] Whereas Kim had approached the subject matter as a human rights issue, Bang believed, she viewed it in very personal terms: "For me, the grandmothers are like my mother."[64] She sought to honor their dignity and show them as women who are not consumed by their past. Bang's critique points to the importance of attending to the experiences of the local, to the experiences of individual women.

Bang wanted Korean audiences to have a glimpse into how the grandmothers are living today, not just a series of recollections of the past: "The grandmothers do not continue to live depressed lives and always say, 'I was a "comfort woman," I am unhappy.'"[65] She added more Korean folks songs such as "Arirang," an unofficial national anthem, to illustrate that survivors enjoy everyday life and are not solely defined by their past.[66] When I saw a production of *Nabi* with my mother at Sookmyung Girls' High School in Seoul on July 23, 2007, we both felt drawn into the narrative by the singing of children's folk songs, including "Doraji Taryeong" (Bellflower Song) and "Saeya, Saeya" (Birds, Birds). The sharing of familiar music helped create a sense of intimacy between the actors and the audience. Another major change in the script was the omission of one survivor's account that Japanese soldiers positioned women at the entrance of a cave as human shields. Bang thought the omission was necessary to alternate the narrative flow of the play between "tension and relaxation" so that viewers did not receive a constant bombardment of harrowing testimony.[67]

Fig. 10. A scene from Chungmi Kim's *Nabi* at Sookmyung Girls' High School in Seoul, July 23, 2007. In this scene, two survivors from Korea (*stage right*) visit with Jina and her grandmother (*stage left*). *Nabi* was produced at secondary schools as part of an education initiative sponsored by the Seoul Department of Education. Directed by Eunmi Bang. Photo by Elizabeth W. Son.

The actors who performed *Nabi* in Korea used theater to teach younger generations about the "comfort women" history and viewed this work as a form of activism. In 2007, *Nabi* was produced in ten secondary schools as part of an initiative sponsored by the Seoul Department of Education.[68] Since it is difficult in Korea to delve into the complexities of the "comfort women" issue in history textbooks, Bang said, the "Seoul Department of Education selected my performance work for live historical education."[69] At a talk after the performance I saw, I was struck by how the director framed her troupe's productions as a redressive gesture. Bang vowed that she and her artistic team would continue to produce the play until Japan apologized. "I find this play meaningful and shocking. It gives us a chance to reflect," shared Song Joon-yong, a third-year student at Gwanghui Middle School, after seeing a production of *Nabi* at his school on July 13, 2007. "Perhaps students like me might not be able to take actions that are immediately meaningful. But at least I hope by seeing a play like this, students like me will pay attention to the painful parts of

our history so that we can have more accurate historical knowledge and live with a fuller understanding of our past."[70] This is exactly the kind of consciousness-raising the troupe had hoped to accomplish.

Performing Wartime Sexual Violence in *The Trojan Women: An Asian Story* (2007)

The same year that secondary school students in South Korea learned about the history of "comfort women" in a play produced in their school auditoriums, audiences in Vienna, Austria, were presented with a very different representation of that history. While *Comfort Women* and *Nabi* localize reckoning with the politics of memory through intergenerational relationships, Aida Karic's *The Trojan Women: An Asian Story* (2007) broadens the temporal and geographical resonances of the history.[71] *The Trojan Women* builds on Euripides's tragedy about the enslavement of the women of Troy after the fall of their city to situate the modern history of sexual violence against women and girls by the military of Imperial Japan.

Traveling between South Korea and Austria, Bosnian-born director Aida Karic spent two years working on *The Trojan Women* with Korean collaborators: choreographer Kim Sam-Jin, composer Oh Seung-Ah, and the Wuturi Players. *The Trojan Women* had its Austrian premiere at the Schauspielhaus Wien for the Weiner Festwochen on May 4, 2007. It ran there until May 16 and then played at the Alexander Kasser Theater in Montclair, New Jersey, on October 18–21, 2007, and at the Seoul Arts Center on November 14–December 2, 2007. At the heart of the production is the question of how to stop the centuries-long practice of sexual violence against women during times of conflict and how to reckon with the devastation it brings to women and their communities.

The Trojan Women brings Korean *pansori* (operatic) singing, survivor testimony, and stylized movements to the telling of Euripides's tragedy. An all-Korean female cast performed the seventy-minute production in Korean with German subtitles in Austria and with English subtitles in the United States. The play opens with a *pansori* singer (played by Kang Sunsook) foreshadowing the destruction of Troy. Queen Hecuba (Lee Hyunsoon) enters and tells the women of Troy to accept their fate. Four women (Mun Kyunghee,

Byun Yoojeong, Baek Eungyung, and Kim Gwangdeok) appear behind her and slowly march downstage. Baek and Kim step forward, narrating accounts as Korean "comfort women," while the other two women and the queen slowly pivot their bodies. Then the four women abruptly converge downstage, alternating between speaking as Trojans and as "comfort women." They disperse, and the naked, bloodied body of Cassandra convulsing at center stage becomes visible. Voices recount the conditions of sexual slavery under the Japanese military. After collapsing, Cassandra sits up and foretells the death of Agamemnon, her future master. A condensed version of Euripides's *The Trojan Women* unfolds: Hecuba learns of the death of her daughter, Polyxena, and Andromache hears the news of her son's imminent death. Interspersed between these scenes, the actors narrate accounts of sexual slavery under the Japanese military and perform stylized reenactments of violence in which the character of Cassandra/"Comfort Woman" is the central figure. The production culminates in a symbolic reenactment of a southern-style *gut*, or Korean shamanic ritual.

The Trojan Women relies on three forms of expression to enact reparative work: *pansori*, survivor testimony, and the movements of shamanic ritual. *The Trojan Women* aurally, visually, and physically oscillates between specific (Korea during World War II) and transhistorical (Euripides's Greece) themes and between violation (portrayed through testimony, the text of the play, and choreographed movement) and healing (*gut*). A successful work of redressive theater shows these diametric elements as two sides of the same coin, working together to create a fuller understanding of the history addressed in the production.

What happened to thousands of "comfort women" resonated with Karic, who lived through the beginning of the war (1992–95) in the former Yugoslavia, where estimates show that between twenty thousand and fifty thousand Muslim women and girls were raped by Bosnian Serb armed forces.[72] "Originally, I wanted to portray women who were raped during the Bosnian civil war, but it was too sensitive of an issue," says Karic. "While I was looking for alternatives, I came across the Korean 'comfort women.'"[73] Karic first learned about sexual slavery under the Japanese military by reading a 2001 novel by Juliette Morillot that was translated from French into German in 2003 as *Die Roten Orchideen von Shanghai: Das Schicksal der*

Fig. 11. The shamanic ritual scene from *The Trojan Women: An Asian Story*, Seoul Arts Center, 2007. Directed by Aida Karic. Photo courtesy of the Seoul Arts Center.

Sangmi Kim [The Red Orchid of Shanghai: The Tragedy of Sangmi Kim].[74] For Karic, the history of "comfort women" was less sensitive than the mass rapes during the Balkan war because of its physical and temporal distance from European audiences, distance that eliminated the possibilities of a web of responsibility.

Karic saw similarities between wartime sexual violence in the Balkans and in Asia. As women of defeated nations, Korean and Bosnian women were considered disposable and thus were vulnerable to sexual violation. Further, the end of war did not end their trauma: their communities and their nations failed both groups of women. These themes appear in Euripides's *The Trojan Women*, which provides a familiar narrative for Europeans that helps frame the "comfort women" history. Karic reinterprets Euripides's tragedy as a contemporary warning about the destructive costs of war for women.

Critics assert that Euripides's *The Trojan Women* was a direct response to the Peloponnesian War (431–404 BC), particularly the imperial policy of violence against the islanders of Melos. Classicist Edith Hall notes that "many scholars have believed that in *The Trojan Women* Euripides was using myth to comment on, or even protest against, the punitive action taken by his compatriots against the islanders of Melos in 416 BC, the year before the play's first production."[75] In this protest play, writes critic Barbara Petsch, Euripides "warns his countrymen of the hubris of conquerors, as the women of the defeated Troy bewail their fate."[76] Karic reinterprets Euripides's tragedy as a vessel for telling a story about a contested history as an act of resistance and redress.[77]

Karic found a receptive audience for *The Trojan Women* in Europe, where outrage against the mass rape of Bosnian women helped foster cultural and political interest in other histories of sexual violence against women. Sponsored by such diverse entities as *Der Standard* newspaper, the Embassy of the Republic of Korea in Austria, the Korean Arts Council, and Wien Kultur and Austria Kultur Kontackt, the Vienna production attracted a large audience that included Austrians, members of the Viennese Korean community, and Austrian and Korean government officials. *The Trojan Women* received enthusiastic reviews. Describing her experience as "an exceptional evening that one cannot easily forget," Austrian critic Petra Rathmanner wrote that the performance demonstrated an "unbelievable depth and penetration: for in not a single instance

does it drift into false pathos, cheap pity, or ethnic kitsch."[78] Petsch noted the effective use of *pansori*, describing it as "traditional epic music theater in Korea" that differed from the sometimes "rigid and formalistic" Asian theater, which "does not always find its deserved appreciation in the West."[79]

The production's longest and most successful run was at the Seoul Arts Center, where it garnered significant media attention and was reviewed in major newspapers.[80] Amazed that a foreign artist would know about sexual slavery under the Japanese military, the Korean reviewers focused on Karic's biography. The reviewers noted that the *pansori* singing and instrumental music created a "heart-moving atmosphere" and contributed to the "theatrical beauty" of the piece.[81]

While the narrative framework of Euripides's *The Trojan Women* transhistorically enlarged the "comfort women" story, the use of *pansori* visually and sonically grounded the production as a Korean tragedy. *Pansori* marks Karic's *The Trojan Women* from the start as a Korean retelling to international audiences. As ethnomusicologist Hae-kyung Um has said, *pansori* has come to "symbolize the cultural and artistic heritage of the Korean nation."[82] Sometimes referred to as an "epic chant," *pansori* makes use of traditional narratives that tell stories of heroic and virtuous deeds by figures who are often tragic. Performances can last for up to eight hours.[83] The hoarseness of the *pansori* singer's voice in songs of loss can give the performance a sorrowful quality.

Like the chorus that communicates with the gods in Greek tragedies, the *pansori* singer offers both "narration and comfort for suffering actors," in Karic's words.[84] In this production, singer Kang Sunsook wore a modified ivory-colored version of the *hanbok*, the traditional Korean dress with its distinctive long, flowing skirt; the color evokes the attire of shamans from Jindo in the southwestern part of the Korean Peninsula. Although the *pansori* singer makes only occasional appearances between scenes, her haunting costume and powerful, plaintive voice set the tone for the production. During the shamanic ritual scene, the singer rings bells as she leads the procession onstage. She then steps aside, providing musical accompaniment as another woman, the Cassandra character, performs the main action. This becomes a recurring theme throughout the production: the *pansori* singing and the singer's physical presence become a kind of cultural signpost, a marker of Koreanness.

The use of *pansori* in the production also raises the issue of the difficult negotiations involved in creating intercultural theater.[85] Theater studies scholars Jacqueline Lo and Helen Gilbert propose a model of cross-cultural exchange as "a two-way flow" in which

> both partners are considered cultural sources while the target culture is positioned along the continuum between them. . . . This fluidity not only foregrounds the dialogic nature of intercultural exchange but also takes into account the possibility of power disparity in the partnership.[86]

This model provides a frame for discussing cross-cultural encounters in the production.

The Trojan Women is ostensibly a work of transnational collaboration. Traveling between South Korea and Austria, Karic spent two years on *The Trojan Women* with her Korean collaborators, including the Wuturi Players, a Korean theater company founded in 2005 by director Kim Kwang-Lim that is known for international collaborations that contemporize Korean performance practices. However, members of the Wuturi Players did not feel that they were partners in the creative process of developing *The Trojan Women*, as producer Claire Sung expressed.[87] Relying on interpreters, Karic and cast members spent two months rehearsing in Vienna. The difficulties of verbal communication led to an unsatisfactory exchange of artistic ideas and visions for incorporating Korean performance practices. Members of the Wuturi Players found that Korean performance practices were often simplified to make the production accessible to a European director/audience. This is not surprising since, as Karic has said, "the play was made for a European audience."[88] Nevertheless, the rehearsal period exhibited what theater studies scholar Daphne P. Lei calls "interrupted cultural flows."[89] For the Korean artists, the process seems to have had some of the shortfalls of what Lei calls "hegemonic intercultural theatre" and lacked "adequate reconnection with Eastern cultural sources."[90] But if the use of *pansori* was minimal, "reconnection" with Korean cultural sources was present in movement, and choreographer Kim Sam-Jin did not express the same level of frustration as members of the Wuturi Players.[91] In fact, Kim seemed pleased with the collaboration.[92] While I share the desire for a fuller incorporation of *pansori* in the production, the varied revisions of *pansori*, survivor testimony, and shamanic-inspired move-

ments came together artistically and politically to create a powerful theatrical treatment of the history of "comfort women."

"Now I can see everything / covered with blood," cries the *pansori* singer, stretching out each word in a deep resonant voice as a single drum echoes through the theater.[93] Four figures dressed in black are barely visible midstage as they pivot their bodies and raise their arms to the rhythm of her elegiac voice. A lone figure, Hecuba, slowly walks onstage, calling on the women of Troy to lift their heads and prepare for the fate that awaits them. The four figures appear behind her and steadily march downstage. They stretch out their arms in slow motion, like a crane flapping its wings, to the music of the lone drum. "My name is Kang Duk-Kyung. I was born in February 1929 in Jinju, Kyung Sang Do" announces Kang (Baek). Kang was deceived into joining a "comfort station" and had to serve thirty to forty soldiers each day.[94] The other four women (including Hecuba) move their bodies in unison as they turn with their arms lifted. A second woman slowly moves downstage, explaining that she, Ahn Jeom-Soon (Kim), was kidnapped and taken to Taiwan before the military transported her across the ocean to Hong Kong and Singapore. The women behind her alternate their weight from right to left foot. Suddenly, the women (except for Cassandra) rush to Kang's side, their bodies fanning out to form a triangle. "Look! Greek ships are getting ready to leave," shouts one. Another asks, "Where to?"[95] They take turns explaining how they were taken from their homes and were transported from one country to another, enduring physical pain.

Testimony is central to the work of witnessing during productions about histories of violence. "The theatre 'performing history,'" writes theater scholar Freddie Rokem, "seeks to overcome both the separation and the exclusion from the past, striving to create a community where the events from this past will matter again."[96] In providing a space for the retelling of the stories of survivors, Karic's *The Trojan Women* goes a step further. It offers a way for survivors to continue to live in cultural memory after they have died.

The sharing of biographical information in the first person in the testimony gives the words authority.[97] The embodiment of these words by an Asian actress speaking in Korean adds to the aura of authenticity of the words. Kang and Ahn's testimony in *The Trojan Women* follows a typical script for the formal testimony that survivors give: date and location of birth, the circumstances in

which the woman entered sexual slavery, her experience during captivity, her return home, and her involvement in the social movement for redress. The actress portraying Kang speaks with a southern Gyongsang Province dialect and boldness that brings to mind the real-life Kang, whose paintings were reprinted on banners used during the Wednesday Demonstrations and who was an outspoken critic of the Japanese.

Karic uses Kang and Ahn's testimony to stand in for the experiences of countless, silenced others who were unable to testify. The first two accounts are the only ones where the audience learns the names of the testifiers. The other stories of military sexual slavery recounted during the performance seem to be drawn from the stories of multiple unnamed survivors. While the testimony of Kang and Ahn initially positions them alongside Hecuba as main characters, Kang and Ahn do not reappear. Only the memory of their words lingers.

The condensed testimony of unnamed women provides insight into the conditions of military sexual slavery for those unfamiliar with the history. Women were forbidden from speaking their native languages and communicating in general with each other; they were forced to be silent. "One night I felt so miserable and I sang a Korean song," says Kang. "And I got beaten horribly."[98] Her words become more poignant as one hears the *pansori* singer giving expression to the feelings of *han* of Kang and other oppressed women. The Japanese military transported sex slaves like cargo throughout the Japanese empire; they crossed the sea just as the women of historical Melos and legendary Troy traversed the Aegean Sea. "We moved from Guang Dong to Hong Kong and Singapore," says Ahn.[99] After the war, countless survivors were unable to return home, many out of a sense of shame in a Confucian-influenced society that valued a woman's chastity. "I didn't go back to my hometown. I was a dead person there anyway," laments Ahn.[100]

As soon as Hecuba tells the women to accept their fate, the four actors move downstage, and the Kang character steps forward. When Kang arrived at a "comfort station," the other women told her to accept her fate: "You poor thing, you're now dead, just do what you're told to do if you want to live."[101] Kang's testimony resonates with the resignation in Hecuba's earlier advice to the women of Troy to "let your destiny lead your way."[102] There is a temporal fluidity be-

tween Hecuba's words of violence to come and Kang's memories of past violence. The history of sexual slavery under the Japanese military functions as the future to the past of centuries of wartime sexual violence that reach as far back as the Peloponnesian War. Sexual slavery under the Japanese military is also the past to present and future wartime violence against women.

Karic does not invoke a narrative of culpability, instead pointing to systemic violence that has for centuries put women at risk during war. In making these broader connections, *The Trojan Women* resonates with two other sites of redressive action, the Women's International War Crimes Tribunal on Japan's Military Sexual Slavery and the Public Hearing on Crimes against Women in Recent Wars and Conflicts. Although the public hearing made explicit connections between different histories of gender-based violence, the Women's Tribunal focused on Japan as the perpetrator of violent acts against "comfort women." The Women's Tribunal, conversely, gestured toward systemic problems such as male aggression in wartime but did not produce a larger picture of responsibility. I do not posit *The Trojan Women* as a corrective to the Women's Tribunal, but as a performance it resonates with the public hearing in ways that encourage spectators to reflect on a long history of gender-based violence.

Even so, *The Trojan Women* misses an important opportunity to examine the structural issues that made possible a system of sexual slavery under the Japanese military. Cultural studies scholar Kandice Chuh emphasizes "an ontology for redress that locates cause not to some seemingly stable identity (as victim), but rather to the (institutionalized) behavior that caused injury."[103] Such behavior is part of a matrix of systemic conditions that have put women at risk during and after wars, such as the male patriarchal view that sexual urges must be accommodated or the view that enemies in wartime are not human beings. These conditions have allowed rape and sexual slavery to be used against civilian populations.

The links between military sexual slavery and present-day forms of violence against women become manifest when Kang and Ahn appear onstage dressed in contemporary clothes. As Kang tells her story, the light focuses on the four women who visually respond to the stories of sexual violence in wartime. Some of them wear black dresses, while others wear dark tops with loose-fitting black pants. Through their stylized movements, the women perform as witnesses

to Kang's narrative. Facing stage left, the women gradually extend their left arms and lift their right legs. When survivor Ahn remembers how they "had to serve soldiers on the wild mountainside," the women shift their weight from one foot to another with their heads limply rocking forward and back.[104] Their movement, which evokes a lifeless rag doll pulled by strings, conveys the sense of helplessness and loss of control over one's body during rape. Pivoting on one foot with elbows bent, they turn their statue-like bodies. As stories of violation are told, the women's meditative movements convey self-possession and dignity. Their graceful movements reclaim and reanimate the immobile and wounded bodies in Kang and Ahn's stories.

As Ahn concludes her testimony, the three other women onstage ask where they will be taken next and recount a litany of hardships endured during sexual slavery under the Japanese military. Their memories become a vision of the future, an answer to the Trojan woman's question, "What is going to happen to us?"[105] At first it is clear that the actor who answers the Trojan woman's question is performing the role of a Korean military sex slave. However, as the other women alternate speaking, one begins to hear and imagine the women of Troy and countless other women violated during contemporary armed conflicts speaking these words: "I had to serve so many soldiers that I couldn't stretch my legs at night."[106]

The set and lighting design of *The Trojan Women* indicate unspecified histories of sexual violence. Three black walls surround the empty stage. At one point, two walls come together to form a V shape at midstage center, and the actors creep along these evocations of the walls of Troy. The minimalist set design creates a blank screen on which multiple histories of sexual violence can be projected. The setting potentially dehistoricizes sexual slavery under the Japanese military until one hears the narratives with clear references to "comfort stations."

After Cassandra foretells the death of her future master, a panel of twenty bright lights upstage center emits a reddish-orange light, and plumes of smoke give the illusion of a fire beginning to smolder. Smoke summons spectators into the fog of remembrance. At the Kasser Theater production, the smoke irritated the eyes of audience members. To compound the discomfort, lights suddenly glared blindingly, making it difficult to look at or read the supertitles. Critic

Peter Filichia observed that "the difficulty in reading matches the women's near-inability to speak about these atrocities."[107]

The Trojan Women provides space for a more intense encounter with representations of sexual violation and the difficulties of representing it. A voice moaning and crying becomes increasingly audible as a bare arm attempts to reach through the legs of the women in the triangular formation. As the women disperse, the audience sees a naked woman covered in blood—the actor playing Cassandra and a "comfort woman." As a cacophony of voices describing the different ways "comfort women" suffered becomes audible through the sound system, the woman's head jerks back and forth and her limbs thrash about. The voices shift from that of a soldier demanding that the girls stand up and turn around to be inspected to that of a woman describing how her body shook uncontrollably as she heard her sister cry like a wounded animal. The lone figure onstage continues to convulse until she collapses. She struggles on the floor as three actors crawl toward her.

Some theater scholars argue that playwrights must present horrific events in ways that audiences can take in. Rokem, whose work analyzes theatrical treatments of the Holocaust, insists that "the Shoah can never be brought onto the theatrical stage in a direct and unmediated form." He argues that metatheatrical techniques such as first-person narrative and a "strong emphasis on the performative" must mediate the presentation of an event as horrific as the Holocaust on the stage. Moreover, "some kind of aestheticization of the narrative is necessary in order to tell what really happened," Rokem writes.[108]

Bringing scenes of rape in the "comfort stations" to the stage calls for such mediation. In *The Trojan Women*, Karic and choreographer Kim created a somatic vocabulary for the experience of sexual enslavement. *The Trojan Women* attempts to represent the inarticulable violence done to "comfort women" and Trojan women through movements that evoke epileptic seizures and marionettes. There is no direct scene of rape. Instead, the actors perform pain by demonstrating or displaying the registering of violence on the body. Focusing on the registering of pain instead of the moment of violation shifts attention from the violator to the victim-survivor. The wartime experience of sexual violation is so painful that it is often be-

yond language.[109] Survivors sometimes rely on physical movement to express their experiences, as Marta Abu Bore did at the Women's Tribunal. Her trauma was beyond any language she could find, so she attempted to use her body to show what pain had done to her. The artists in *The Trojan Women* use stylized performances of pain as an ethical way to visualize scenes of rape and minimize the spectacularization of the violence.[110]

Ultimately, to perform pain is to desire healing, and *The Trojan Women* culminates in a symbolic restaging of a shamanic healing ritual. The play thus dramatically revises the ending of Euripides's *The Trojan Women*. There is no funeral scene for Astyanax (the murdered son of the hero, Hector), as there is in Euripides's version. The city is smoldering, smoke permeates the air, and the stage is empty as the women prepare to be taken away. Instead, the sound of handbells announces the *pansori* singer as a shaman figure. She leads the women onstage for a *gut*, a ritual that makes symbolic amends for the wrongdoing inflicted on military sex slaves through an overdue funeral, an act of redemptive mourning for the countless women who have suffered and died as a consequence of wartime violence. This penultimate scene of grieving the loss and celebrating survivors critically counterbalances previous representations of sexual violence.

The visual and movement vocabulary for the ritual scene most closely draws on the Jindo *ssitgim gut*, a cleansing ritual that is usually performed the night before a burial and that includes singing, chanting, offerings, and physical movement.[111] The signature white cloth used in the ritual represents the passageway between worlds and is sometimes tied into knots to signify *han*. In *The Trojan Women*, two actors help carry two strands of a long white cloth diagonally across the stage, down into the space of the audience, and out the doors of the theater. The actors and the singer invite the spirits of deceased military sex slaves and other women wronged during wars to travel along the long white cloth to the next world and to find peace. A sharp sound of ripping cloth fills the air as the actor who plays a Greek messenger and Kang uses her body to cut one of the strands in two. She runs her body through the cloth to the rhythm of the chanting and the drums. Then Cassandra/"Comfort Woman" finds her way into the middle of the three lengths of cloth.

In a re-visioning of the use of the white cloth in shamanic rituals,

Cassandra/"Comfort Woman" weaves the fabric into a thick braid above her head and then lowers the braid, trapping her neck in the knotted strands of the cloth. To me, the braided white cloth signified the accumulation of *han*. She mimics again the jerky movements of a marionette, symbolizing possession of her body by former military sex slaves. Some of the actors swirl clockwise and others counterclockwise, enacting a symbolic trance dance that summons the spirits of the dead to enter the space of the living. There is a jubilant, almost frenetic pace to their movements. After jerking her body around, Cassandra/"Comfort Woman" starts spinning, allowing her body to become the main vessel through which the spirits of the dead reappear. Suddenly, Cassandra/"Comfort Woman" jumps up and down as she unties the cloth, releasing and purging the *han* of all the women who have suffered.[112]

Cassandra/"Comfort Woman" confronts the spectacle-making of pain by replacing her puppet-like epileptic self with her mourning self, who braids the strands of the cloth and then undoes the knot. She takes the reparative act into her own hands and demonstrates agency in the healing process. The layering of her shaman body over the bloodied body of the "Comfort Woman" character transforms her performance into an act of symbolic reanimation of the violated/dead body and a reclaiming of painful memories.

While the shamanic ritual offers symbolic reclamation of violated bodies, *The Trojan Women* ends on a slightly more ambiguous note. The last scene tempers the cathartic possibilities of the shamanic ritual and resists providing easy closure. Although tranquility and quiet pervade the last scene, the memory of violation lingers, as physicalized in the slight bodily tremors of the actors. The women sit facing the audience, reversing the gaze of the viewers, as if asking what they will do with their new knowledge. The final scene does not end with a narrative of reconciliation, as we see in many stage productions about the "comfort women."[113] *The Trojan Women* instead leaves the audience with a sense of uncertainty about the future of the women, an approach that may be more politically efficacious in honing the social consciousness of audiences.

The playbill for the American production suggests one possible metatheatrical next step. It advertises an upcoming event, Montclair State University's Women's Studies Lecture Series on "Bodies in Bondage: Trafficking in Women and Girls," which includes two

lectures about the work of nonprofit organizations that provide services to victims of human trafficking and advocate for policy change. The description urges audience members to take action: "The next step is yours—come and find out how you can join the fight against human trafficking."[114] The lecture series points to the importance of connecting the issue of sexual slavery under the Japanese military to ongoing instances of sexual exploitation. Contemporary examples such as human trafficking are part of a larger culture in which sexual violence occurs against women and in which perpetrators receive impunity.

The Call to Remember: *Bongseonhwa* (2013–2014)

Based on the 1982 novel *Emi Ireumeun Josenppiyeotda* [Mother's Name was Chosun P] by original author and playwright Yoon Jungmo, *Bongseonhwa* [Garden Balsam] combines choreographed movements with video projections and voice recordings of survivors' testimony.[115] Unlike the novel, which focuses on the relationship between a survivor and her son, the theatrical adaptation explores how three generations of a Korean family struggle to come to terms with the legacies of a colonial past in which everyone is implicated in perpetuating pain and silence. "Back in 1982 it was right, age-wise, to deal with only two generations," explained Yoon, but by 2013, when the play was written, "the time called for a third generation."[116]

The Seoul Metropolitan Theater Company's production of *Bongseonhwa*, directed by Koo Tae-Hwan, premiered at the Sejong Center for the Performing Arts on November 15, 2013. It had domestic runs at major theaters and community centers throughout 2014 and toured to the United States in the summer of that year. *Bongseonhwa* attempts to make the "comfort women" history relevant to contemporary audiences and raises further questions about the promises and limitations of theater as a venue for "comfort women" stories and the pressure to demonstrate facticity onstage when performing "comfort women" histories. Though *Bongseonhwa* has some predictable plotlines, it differs from other theatrical productions about the "comfort women" in that it directly critiques Korean society for its apathy and silence about the "comfort women." *Bongseonhwa* points out the complicity of Koreans in the violence

against "comfort women" and the responsibility of Koreans and others to work toward justice for survivors. It also links the violence done to "comfort women" to the structural problem of domestic violence, making the seemingly distant history of sexual slavery under the Japanese military more relevant to contemporary audiences. *Bongseonhwa* addresses what is often unspoken during activist public events—the efforts of survivors and their kin to reckon with what happened.

Bongseonhwa centers on the relationship between elderly survivor Kim Soonee; her son, Munha; and her granddaughter, Suna. The play moves between scenes of the present, where Munha has a successful career as a dean at a university, and scenes from his childhood and his mother's time in "comfort stations." When Suna, who is studying for a master's degree at her father's university and is unaware of his and his mother's history, decides to write her thesis on "comfort women," the family disapproves. Suna's interest prompts Munha to reflect on his past. Soonee was kidnapped as a teenager and taken as a military sex slave to the Philippines, where she saved the life of Kwangsu, a young Korean man drafted into the Japanese military. When they returned to South Korea, Kwangsu and Soonee married and had a son, Munha. Kwangsu became a drunkard and verbally and physically abused his wife for having been a "comfort woman." After Kwangsu's death, Soonee disappeared from her son's life and broke off communication with him, fearing that her past would interfere with Munha's success in life. He married and built an academic career. As Suna and her friend, Jinho, research their projects, they meet Soonee for the first time at the House of Sharing, a home outside Seoul for the elderly survivors of Japanese wartime violations, and Jinho comes across an anonymous novel, *Chosun P.*

Between scenes of Soonee telling her story at the House of Sharing, there are reenactments of her time in "comfort stations" in the Philippines with her childhood best friend, Okbun, whom she hoped to find at the House of Sharing. Jinho notices similarities between Soonee's testimony and the novel, and he sees Munha stealthily visiting the House of Sharing to catch a glimpse of his mother without her knowledge. Both Suna and her friend face resistance from the university and are unable to go forward with their projects. They eventually discover that the source of the resistance is Suna's father. At the play's climax, Suna confronts her father in a projection room

Fig. 12. Soonee (*right*) watches the two actors playing her younger self and her best friend (*left*) in a performance of Jung-mo Yoon's *Bongseonhwa* at the Sejong Center for the Performing Arts, 2013. Directed by Tae-Hwan Koo. Credit: © Yonhap via Newscom/ZUMA.

at the university and reads him excerpts from *Chosun P* while a video montage of archival photographs and documentary footage of "comfort women" and the war plays in the background. When Suna asks her father if he wrote the novel, Munha tells her that he wanted to give his mother a new life, free from her past, but she just disappeared. It becomes clear that he is the author of *Chosun P*. In the denouement, Suna shows Munha a video clip of his mother saying that she had watched his success from a distance and was brought to tears when she saw him looking at her through a window at the House of Sharing. He collapses while sobbing when he sees the next image: his mother's tomb, with Suna leaving *bongseonhwa* [garden balsam] at her grave. The stage goes black, and the screen comes down. After the actors bow and leave, voices of survivors recalling their time in "comfort stations" can be heard.

The artistic team behind *Bongseonhwa* envisioned the production as a call to arms in response to continual obfuscations by Japanese politicians regarding the "comfort women." In the same year that *Bongseonhwa* premiered, the mayor of Okaska, Hashimoto Toru, a nationalist and prime ministerial hopeful, said that the

"comfort women system" was "necessary" to provide "relief" for "war-crazed soldiers" who were risking their lives for the country and that no evidence indicates that Japanese authorities "forced women into servitude."[117] "His comments," writes journalist Hiroko Tabuchi, "followed those of a string of Japanese politicians who have recently challenged what they say is a distorted view of Japan's wartime history. Last month, Prime Minister Shinzo Abe seemed to question whether Japan was the aggressor during the war, saying the definition of 'invasion' was relative."[118] In a climate of state denials of the survivors' experiences, the team behind *Bongseonwha* used artistic means to counter the politics of amnesia. "If the audience does not stop at feeling sad for" survivors, explained the director of *Bongseonhwa*, "but is actually moved to act and make change, then I will have fulfilled the wish of this play."[119] Though he did not explicitly state what that "change" looks like, the play points to historical education, memorialization, and fostering dialogue in private and public spaces as facets of making change. "If the issue is not resolved in three generations, it will get buried," explained Yoon. "It's the story of our lives. We should publicize the issue and resolve it as soon as possible."[120]

In the play, Yoon explores how a survivor's family might have contended with her past. Though they differ in their delivery of their rejection of her former life, both Soonee's abusive husband and her son condemn her for her past experience. Attempting to take the money she has earned and set aside for her son's tuition, Kwangsu hisses, "You dirty bitch, fussing over a pittance." Without flinching, she hollers back as she rises from the stage floor after getting knocked down, "Who are you calling dirty?" In response to her statement that Munha is a good student and that she has "skimped and saved for his education, penny by penny," the husband retorts, "Hmph, even if he goes to college he is still the son of a whore!" Clenching both her fists and moving toward her husband, she yells, "Son of a whore? Who are you calling a whore?" Munha walks in on his parents and tells his father to leave the money, prompting Kwangsu to beat both Munha and his mother as she tries to protect him.[121] Her sense of pride in herself and anger at her husband come through via physical movement: her refusal to stay at ground level, her glaring eyes, and her clenched fists. She is portrayed not as a passive victim but as a survivor who refuses to be knocked down again.

Bongseonhwa raises the possibility for audiences to see how different histories of gender-based violence, one on the warfront and another at home, are interconnected. Soonee's suffering continues into her postwar life, where she faces abuse as a woman, as a mother, and as a victim of sexual violence. Scenes of domestic violence are echoed later in the production through the physical movements of male actors who push down female actors during the scenes where an elderly Soonee remembers her time as a "comfort woman." The connections between the histories portrayed in the Chicago production and contemporary domestic violence were likely clear to local audiences, who passed by a table of materials produced by KAN-WIN, a local nonprofit, as they entered the theater. The organization, which initially focused on the Korean population, provides legal advocacy, transitional housing, education, and child care support to Asian survivors of domestic violence and/or sexual assault.[122] KAN-WIN is also the main sponsor in Chicago of Wednesday protests in support of survivors of Japanese military sexual slavery and testimonial events with survivors visiting from South Korea. The presence of KAN-WIN in the lobby is one example of a metatheatrical component of *Bongseonhwa*'s production life in the United States that illuminates the cultural work of the play. *Bongseonhwa* encourages audiences to see domestic violence not merely as a relationship problem but as part of systemic oppression.

The play's narrative moves between condemnation of the Japanese state and condemnation of Korean society; it is most effective when doing the latter. It shows the responsibility of family members for perpetuating silence and pain for survivors. After his father's death, Munha tells his mother with relief, "Your past is now locked up in a dead mouth forever. . . . From now on, you can hold your head high."[123] While the son wants his mother to forget her past and never speak of it again, the mother does not agree. She turns away from her son and looks downcast. In one of the most moving scenes in the play, Soonee tries to explain to her son how she is not ashamed of herself:

> SOONEE: When it seemed the liquor had you opened up, I told you what had happened to me in the Philippines. That day you left home and didn't come back for several days. Was it because you felt ashamed of your mother?

MUNHA: It's nothing to brag about, is it? But now I'm okay. It's our secret just between you and me. We just need to erase it from our memory. From now on you will become a completely different person.

SOONEE: Is a frog ashamed to have been hit by a stone? Is it a disgrace to have been beaten by street thugs? The same is true with what happened to me. They're unfair and mortifying incidents, not shameful things.[124]

It is clear that the son is still ashamed of his mother's past and believes that she will be a "different person" if she forgets her past. The mother is insistent on rejecting this imposition of shame and articulates her innocence and her helplessness as a victim of violence. As Korean audience member Lee Seonah put it, the play "critically comments on those who are near [survivors] and on society to question how we have been educated to view them. My own viewpoint was not so much different from what Soonee Halmeoni criticizes in the play. I tended to view the nature of this tragedy as something that is shameful rather than realizing the catastrophic nature of it."[125] The son ultimately fails to change his view and fails his mother in his inability to accept her past, leading to her absence from his adult life.

Suna, however, becomes a different kind of witness from her father. For most of the play, she is unaware of her close familial ties to the "comfort women" history. Similar to Jina in *Comfort Women*, Suna is an idealistic and passionate university student who becomes interested in the "comfort women" history through her studies. For both families, the pain and social stigma are too raw for the children of the survivors to face their mothers' past, and only the third generation is able to engage with this past. Not surprisingly, Suna faces a lot of opposition from her family in pursuing this topic, from her maternal grandfather, who questions "what was so bad about Japanese colonialism," to her father, who tells her not to think "about such sordid things."[126] Suna also feels as if she is doing her part for a worthwhile cause: "I threw myself into this to make people hear their cries of protest."[127] While Suna problematically invokes the rhetoric of "breaking the silence" of victims, she nonetheless desires to do her part in supporting survivors and remembering their history through her studies.

One of the play's most important interventions is the open discussion of Korean complicity in crimes of Japanese military sexual slavery and the opportunity for introspection and extrospection. "When we think of Japanese military 'comfort women,'" writes Kim Hye Ryun, the general artistic director of the Seoul Metropolitan Theater, "we always blame Japan, but we can do better as well. A *halmeoni* during the Wednesday Demonstration once cried out, 'how is it that you all are just watching,' and I felt much shame."[128] By calling out the Korean public for its inaction and apathy, this survivor motivated Kim to use theater as a way to do more than just watch the *halmeonidul*. *Bongseonhwa* invites audiences to consider how they can do better at understanding and supporting survivors. Earlier in the play, Suna and Jinho discuss how artists and female university students recruited women for the *yeojageunno jeongsindae* [women's labor corps]. *Jeongsindae* means "offering-up-one's-body corps" and refers to Imperial Japan's mobilization of men and women as factory operatives in Japan's expanding empire. Some women were deceived into the "comfort women" system under the guise of joining the *jeongsindae*, and Koreans mistakenly conflated "comfort women" victims with *jeongsindae*.[129] "I would like to find a student who participated in that," remarks Suna. "I want to know whether she knew then that the girls she recruited would become comfort women." Later in the play, Suna learns that her own maternal grandmother was a recruiter who encouraged classmates to join the labor corps and "lived with a life-long guilty conscience."[130]

The play directly points to the memorial-building movement among Korean Americans as a contrast to Korean society's apathy and slow coming to terms with its colonial past. After Jinho explains that "these days, in Japan, right wing politicians are trying to whitewash their history," Suna says to her father, "A statue was erected in the United States to remember the 'comfort women' and to denounce acts of brutality by Japan. But our people just turn a blind eye."[131] She is referring to the statue of a girl erected in Glendale, California, in 2013 by activists who wanted to commemorate the Wednesday Demonstrations and remember the historical experiences of "comfort women." This was the first such statue built in the United States, and similar statues were erected in South Korea in 2013 (one statue), 2014 (five), and 2015 (fourteen).[132] Whether or not *Bongseonhwa* directly inspired communities to build these me-

morials, it is clear that Koreans are using memorial building as a way to show their support for survivors and to foster public dialogue on this history.

In addition to attempting to stir local Korean audiences out of apathy and to incite them to support survivors by pointing out that those outside of Korea are doing more, *Bongseonhwa* also directly asks those in the diaspora to consider their responsibility in the process of reckoning with the history of "comfort women." In discussing German reckonings with the Holocaust, Suna's research partner tells her that a "united Jewish community stood up and forced Germany to admit their war crimes."[133]

"They say I am the eighty-fifth witness. Appropriate since I am now eighty-five years old," begins Soonee in her public testimony at the House of Sharing.[134] Soonee's testimony is beautifully reenacted onstage by an ensemble. Soonee sits at a narrow wooden table stage right that is positioned diagonally so it opens out to the audience. Thus, the theater becomes the testimonial hall in the House of Sharing. When the testimonial sequence ends, the stage is empty except for Soonee at the table and Suna, who asks about what happened after the war ended. During this brief exchange, Jinho, who makes documentaries, is holding a video camera pointed at the audience. This breaking of the fourth wall through the gaze of the video camera gestures toward the importance of self-scrutiny for audience members listening to testimony, making them aware of their own role in the testimonial exchange. The turn of the camera also raises the question of what it would mean for the audience to be documented and how viewers could become more visible and present.

The memory sequence recounts a moment when Soonee and Okbun play in a field before they are kidnapped, their time in a "comfort station" in Manila, and their time in an internment camp in the Philippines after the Japanese surrender. The first memory scene brings to life a scene of youthful naïveté and merriment. Wearing their hair in long braids, the custom for unmarried women in Korea at the time, two actresses in pastel-colored *hanboks* skip across the stage and hop on wooden crates as if they are running through a field. The actresses playing sixteen-year-old Soonee and fourteen-year-old Okbun playfully discuss what it will be like to meet their husbands, Okbun's changing body as she undergoes puberty, and Okbun's fingernails, which are dyed from crushed *bong-*

seonhwa petals. Korean women believed that if the color stayed on their nails until the first snow, "they would find true love."[135] The title of the play was changed from *Emi Ireumeun Josenppiyeotda* to *Bongseonhwa* to represent the "crushing of innocence" of the young women taken into military sexual slavery.[136] In a sense, *Bongseonhwa* is about the wartime crushing of innocence and the ensuing struggles over acceptance and atonement. The actresses playing Soonee and Okbun are joined onstage by three other actresses, each wearing a *hanbok* with a white *jeogori* [top] and black *chima* [skirt], a school uniform in the early twentieth century. As the women dance around and atop wooden crates, four male actors wearing black tank tops and pants appear onstage and approach the crates. When each actress steps on top of a crate, she pauses and freezes with her mouth agape and hands outstretched, as if reaching for help, until all the women are frozen in place on top of the crates. The women become like statues, evoking the original bronze girl statue in front of the Japanese Embassy in Seoul. The women are "dragged away by Japanese MPs [military police]," reads the script;[137] the four male actors carry them backstage before the lights fade.

Subsequent memory scenes move between the present, where the elderly Soonee is telling her story at the House of Sharing, and her past in a "comfort station" in Manila. Videos of a ship full of passengers and bombs falling and photographs of "comfort women" and soldiers lined up in front of a "comfort station" are projected onto the upstage back wall. The use of documentary images speaks to the director's desire to "portray the reality of comfort women, almost like a documentary."[138] The projections of archival material bring the production, in the words of theater scholar Carol Martin, "closer to actuality than fiction."[139]

In this play, like *The Trojan Women*, scenes of rape are represented through effective stylized movement. The four male actors use heavy, stomping movements around the supine bodies of the actresses playing "comfort women" to convey sexual violation and physical abuse. In the scene depicting the rape of Soonee and Okbun, the male actors push the two female actresses around before throwing them to the floor. The actors stomp between their legs and arms and around their torsos as the women roll around. In another representation of sexual violence, the women kneel on the floor, pushing the wooden crates in front of them back and forth. This approach

positions representations of sexual violence in the interstices between realism and nonrealism, a strategy similar to performances of pain in *The Trojan Women*.

Bongseonhwa received mostly positive reviews in South Korea. Critic Song Tae Hyung wrote that the play "shows convincingly how the wounds of the comfort women *halmeoni-dul* are passed down to us across generations, and that we could be the victim and wrongdoer simultaneously."[140] "Minimal use of stage effects and the music," commented writer Yeom Ji Eun, "give clarity to the lines that are spoken." Through Soonee, Munha, and Suna, Yeom continued, "the play presents the pain of the war and the brutality of the Japanese empire, reminding us that the issue of the comfort women is not something belonging to a forgone past but that it matters today."[141] Gang Iseul, however, wrote that he could find "no innovation in terms of directing or any unique feature of its own to take notice."[142] But *Bongseonhwa* is unique in its focus on Korean complicity and on making connections to contemporary domestic violence.

Conclusion

Surprisingly, survivors have been the most outspoken critics of *Bongseonhwa*. On the one-year anniversary of the unveiling of the bronze girl statue in Glendale, the Korean-Glendale Sister City Association hosted an art exhibit at the Glendale Central Library, art and dance performances at the Alex Theatre and in Central Park by the statue, and Seoul Metropolitan Theater Company's production of *Bongseonhwa*.[143] Survivors Yi Ok-seon and Kang Il-chul were in Glendale with plans to attend the events.[144] However, after viewing *Bongseonghwa*, the two women decided to boycott the anniversary event in the park because they believed that the play depicts an "inaccurate scene in which comfort women, wearing kimonos, throw around money."[145] In the controversial scene, a young woman dressed in a pastel pink *yukata*, a casual kimono-like garment worn in the summer, climbs the stacked crates barely holding on to a large bundle. Military notes fall to the ground as Okbun frantically tries to gather the bills into her arms. A scene of frenetic chaos ensues onstage after sirens alert the "comfort women" that Allied forces are dropping bombs in the Philippines.

The House of Sharing released an official statement that said, "The performance of 'Bongseonhwa' is a step back from the human rights activism of the former comfort women, and we officially request a modification of the inaccurate scene."[146] The controversy raises interesting questions about proper depictions of the "comfort women" and how to balance political intervention with artistic license. Is fictionalizing any aspect of the "comfort women" history acceptable in the eyes of the victims? Should all artistic representations of historical atrocities be documentary-like? What responsibility, if any, do artists have to survivors? While the money-throwing scene was a visual spectacle that did little to drive the play's dramatic action and disrupted the powerful memory scene sequence, describing the play as a "step back from . . . human rights activism" seems somewhat extreme. If we assign productions about the "comfort women" history the burden of being as close to fact as possible, we limit the range of critiques and interventions artists can make. However, artists do have a responsibility to create work that fosters a critical engagement with the complexity of the "comfort women" history. That kind of engagement may lead to shifts in the perception of victims of sexual violence or to participation in the social movement via a memorial-building project.

Hanako/Comfort Women/Nabi, The Trojan Women, and *Bongseonhwa* are examples of productions about the "comfort women" that illuminate the complexity of the history and its traumatic impact on communities. These three works narrate forgotten histories that expose the gendered politics of communal, familial, and individual silencing around the "comfort women" violence. As redressive theater, these works cultivate a critical social consciousness among audiences through introspection and extrospection. While *Hanako/Comfort Women/Nabi* and *Bongseonhwa* encourage more introspection through the second-generation university student, the plays also question dominant narratives surrounding the history, such as the idea that the "comfort women" issue is strictly an Asian concern. *The Trojan Women* expands the temporal and geographical resonances of the "comfort women" violence, situating it within the long history of wartime sexual violence against women. In so doing, the play demonstrates an ethical way to visualize violence through stylized performances of pain that are counterbalanced by ritual movements. *Bongseonhwa* fosters both intro-

spection and extrospection in its critique of Korean apathy toward survivors and in linking militarized sexual violence with the structural problem of domestic violence.

The artists who created *Hanako/Comfort Women/Nabi*, *The Trojan Women*, and *Bongseonhwa* share a belief in the redressive possibilities of art that remembers and honors survivors. These theatrical works treat remembrance and witnessing from introspection and extrospection as possibilities enacted through the gathering of communities at productions in the United States, South Korea, Austria, and Canada. Ultimately, redressive theater creates spaces where artists, activists, audiences, and scholars can interrogate and bear witness to the history of "comfort women" and its social and cultural legacies.

Performances of Care: Memorial Building in the Korean Diaspora

On December 14, 2011, at the one thousandth Wednesday Demonstration, five elderly survivors in their signature yellow protest vests lifted their voices with the crowd of about a thousand supporters, asking for redressive measures from the Japanese government.[1] "Japanese government, apologize soon before the *halmeonidul* leave this earth," shouted Kim Bok Dong, who was fourteen years old when she was forced into becoming a "comfort woman" in 1940 and "dragged to Taiwan, Guangdong, Malaysia, Sumatra and Singapore to serve Japanese soldiers."[2] The poignancy of Kim's words was heightened by the highlight of the event, the unveiling of a realistically rendered bronze statue of an adolescent girl to commemorate the protests and the women who endured Japanese military sexual slavery. Since 1998, public memorials to honor survivors have been erected around the world—in Gyeongju-City, South Korea (1998); Manila, the Philippines (2003); Miyako Islands, Japan (2006); Palisades Park, New Jersey (2010); Westbury, New York (2012); Hackensack, New Jersey (2013); Glendale, California (2013); Alexandria, Virginia (2014); Union City, New Jersey (2014); Southfield, Michigan (2014); Toronto, Canada (2015); Nanjing, China (2015); Sydney, Australia (2016); and Beijing, China (2016), among others.[3] By September 2016, forty-four of the bronze statues had been erected in South Korea, the United States, Canada, and Australia.[4] The majority of bronze girls have been installed in South Korean cities, including statues that depict both a Chinese girl and a Korean girl.[5] Outside South Korea, the largest concentration of "comfort women" memorials is in the United States.

American studies scholar Erika Doss calls the flourishing of different kinds of memorials in the United States "memorial mania," a process that became more prominent after September 11, 2001. She notes an "obsession with issues of memory and history and an urgent desire to express and claim those issues in visibly public contexts."[6] Why do Korean and Korean American communities invest in memorializing the history of "comfort women"? What do such commemorative practices say about the memory and activism of survivors? How is memorialization a form of redress for survivors and their supporters?

This chapter considers the redressive potential of memorial building by Koreans and Korean Americans in Seoul, Palisades Park, and Glendale. Seoul is home to the original bronze girl statue, the most well-known "comfort women" memorial. Palisades Park is the site of the first "comfort women" memorial in the United States, and Glendale is home to the first bronze girl statue outside South Korea. My analysis is based on ethnographic fieldwork at protests in Seoul in 2013 and dedication ceremonies in Palisades Park in 2010 and in Glendale in 2013; interviews with artists, politicians, and community members in these three cities; and news articles, ceremony programs, and pamphlets.

An examination of these memorials brings to light a nexus of individual, collective, and national desires related to the memory of "comfort women." According to cultural studies and visual studies scholar Marita Sturken, "Memory is crucial to the understanding of a culture precisely because it indicates collective desires, needs, and self-definitions. We need to ask not whether a memory is true but rather what its telling reveals about how the past affects the present."[7] The telling of the memory surrounding "comfort women" through the production and reception of memorials illuminates both how this past impacts national and local politics and how the present shapes memories of the past. As Asian American studies scholar Cathy J. Schlund-Vials illustrates, memory work surrounding a history of state violence and silence that implicates the United States on some level must contend with multiple "resistive registers" against remembering.[8] This reckoning can happen through embodied engagements with memorials. English and Judaic studies scholar James E. Young reminds us that every memorial space is "fundamentally interactive."[9] In its examination of the dialogical nature of me-

morials, this chapter joins a growing body of literature in performance studies that examines the relationship between memorial objects and performance.[10] I look more closely at what prompts and shapes embodied engagement and what these performances tell us about the interrelationship between memory, transnationalism, and political action.

This chapter examines the desires and feelings that drive community members to commemorate the "comfort women" history and their manifestation in embodied interactions. Doss writes, "Memorials . . . are archives of public affect, 'repositories of feelings and emotions' that are embodied in their material form and narrative content."[11] However, memorials to "comfort women" are more than just repositories or archives; they are examples of what performance studies scholar Robin Bernstein calls "scriptive things": "A scriptive thing, like a playscript, broadly structures a performance while allowing for agency and unleashing original, live variations that may not be individually predictable." Bernstein argues that "within each scriptive thing, archive and repertoire are one."[12] As scriptive things, "comfort women" memorials invite not just individual but collective engagement in the ethical work of remembering histories of violence.

I am interested in how memorials as scriptive things specifically invite *performances of care*, or embodied acts that materialize concern and interest by providing for the needs of or looking after what one is caring for—in this case, memorials. The roots of the word *care* capture a sense of loss—of mourning, or feeling regret or sadness about a loss or disappearance—and the action of providing for the needs of those who have suffered a loss or of commemorating a loss.[13] The materiality, design, and location of memorials shape how they prompt or invite behaviors of care as scriptive things.

The Bronze Girl: Seoul (2011)

> December 14, 2011 marks the 1000th Wednesday Demonstration for the solution of Japanese Military Sexual Slavery issue after its first rally on January 8, 1992 in front of the Japanese Embassy. This peace monument stands to commemorate the spirit and the deep history of the Wednesday Demonstration.
>
> —Inscription at the bronze statue in Seoul

Multiple memorial desires are materialized in the bronze statue in Seoul. First, it reminds the public of the long history of the Wednesday Demonstrations (see chapter 1). Second, it is a reminder of the fact that the most vulnerable and helpless were abused in the "comfort stations." Third, the statue is a symbolic act of reclaiming youth and innocence as qualities that still rightfully belong to the women.

A Korean artist couple, Kim Eun Sung and Kim Seo Kyung, designed and created the bronze girl statue, which was funded with donations from the Korean public.[14] After walking by the Japanese Embassy during a Wednesday Demonstration in 2011, Kim Eun Sung, "felt sorry and regretted that I hadn't done anything to help in the past 20 years. I went to the Korean Council . . . introduced myself as a sculptor and asked if there was anything I could do."[15] The Korean Council first proposed that he design a black stone memorial, but Kim felt that that was not the right move: "We thought a stone isn't quite accessible. We wanted it to be more moving, so we changed the design from a stone to a girl statue, to the bronze girl. There were about twenty ideas in the process and the bronze girl was the one that got developed."[16] Among those other ideas were a single rose, a shoe, an empty chair, and a butterfly.[17] The couple worked together on the sculpture, but Kim Seo Kyung took the lead on sculpting the details of the statue because she felt that a woman's sensibility was needed. "What was most important was making it look young but strong at the same time, and having a little bit of rage," she explained. "I wanted to portray a girl that has inside her the energy of a strong, almost scolding *halmeoni*." Though the face is not modeled after anyone, the couple's adolescent daughter put on a *hanbok* and posed for the statue, and Kim Seo Kyung "put special attention to making the girl dignified in appearance, rather than using anger, sadness, or weakness. It's an expression of the determination that they will not give up until they have an apology."[18]

The Japanese government strongly disapproved of the statue. According to an article by journalist Sang-hun Choe, "The Japanese government's main spokesman, the chief cabinet secretary Osamu Fujimura, called the installation of the statue 'extremely regrettable' and said that his government would ask that it be removed." In response, however, the Korean government declared that it had "no intention of forcing the protesters to remove the statue" and called on Japan to take responsibility for its military's use of sexual slavery.[19]

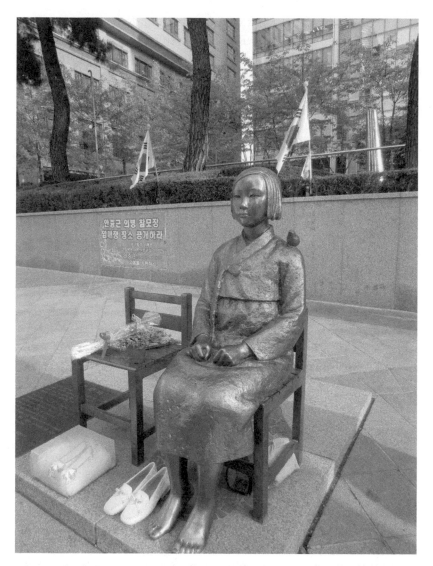

Fig. 13. The bronze statue in Seoul, November 4, 2013. People have left gifts for the statue, and a rolled-up raincoat lies underneath it. Photo by Elizabeth W. Son.

The obsidian plaque next to the statue announces, "This peace monument stands to commemorate the spirit and the deep history of the Wednesday Demonstration." The inscription appears in Korean, English, and Japanese (in that order), illustrating an awareness of the multiple domestic and international audiences that participate in the protests and read about or watch them in different media. By labeling the statue a "peace monument," the plaque highlights activists' desire for a peaceful resolution while situating the Wednesday Demonstrations as the means of achieving that goal. In contrast to the belligerent responses from the Japanese government and ultraconservatives, the protests have been characterized by a spirit of peace and reconciliation. In positioning peace as central to the deep history of the protests, activists seek to enlarge the scope of the Wednesday Demonstrations, imbuing them with a sense of utopic longing for a world without war and gender-based and sexual violence.

This rhetoric of peace and reconciliation contrasts with the visuals of the statue. Dressed in a *hanbok*, the barefoot bronze girl sits next to an empty bronze chair. The statue's shadow is laid out in a mosaic of flat gray granite stones behind her that outlines the silhouette of a seated woman. Her bent back and her bun mark her as elderly. The girl sits stoically with clenched fists and closed lips. She stares straight ahead at the Japanese Embassy in an accusatory manner, though one could also read a sense of peace and self-possession in her stillness. Her body language conveys defiance and confidence: her head is held high and her back is straight. A small bird, representing a medium between this world and the next, perches on her left shoulder.[20]

Similar to the statue, the Wednesday Demonstrations cannot simply be characterized as protests for peace. Although they have been for the most part nonviolent and peaceful, an undercurrent of indignation pulsates through the protests. Theater studies scholar Carol Fisher Sorgenfrei describes the Wednesday Demonstrations as a "performance of outrage and agency."[21] Protesters perform outrage by shouting for an apology and collectively raising their fists; survivors such as Lee Yong Soo have angrily shouted their claims and given testimony at the protests. However, outrage also does not fully characterize the Wednesday Demonstrations, which allow for a spectrum of affective engagements and expressions. They also

have a celebratory air as supporters sing together and excitedly wait to greet survivors.

The statue is located on a sidewalk directly across from the front gates of the Japanese Embassy, public space that is part of the city of Seoul. Though the statue is called the Peace Monument, its location and the positioning of the girl launch an undeniable accusation directed at the Japanese government. The location of the statue also allows multiple audiences to view it: the Korean public, the international public, and the Japanese state. The area is accessible to the public, and the statue's placement on the sidewalk allows passersby to pause and interact with the statue without worrying about traffic. Embassy workers and Japanese dignitaries entering and leaving the embassy can easily see the statue. Japanese ambassador to South Korea Bessho Koro, who works in the embassy, has said that the statue was "not helping to solve problems in Japanese-South Korean relations": "Every day I go to work at the embassy and I see that statue; I don't think it was the right decision to put it there."[22] Bessho views the statue not as a symbol of peace but as a symbol of discord between the two countries. His discomfort with the statue's proximity to the embassy reinforces its status as a public indictment of Japan's refusal to resolve the issue.

South Koreans often dress the bronze statue. Although this practice resonates with the Japanese Buddhist practice of dressing Jizo statues in bibs and hand-knit hats, animist belief does not drive the desire to care for the bronze statue.[23] However, in this Buddhist framework, a dressed statue may displease a Japanese viewer such as Bessho, who finds the practice offensive because of the association of the "comfort woman" figure with spirituality. The statue clearly has become a reminder of the history of the "comfort women" and their desire for redress. Aside from the location, what makes the statue elicit such strong responses from the public? The depiction of the young girl may make the ambassador more uncomfortable than would a statue of an elderly survivor or a stone memorial with a plaque.

The artists and the South Korean public colloquially refer to the statue as the Sonyeosang [Girl Statue]. Activists however, call it the Pyeonghwabi [Peace Monument].[24] The Sonyeosang name anthropomorphizes the memorial: supporters refer to the statue as *her* and perform caring actions that would be appropriate for a human. The

lifelike nature of the memorial as a scriptive thing invites these performances of care. Her small frame, hairstyle, and simple outfit identify her as an adolescent girl. Her lack of shoes indicates that she may have been from a poor family or was playing out in the fields when she was taken. In another scenario, her bare feet may indicate that she was rescued straight from a "comfort station." The fact that the balls of her feet barely touch the ground conveys a sense of unsettlement and vulnerability that contrasts with her composure and clenched fists. Japanese opposition to the statue shaped the design of the sculpture's hands: according to Kim Seo Kyung, "We got so angry after we heard that the Japanese were opposed to the installation of the statue. We changed the shape of the girl's hands after that."[25]

The statue evokes the rhetoric of youth and innocence that prevails and still rallies support at the Wednesday Demonstrations and in the public discourse surrounding the "comfort women" cause. "The 'comfort women' had to go through horrible sufferings when they were just teenage girls," explained Kim Seo Kyung, "so we thought the statue must be an image that commemorates their lost youth."[26] The youth and vulnerability the statue represents heighten the repulsiveness of the crimes of sexual slavery and accentuate the culpability of the Japanese military in deceiving and abusing young girls. The figure's youth also memorializes the fact that young girls were forced into sexual slavery and reaffirms the victimhood of the "comfort women." Further, the statue evokes the survivors' strong sense of defiance and their reclaiming of their lost sense of self. If the statue could speak, it would say, "You tried to destroy that girl, but you did not. Her spirit lives on."

The shadow of the elderly woman behind the bronze girl further complicates an understanding of the statue.[27] The artists' daughter came up with the idea of the shadow of the *halmeoni* in the present looking over the girl statue. According to the artists, the shadow represents the grandmothers and their endurance of the passage of time with no redressive measures from the Japanese government.[28] The pairing of these two figures also brings to mind ethnomusicologist Joshua Pilzer's observation of the centrality of images of young girls and grandmothers in the symbology of the "comfort women" movement and in South Korean public culture; these images promulgate a narrative of Korean victimization and Japanese culpability.[29] Furthermore, the ages of these two figures radically desexualize the "com-

fort women" survivors, enabling an analogy between their individual pain and injury and national injury.[30] The women become legible to the public and state when they are emptied of sexual desire and positioned as sexually and morally pure.

The clothes on the statue are significant. The statue's dress resembles a *hanbok*, a traditional Korean dress with a *jeogori* [top] and a long, flowing *chima* [skirt]. Female elementary and secondary school students commonly wore a white *jeogori* and black *chima* during the World War II era, and the actresses in *Bongseonhwa* wear the same *hanboks* in the scene where they are abducted and forced into military sexual slavery (see chapter 3). "When you look at Kang Duk-kyung Halmeoni's paintings, you always see them being dragged away dressed like that," said Kim Eun Sung.[31] Kang's paintings have resonated with and inspired participants in the "comfort women" movement (see chapter 1).

The statue's *hanbok* also embodies ethnocentric ideas about beauty and sexual chastity. In her discussion of the traditional Korean dress (called *joseonot* in North Korea) and its relation to changing ideals of femininity and womanhood through state-monitored sartorial options for North Korean women, performance studies scholar Suk-Young Kim writes that the "state's promotion of modified *joseonot* was predicated on a nationalistic dress code borrowed from traditional sartorial motifs that emphasized modest feminine beauty and virtue."[32] Dressing the statue in the *hanbok* could also be seen as a symbolic reclamation of feminine beauty and virtue for the survivors.

The statue's dress may script certain kinds of behavior—for example, adorning her with additional clothing items as a way to "protect" her from the elements. In the winter, people put blankets on her or dress her in scarves and hats. On one frigid day in January 2012, the bronze girl wore a white wool cap with a matching scarf carefully wrapped around her neck. Her body was covered in a plaid blanket. Even her feet were wrapped with a scarf. "For activists, the statue is more than a symbol," writes journalist Jung-yoon Choi. "It is a cause to be kept alive. In the frigid days of winter, they have assembled each week to dress the statue as they would a child sentry."[33] Those who dress the statue include not only the supporters of the Korean Council but also ordinary people. As one Korean individual put it, "From the Japanese Embassy's point of view, they can

Fig. 14. A woman carefully places a scarf on the bronze statue, December 28, 2016. Courtesy of Kyodo via AP Images.

see that Koreans are not neglecting the statue but tending to it with care, treating her like a family" member.[34]

When it rains, the bronze girl sometimes wears a raincoat. When I visited in the fall of 2013, a rolled-up pink vinyl raincoat lay under the statue. Park Se Hwan, a man in his sixties who holds all-day solo protests in front of the embassy against Japan's claim to the Dokdo Islets and the visits of Japanese prime ministers to the Yasukuni Shrine, or the riot police guarding the statue sometimes put the raincoat on the statue. According to Park, most of the people who visit the statue are young women who look like students or people in their twenties or thirties who work in the area; the statue's outfits frequently change. "They're being patriotic quietly," mused Park. He sees the bronze girl statue as a symbol of international politics and considers performances of care to be acts of patriotism.[35]

Another performance of care is giving gifts to the statue. Visitors leave letters, shoes, stuffed animals, pocket money, flowers, and food such as rice cakes and clementines at the feet of the statue or on the empty chair next to the girl. Kim Seo Kyung believes "that the Girl Statue is loved by people, regardless of their gender, age, or politics."[36] The public's love for the statue manifests poignantly in gifts of footwear. When I visited in 2013, a pair of yellow loafers with tassels and another pair of traditional Korean embroidered shoes with pointed tips lay next to the statue. Such loafers would be given before special occasions like a birthday, while the embroidered shoes would be given before a wedding. The traditional shoes were embroidered with butterflies, the mascot of the social movement and a beloved symbol of the survivors. A bronze girl statue installed in 2015 in Haenam, South Korea, was dressed in a pair of hand-knit yellow slippers.[37] The fact that the slippers were fitted meant that someone had carefully measured the feet of the bronze girl and took the time to knit the slippers accordingly. The yellow yarn evokes the yellow vests at the Wednesday Demonstrations. These kinds of small acts of care show how a scriptive object can invite people to find their own way of giving back and showing love and support for the survivors.

The empty chair next to the statue is also an important scriptive object. According to the artists, the chair has three layers of meaning: first, it evokes the survivors who have already passed away; second, it is there so people can sit next to the statue as they reflect on the wartime past and the present state of affairs; and finally, it represents

future generations who will continue the fight.[38] The artists' vision of the layered temporal orientations of the individual who occupies the chair brings to mind theater scholar Alice Rayner's beautiful analysis of an empty chair: "The pathos of an empty chair holds both memory of a loss and anticipation of return in all the particularity of a person, in character, in quality."[39] The empty bronze chair holds memories of the "comfort women" who are no longer with us and anticipates the next person who will take a seat by the bronze girl in solidarity. Some people choose not to sit in the chair out of respect for the women who have died but instead stand by the statue. In such cases, the chair still works as a scriptive thing because as an object for resting it invites the viewer to pause. Furthermore, its positioning directs one to face the embassy. People who sit in the bronze chair likely become aware of their live warm skin against the sculpture. Whether standing or sitting, visitors see the embassy, the statue next to them, and live bodies walking by, becoming aware of the dead and the living, the past and the present commingled in what has not been done and what remains to be accomplished. The person sitting in the chair or standing next to the memorial invokes memories of the people who have gathered in this space for the protests. The seat invites us to become part of a chain of co-presence, insisting that we can keep the issue alive only by literally putting our bodies on the line next to the statue.

The placement and materiality of the bronze statue elicit other embodied engagements, such as empathetic touching, as another kind of performance of care. The placement of the statue close to the ground (not on a pedestal) and in a seated position makes the figure more accessible and approachable. People often physically interact with her, patting her head or stroking her shoulder. The smoothness of the bronze also attracts physical contact. Touching the materiality of the bronze girl invokes comparisons to how people interact with the Vietnam Veterans Memorial: "The etched surface of the memorial has a tactile quality, and viewers are compelled to touch the names and make rubbings of them," writes Sturken.[40] Similarly, visitors to the bronze statue touch a materialization of a history or an issue that has become distant or abstracted. Touching makes the past seem less distant.

Because the statue's dress has an uneven texture, visitors' fingers do not effortlessly glide over the surface; it appears to be textured

from repeated touch or wear and tear. This contrasts with the smoothness of the uncovered parts of the body underneath. Unlike copper, bronze is more resistant to changes in color over time. However, bronze can become shinier where it is touched the most; over time, it will become clear where people have touched the statue most often. I think the shoulders will show the most wear because the gesture of patting another person's shoulder or upper back demonstrates support and comfort.

The bronze statue also invites nationalistic performances. In 2012, two elderly men had very different responses to the statue. On June 18, 2012, Suzuki Nobuyuki, a far-right Japanese politician, vandalized the statue by tying to its leg a three-foot-long wooden stake with the words "Takeshima is Japanese territory" in Korean and Japanese: he was claiming that the disputed Dokdo Islets belong to Japan.[41] A video of Suzuki's act shows him announcing, "There is a comfort woman prostitute statue right in front of the Japanese Embassy." Activists, survivors, the Korean public, and the Korean government responded with outrage: declared Lee Yong Soo, "He's not even a human being."[42] A group of survivors went so far as to sue Suzuki, and the Korean government banned him from entering the country again.[43] In response, an elderly Korean man identified only by the surname Kim drove his truck into the gate of the Japanese Embassy. He had tied a banner to his truck that said "Dokdo is Korean territory" and—though the crash turned out to be not fatal—had a memo in his pocket indicating that he wanted his cremated ashes to be dispersed in the waters near Dokdo.[44] Both Suzuki and Kim viewed the "comfort women" issue in patriotic terms and used the presence of the statue as an opportunity to express their nationalistic grievances.

The bronze statue creates a space for embodied engagements that add another layer of performative memory to the legacy of the survivors. Its presence has also rescripted the Wednesday Demonstrations. These demonstrations begin with protesters gathering behind the survivors on the sidewalk facing the embassy and the emcee speaking to the crowd. As more people show up, they spill onto the street and eventually form a circle behind and around the survivors and the statue. In the summer of 2007, eight survivors attended the demonstrations; by the fall of 2013, only two survivors were attending. The bronze girl may soon be the only survivor presence at the protests. As

an effigy, the bronze girl statue not only "fills by means of surroga-
tion a vacancy created by the absence of any original," as theater and
performance studies scholar Joseph Roach argues, but also marks the
impossibility of completely filling that absence.[45] Moreover, the me-
morial as scriptive thing invites the public and reminds its members
of their role in remembering the women and continuing their legacy.
The presence of the bronze girl alongside the elderly survivors pow-
erfully highlights the urgent need to transfer epochal memory to the
next generation. As part of that transmission of memory, Korean
American communities are increasingly turning to memorial proj-
ects as powerful redressive acts.

Transpacific Memorializations: Palisades Park, New Jersey (2010)

> In memory of the more than 200,000 women and girls who
> were abducted by the Armed Forces of the Government of Im-
> perial Japan, 1930s–1945, known as "comfort women." They
> endured human rights violations that no peoples should leave
> unrecognized. Let us never forget the horrors of crimes against
> humanity.
>
> —Inscription on the memorial in Palisades Park

On December 15, 2011, a few days after the installment of the
bronze girl statue in Seoul, survivors Lee Yong Soo and Yi Ok-seon
joined local officials, residents, and two female Holocaust survivors
at the public library in Palisades Park, New Jersey, for lunch and a
viewing of the first "comfort women" memorial built in the United
States. The event was planned to coincide with the one thousandth
Wednesday Demonstration in Seoul. "The Japanese government is
waiting for us to die, one by one, because all the victims are so old
and there aren't many victims in Korea," said Lee.[46] The World War
II survivors had been brought together by organizers from the Ko-
rean American Civic Empowerment (KACE, formerly known as the
Korean American Voters' Council) to bring awareness of the suffer
ing of both groups.[47] KACE, founded in New York in 1996 and in
New Jersey in 2000, is dedicated to "empowering and mobilizing
the Korean American community to take action locally, nationally,

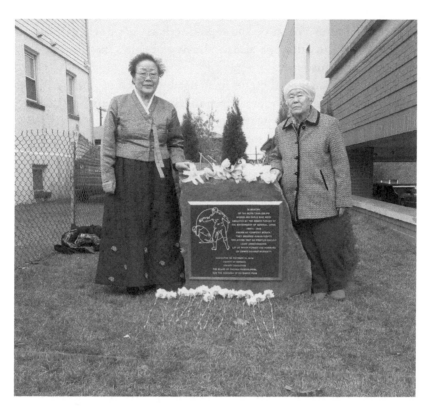

Fig. 15. Survivors Lee Yong Soo (left) and Yi Ok-seon stand next to the first "comfort women" memorial in the United States, Palisades Park, New Jersey, December 15, 2011. Photo by Steven Cavallo.

and internationally to address concerns of the community."[48] Program director Chejin Park, a KACE staff attorney, explained that the organization was connecting two war crimes against humanity in the hope of increasing support from the international community.[49] The gathering of Holocaust and "comfort women" survivors embodied how KACE organizers have framed the "comfort women" issue to make it legible to larger communities.[50] Their use of the discourse of human rights is designed to ensure that the "comfort women" issue will not be ghettoized as simply a nationalistic issue between Korea and Japan but will be seen as part of a larger history of crimes against humanity committed during World War II. How have Korean American activists garnered support for the cause of survivors? How is the "comfort women" history commemorated in

the United States? What do these practices say about the politics of memory and the different desires driving people's commitment to remembering this past?

Memorials such as the one in Palisades Park not only offer the public an opportunity to remember survivors and their fight for justice but also exemplify how the appeal of the "comfort women" issue mobilizes political energy for other causes in Korean American communities such as building political alliances, increasing the voter base, or expressing a group identity. For many Korean Americans, commemorative practices express a transpacific affinity for the "comfort women" cause that is rooted in a belief in social justice. Others see the memorials as a way to express nationalistic claims or to assert an identity as a US citizen. The lines between these different motivations are not always clearly demarcated.

In Palisades Park, home to one of the largest Korean American populations outside of Los Angeles County and Orange County, California, and Queens County, New York, members of KACE, local artist Steven Cavallo, and local politicians such as Mayor James Rotundo were the key players behind the erection of the memorial.[51] The memorial itself and the dedication ceremony were funded primarily by donations from the local Korean community. The stone memorial is located on a grassy plot adjacent to the public library. This location seemed a suitable site for the memorial because it is a place of education and a popular local landmark.

The idea for the memorial emerged from a chance encounter. In April 2009, as KACE staff attorney Chejin Park walked by the Bergen County Courthouse in Hackensack, he noticed that a group of African Americans was attending a dedication ceremony for a memorial to the history of slavery. Park noticed that a "ring of memorials" surrounded the flagpole, including one to the Irish famine, one to the Holocaust, and one to the Armenian genocide.[52] Park thought that adding the "comfort women"—an Asian example of a human rights violation—would be a way to continue the activism that had led to H.R. 121 two years earlier.[53] KACE wanted to build a memorial to educate the local community about the violation of the "comfort women" and to convey the concept that human rights "can be violated during wartime in other ways besides slaughter."[54]

Korean American communities across the country organized an "intense grassroots lobbying campaign" in support of H.R. 121.[55]

Representative Mike Honda, a third-generation Japanese American who as a child was interned during World War II, introduced H.R. 121 on January 31, 2007. House Committee on Foreign Affairs chair Tom Lantos shepherded the resolution through his committee.[56] KACE recruited community organizer Annabel Park to help coordinate the grassroots campaign in support of the resolution and partnered with Mindy Kotler at Asia Policy Point, Korean American organizations across the country, and other human rights and pan-Asian and Asian American civic organizations such as Friends of the Lolas, a Filipino American organization. These organizations and others formed the 121 Coalition, which spearheaded a national campaign in support of the resolution.[57]

The 121 Coalition used social media platforms such as YouTube to gain visibility for the campaign and to garner public support among first- and second-generation Asian Americans who could reach out to their representatives in Congress. In the first six months of 2007, grassroots groups raised one hundred thousand dollars for advertising and organized e-mail and letter-writing campaigns to congressional representatives soliciting their sponsorship of the resolution. The bill ultimately garnered 167 cosponsors and passed unanimously.[58] Organizers worked with the Korean Council to arrange visits of survivors to the United States to testify before Congress. According to Chejin Park, the presence of survivors, especially at the February 2007 congressional hearing, was incredibly helpful to the cause.[59]

The passage of H.R. 121 was a significant political moment for Korean American grassroots organizing. Chejin Park felt that the mobilization of Korean American communities on a national level proved the community's political power.[60] Although KACE expected some kind of reaction from the Japanese government after the resolution passed, none was forthcoming. Every year, KACE organizes an anniversary event in Washington, D.C., gathering members of Congress, survivors, representatives from Korean American civic organizations, and other guests to remind people that the issue is still not resolved and to reaffirm the relationships between members of Congress and Korean American communities.

Korean newspapers focused primarily on politicians as the engine behind the memorial when in fact Korean American youth and a number of non-Koreans were crucial to its creation. In 2009, KACE developed the idea of the memorial as a project for its summer in-

ternship program, which trains high school students in grassroots activism and community involvement. The students petitioned and gathered signatures in New York and New Jersey, primarily in Bergen County. Cavallo, who is the arts program coordinator at the Palisades Park Public Library, designed the memorial plaque and coordinated communication between Koch Monuments, which provided the stone; KACE; and the mayor of Palisades Park, a key supporter of the memorial. During the summer, the interns met with various Bergen County officials, among them Valerie Dargen, director of the Department of Human Services, and Wendy Martinez, director of Multicultural Community Affairs. After the interns delivered one hundred written petitions and gave a presentation on the project, Dargen told them that county executive Dennis McNerney and the Board of Chosen Freeholders supported the project. Over the next year, the City Council of Palisades Park passed the Comfort Women Memorial Resolution and designated the Palisades Park Public Library as the site for the memorial. The groundbreaking ceremony was held on October 12, 2010; eleven days later, the memorial was unveiled.[61]

The memorial is a low trapezoidal block of gray stone with a bronze plaque with dark brown oxidation. It is just high enough for someone to comfortably place a hand on its top, encouraging a downward-looking meditative pose. The grassy area around the memorial invites people to approach it. The cast-bronze plaque measures twenty-four inches wide and twenty inches tall and depicts an outline drawing of a soldier and a woman. Cavallo designed the artwork, inspired by "testimonies of the former 'comfort women' and how they would cower in the corner. How they were not just being raped but they were being beaten by the soldiers. They said the officers were far worst [sic] than the average soldier."[62] Cavallo first learned about the history of Japanese military sexual slavery in the 1990s. He felt compelled to use his paintings to let others know about this history.[63] He has made several visits to survivors at the House of Sharing and incorporated their history into an exhibit, *Playing Army*, about militarism and the tragedies of World War II, including the Holocaust and Hiroshima, and into subsequent exhibits.

The plaque depicts a soldier facing away from the viewer and extending his left arm toward the woman, as if to strike her. The woman is cowering below the towering soldier while holding her knees to her chest. He remains faceless, while the woman's profile

and eyes are visible as she turns her head toward the viewer. A large circle in the background forms the backdrop for the woman; the soldier is outside this encircling frame.[64] The organizers wanted the woman's dress to be nationally ambiguous so that the memorial honored not solely Korean "comfort women" but all the enslaved women from across the Pacific. This is one way the Palisades Park memorial differs from the bronze girl statue in Seoul, where the subject is clearly defined as Korean. Another difference is the demeanor of the female figure in the two memorials. The woman depicted on the Palisades Park plaque is frozen in a moment of victimization, whereas the bronze girl statue sits defiantly in the present: she is at the Wednesday Demonstrations.

The inscription's language regarding "human rights violations" and "crimes against humanity" places the violence done to "comfort women" into a larger framework. However, the exact nature of the violations is unclear, though the mention of abduction and the figure of the soldier hint at wartime violence. The bottom portion of the plaque details those behind the memorial: Bergen County, the county executive, the Board of Chosen Freeholders, and the borough of Palisades Park. KACE is deliberately not mentioned to avoid labeling the memorial as Korean American. It is only read and framed as a Korean American memorial in light of the facts that Palisades Park is home to a large Korean American community, that Korean Americans played the primary role in organizing and funding the memorial, and that small Korean and American flags surround the memorial.

The memorial had a quiet presence in the city until two separate delegations of Japanese officials met with Mayor Rotundo and community representatives in 2012.[65] On May 1, 2012, a delegation led by Shigeyuki Hiroki, Japan's consul general in New York, read aloud a 1993 statement from Yohei Kono, chief cabinet secretary of Japan at the time, and a 2001 letter from Junichiro Koizumi, prime minister at the time, as evidence that the Japanese government had acknowledged and apologized for its soldiers' role in military sexual slavery. The delegation brought gifts of cherry trees. Five days later, four members of the Liberal Democratic Party of the Japanese House of Representatives visited Rotundo to explain that the "comfort system" had been managed by private businesses and that "Korean women participated voluntarily." Both delegations asked that the memorial be removed. The mayor rejected both requests,

explaining that the "goal of the monument was to alert future generations to the horrors of war, not to criticize Japan" and that the "monument was erected by US taxpayers rather than Koreans and that the city council checked the historical accuracy before putting it up."[66] In Cavallo's words, Rotundo basically said, "Well, thank you so much for coming. You can keep your trees, and we are going to keep our monuments."[67]

Five days after the second delegation visited Mayor Rotundo, 32,075 signatures were posted on the White House's "We the People" website calling for the removal of the Palisades Park memorial.[68] However, Japanese lobbying efforts against the memorial in Palisades Park backfired, "spurring Korean groups in the New York region and across the country to plan more such monuments." After hearing of the Japanese government's request that the Palisades Park memorial be removed, Korean American organizations and citizens in twenty-two other US locations began planning additional memorials.[69]

On October 26, 2012, a stake with the message "Takeshima is Japanese territory" written in Japanese was pounded into the ground next to the memorial.[70] Suzuki Nobuyuki, the same far-right Japanese politician who had tied a stake to the bronze statue in Seoul, also claimed responsibility for defacing the Palisades Park memorial. KACE described the act of vandalism as defilement, echoing the language used to describe the defacement in South Korea.[71]

Like the bronze girl in Seoul, the Palisades Park memorial invites performances of care. During the particularly hot summer of 2012, Cavallo came out every morning and spent forty-five minutes watering the shrubbery and lawn. He said that people often come by to take photos of themselves by the memorial, showing the "same respect for the monument" as demonstrated by visitors to the bronze statue in South Korea. Korean Americans tend to the memorial and its surrounding landscape like a relative would tend to the landscaping around a gravesite, trimming the shrubbery, leaving potted plants, and tidying up the area. According to Cavallo, the number of visitors increased after the Japanese protests of the memorial provoked public interest in it.[72]

After the desecration incident, Gumjong Yoon came every day to clean the area around the memorial and make sure there was no damage. "I am a Vietnam War veteran, and I'm a member of the New Jersey branch of the Association of Vietnam Veterans of Korea," Yoon

said when he was asked why he tends to the memorial. "I know very well about the pain of war. I want to protect the grandmothers who suffered from the war; that's why I look after the comfort women memorial."[73] Yoon's comments may constitute an oblique reference to the sexual violence Korean soldiers committed against Vietnamese women during the war in that country. Korean "comfort women" survivors and the Korean Council have worked to shed light on this history, supporting victims of sexual violence in Vietnam with resources from the Butterfly Fund.[74]

Landscaping has become a meaningful form of activism for another Korean American resident of New Jersey, Young H. Paek, founder of the 1492 Green Club, which seeks to educate the public about the environment. The club has been donating trees to local communities since about 2003.[75] Paek has redone the landscaping around the memorial, planting lilac bushes, coniferous bushes, and a four-foot-tall juniper bonsai that was fourteen years old when he planted it in 2012: its age symbolized the kidnapping and enslavement of a fourteen-year-old girl. The tree also has two knots, "one for the girl and one for her family's *han*."[76] The discourse of youth that is personified in the bronze girl statue has thus found new embodiment in a tree. Enormous time and care went into pruning, trimming, and directing the branches into a knot, and Paek hopes to untie the knots when the issue is resolved, not just with survivors and Koreans but also with the Japanese.[77]

I met Paek at the dedication ceremony for the "comfort women" memorial in Bergen County, New Jersey, on March 8, 2013. "These people think it's a passing issue in the news, but for us it's something that happened to our people, our people, so until we resolve this with the Japanese, it's going to be a wound, and to those people it's going to be shameful, and a wound for the future, and for us, a wound of the past," he said.[78] Paek also started a global campaign to plant bonsai trees that evoke the large number of victims of Japanese military sexual slavery. "I'm going to plant 200,000 trees, starting in New York and New Jersey," Paek said, "and then all around the world, honoring the sacrifice made by more than 200,000 'comfort women.'"[79] In 2014, Paek placed a "winter blanket," a bouquet made of spindle tree branches tied together with a red ribbon, in front of the memorial as a way to keep the stone "warm."[80] Whether or not one reads his performances of caring for the "wound" as nationalis-

tic, Paek's landscaping activism is a redressive act that allows him to honor the survivors.

Traveling Bronze Girl: Glendale, California (2013)

> Peace Monument. In memory of more than 200,000 Asian and Dutch women who were removed from their homes in Korea, China, Taiwan, Japan, the Philippines, Thailand, Vietnam, Malaysia, East Timor and Indonesia, to be coerced into sexual slavery by the Imperial Armed Forces of Japan between 1932 and 1945. And in celebration of proclamation of "Comfort Women Day" by the City of Glendale on July 30, 2012, and of passing of House Resolution 121 by the United States Congress on July 30, 2007, urging the Japanese Government to accept historical responsibility for these crimes. It is our sincere hope that these unconscionable violations of human rights shall never recur. July 30, 2013.
>
> —Inscription on the plaque next to the statue in Glendale

The sun was high in the sky and the air felt warm. Under the cool shade of a cluster of trees in Glendale, California, a large group of elderly Asian men and women slowly moved their arms through the air in tai chi movements. A hundred yards away, a large rectangular purple cloth covered with colorful paper butterflies lay over a pointed object. A handful of cameramen and volunteers were setting up equipment and tents for the dedication ceremony of the first bronze girl statue outside South Korea. On July 30, 2013, hundreds of mostly Korean Americans and local non-Korean politicians gathered in the park to unveil the statue, the first "comfort women" memorial built on public land on the West Coast of the United States.[81] The memorial is in Central Park, which is bordered by the Central Public Library and an adult recreation center. Organizers of the Korean American Forum of California (KAFC) worked with Glendale City Council members to build the memorial, which was funded by local Korean Americans. While the memorial was planned over a period of twelve months, the statue had roots in the 2007 passage of H.R. 121.

KAFC organizers were part of the campaign for the US House resolution, partnering with KACE to find ways to encourage local communities to mobilize the support of their congressional represen-

tatives. After the resolution passed, Joachim Youn led a group of six individuals who started the KAFC as a way to continue the spirit that had led to H.R. 121. Unlike KACE, KAFC focuses solely on raising awareness of the "comfort women" history as part of the effort to pressure the Japanese government to acknowledge and apologize for Japanese military sexual slavery and to teach future generations about that history.[82] After the Palisades Park "comfort women" memorial was unveiled, KAFC organizers decided that their next logical step was to begin efforts to build memorials in California.

KAFC reached out to several city councils in the Los Angeles area. Glendale city commissioner Chang Y. Lee helped foster a relationship between KAFC and the city's mayor, Frank Quintero, who became a champion of the survivors' cause and strongly advocated on behalf of the statue. In addition to supporting the installation of the statue on public land, the City of Glendale declared July 30, 2012, the fifth anniversary of the passage of H.R. 121, Korean Comfort Women Day. In partnership with the Korean-Glendale Sister City Association, KAFC gathered donations from local Korean Americans and commissioned Kim Eun Sung and Kim Seo Kyung to create a bronze girl statue.[83]

The Glendale City Council faced strong opposition from older Japanese Americans in the area. At a public hearing on July 9, 2013, the majority of speakers who opposed the memorial were Japanese Americans. As journalist Brittany Levine reported, "They denied that the Japanese military coerced women into sexual servitude and said a US city should not meddle in Japanese and Korean affairs."[84] Mayor Quintero pointed out that media accounts of the hearing failed to acknowledge that these opponents were mostly older Japanese nationalists who identified as first-generation Japanese Americans and that the Japanese American community as a whole had been supportive throughout the process.[85] After the statue was installed, multiple delegations of conservative Japanese politicians asked the city council to remove the statue, with one group claiming that the "women willingly had sex with soldiers and the monument is propagating a false version of history."[86] In February 2014, a group of residents sued the City of Glendale to have the statue removed. Levine identified the opponents as two Japanese Americans and the Global Alliance for Historical Truth–US Corporation, "an organization that works to block recognition of the former sex slaves." They

claimed that "by installing the statue, Glendale infringed upon the federal government's exclusive power to conduct foreign affairs, violated the Supremacy Clause of the Constitution and caused opponents to avoid Central Park because the statue made them feel excluded and angry."[87] A federal judge dismissed the lawsuit the following August, and two years later, a court rejected the plaintiffs' appeal.[88] Japanese right-wing opposition to the growing number of "comfort women" memorials in the United States continues.[89]

The dedication ceremony, which included an indoor program and outdoor unveiling ceremony, was a carefully orchestrated event that helped frame the memorial as a nonpartisan issue that cuts across national and ethnic differences. Videotaped messages from members of Congress and the presentation of awards to key local supporters highlighted the broad scope of support, which ranged from politicians in Washington, D.C., to local Korean American contractors who donated their time. Speeches by members of the Japanese American and Armenian American communities tied the movement that builds "comfort women" memorials to the Japanese American movement for redress for internees and to memories of the Armenian genocide.

City Council member Zareh Sinanyan explained that he voted in favor of the statue because he understood that acknowledgment of pain can be a way to "heal the wounds." Sinanyan, the grandson of a survivor of the 1915–17 Armenian genocide, felt that the wounds of that event have remained fresh because no proper acknowledgment of the genocide has come. He hoped that the statue would help with the work of healing so that survivors and Koreans and Korean Americans can move on. Kathy Masaoka of Nikkei for Civil Rights and Redress discussed her group's ten-year grassroots campaign to win redress from the US government for the internment of Japanese Americans during World War II. Expressing her organization's support for the survivors, she voiced the importance of an apology and reparations: "When Japan sincerely apologizes and pays its reparations to each of the 'comfort women' before it's too late, it will help these survivors heal, and show that Japan has learned from its past." Masaoka continued, "This monument for the 'comfort women' has also reminded all of us that the abuse and trafficking of women into forced prostitution or domestic slavery continues today, even in this country."[90]

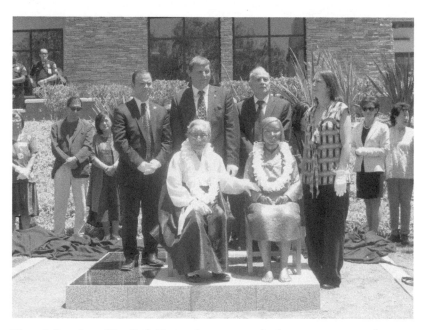

Fig. 16. Survivor Kim Bok Dong sits next to the bronze statue at the dedication ceremony for the memorial in Glendale, California, July 30, 2013. Behind her stand Glendale City officials (*left to right*) Zareh Sinanyan, Aram Najarian, Frank Quintero, and Laura Friedman. Behind Sinanyan stand Kim Eun Sung (*left*) and Kim Seo Kyung, the artists who created the bronze statue. Photo by Elizabeth W. Son.

Masaoka's comments raise an important question about what is forgotten when the experiences of "comfort women" are historicized through memorials like the one in Glendale. The plaque invokes the "never again" mantra common to memorials to mass violence: "It is our sincere hope that these unconscionable violations of human rights shall never recur."[91] However, the ceremony made no mention of how these "violations of human rights" might be occurring in the sex trafficking of laborers into the Los Angeles area or in the sex industries near US military bases in Asia. Perhaps these absences are invoked in the empty chair situated on US soil. As transnational Asian studies scholar Lisa Yoneyama writes, "Indeed, the marked absence signified by the empty chair placed next to the statue of the girl unsettles viewers by reminding us of other injuries from state violence that remain equally unseen and unredressed."[92]

Kim Bok Dong's speech was the most powerful performance of

the day. Dressed in a *hanbok* with a white *jeogori* and black *chima*, Kim was the living embodiment of the bronze girl. Her outfit was both a reminder of her age when she was forced to become a sex slave and a powerful gesture of reclamation of that lost time. Elegantly clad and speaking in clear, steady words, Kim declared, "As I've been traveling, I have been saying that if Japan does not come forward and apologize, then I will go around the world and build memorials. But I am really happy that the city of Glendale is installing this memorial." Building a memorial is a call for redress and an act of redress itself. "The memorial is a representation of the past history, so I ask you to try to protect and maintain the peace memorial here," said Kim. "I urge you to join me in the effort to pressure Japan to stop making senseless remarks but instead to make a straightforward apology, an official apology for us, and to also help us make this world war-free, because if there is war, there will be victims like us, and that inevitably happens. I hope our descendants can live in a peaceful world."[93] Kim invoked the language of protection for the memorial and for the future of her descendants, echoing the use of the term by Lee Yong Soo and Gil Won Ok. In inviting others to join her in her fight for justice, she also articulated a broad horizon of peace for future generations.

The day after the dedication ceremony I met the Oh family. They were from Riverside and had driven to Glendale to see the bronze girl statue. The son, a student at West Point, had come home for a visit, and the father, Stephen Oh, thought that "it seemed like a good opportunity to talk about Korean history." Oh found the statue quite moving: "Articles make it seem like someone else's story, but seeing the statue in person makes it seem like my story."[94] The son, Joseph Oh, also felt that the statue brought history to life for him and made him feel a deeper connection to Korea: "Coming here and sitting around the dinner table and my parents telling me stories about their past, about their history, and coming out here, brings [it] a lot closer to home, you know, being able to visually see what they're talking about."[95] Their sentiments echo what others have said about meeting survivors in person or listening to their public testimonies.

The Glendale statue, which is a replica of the memorial in Seoul, is located on an open green facing west toward a group of tall trees. The statue and the chair are elevated five inches off the ground on a stone block in the middle of a gravel clearing. The elevated position

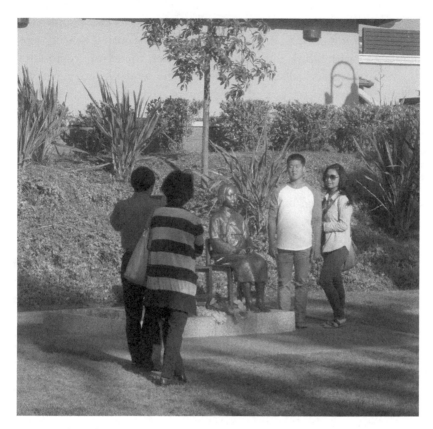

Fig. 17. The Oh family visits the bronze statue in Glendale, California, July 31, 2013. Photo by Elizabeth W. Son.

of the memorial discourages people from sitting in the chair and likely encourages people to treat it like a shrine or grave. Instead of sartorial performances of care, which seem less necessary in Southern California's warmer weather, people leave bouquets, potted plants, and flowers in vases around the statue.

As in New Jersey, local residents tend to the area around the statue. Kimberly Choi of Glendale stops by the memorial to remove dead flowers and water the potted plants. For Choi, the statue ensures that the "next generation does not forget what happened." She views the statue as a "symbol of peace" that "brings awareness to a human rights issue" that continues to plague other parts of the world.[96] Phyllis Kim, a Korean American resident of Glendale and the executive director of KAFC, visits the statue for ten minutes ev-

ery week. As a ritualistic performance, she holds the memorial's hand in a moment of silence and tends to the potted flowers and bouquets surrounding the memorial. For her, the statue represents "justice not yet served" and offers a powerful way to educate people: "The world has to know, and be educated—that is the only solution to this vicious cycle of violence against women and children. It is important to remember what happened."[97]

The area in front of the bronze girl statue in Glendale has become a space for news conferences, commemorative events, music performances, vigils, and rituals.[98] The most special visitors to the park are survivors. On a speaking tour in May 2015 that coincided with Prime Minister Shinzo Abe's trip to the United States, Lee Yong Soo visited the bronze girl statue in Glendale. She sat in the chair next to the bronze girl, reflecting, "I was just like her. I was her age, but now I am like this." She caressed and kissed the statue's face and held its hands. Lee wrapped a favorite pink scarf carefully around the statue's neck and spoke to the statue of her "determination to win an apology." "Until then, you will remain like this with clenched fists and bare feet," said Lee to the statue, as if comforting a friend.[99] Lee's words remind us that the bronze girl also memorializes survivors' resolve to continue the fight for justice.

Conclusion

The memorials in Seoul, Palisades Park, and Glendale are not simply objects with static meanings. As scriptive things, these memorials invite behaviors that illuminate the range of people's attachments to and feelings about survivors and their cause. Through sartorial and horticultural performances of care, individuals and communities in South Korea and the United States demonstrate how survivors have touched people's hearts and motivated them to engage with a difficult historical past. Approaching memorial building through the lens of performance illuminates the varied desires that inform Koreans' and Korean Americans' commemorative practices. Those who dress the bronze girl care for the women who were sex slaves as young girls and genuinely want to honor their memory. Others, like the man who desecrated the memorials in Seoul and Palisades Park, see the memorials as symbols of geopolitical issues. Some, like the Palisades

Park gardener, see and want to protect a Korea of the past. Others, like the Japanese American activist in Glendale, connect the memorials to a larger fight to eradicate sex trafficking. The new generation of caretakers in South Korea has a more complex motivation—a combination of outrage about the 2015 South Korea–Japan Agreement (see introduction), fear that a symbol that is important to them will be removed, and genuine feelings of tenderness toward the young girls who were taken into sexual slavery.

Similar to protests, tribunals, and theater, memorial building constitutes a site where change becomes possible through community formation and knowledge production. Through interactions such as performances of care, people become part of communities of remembrance. They are commemorating not only the wartime experiences of survivors but also their brave activism. Moreover, ordinary citizens are meeting two of the redress demands of the Korean Council activists and survivors: providing education about the history and memorializing the experiences. "I hope the girl statue becomes a textbook for the future generations in America to learn that injustice like this happened in the past—a textbook to teach beyond my death," said Kim Bok Dong.[100] As the Oh family illustrates, Kim's words are already coming true.

Memorial building brings together a variety of desires for remembering the "comfort women" history. The act of sitting by the statue's side, wrapping clothes around it, or leaving gifts literalizes "keeping alive" the issue and memory of these women while giving people a chance to show public support and express anger against detractors. The complex stories behind memorials in the United States show how the "comfort women" cause can mobilize and foster political alliances and become rescripted into nationalistic agendas. Sartorial and horticultural performances of care provide people with the chance to participate in something larger than themselves, share the "comfort women" history with others, and honor survivors. These performances remind us of the vitality of everyday acts of redress.

Until the End

"I didn't know where I was. I was forced," stated Mun Pil Gi before she matter-of-factly described for the prosecutor that she was raped and physically abused during the time she was imprisoned in a "comfort station" in Manchuria.[1] Mun was one of the sixty-four women who attended at the Women's International War Crimes Tribunal in December 2000. Mun's participation was no surprise: she had been involved in the social movement for redress since the early 1990s. Born in 1925, Mun was seventeen years old when a Korean man working under the local Japanese police lured her into leaving her home in hopes of finding a job and getting an education.[2] She was taken to Manchuria, where she spent three years enslaved in a "comfort station." Mun, who first gave public statements about her experience in 1992, regularly participated in the Wednesday Demonstrations and traveled abroad multiple times to give her testimony.

Mun passed away in the spring of 2008, a few months before I went to the House of Sharing to visit her. The House of Sharing has multiple buildings: living quarters with a common living room, a dining area, and bedrooms; staff offices; a testimonial hall where survivors share their stories with visitors; memorials; and a museum that includes a replica of a room in a "comfort station," historical artifacts from the war such as condoms and maps, paintings by survivors, and other artwork.

In the museum, I came across a glass case full of a survivor's personal effects. Upon closer inspection, I realized that I was looking at objects that had belonged to Mun, that she had passed away before my arrival: her badge from the Women's Tribunal; her brown leather slippers, watch, headband, lipstick, mirror, jewelry, keys, nail clip-

pers, dentures, toothbrush, prescription medications, oxygen mask, inhaler, and passport; a painting of a girl with braids; and photos of Mun with other survivors. One of Mun's outfits, a floral-print blouse with loose pants with a worn brown handbag slung across the top, was arranged on a hanger above the case, evoking the body of the woman who had touched the objects in the case below. Unlike Mun's performance at the Women's Tribunal, the curated display of objects did not testify to a life defined by wartime violence. Instead, it provided glimpses into the mundane life of an elderly woman who had health problems yet was attentive to the simple pleasures of self-care, art, and social outings with friends.

I left the museum and encountered a wall that featured gold-leaf molds of the hands and feet of all the survivors who had lived at the House of Sharing; below were clay imprints of their hands. The gold surfaces accentuated the deep-set wrinkles in the palms of the hands and the swollenness of the soles of the feet. The gold-leaf molds are encased in glass frames, creating displays that are performances of mourning for the artist and the viewer. They also powerfully capture the desire to hold on to the physical presence of deceased survivors and find ways to attest to the fact that they did indeed exist. As the survivors pass away, an absence emerges that calls for forms of embodiment to keep the memory of survivors alive. The increasing number of theatrical productions about the "comfort women" have striking similarities with the glass case of Mun's objects and the wall of handprints and footprints—they point to the desire to keep present and kindle the memory of those who are no longer here and to pass on their histories.

Adjacent to the museum at the House of Sharing, in the round testimonial hall, another survivor, Yi Ok-seon, was finishing her story for a group of foreigners. Yi spoke with authority as she retold in detail what she endured in the "comfort stations" in China for three years and the lasting physical effects on her body. Born in 1927, Yi was fifteen years old when she was kidnapped and taken to northwest China; she did not return to South Korea until 2000. The elderly survivors living at the House of Sharing also share their life stories with visitors in their private rooms. When Yi welcomed me into her room on July 21, 2007, I followed a long line of sojourners—students, activists, volunteers, tourists, artists, and researchers—who have visited the survivors since the 1990s.

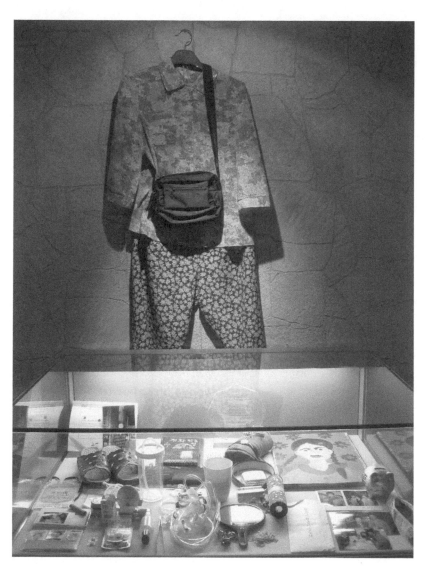

Fig. 18. A display of the clothes and personal effects of survivor Mun Pil Gi at the House of Sharing Museum. Photo by Elizabeth W. Son.

Yi sat on her bed with a wall of photos behind her, while I sat on the floor and listened to her talk about her body aches and about her family.[3] She had met a widower with two children after the war and had helped raise those children as her own, a topic that rarely received mention during public testimony because it did not fit the script that focused on wartime violation. I felt uneasy and reluctant about recording our interview because I sensed that I was contributing to the commodification of survivors' narratives. But I knew it was important to record her words and to try to make sure that her story and the stories of other survivors were not simply extracted and reframed for facile consumption and circulation. It was important to situate my experience, their embodied testimonies, and their histories in larger cultural, political, and social contexts.

Yi participated in the Wednesday Demonstrations for many years, and she traveled abroad to give her public testimony at universities, conferences, and special events. But as she and her fellow survivors at the House of Sharing aged and their health deteriorated, the women lost the ability to participate in the weekly protests. Yi and others made a rare appearance at the Wednesday Demonstrations on January 13, 2016, to condemn the agreement between South Korea and Japan to "resolve" the "comfort women" issue and to show her support for students who had been braving the cold winter to show their solidarity with the survivors' cause.

In late January, a group of students huddled under a clear vinyl sheet to block out the wind as they kept vigil by the side of the bronze girl statue in Seoul. Since December 30, 2015, teams of students had held round-the-clock vigils to protect the statue.[4] They joined a growing number of Koreans who were upset by the news of the December 28 agreement and by growing pressure from the Japanese government to remove the statue. "The statue has . . . become a rallying point for the victims and their supporters who have refused to accept the deal, prompting the students to hold a sit-in to protect it from being taken down," wrote journalist Hyun-ju Ock. People came by with "energy drinks, warm food, heat packs and blankets every day to display their support," students told Ock.[5] One of the students said that "the statue tells us that the issue of wartime sex slavery is not resolved and asks us not to forget" the victims.[6] On March 1, 2016, after sixty-three days, many of the students ended their vigil and returned to classes after the long winter break.[7] But others took

their place, and more than a year later, students were still keeping watch over the statue.[8] They have helped spark a nationwide movement to rally behind the survivors.

On January 15, 2016, 335 individuals and 383 organizations started a national campaign, led by the Korean Council, "that seeks to force the South Korean government to scrap its settlement with Japan on the comfort women and that hopes to achieve a just solution to the comfort women issue." As part of this campaign, supporters established the Justice and Memory Foundation for the Imperial Japanese Army's Comfort Women, which will support activities including "preserving related records," "setting up more statues of the young girl," and "providing education related to the comfort women."[9]

Artists Kim Eun Sung and Kim Seo Kyung joined in the effort to raise money for the alternative fund so that survivors would not have to accept money from the Japanese government. The sculptors started a public art project, the Little Girl Statue, with donors receiving a miniature replica of the bronze girl statue. "My wish is that the surviving victims receive a sincere apology from Japan and that our work contributes to help recover their honor," said Kim Eun Sung.[10] As of October 2016, more than nine thousand people had participated in the campaign, raising $240,000.[11] The artists continue to collaborate with community organizations around the world to build bronze girl statues.[12] It will be fascinating to see how people use their miniature bronze girl memorials to continue their own acts of remembrance.

People have also begun to stage live performances of the bronze girl. In Busan, South Korea, where there was no "comfort women" memorial until December 2016, people started a "human statue relay" to protest the agreement between Japan and South Korea. Every day since January 6, 2016, between noon and one o'clock, people have taken turns "becom[ing] the statue of the young girl" by sitting in a wooden chair next to an empty chair in front of an entrance to the Japanese consulate.[13] Twenty-five-year-old university student Ji-hae Kim became the sixth person to perform as the statue, declaring, "Since there isn't a girl statue in Busan and as a way to deal with Japan's blunt remarks, I looked for something that I could do. I heard that you could become a human girl statue, so I made up my mind to become a human girl statue."[14]

Dressed in a white *jeogori* with a black *chima*, Kim sat next to an empty wooden chair. Three police guarding the entrance to the Japanese consulate stood a few feet from her. She held a sign with an image of the bronze girl statue wearing a yellow cap and the message "Guryokjeogin Maegukyeopjeong Wianbu Habui Bandae" [Opposing the Humiliating, Treacherous Comfort Women Agreement] above the image and the message "Jeoreul Jikycojuseyo" [Please Protect Me] in a caption bubble near the statue's mouth.[15] Kim's performance was an act of protest against the agreement, particularly in relation to the Japanese government's calls to remove the statue and the uncertain future of the bronze girl statue across from the Japanese Embassy in Seoul. It was also a commemoration of the Wednesday Demonstrations.

Kim's embodied representation of "comfort women" is clearly a living body dressed as the bronze girl. Her long, flowing hair and her black sneakers with colorful laces accentuate her differences from the bronze girl with short hair and bare feet. Kim and her fellow live statues bring to mind the countless university students who make up the majority of protesters at the Wednesday Demonstrations. Her body marks the passing of the struggle to younger generations. They will sit in empty chairs long after Yi Ok-Seon, Kim Bok Dong, Lee Yong Soo, Gil Won Ok, Lee Mak Dal, and other survivors have passed from the scene.

People came by to take care of Kim, giving her warm drinks and placing a furry white shawl over her shoulders because her outfit, like that of the bronze girl statue, was not warm enough for winter weather. "Since someone is out here every day, the only thing I can do is to put a warm shawl on her or bring her some tea. My heart breaks," explained Bae So-yeong.[16] In December 2016, supporters installed a bronze girl statue in Busan; the statue, however, became a point of contention between the South Korean and Japanese government because it, too, was installed near a Japanese diplomatic mission.[17] Though the "human statue relay" ended because of the successful installation of the statue, supporters have continued the work of redress and remembrance. Students occasionally stand guard by the statue to protect it from removal, and supporters adorn the memorial in hand-knit hats, scarves, and shoes and leave flowers and food for the statue.[18]

Live bronze girl statues have performed in Taipei, Tokyo, London,

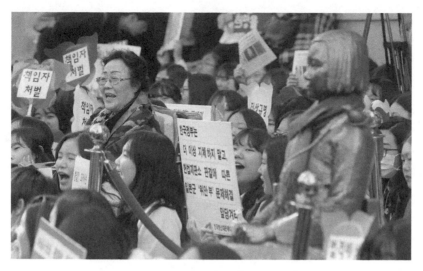

Fig. 19. Survivor Lee Yong Soo sits a few feet away from the bronze statue at the Wednesday Demonstration, Seoul, October 28, 2015. Photo by Lee Jin-man. Courtesy of AP Images.

and Chicago, among other places, where there are no "comfort women" memorials. These people have taken to heart the idea that ordinary citizens can take part in advocating for state redress while performing redress themselves. Even as they have fought for state accountability, survivors and their supporters have called for an expansive view of redress that is legal, political, social, cultural, and epistemological. Through public, embodied ways, the survivors have formed multivalent identities for themselves beyond victim; helped create a transnational social movement that raises awareness of institutionalized sexual violence against women; put their stories on the official record and corrected the historical narrative regarding their past; educated new generations; found healing in relationships; and inspired commemorative practices that honor survivors and their activism.

Redressive acts invite multiple audiences to reckon with the "comfort women" history. Survivors, activists, and artists teach us that redress does not belong solely in the hands of the government or courts. Redress is brought to life and nurtured by a community that gathers on a rainy day for a protest, organizes a tribunal in a hostile environment, rehearses survivor testimonies, watches a story come

to life onstage, and places a scarf around a statue. Transpacific redress emerges from these varied social, cultural, and political formations. Survivors and their supporters transform the way people think about gender-based and sexual violence and practice redressive actions. It is unlikely that the Japanese government will ever offer adequate apology and reparations to the survivors, but the struggle for official redress has sparked a transnational movement among supporters and artists to find creative ways to remember the women's history and to advocate for gender justice for other victims of sexual violence. Lee Yong Soo's words from a 2013 protest echo even more loudly: "I will keep fighting until the end, until the end!"[19] It is uncertain when or what the end will be for survivors, but their brave words and fierce activism inspire us to continue dreaming of and fighting for a more just world.

Notes

Prologue

1. The testimonial event consisted of a short film on the history of Japanese military sexual slavery; Mak Dal Lee's testimony; remarks by Ji-Yeong Im, a representative from the Korean Council for the Women Drafted for Military Sexual Slavery by Japan; and a Q&A session.

2. Estimates of women in "comfort stations" range from several thousand to two hundred thousand. See Yoshimi, *Comfort Women*, 91–94.

3. Ibid., 91.

4. A confluence of social, cultural, and political factors kept this issue out of public view. However, as Joshua D. Pilzer points out, the monolithic discourse of silence obscures the private modes through which survivors have expressed their wartime experience. For more on self-reconstruction through song in the lives of Korean survivors, see Pilzer, *Hearts of Pine*.

5. I am ambivalent about state redress, and I recognize that no reparations could possibly undo the damage that was done. However, an official apology and legal reparations are important because they are material expressions of an acknowledgment of this history by those who represent the perpetrators.

6. Harvey Young's writing about his embodied experience of ancestral histories helped me frame this reflection on my kindred ties with Lee. Young writes, "To look at my skin, my own body, and my image reflected in a mirror is to see not only me—standing there looking at myself—but also to view the various parts of these other bodies that ghost my own" (*Embodying Black Experience*, 138).

7. Survivors choose to be called *halmeoni* (pl. *halmeonidul*), a term that both denotes a biological grandmother and serves as an honorific to refer to an elderly woman with no biological ties to the speaker. In Korean, the surname comes before *halmeoni*, so Grandmother Lee is Lee Halmeoni.

1. Quoted in Jun-ho Bang, "Comfort Women and Supporters Vow to 'Keep Fighting' at Year's Final Protest," *Hankyoreh*, December 31, 2015, accessed January 2, 2016, http://english.hani.co.kr/arti/english_edition/e_international/724276.html

2. The police put the figure closer to seven hundred (ibid.).

3. Sang-Hun Choe, "Apology, if Not Closure, for 'Comfort Women,'" *New York Times*, December 29, 2015, A1.

4. "Full Text: Japan–South Korea Statement on 'Comfort Women,'" *Wall Street Journal*, December 28, 2015, accessed January 2, 2016, http://blogs.wsj.com/japanrealtime/2015/12/28/full-text-japan-south-korea-statement-on-comfort-women/

5. Ibid.

6. Korean Council for the Women Drafted for Military Sexual Slavery by Japan, "The Official Statement from the Korean Civil Society Regarding the Agreement on the Military Sexual Slavery ('Comfort Women') Issue during the Korea-Japan Ministerial Meeting," December 28, 2015, accessed January 2, 2016, https://www.womenandwar.net/contents/board/normal/normalView.asp?page_str_menu=2301&action_flag=&search_field=&search_word=&page_no=1&bbs_seq=14431&passwd=&board_type=&board_title=&grade=&title=&secret=&user_nm=&attach_nm=®_dt=&thumbnail=&content=

7. Ibid.

8. Quoted in Michael Solis, "Japan and South Korea's Non-Solution for the 'Comfort Women,'" *World Post*, January 5, 2016, accessed October 20, 2016, http://www.huffingtonpost.com/michael-solis/japan-and-south-koreas-no_b_8908868.html

9. Mee-hyang Kim and Ji-hoon Kim, "Government Begins Cash Payments to Former Comfort Women," *Hankyoreh*, October 15, 2016, accessed October 20, 2016, http://english.hani.co.kr/arti/english_edition/e_international/765828.html

10. Korean Council for the Women Drafted for Military Sexual Slavery by Japan, "The Official Statement from the Korean Civil Society Regarding the Agreement on the Military Sexual Slavery ('Comfort Women') Issue during the Korea-Japan Ministerial Meeting," December 28, 2015, accessed January 2, 2016, https://www.womenandwar.net/contents/board/normal/normalView.asp?page_str_menu=2301&action_flag=&search_field=&search_word=&page_no=1&bbs_seq=14431&passwd=&board_type=&board_title=&grade=&title=&secret=&user_nm=&attach_nm=®_dt=&thumbnail=&content=

11. Ibid.

12. Won Ok Gil, interview.

13. Ibid.; and Norimitsu Onishi, "Denial Reopens Wounds of Japan's Ex-

Sex Slaves," *New York Times*, March 8, 2007, accessed February 20, 2017, http://www.nytimes.com/2007/03/08/world/asia/08japan.html.

14. Ibid.

15. Christine Ahn, "Seeking Justice—Or at Least the Truth—for 'Comfort Women,'" *Huffington Post*, June 25, 2014, accessed March 20, 2015, http://www.huffingtonpost.com/christine-ahn/seeking-justiceor-at-comfort-women_b_5526919.html. For more on the activism of Won Ok Gil, see Hsiung, *The Apology*.

16. In their groundbreaking collection on the politics of war memory in the Asia-Pacific region, T. Fujitani, Geoffrey M. White, and Lisa Yoneyama stress the importance of understanding the multiple histories and conflicts that compose the 1931–45 Asia-Pacific war(s) (introduction, 1–7). Other scholars also note the origins of the Japanese military sexual slavery system in the country's licensed prostitution system (Oh, "Japanese Imperial System," 4–9).

17. Yoshimi, *Comfort Women*, 43–48, 65–72.

18. Ibid., 49–65.

19. For contemporaneous examples of military officials' sanction of the use of brothels for their troops and occupying troops' rape of local women, see Roberts, *What Soldiers Do*; and Grossman, *Jews, Germans, and Allies*.

20. Yoshiaki Yoshimi notes that this has been confirmed in official documents (*Comfort Women*, 94).

21. Pyong Gap Min explains how Korea's status as a colony of Japan and the detrimental impact of this status on the economy made poor and working-class women susceptible to the "comfort women" system ("Korean 'Comfort Women,'" 944–45).

22. Hanguk Jeongsindae Munje Daechaek Yeobuihoe, *Jiulsu Eomneun Yeoksa*, 23.

23. Yoshimi, *Comfort Women*, 88–91.

24. The "comfort stations" managed by civilian operators were "supervised and regulated by military personnel or civilian military employees" (Ibid., 89).

25. Yuki Tanaka writes that each woman served up to ten men a day. The number increased to thirty or forty men for each woman "shortly before and after each combat operation" (*Japan's Comfort Women*, 52). Yoshimi writes that sex slaves were forced to serve "as many as twenty or thirty men a day" in "comfort stations" reserved for "noncommissioned officers and enlisted men" (*Comfort Women*, 139).

26. Mak Dal Lee, interview.

27. US House, "H.Res. 121."

28. Mak Dal Lee, interview.

29. Yoshimi, *Comfort Women*, 35.

30. Hanguk Jeongsindae Munje Daechaek Yeobuihoe, *Jiulsu Eomneun Yeoksa*, 31.

31. Coomaraswamy, "Report."

32. Mak Dal Lee, interview.

33. Totani, *Tokyo War Crimes Trial*, 185–86.

34. For more on the political and social aspects of this silencing, see Na-Young Lee, "Korean Women's Movement," 74–76. See also Soyang Park, "Silence, Subaltern Speech and the Intellectual."

35. The transnational activism on behalf of survivors constitutes a *social movement* as Sidney G. Tarrow defines the term. For Tarrow, social movements are "collective challenges, based on common purposes and social solidarities, in sustained interaction with elites, opponents, and authorities"; "this definition has four empirical properties: collective challenge, common purpose, social solidarity, and sustained interaction" (*Power in Movement*, 9).

36. Sex tours in Korea, which targeted Japanese male tourists, were known as *kisaeng* tours. Historically, *kisaeng* were educated courtesans who entertained men and sometimes provided sexual services. For more on *kisaeng* tourism, see Soh, *Comfort Women*, 217–25. For more on these global shifts after the fall of the Soviet Union, see Yoneyama, *Cold War Ruins*, 4–5.

37. Hanguk Jeongsindae Munje Daechaek Yeobuihoe, *Jiulsu Eomneun Yeoksa*, 34–35; and Na-Young Lee, "Korean Women's Movement," 76–77.

38. Hanguk Jeongsindae Munje Daechaek Yeobuihoe, *Jiulsu Eomneun Yeoksa*, 35–36; and Soh, "Korean 'Comfort Women,'" 1232.

39. Ibid.

40. Soh, "Korean 'Comfort Women,'" 1232; and Oh, "Japanese Imperial System," 15–16.

41. Na-Young Lee, "Korean Women's Movement," 77. The organizations included, for example, Korea Church Women United, Korean Buddhist Women's Association United, Korean Council for College Women Representatives, Korea Women's Associations United, and Korean Women's Hot Line. See Hanguk Jeongsindae Munje Daechaek Yeobuihoe, *Jiulsu Eomneun Yeoksa*, 34.

42. In Tetsuo Yamatani's 1979 film, *Okinawa no Harumoni* [A Grandmother in Okinawa], Bong-gi Bae was the first Korean women to share her testimony in a film. See Hanguk Jeongsindae Munje Daechaek Yeobuihoe, *Jiulsu Eomneun Yeoksa*, 37; Cumings, *Korea's Place in the Sun*, 179; and Hicks, *Comfort Women*, 159.

43. Two hundred and thirty-eight are officially registered with the South Korean government as survivors and seven are recognized as survivors. See Mee-hyang Kim and Ji-hoon Kim, "Government Begins Cash Payments to Former Comfort Women," *Hankyoreh*, October 15, 2016, accessed October 20, 2016, http://english.hani.co.kr/arti/english_edition/e_international/765828.html

44. Ibid.

45. Korean Council, "Objectives & Activities."

46. For more on activism in the Philippines and Taiwan, see Mendoza, "Freeing the 'Slaves of Destiny'"; and Suzuki, "Competition to Attain Justice."

47. Mak Dal Lee, interview.

48. Korean Council, "Objectives & Activities."

49. Brooks, *Atonement and Forgiveness*, 142.

50. Ibid., 142–43. Brooks also edited a collection with a section devoted to the redress claims of survivors of Japanese military sexual slavery. See Brooks, *When Sorry Isn't Enough*, 87–151.

51. Won Ok Gil, interview. *Han* can be experienced individually or collectively. Elaine H. Kim writes, "*Han* is a Korean word that means, loosely translated, the sorrow and anger that grow from the accumulated experiences of oppression" ("Home Is Where the *Han* Is," 215). Jung-Soon Shim describes *han* as the "Korean national ethos, which is traditionally associated with rather negative emotions such as frustrated desire, resentment, regret, and a sense of loss and sorrow" ("Female Trance," 65). She also notes that *han* is commonly used in Korean dramatic narratives as an aesthetic principle ("Shaman and the Epic Theatre," 216–18).

52. Won Ok Gil, interview.

53. Ibid.

54. For more on Japanese state denials and Yoshimi's work, see Norimitsu Onishi, "In Japan, a Historian Stands by Proof of Wartime Sex Slavery," *New York Times*, March 31, 2007, A4. For more on the Japanese government and military's direct involvement, see Yoshimi, *Comfort Women*.

55. Largely funded by private donations from Japanese citizens, the Asian Women's Fund provided modest "atonement money," medical welfare support, the publication of historical documents, and a letter of apology from the prime minister. The fund reports that 285 survivors in the Philippines, South Korea, and Taiwan participated. As Yoshimi notes, most of the recipients were likely Filipina women "who have little hope of receiving any form of aid from their own government" (*Comfort Women*, 24). He outlines the reasons why many survivors, their advocacy groups, and the governments of South Korea and Taiwan rejected the fund. Most notably, no state reparations were given to the women: the cash payments were funded by donations. In addition, the letter of apology was an expression of the prime minister's personal feelings, not those of the government. See Asian Women's Fund, "Closing"; Asian Women's Fund, "Establishment"; and Yoshimi, *Comfort Women*, 23–25.

56. Yoneyama writes, "The Korean Council, however, immediately objected to the operation of the Asian Women's Fund, arguing that its nonjuridical, moral solution would deter the Japanese state from facing its accountability. The Korean Council's and its supporters' insistence on repa-

ration in the name of the law and the State continues to pose multivalent challenges to the immunity of the previously agreed upon state-to-state normalization treaties" (*Cold War Ruins*, 27).

57. Norimitsu Onishi, "In Japan, a Historian Stands by Proof of Wartime Sex Slavery," *New York Times*, March 31, 2007, A4. See also Justin McCurry, "Japan Rules Out New Apology to 'Comfort Women,'" *Guardian*, March 5, 2007, accessed February 17, 2017, https://www.theguardian.com/world/2007/mar/05/secondworldwar.japan

58. The Japanese and Korean governments play an important role in shaping junior high and high school history textbooks. In both countries, history textbooks are considered "representations of state discourses on national history." See Hyun Sook Kim, "History and Memory," 75. In Japan, teams write the textbooks, which the Ministry of Education then vets, and the Korean Ministry of Education writes the textbooks. In the 2002 editions of eight Japanese junior high school history textbooks, only one mentioned "comfort women"; two others included the phrase "comfort facility." In the 2006 editions, none of the drafts referred to "comfort women." See Nozaki, "'Comfort Women' Controversy."

59. According to the terms of the treaty, the Korean government received eight hundred million dollars in economic grants and loans from Japan. In exchange, "South Korean citizens would give up their right to make individual claims against the Japanese government." The Korean government used most of the funds for "nation-building construction projects"; only Koreans with families killed by the Japanese and owners of destroyed property received modest compensation. The treaty did not mention compensation for the "comfort women." See James Card, "A Chronicle of Korea-Japan 'Friendship,'" *Asia Times*, December 23, 2005, accessed October 28, 2016, http://www.atimes.com/atimes/Korea/GL23Dg02.html

60. Ibid.; and Rahn Kim, "Comfort Women to Petition Constitutional Court," *Korea Times*, July 4, 2006, accessed July 4, 2017, http://www.lexisnexis.com.turing.library.northwestern.edu/lnacui2api/api/version1/getDocCui?lni=4KB5-MTP0-TX51-F21D&csi=174045&hl=t&hv=t&hnsd=f&hns=t&hgn=t&oc=00240&perma=true

61. See, for example, "Comfort Women of the Empire"; and Sangjin Lee, "Jeongsindaemunjedaechaekyeobuihoeneun Jwapaseonghyangui Danche."

62. See, for example, Jae-won Kim, "Scholar Raises Questions on Stereotype of 'Comfort Women,'" *Korea Times*, March 28, 2016, accessed October 21, 2016, http://www.koreatimes.co.kr/www/news/people/2016/03/178_201303.html

63. Choi, "Politics of War Memories," 398.

64. See, for example, Taylor, *Disappearing Acts*; Taylor, *Archive and the Repertoire*; Cole, *Performing South Africa's Truth Commission*; Madison, *Acts of Activism*; Thompson, *Humanitarian Performance*; and Breed, *Performing the Nation*.

65. Taylor, *Disappearing Acts*, 196, 198.

66. Cole, *Performing South Africa's Truth Commission*, xiv-xvii, xx–xxi.

67. See, for example, Suk-Young Kim, *Illusive Utopia*; Suk-Young Kim, *DMZ Crossing*; Kwan, *Kinesthetic City*; Larasati, *Dance That Makes You Vanish*; and Lim, *Brown Boys and Rice Queens*.

68. Lowe, "International within the National," 30. For more on trans-pacific cultural practices of memory and justice, see, for example, Yoneyama, "Traveling Memories, Contagious Justice"; Schlund-Vials, *War, Genocide, and Justice*; Tran, "Remembering the Boat People Exodus"; Yoneyama, *Cold War Ruins*; and Jodi Kim, *Ends of Empire*.

69. In her illuminating study of what she calls a "transborder redress culture," Yoneyama argues that "the post-1990s redress culture centering on the discourse on Japanese imperial violence contains profound critiques of the way the transpacific arrangement of Cold War justice has set the parameters of what can be known as violence and whose violence, on which bodies, can be addressed and redressed." As she points out, the United States is deeply enmeshed in this "transpacific arrangement of Cold War justice" (*Cold War Ruins*, viii, 8).

70. See Tanaka, *Japan's Comfort Women*; and Moon, *Sex Among Allies*.

71. For more on negotiating loss in creative and political ways, see Eng and Kazanjian, *Loss*.

72. Schlund-Vials, *War, Genocide, and Justice*, 194. Cathy Schlund-Vials importantly locates this "generational impulse" in artistic practices that interrogate "the Cambodian Syndrome, a transnational set of amnesiac politics revealed through hegemonic modes of public policy and memory" and in turn articulate a Cambodian American selfhood (13). *War, Genocide, and Justice* is part of a growing body of excellent American studies scholarship on histories of violence, redress, and remembrance. See, for example, Tran, "Remembering the Boat People Exodus"; Martinez, "Recuperating Histories"; Paik, *Rightlessness*; and Nguyen, *Nothing Ever Dies*.

73. See Choi, *Comfort Women*; Yoshimi, *Comfort Women*; Stetz and Oh, *Legacies*; Soh, *Comfort Women*; Kimura, *Unfolding the "Comfort Women" Debates*; and Norma, *Japanese Comfort Women*. For collections of testimonies, see Howard, *True Stories*; Kim-Gibson, *Silence Broken*; and Qiu, with Zhiliang and Lifei, *Chinese Comfort Women*. For illuminating work on the "politics and ethics of representing and producing knowledge 'about' 'comfort women,'" as Chuh puts it, see Chuh, "Guest Editor's Introduction"; Chuh, "Discomforting Knowledge"; Kang, "Conjuring 'Comfort Women'"; and Yoneyama, "Traveling Memories, Contagious Justice."

74. See Pilzer, *Hearts of Pine*.

75. Yong Soo Lee, interview.

76. For the history of the different terms, see Hanguk Jeongsindae Munje Daechaek Yeobuihoe, *Jiulsu Eomneun Yeoksa*, 8–10.

77. "Clinton Says 'Comfort Women' Is Incorrect Term," *Chosun Ilbo*,

July 9, 2012, accessed October 21, 2016, http://english.chosun.com/site/data/ html_dir/2012/07/09/2012070900793.html; and Eric Randall, "Hillary Clinton and Japan Are in a Tiff over 'Sex Slaves' and 'Comfort Women,'" *Atlantic Wire*, July 12, 2012, accessed October 21, 2016, http://www.theatlantic.com/ international/archive/2012/07/hillary-clinton-and-japan-are-tiff-over-sex-slaves-and-comfort-women/325986/

78. Soh, *Comfort Women*, 72.

79. Hanguk Jeongsindae Munje Daechaek Yeobuihoe, *Jiulsu Eomneun Yeoksa*, 43. Kimura also writes about examples of "transformation to survivor-activists" (*Unfolding the "Comfort Women" Debates*, 213-214).

80. Hyun Sook Kim notes the "multivocal identities" the survivors present ("History and Memory," 74).

81. I thank Amina El-Annan for helping me to see this point.

82. The activists' and survivors' invocation of victimhood needs to be differentiated from the Korean public's framing of the women's wartime victimization as a national injury. Pilzer notes that when survivors first came forward, the issue entered a "prepared ideological landscape," an ideology of national woundedness, in which the women's colonial suffering became the "violation of a metaphorically female national body." He points out how this "woundedness ideology" has circulated in the South Korean public sphere in "media reports, photographs, works of fiction, plays, artworks, and other media," without explicitly addressing how activists—spearheaded by the Korean Council—engaged with this ideology. Pilzer does point out how the House of Sharing perpetuates this ideology by explicitly sharing the wound. He argues that the undue focus on the "perpetual wound" in Korean public culture has blinded people to the "women's efforts at self-reconstruction" (*Hearts of Pine*, 25-27).

83. Na-Young Lee, "Korean Women's Movement," 84.

84. Survivors Bok Dong Kim and Won Ok Gil have become what Na-Young Lee describes as "human rights activist[s]." Lee writes, "*Halmeoni*, once a defiled girl in the colonized Korean territory, now identifies herself as a human rights activist troubling our colonized consciousness by asking for social justice for other wartime victims and future generations" ("Korea Women's Movement," 87). Butterflies have long been a symbol of the survivors and the social movement; they represent the liberation of the women from their painful pasts and celebrate the dignity and beauty others see in them. Butterflies also convey hope and the sense of transformation that the survivors have experienced when they have called for redressive demands. Since 2005, protesters have been holding butterfly-shaped pickets, and butterfly images are used frequently on the movement's website, booklets, and flyers.

85. Kyoung-tae Koh and Mi-hyang Yoon, "Vietnamese War Victims Speak of Sexual Violence by S. Korean Troops for the First Time," *Hankyoreh*, April

25, 2015, accessed January 6, 2016, http://english.hani.co.kr/arti/english_edition/e_international/688435.html

86. Korean Council for the Women Drafted for Military Sexual Slavery by Japan, "Butterfly's Journey 2. Vietnam," accessed October 22, 2016, https://www.womenandwar.net/contents/general/general.asp?page_str_menu=220302

87. "As embodied performances, rituals incarnate and make visible abstract principles and inchoate concepts—such as 'Justice,'" writes Lorne Dwight Conquergood. "Justice can be seen only when it is acted out" ("Lethal Theatre," 343).

88. E. Tammy Kim, "Performing Social Reparation," 237. This entire issue of *Women and Performance: a journal of feminist theory*, which was edited by Joshua Chambers-Letson and Robert G. Diaz, was devoted to the topic of performance, feminism, and reparations.

89. Ibid., 238.

90. My focus on the process of redressive acts joins the work of performance scholars who challenge the myopic attention on efficacy in assessments of socially engaged theater and performance. See, for example, Román, *Acts of Intervention*; Kuftinec, *Staging America*; Dolan, *Utopia in Performance*; Cohen-Cruz, *Local Acts*; Thompson, *Performance Affects*; Anderson, *So Much Wasted*; Jackson, *Social Works*; Snyder-Young, *Theatre of Good Intentions*; and Macki Braconi, *Harlem's Theaters*.

91. Schechner, *Between Theater and Anthropology*, 36.

92. Pilzer points out that Korean "wounded nationalism insisted on the persistence and the preservation of the wound and asked for infinite encores of the performance of suffering" (*Hearts of Pine*, 59). Redressive acts, as I define them, are not simply performances of suffering and are not about maintaining the wound.

93. Turner, *Dramas, Fields, and Metaphors*, 37–42. For a brief summary of Turner's work, see Carlson, *Performance*, 15–17.

94. Vivian Patraka's "Holocaust performative" resonates with my conception of redressive acts in its "constant iteration against the pressure of a palpable loss" (*Spectacular Suffering*, 7), but I focus more on the social and cultural possibilities of repeated engagement. Catherine Cole also notes, "Repair is a continuous process, at once practical and immediate" (*Performing South Africa's Truth Commission*, 136). Medical and scientific discourse sometimes pathologizes the repetitiveness of redressive acts as an inability to recover from trauma. I share Ann Cvetkovich's hope "to seize authority over trauma discourses from medical and scientific discourse in order to place it back in the hands of those who make culture, as well as to forge new models for how affective life can serve as the foundation for public culture" (*Archive of Feelings*, 20).

95. Franko, *Work of Dance*, 2.

96. For more on the emerging field of transpacific studies, see Hoskins and Nguyen, *Transpacific Studies*.

97. Lionnet and Shih, *Minor Transnationalism*, 8.

98. Shigematsu and Camacho, introduction, xv.

99. Jelin, *State Repression*, 8.

100. As Marita Sturken reminds us, "memory and forgetting are co-constitutive processes; each is essential to the other's existence" (*Tangled Memories*, 2). The "dialectics of remembering," as Lisa Yoneyama illustates, "necessarily entails the forgetting of forgetfulness" (*Hiroshima Traces*, 31-2).

101. Roach, *Cities of the Dead*, 26.

102. Ibid., 93.

103. Yoneyama, *Hiroshima Traces*, 33.

104. Nguyen, *Nothing Ever Dies*, 16.

105. Román, *Acts of Intervention*, xxvi. See also Dolan, *Feminist Spectator* 120-21; and Dolan, "Critical Generosity."

106. Román, *Acts of Intervention*, xxvii.

107. For example, see Mona Higuchi, *Bamboo Echoes*, Isabella Stewart Gardner Museum, Boston, September 20–December 26, 1996; Keller, *Comfort Woman*; Chang-rae Lee, *Gesture Life*; Kim-Gibson, *Silence Broken*; Dohee Lee, *Unblossomed*, EastSide Arts Alliance and Cultural Center, Oakland, 2007; and Yong Soon Min, *Wearing History*, 2007. Other notable works produced in Japan, South Korea, and the Philippines include Tomiyama, *Memories of the Sea*; *Najeun Moksori*; *Najeun Moksori 2*; *Sumgyeol*; and *Trauma, Interrupted*, Cultural Center of the Philippines, Manila, June 14–July 31, 2007. For a list of theater productions, see chap. 3, n. 5.

Chapter 1

1. Quoted in Chul Hwan Jung, "Wianbu Halmeoni Hanmaejhin Eolgul Pyeojilnal Eonjeilkka" [When Will the Han-Filled Faces of Comfort Women Grandmothers Be Relieved?], *Hankook Ilbo* [Korea Times], March 16, 2006, 9.

2. Yong Soo Lee, "Wontonghaeseo Motsalgetda," 123–32.

3. Ibid., 123.

4. Ibid., 127–29.

5. Yong Soo Lee, interview.

6. Ibid.

7. For a full transcript of Lee's 2007 testimony before the US House of Representatives and for her written testimony, see US House of Representatives, Committee on Foreign Affairs, *Protecting the Human Rights of Comfort Women*, 15–23.

8. The Korean word *suyo* translates as "Wednesday" and *siwi* as "demonstration." Wednesday was not chosen for any particular reason, but the day happened to be close to the visit of Prime Minister Kiichi Miyazawa to Korea in January 1992. The official name of the protests is Ilbongun Wianbu Munje

Haegyeoreul Wihan Jeonggi Suyosiwi [The Regular Wednesday Demonstrations to Resolve the Japanese Military Comfort Women Issue]. See Korean Council for the Women Drafted for Military Sexual Slavery by Japan, "Suyo Siwi," accessed July 10, 2017, https://www.womenandwar.net/contents/general/general.asp?page_str_menu=020101; and Hanguk Jeongsindae Munje Daechaek Yeobuihoe, *Jiulsu Eomneun Yeoksa*, 42. For more on South Korea's rich tradition of political protest, see, for example, Shin, *Peasant Protest*; Namhee Lee, *Making of Minjung*; Yeo, *Activists, Alliances*; and Chang, *Protest Dialectics*.

9. Seonju Lee, "Cheot Gungnae Jeungin Gimhaksunhalmeoni" [The First Domestic Witness Grandmother Kim Hak-soon], *Chosun Ilbo*, August 16, 1991, 22.

10. The only time protesters did not gather on Wednesday was after the devastating 1995 earthquake in Kobe, Japan.

11. Korean Council for the Women Drafted for Military Sexual Slavery by Japan, "History: Wednesday Demonstration," accessed July 10, 2017, https://www.womenandwar.net/contents/general/general.asp?page_str_menu=220101

12. Ibid.

13. House of Sharing was first established in 1992 in Seodaemun, Seoul, and was relocated to Gwangju City in 1995. Our House was established in Seoul in 2003 as a "shelter and medical center for the victims." Our House is now called Shimteo [Resting Home]. The House of Sharing and the Korean Council are the two main organizations that support survivors and advocate for redress. For more on the organizations, see Hanguk Jeongsindae Munje Daechaek Yeobuihoe, *Jiulsu Eomneun Yeoksa*, 41.

14. When possible, I name the individual survivors.

15. The activists the Korean Council employs are women from their late twenties to their fifties. The volunteers are men and women, mainly in their twenties, from South Korea, Japan, and the United States.

16. The riot police force, which is part of the Korean National Police force, guards government buildings and embassies; most of their eight-hour shifts involve "routine gate monitoring." See Hae-rym Hwang and Teri Weaver, "Families of South Korean Riot Police Ask Protesters for Restraint," *Stars and Stripes*, February 3, 2006, accessed July 10, 2017, https://www.stripes.com/news/families-of-s-korean-riot-police-ask-protesters-for-restraints-1.44413#.WWOpeTOZO-o. See also Jimmy Norris and Hae-rym Hwang, "Riot Policeman Tells of Often Violent, Exhausting Job," *Stars and Stripes*, October 26, 2008, accessed July 10, 2017, https://www.stripes.com/news/riot-policeman-tells-of-often-violent-exhausting-job-1.84520#.WWOqxzOZO-o

17. A colored police barricade tape prevents protesters from blocking the whole street.

18. Inhyeok Yu wrote the protest song "Bawi Jeoreom" [Like a Rock] dur-

ing the Minjung Undong [People's Movement] of the 1990s, which helped bring an end to authoritarian rule in South Korea. The song remains popular among some Korean Council activists who were part of the student democratization movement. See Pilzer, *Hearts of Pine*, 17.

19. I follow David Eng and David Kazanjian's definition of loss: "'Loss' names what is apprehended by discourses and practices of mourning, melancholia, nostalgia, sadness, trauma, and depression." The essays in their edited collection "examine both individual and collective encounters with twentieth-century historical traumas and legacies of, among others, revolution, war, genocide, slavery, decolonization, exile, migration, reunification, globalization, and AIDS" (*Loss*, 2).

20. The Wednesday Demonstrations have an evolving repertoire and an unfinished history. See Mee Hyang Yoon, *25nyeonganui Suyoil*.

21. Won Ok Gil, interview.

22. Thiong'o, *Penpoints, Gunpoints, and Dreams*, 41.

23. For more on the demolition of the Government-General Building, see Jin, "Demolishing Colony." For more on the relationship between the reconstructions of Gyeongbokgung and Korean modernity, see Michael Kim, "Collective Memory."

24. Despite city restrictions on rallies and demonstrations in Gwanghwamun Square, it has become a vibrant protest site. Bereaved families of victims of the Sewol ferry disaster protested there, and in 2016 Amnesty International Korea organized a holographic demonstration against restrictions on the freedom of assembly. See Mee-yoo Kwon, "Demonstrations Banned at Gwanghwamun Plaza," *Korea Times*, August 3, 2009, accessed February 20, 2017, http://koreatimes.co.kr/phone/news/view.jsp?req_newsidx=49541; Boeun Kim, "Seoul to Scale Down Sewol Protest Tents," *Korea Times*, May 4, 2016, accessed February 20, 2017, http://www.koreatimes.co.kr/www/news/nation/2016/05/116_204058.html; Hyun-ju Ock, "51 Detained after Violent Protests," *Korea Herald*, November 15, 2015, accessed February 20, 2017, http://www.koreaherald.com/view.php?ud=20151115000457; and Jenny Starrs, "Activists Stage Holographic 'Ghost Rally' in South Korea," *Washington Post*, February 25, 2016, accessed February 20, 2017, https://www.washingtonpost.com/news/morning-mix/wp/2016/02/25/activists-stage-holographic-ghost-rally-in-south-korea/?utm_term=.f985dccd0580

25. Elaine H. Kim and Choi, introduction, 3.

26. Since 2015 the Japanese Embassy has been undergoing major renovations, and the mission has temporarily moved to another building. The renovated Japanese Embassy will include an extra floor above ground and two additional floors below ground. It is unclear how the renovated embassy will impact the dramaturgy of the Wednesday Demonstrations. I predict that the protests will continue in the same space. For more on the renovations, see "Japanese Embassy to Move to Temporary Location," *Chosun Ilbo*, June 23,

2015, accessed June 27, 2016, http://english.chosun.com/site/data/html_dir/2015/06/23/2015062301229.html

27. Thiong'o, *Penpoints, Gunpoints, and Dreams*, 41.

28. Certeau, *Practice of Everyday Life*, 117.

29. Roach, *Cities of the Dead*, 28. As sovereign spaces within nations, embassies "are territories in urban space that do not come under the administration of the countries in which they are situated physically." "Their physical structure belongs to the urban space," explains Irene Campari, "while their legal space belongs to other countries with other laws, rules and traditions" ("Uncertain Boundaries," 61). Consequently, only embassy employees, citizens of the country represented by the embassy, and guests with special permission are permitted on the physical grounds of the embassy.

30. Roach, *Cities of the Dead*, 28.

31. For example, the nationalists who gather in front of the embassy to protest Japan's claims to the Dokdo Islets have engaged in such activities as cutting their fingers, burning flags, and self-immolation. See James Card, "A Chronicle of Korea-Japan 'Friendship,'" *Asia Times*, December 23, 2005, accessed February 20, 2017, http://www.atimes.com/atimes/Korea/GL23Dg02.html

32. For more on the private modes through which Korean survivors have expressed their wartime experience through song, see Pilzer, *Hearts of Pine*.

33. For more on public "silencing," see Na-Young Lee, "Korean Women's Movement," 74–76; and Soyang Park, "Silence, Subaltern Speech and the Intellectual."

34. Many scholars take note of the movement's invocation of national injury through sexual slavery. See Soh, "Korean 'Comfort Women'"; Choi, "Nationalism and Construction of Gender"; Choi, "Politics of War Memories"; and Hyunah Yang, "Re-Membering the Korean Military Comfort Women."

35. Hyunah Yang points out the recurrence of the Korean phrase *minjokuijajonsim* [national pride] in Korean editorials, articles, and readers' letters about wartime sexual slavery ("Re-Membering the Korean Military Comfort Women," 128–35).

36. Koreans were forced to take Japanese names, speak Japanese, and serve the Japanese emperor. Korean colonial subjects, from male laborers to female sex slaves, were coercively drafted by the state and were often shipped to the front lines in remote countries. The fact that a majority of the women in the "comfort system" were Korean exacerbates this sense of national shame. For more, see Pyong Gap Min, "Korean 'Comfort Women.'"

37. Pilzer also points out how the "movement finds itself compelled to draw on Korean victimological nationalism vis-à-vis Japan in order to mobilize the populace" ("'My Heart, the Number One,'" 11).

38. Hyunah Yang, "Re-Membering the Korean Military Comfort Women," 127.

39. For more on Korean complicity, see Soh, *Comfort Women*. For Korean police complicity, see Dudden, "'We Came to Tell the Truth,'" 599. For more on the participation of Korean men in the mobilization of women for the "comfort system," see Cumings, *Korea's Place in the Sun*, 179.

40. Soh, *Comfort Women*, xvi.

41. Yong Soo Lee, interview.

42. See, generally, Hadl, "Korean Protest Culture."

43. Mee Hyang Yoon, interview.

44. For more on the demands, see Korean Council, "Objectives & Activities."

45. During the colonial period, people mistook enslaved women for *jeongsindae*, a word referring to women conscripted into the labor force by Imperial Japan. *Jeongsindae* translates into "offering-up-one's-body corps" and refers to Imperial Japan's mobilization of men and women recruits as factory operatives in Japan's expanding empire. Some women were deceived into the "comfort women" system under the guise of joining the *jeongsindae*, and Koreans mistakenly conflated "comfort women" victims with *jeongsindae*. See Janice C. H. Kim, *To Live to Work*, 130; and Hanguk Jeongsindae Munje Daechaek Yeobuihoe, *Jiulsu Eomneun Yeoksa*, 10.

46. Mourners in Korea traditionally have worn hemp cloth, a coarse and thick fabric, to express their grief. Yoon refers to *sambae* [hemp cloth]. *Sangbok* [traditional mourning clothes] are yellowish-ivory in color and made from "rough, undyed hemp." People continue to wear hemp, adornments made from hemp, or white clothes during the wake, funeral, and postfuneral mourning period, which can last from a few months to a few years. See Sunny Yang, *Hanbok*, 37–8, 161–67.

47. Mee Hyang Yoon, interview.

48. Ibid.

49. Shin, Westland, Moore, and Cheung, "Colour Preferences," 50. Yellow is one of the five main colors used in traditional Korean clothing, wrapping cloths, and decorations. The other colors are blue, red, white, and black. These colors signify different directions, seasons, weather, natural elements, and blessings. See Huh, "History and Art," 21.

50. Mee Hyang Yoon, interview.

51. Ibid.

52. Grewal, *Transnational America*; Grewal and Kaplan, "Transnational Feminist Practices"; Hua, *Trafficking Women's Human Rights*; Volpp, "Talking Culture"; Kang, *Compositional Subjects*; and Kang, *Traffic in Asian Women*.

53. Since 2014, survivors do not always wear the yellow vests. It may be difficult for the elderly survivors to put on the vests, and they may no longer need the yellow vests to bring visual attention to where they are: they are easily spotted by their chairs and their position in the center of the activity.

Korean Council activists and volunteers helping out for the day still wear the yellow vests.

54. After H.R. 121 passed in the US House of Representatives in July 2007, activists and survivors gathered in front of the Japanese Embassy for a press conference. News photographers gravitated toward Soon-duk Lee, the survivor who looked the oldest and weakest. Subsequent news images prominently featured her picture. For example, see Chung-a Park, "Ex-Sex Slaves Welcome US Resolution," *Korea Times,* July 31, 2007, accessed July 11, 2017, http://www.koreatimes.co.kr/www/news/nation/2007/08/117_7491.html

55. Some critics have charged that the survivors do not look old enough. In April 2005, well-known far-right-wing writer Man-won Ji wrote that some of the survivors "look too young and healthy to be credible as real sex slaves to the Japanese military" and that he had "even heard they get paid 30,000 won ($30) for attending a weekly protest in front of the Japanese embassy in Seoul every Wednesday." The Korean Council asked the press not to make an issue out of Ji's "intentionally biased claims" and considered filing a compensation lawsuit against Ji. See Jin-woo Lee, "Writer Angers Comfort Women," *Korea Times,* April 16, 2005, accessed July 11, 2017, http://www.lexisnexis. com.turing.library.northwestern.edu/lnacui2api/api/version1/ getDocCui?lni=4FYX-TTX0-00JP-S1W6&csi=174045&hl=t&hv=t&hnsd=f& hns=t&hgn=t&oc=00240&perma=true

56. For more on women's symbolic and material relation to the nation, see McClintock, *Imperial Leather;* Kaplan, Alarcón, and Moallem, *Between Woman and Nation;* and Enloe, *Bananas, Beaches, and Bases.*

57. Materials have included sturdy cloth and cloth with vinyl backing.

58. Duk-Kyung Kang (1929–97), who spent the last ten years of her life living in the House of Sharing, participated in weekly protests. Kang took up painting as a form of art therapy. Her paintings are displayed in the House of Sharing's museum in the "Indictment Room" and have traveled in exhibits to the United States and Canada.

59. This is part of the pervasiveness of what Pilzer calls the "dyad of the innocent girl and the wrinkled grandmother" in the "discourse and imagery of the 'comfort women' in the South Korean public sphere" (*Hearts of Pine,* 94). See Pilzer, "'My Heart, the Number One,'" 36; and Pilzer, *Hearts of Pine,* 24, 94.

60. Pilzer, "'My Heart, the Number One,'" 37. Pilzer's study on singing in the lives of survivors counters this archetype and the glancing over of the lives that survivors led.

61. Camptowns were districts with shops, restaurants, bars, and residences that sprang up near US military bases. See Yuh, *Beyond the Shadow,* 10.

62. Ibid., 20.

63. The question of consent has been a sticking point between Japanese

neoconservative historians and politicians who discredit the testimonies of survivors, labeling them prostitutes who willingly worked in "comfort stations." "Yet although [Japanese Prime Minister Shinzo] Abe admitted coercion by private dealers, some of his closest allies in the governing Liberal Democratic Party have dismissed the women as prostitutes who volunteered to work in the comfort stations," writes Norimitsu Onishi. "They say no official Japanese government documents show the military's role in recruiting women" ("Denial Reopens Wounds of Japan's Ex-Sex Slaves," *New York Times*, March 8, 2007, accessed February 20, 2017, http://www.nytimes.com/2007/03/08/world/asia/08japan.html).

64. A number of scholars who research military sex work in South Korea draw parallels between the experiences of camptown military sex workers and those of "comfort women" (Moon, *Sex Among Allies*; Moon, "South Korean Movements"; and Yuh, *Beyond the Shadow*), explicating how the historical memory around Japanese military sex slaves impacts public perception of camptown military sex workers (Na-Young Lee, "Construction of U.S. Camptown Prostitution") or mapping the figure of the "comfort woman" as the shadow to the figure of the *yang gongju* in the Korean diasporic imaginary (Grace M. Cho, *Haunting the Korean Diaspora*).

65. Mee Hyang Yoon, interview.

66. The first photograph of this banner in the archives dates to July 4, 2001. I have seen this banner in photos posted online by participants. This banner was not used on a weekly basis. This photograph is part of the digital archives housed at the Korean Council.

67. Jae Hyeok Choi, "Jeongsindaemunje Daechaekyeop, Eel Waegok Gyogwaseo Bandaeseongmyeong" [Korean Council Statement Against Distorted Japanese Textbook], *Chosun Ilbo*, April 4, 2001, accessed July 19, 2017, http://news.chosun.com/svc/content_view/content_view.html?cont id=2001040470264. For more on the Japanese history textbook controversy, see Nozaki, "Japanese Politics." For more context on textbook controversies surrounding the "comfort women" history, see Hein and Selden, "Lessons of War," 23–29.

68. *Ppaeatgin Sunjeong*, 1995, 87 × 130 cm, acrylic on canvas. See Wonhaeng, *Painting Edition*. The makers of the banner changed the title from "Innocence Stolen" to "Purity Lost Forever" to emphasize the magnitude of the loss.

69. *Quest for Justice* tells the story of survivor Soon Duk Kim, who explains that in this painting, Kang renders memories of being raped for the first time by a Japanese soldier.

70. *History That Can't Be Erased*.

71. Survivors' testimonies frequently repeated that "recruitment" for the "comfort system" was coercive, using violence or deception that offered young women false promises of employment in Japan (Chung, "Korean Women Drafted," 19).

72. This was a strategy to garner public support during a particular historical period. National recuperation is not part of the activists' work on behalf of survivors.

73. The first photograph of this banner dates from June 13, 2001 (the 464th Wednesday Demonstration), and the last one dates from October 3, 2007 (the 781st Wednesday Demonstration). Both are in the digital archives housed at the Korean Council.

74. Photo SC-230417, RG 306, Records of the US Information Agency, National Archives and Records Administration, Washington, D.C.

75. Barthes, *Camera Lucida*, 27.

76. Schneider, *Performing Remains*, 179.

77. The Korean Council has asked the Korean government to provide economic support for survivors who have registered with the government. In 1993, the government began providing survivors with housing, living expenses, and free medical care. See Hanguk Jeongsindae Munje Daechaek Yeobuihoe, *Jiulsu Eomneun Yeoksa*, 40. The Korean government's willingness to pressure the Japanese government to make redressive amends has fluctuated over the years, to the frustration of survivors and their supporters.

78. Quoted in Hoo-ran Kim, "For 22 Years, Former Military Sex Slaves Rally for Justice: Time Running Out for Dwindling Number of Surviving Victims," *Korea Herald*, January 27, 2014, accessed July 8, 2016, http://www.koreaherald.com/view.php?ud=20140127000736

79. Foster, "Choreographies of Protest," 395.

80. Kwan, *Kinesthetic City*, 4.

81. Foster, "Choreographies of Protest," 401.

82. Neither of the women had ever participated in the protests. One woman said that the only time they could hear the protesters was when the embassy windows were open (author's conversation with embassy workers, Seoul, August 6, 2008).

83. Anderson, *Imagined Communities*, 6, 35; and McClintock, *Imperial Leather*, 374.

84. Joseph, *Nomadic Identities*, 3.

85. Sharp, *Politics of Nonviolent Action*, 371. Quoted in Foster, "Choreographies of Protest," 395.

86. Since 2004, police from the Chongno Police Station, which monitors the area, have set up barricade tape on the street to rope off the area where protesters can gather to keep traffic flowing. Protesters not only take over the whole sidewalk across from the embassy but occupy a good portion of the street as well, barely leaving enough room for cars to pass.

87. Korean middle school and high school students are conspicuous because of their school uniforms.

88. While I can see how the term *halmeoni* could be problematic for how it "conveniently erases the actual feminine sexuality of former comfort

women," I do not agree with Soh's argument that the use of the term *halme-oni* masks "their personal identity as individuals" (*Comfort Women*, 75).

89. I never saw or heard of survivors' family members participating in the Wednesday Demonstrations until the son of the late Hyo Soon Lee spoke on December 30, 2015. See Junho Bang, "Wianbu Halmeoni 'Choejong Habuira-neun Mallo Uril Dubeon Sebeon Jugyeo'" [Comfort Women Grandmothers Said, "By Calling It the Final Agreement, It Kills Us Twice, Three Times"], *Hankyoreh*, December 30, 2015, accessed July 5, 2016, http://www.hani.co. kr/arti/society/society_general/724147.html

90. Yong Soo Lee, interview.

91. Laub, "Bearing Witness," 69.

92. Yong Soo Lee, interview.

93. Ibid.

94. Ji-eun Lee, "Geureongosen Jeoldae Pabyeongandwae" [Troops Should Never Be Sent to a Place Like That], *Hankyoreh*, May 12, 2004, accessed July 8, 2016, http://legacy.www.hani.co.kr/section-005000000/2004/05/00500 00002004051211849598.html

95. Román, *Acts of Intervention*, 26.

96. Quoted in Ji-eun Shin, "Wianbu Halmeoni Jeonggi Suyojipoe 600hoe" [Comfort Women Mark 600th Weekly Rally], *Chosun Ilbo*, March 17, 2004, accessed July 9, 2014, http://news.chosun.com/svc/content_view/content_ view.html?contid=2004031770366

97. Ji Soo Kang, interview.

98. Yong Soo Lee, interview.

99. Yi, "Return My Youth," 94. Yong Soo Lee's name is spelled differently in books and news articles. I follow the spelling on her passport.

100. Won Ok Gil, interview.

101. Ibid.

102. Photographs from the 680th Wednesday Demonstration (October 26, 2005) in the digital archives of the Korean Council. *Pungmullori* usually includes these four instruments, which represent thunder and lightning (*kkwaenggwari*), rain (*janggu*), wind (*jing*), and clouds (*buk*). There are different variations of *pungmullori*. The Durae children perform *samullori*, during which the performers are usually seated.

103. At the August 1, 2007, Wednesday Demonstration, I saw a white woman holding a copy of *Lonely Planet*. I am not sure which edition she had, but the 2006 edition of *Lonely Planet: Seoul* included a listing for the Wednesday Demonstrations in the "Sights" section for the downtown area of Gwang-hwamun. It reads: "Korean Comfort Women Protest, Outside Japanese embassy; noon Wed; subway Line 3 to Anguk, Exit 6: Every week a handful of elderly Korean comfort women, who were forced into prostitution during WWII, gather outside the Japanese embassy. Together with their supporters they wave placards and shout slogans. One of them, Hwang Geum-joo, says she will never give up: 'Our numbers are dwindling every year, but we are

still full of anger and they should apologise for what they did to us!' The protest started in 1992 but the ladies are still waiting for a heartfelt apology and compensation for their suffering" (Robinson, *Lonely Planet*, 51).

104. Banko Takatsuka, conversation with author, Seoul, July 23, 2008.

105. Dong-yeong Yoon, "Wosingteoneseo Yeollin Baniljipoe" [Anti-Japan Protest in Washington], *Yeonhap Nyuseu* [Yonhap News], March 23, 2005, accessed October 24, 2016, http://news.naver.com/main/read.nhn?mode=LS D&mid=shm&sid1=115&oid=001&aid=0001896804

106. Dong-yeong Yoon, "Miseo Gangjewianbu Hangsosim Jaesim Cheot Byeollon" [First Proceeding on "Comfort Women" after the Review by an Appellate Court of an Appeal in the US], *Yeonhap Nyuseu* [Yonhap News], March 23, 2005, accessed October 24, 2016, http://news.naver.com/main/read.nhn?mode=LSD&mid=shm&sid1=102&oid=001&aid=0000950285

107. Koreans' claims to the disputed islets have become an expression of anti-Japanese sentiment and nationalist pride.

108. I thank Jinah Kim for alerting me to this point.

109. In 2000, fifteen survivors from South Korea, China, Taiwan, and the Philippines filed a class-action lawsuit before the US District Court for the District of Columbia under the Alien Tort Claims Act, which gives foreign citizens the "right to sue other foreign citizens and entities for abuses of international law." In 2003, after two previous dismissals, the survivors filed a cert petition with the US Supreme Court, which remanded the case to the D.C. Circuit Court of Appeals. That court dismissed the case in June 2005, and the Supreme Court denied cert and closed the case in 2006. See Center for Justice and Accountability, "Comfort Women Case"; "Comfort Women Miss Chance to Sue Japan," *Sydney Morning Herald*, June 29, 2005, accessed February 26, 2011, http://www.smh.com.au/news/World/Comfort-women-miss-chance-to-sue-Japan/2005/06/29/1119724683255.html?oneclick=true; and "U.S. Appellate Court Rejects Sexual Slavery Lawsuit against Japan," *Associated Press Newswires*, June 28, 2005, accessed July 11, 2017, https://global-factiva-com.turing.library.northwestern.edu/redir/default.aspx?P=sa &NS=16&AID=9NOR002400&an=APRS000020050628e16s001qh&cat=a&e p=ASI

110. Yoneyama, "Traveling Memories, Contagious Justice," 61.

111. Richards, "What Is to Be Remembered?" 93. Richards's work on the memorialization of the transatlantic slave trade in Ghana prompted me to think more about the materiality of bodies in invoking memory.

112. Román, *Acts of Intervention*, 37, 8.

113. I draw from the multiple meanings of *embody* as outlined in the *Oxford English Dictionary*: "to give a concrete form to (what is abstract or ideal); to express (principles, thoughts, intentions) in an institution, work of art, action, definite form of words, etc."

114. See Hanguk Jeongsindae Munje Daechaek Yeobuihoe, *Jiulsu Eomneun Yeoksa*, 43.

115. Since 1977, these women have marched around the plaza on Thursday afternoons to protest the government's kidnapping, torture, and murder of their children during the "Dirty War" and to demand accountability. The Wednesday Demonstrations also resonate with Wednesday protests in Belgrade in the early 1990s by Women in Black, a peace association that networked with solidarity organizations all over the world. For more on Women in Black, see Knezevic, "Marked with Red Ink."

116. See Taylor, *Disappearing Acts*; Bejarano, "Las Super Madres"; Taylor, *Archive and the Repertoire*, 161–89; Bosco, "Human Rights Politics"; and Benegas, "'If There's No Justice . . .'"

117. Taylor, *Disappearing Acts*, 198, 203.

118. Elizabeth Borland points out how "aging and activism remains an understudied area of the literature on social movements" ("Mature Resistance," 116). She does address the question of age in relation to the *madres* movement, but she focuses on how the *madres* have used "their presence as aging veteran activists" to broaden "their work to encompass critiques of neoliberalism" (116).

119. Diana Taylor's question about whether the "public spectacles against forgetting" of the *madres* in the Plaza de Mayo "were little more than a public display of the failure of spectacle itself" (*Disappearing Acts*, 15) prompted me to think about the "failure" of the Wednesday Demonstrations to obtain official acknowledgment from the Japanese government.

120. Yong Soo Lee, interview.

121. Boal, *Theatre of the Oppressed*, 141.

Chapter 2

1. I watched video recordings of the proceedings of the Women's International War Crimes Tribunal on Japan's Military Sexual Slavery at the Korean Council for the Women Drafted for Military Sexual Slavery by Japan in Seoul in the summer of 2008 and rewatched selected segments of the proceedings at the Women's Active Museum on War and Peace in Tokyo in May 2010. Videos located in the collections at the Korean Council are cited as KC, and those at the Women's Active Museum are cited as WAM. All recordings had voice-overs in English, which was the main language used at the tribunal. Although the Korean Council has transferred videotapes of the proceedings onto DVDs, the collection is incomplete due to poor video quality. The Women's Active Museum, which is the main repository for archival material for the Women's Tribunal, has a complete collection of videos. For Marta Abu Bore's testimony, see Women's Tribunal (KC), DVD #9, December 10, 2000; and Women's Tribunal (WAM), Video #30149, December 10, 2000.

2. I list countries in the order they presented at the Women's Tribunal. North Korea and South Korea gave a historic joint presentation.

3. *Prosecutors and the Peoples of the Asia-Pacific Region*, 8–9.

4. Imamura Tsugo, an attorney specializing in war reparation cases, was the amicus curiae who submitted the brief and presented it at the tribunal. See Puja Kim, "Global Civil Society," 618, n. 5; and *Prosecutors and the Peoples of the Asia-Pacific Region*, 8.

5. East Timor's participation was significant because the prosecution team had been formed just months before the start of the tribunal, when the country won its independence from Indonesia. See Puja Kim, "Global Civil Society," 616.

6. For introducing me to Jacques Rancière's concept of dissensus, I thank Maurya Wickstrom, who led the 2008 American Society for Theatre Research working group Theorizing Dissensus: Neoliberalism, Performance, and the Discourse of Human Rights and International Law, and Marcela Fuentes, who presented a paper to the working group, "The Politics of Casting in Federico León's *Artistic Shantytown*."

7. Rancière, "Who Is the Subject?" 304.

8. Ibid.

9. Charles Bingham and Gert Biesta write that an Austinian "performative understanding is implied throughout Rancière's work on both politics and poetics" (Bingham, Biesta, and Rancière, *Jacques Rancière*, 61). I see the performativity of dissensus at work in the Women's Tribunal through the lens of J. L. Austin's theory of the speech act as "the performing of an action" and Judith Butler's theory of gender performativity as the "reitcrative power of discourse to produce the phenomena that it regulates and constrains." See Austin, *How to Do Things*, 6–7; and Butler, *Bodies That Matter*, 2.

10. "Devised as a way to cope with the aftermath of systematic and large-scale violations of human rights, transitional justice has achieved its most notable impact via truth commissions," explains Cole. "Such commissions grapple with the ultimate failure of traditional jurisprudence in the face of contending demands for justice, reparation, acknowledgement, mourning, healing, reconciliation, and the promulgation of public memory" (*Performing South Africa's Truth Commission*, x). For more on changes in transitional justice since the 1990s, see Roht-Arriaza and Mariezcurrena, *Transitional Justice*.

11. For example, South Africa's Truth and Reconciliation Commission held two kinds of hearings: "Human Rights Violations Committee (HRVC) hearings, in which victims told 'narrative truths' about their experiences, and Amnesty Committee hearings, in which perpetrators came forward in the hope of being granted amnesty" (Cole, *Performing South Africa's Truth Commission*, 4).

12. "A peoples' tribunal can thus combine in a single process elements of both war crimes trials and truth commissions" (Chinkin, "Women's International Tribunal," 339).

13. By "officially sanctioned tribunals," I mean those sanctioned by a government, such as a truth commission, or by an international body such as the United Nations.

14. The United Nations has established a number of tribunals to address mass violence and atrocities. The most notable are the International Criminal Tribunal for the Former Yugoslavia (ICTY, 1993–) and International Criminal Tribunal for Rwanda (ICTR, 1995–2015), which were established by the UN Security Council. State governments have also cooperated with the UN in setting up tribunals—for example, in the Residual Special Court for Sierra Leone (2002–13) and in the Khmer Rouge Tribunal/Cambodia Tribunal (2007–). Other international mechanisms for justice include the International Court of Justice (the principal judicial organ of the UN) and the International Criminal Court (ICC). The ICC, the "world's first permanent international criminal court," is governed by the Rome Statute in its work of adjudicating cases related to large-scale human rights violations. It operates independently of the United Nations. See Marlise Simons, "International Court Begins First Trial," *New York Times*, January 26, 2009, accessed July 21, 2016, http://www.nytimes.com/2009/01/27/world/europe/27hague.html?_r=0. For more information on the ICC, see "About," *International Criminal Court*, accessed July 14, 2017, https://www.icc-cpi.int/about

15. The legal counsel at the Women's Tribunal were called prosecutors because they were presenting a multinational case that was prosecuting the emperor and select military officials.

16. Sarat, "Editorial," 137–38. For more on the four elements of the "project of relating law to literature," see Freeman and Lewis, *Law and Literature*, 2: xiii.

17. Sarat, "Editorial," 137.

18. See, for example, Hibbitts, "De-Scribing Law"; Roach, *Cities of the Dead*; and Auslander, *Liveness*.

19. For more on transitional justice and a documentation of forty truth commissions, see Hayner, *Unspeakable Truths*.

20. Cole, "Performance, Transitional Justice," 186; *Performing South Africa's Truth Commission*, xiv, xx–xxi.

21. Cole, *Performing South Africa's Truth Commission*, xii.

22. Such works include Chambers-Letson, *Race So Different*; Breed, *Performing the Nation*; and Guterman, *Performance, Identity, and Immigration Law*. For example, Joshua Chambers-Letson evocatively demonstrates "not simply that the law has both a performative and an aesthetic dimension but that aesthetic performances often take on a legal function by serving as agents of the law" (7). He reminds me to be attentive to the imbrication of the law with aesthetic practices.

23. See, for example, Argibay, "Sexual Slavery"; Chinkin, "Women's International Tribunal"; Dudden, "'We Came to Tell the Truth'"; Henry, "Memory of an Injustice"; Puja Kim, "Global Civil Society"; Matsui, "Women's International War Crimes Tribunal"; and Suzuki, "Overcoming Past Wrongs."

24. Korean Council, "Objectives & Activities."

25. Bertrand Russell and Jean-Paul Sartre led an international people's tribunal that tried the United States, Australia, New Zealand, and South Korea for their acts of aggression during the Vietnam War. See *Prosecutors and the Peoples of the Asia-Pacific Region*, 14–15. For more on the original Russell Tribunal and its successors, see Torell, "Remember the Russell Tribunal?"

26. Falk, "Rights of Peoples," 29. Quoted in *Prosecutors and the Peoples of the Asia-Pacific Region*, 14.

27. *Prosecutors and the Peoples of the Asia-Pacific Region*, 1.

28. The ICTY and ICTR cite legal opinions from the Tokyo War Crimes Trials, which have become "an integral part of the historical development of the international justice system rather than a judicial anomaly" (Totani, *Tokyo War Crimes Trial*, 4).

29. Ibid., 101.

30. Koikari, *Pedagogy of Democracy*, 7. For an excellent overview of the scholarship on the US occupation of Japan, see Koikari, *Pedagogy of Democracy*, 6–17.

31. The Tokyo War Crimes Trials were originally envisioned as multiple international courts, but in the end there was only one international tribunal. There were also fifty "separate special war crimes courts in the former theaters of war in the Asia-Pacific region, which fell under national jurisdiction of the individual Allied countries" (Totani, *Tokyo War Crimes Trial*, 7, 10, 22).

32. Totani, *Tokyo War Crimes Trial*, 1. Class A war criminals were prosecuted in Tokyo, while thousands of individuals were indicted for Class B and C war crimes at the special war crimes courts in other countries. See Dower, *War without Mercy*, 447–49; and Totani, *Tokyo War Crimes Trial*, 22–23.

33. Women's Tribunal (KC), DVD #1, December 8, 2000; and Women's Tribunal (WAM), Video #30131, December 8, 2000.

34. *Prosecutors and the Peoples of the Asia-Pacific Region*, 19.

35. Ibid., 1. An exception was the Batavia (Indonesia) Trial, a case against twelve Japanese army officers for the victimization of thirty-five Dutch survivors of military sexual slavery in the Dutch East Indies. The case resulted in one execution and the imprisonment of the other officers. See VAWW-NET Japan, "Background and Purpose." Tanaka sees the failure to prosecute as an example of the military's racism and androcentric ideology regarding Asian women (*Japan's Comfort Women*, 86–87).

36. Totani, *Tokyo War Crimes Trial*, 26, 80, 98–103.

37. Ibid., 185. In the case of China, the judges came very close to concluding that these types of atrocities were war crimes but stopped short of doing so (185). As Yuma Totani writes, "In all probability, the Tribunal concluded that the prosecution did not meet the burden of proof for establishing the responsibility of the central government" (186).

38. Ibid., 178.

39. Ibid., 102–3.

40. Ibid.

41. Matsui, "Women's International War Crimes Tribunal," 131.

42. Tanaka points to a combination of racism, sexism, and insensitivity regarding services provided by women as reasons why sexual slavery might not have been viewed as a serious war crime (*Japan's Comfort Women*, 87).

43. Matsui, "Women's International War Crimes Tribunal," 127.

44. Dower, *Embracing Defeat*, 27–28.

45. Matsui, "Women's International War Crimes Tribunal," 127–28.

46. Scholars argue that there are at least two general phases of the US occupation of Japan: the initial idealistic phase of "radical reforms aimed at demilitarization and democratization" and the second phase, which began in 1947 with the emergence of the Cold War and saw "increasingly repressive measures of remilitarization, economic recovery, and political containment of the left" (Koikari, *Pedagogy of Democracy*, 8).

47. Real, "Continuing the Quest."

48. Watanabe, "NGO Briefing," 2.

49. The bilateral agreement is formally known as the Treaty on Basic Relations between Japan and the Republic of Korea. See Memory and Reconciliation, "Korean Comfort Women"; and Rahn Kim, "Comfort Women to Petition Constitutional Court," *Korea Times*, July 4, 2006, accessed July 4, 2017, http://www.lexisnexis.com.turing.library.northwestern.edu/lnacui2 api/api/version1/getDocCui?lni=4KB5-MTP0-TX51-F21D&csi=174045&hl= t&hv=t&hnsd=f&hns=t&hgn=t&oc=00240&perma=true

50. "Comfort Women Miss Chance to Sue Japan," *Sydney Morning Herald*, June 29, 2005, accessed February 26, 2011, http://www.smh.com.au/ news/World/Comfort-women-miss-chance-to-sue-Japan/2005/06/29/ 1119724683255.html?oneclick=true

51. Center for Justice and Accountability, "Comfort Women Case."

52. "U.S. Appellate Court Rejects Sexual Slavery Lawsuit Against Japan," *Associated Press Newswires*, June 28, 2005, accessed July 11, 2017, https:// global-factiva-com.turing.library.northwestern.edu/redir/default.aspx?P=sa &NS=16&AID=9NOR002400&an=APRS000020050628e16s001qh&cat=a&e p=ASI; and Ibid.

53. Norimitsu Onishi, "World War II Sex Slaves Lose in Japanese Court," *New York Times*, April 28, 2007, accessed August 1, 2016, http://www.ny times.com/2007/04/28/world/asia/28iht-web0428-japan.5484528.html

54. Iovino, "Judge Dismisses Comfort Women's Claim."

55. VAWW-NET Japan, "Message."

56. VAWW-NET Japan, "Background and Purpose."

57. Dudden, "'We Came to Tell the Truth,'" 592–93.

58. VAWW-NET Japan, "Message."

59. Different scholars emphasize different aspects of these objectives. See

Matsui, "Women's International War Crimes Tribunal," 120; Dudden, "'We Came to Tell the Truth,'" 591; and Puja Kim, "Global Civil Society," 611–12. For a list of the official objectives of the tribunal, see VAWW-NET Japan, "Background and Purpose."

60. The charter of the Women's Tribunal outlines the parameters of the trial, its legal principles, and, most important, its jurisdiction. The charter refers to "the principles of law, human conscience, humanity and gender justice that were an integral part of international law at the time of and that should have been applied by the International Military Tribunal for the Far East, as well as taking into account the subsequent developments in international law, particularly in relation to women's human rights, which have come to be recognized by the international community as a priority matter as the result of brave struggles of many people including women survivors themselves and insofar as these developments illuminate the proper application of international law to the crimes against women and embody evolving principles of state responsibility for past violations" (VAWW-NET Japan, "Charter").

61. Felman, *Juridical Unconscious*, 61.

62. Joseph Roach writes that "genealogies of performance document—and suspect—the historical transmission and dissemination of cultural practices through collective representations" (*Cities of the Dead*, 25).

63. Jakovljević, "From Mastermind to Body Artist," 66.

64. Ibid.

65. Puja Kim, "Global Civil Society," 613.

66. Tanaka, *Japan's Comfort Women*, 67.

67. Puja Kim, "Global Civil Society," 614.

68. Matsui, "Women's International War Crimes Tribunal," 119.

69. Women's Tribunal (WAM), Video #30131, December 8, 2000. Activism in Japan emerged in partnership with feminist work in South Korea, particularly regarding the issue of Japanese sex tourism. The Asian Women's Association has partnered with other Asian countries to work on issues from Japan's colonial past. The Uli-Yosong (Our Women) Network on "Comfort Women," founded in 1991 by Korean residents of Japan, has supported survivors and their cause. See Mackie, *Feminism in Modern Japan*, 217–18; and Puja Kim, "Looking at Sexual Slavery," 157.

70. For a detailed list of meetings, see VAWW-NET Japan, "Events."

71. VAWW-NET Japan, "Organizers."

72. Puja Kim, "Global Civil Society," 614; and Mohanty, *Feminism without Borders*, 2.

73. Mohanty, *Feminism without Borders*, 46.

74. The judges were Gabrielle Kirk McDonald (United States), former president of the ICTY; Christine Chinkin (United Kingdom), professor of law at the University of London; Carmen Maria Argibay (Argentina), justice on the Argentine Supreme Court and president of the International Women's

Association of Judges; and Willy Mutunga (Kenya), executive director of the Kenya Human Rights Commission and lecturer at the University of Nairobi. Co-chief prosecutors were Patricia Viseur-Sellers (United States), legal adviser for gender-related crimes in the Office of the Prosecutor of the ICTY and ICTR; and Ustinia Dolgopol (Australia), senior lecturer at Flinders University.

75. Matsui, "Women's International War Crimes Tribunal," 132.

76. UN/International Criminal Tribunal for the Former Yugoslavia, "About the ICTY."

77. *Prosecutors and the Peoples of the Asia-Pacific Region*, 137.

78. Argibay, "Sexual Slavery," 384–85.

79. Totani, *Tokyo War Crimes Trial*, 10, 8–9.

80. Michiko Nakahara, interview.

81. Kobayashi, "State and Religion in Japan," 70, 72.

82. Ibid., 72.

83. Yasukuni Shrine, "About Yasukuni Shrine."

84. Japanese prime ministers have visited the Yasukuni Shrine since the end of the war, but annual visits by prime ministers started in 2001. See Cheung, *Political Survival*, 33-5; and Kyodo News, "Paper: Yasukuni, State in '69 Ok'd War Criminal Inclusion," *Japan Times*, March 29, 2007, accessed August 2, 2016, http://www.japantimes.co.jp/news/2007/03/29/news/paper-yasukuni-state-in-69-okd-war-criminal-inclusion/#.V6Dbj2VjrX8

85. Women's Tribunal (KC), DVD #5, December 9, 2000; and Women's Tribunal (WAM), Video 10/11, #30139, December 9, 2000.

86. Field, "Courts, Japan's 'Military Comfort Women.'"

87. Ibid.

88. Norimitsu Onishi, "Abe Rejects Japan's Files on War Sex," *New York Times*, March 2, 2007, accessed October 2, 2015, http://www.nytimes.com/2007/03/02/world/asia/02japan.html?_r=0

89. Women's Tribunal (KC), DVD #1, December 8, 2000; and Women's Tribunal (WAM), Video #30131, December 8, 2000. A registrar ensures that a tribunal's proceedings run smoothly. At the Women's Tribunal, the registrar was responsible for the "administration and servicing of the Tribunal" (*Prosecutors and the Peoples of the Asia-Pacific Region*, A-5).

90. Although the Women's Tribunal took place on the main stage of Kudan Kaikan, the judgment was rendered at the Nippon Seinenkan, a larger venue. Kudan Kaikan includes a hotel, restaurants, a wedding hall, and a large auditorium. The building is currently slated for demolition. According to Puja Kim, at one time it served as a military assembly hall under the name Gunjin Kaikan. Beginning in 1953, Kudan Kaikan was leased by a right-wing group, the Association of Bereaved Families (formerly the Japanese Association for the Welfare of Families of War Casualties), that was started in 1947 and had "close ties to Yasukuni Shrine" (Hammond, "Commemoration Controversies, 105). Constructed in 1934 by the Imperial Forces Veterans Asso-

ciation, the building "functioned as a social club for servicemen and veterans until 1945" (106). See also *Kudan Kaikan* website; and Puja Kim, "Global Civil Society," 611.

91. Matsui, "Women's International War Crimes Tribunal," 121.

92. Freddie Rokem's description of a set (*Performing History*, 22–23) prompted me to think about the fluidity between the stage and auditorium.

93. The group from the Philippines consisted of Tomasa Salinog and several women from Mapanique who had been gang-raped and enslaved by Japanese soldiers in 1944. See *Breaking the History of Silence*.

94. Women's Tribunal (KC), DVD #1, December 8, 2000; and Women's Tribunal (WAM), Video #30131, December 8, 2000.

95. *Breaking the History of Silence*.

96. *Prosecutors and the Peoples of the Asia-Pacific Region*, 160.

97. Women's Tribunal (KC), DVD #1, December 8, 2000; and Women's Tribunal (WAM), Video #30131, December 8, 2000.

98. *Breaking the History of Silence*; and Women's Tribunal (WAM), Video #30131, December 8, 2000.

99. The Koreas' presentation took almost three hours; most of the other presentations lasted one hour. The comparatively ample time given to the Korean prosecution resonates with the privileged status the Korean narrative has often been given in the transnational movement. When I asked Michiko Nakahara about this, she surmised that it was because Korea had one of the largest groups of witnesses and was represented by the Korean Council, the organization at the forefront of the movement. She also suggested that the order was based on the number of military sex slaves from each country: since the majority of sex slaves were Korean, Korea went first (Michiko Nakahara, interview).

100. Dower, *Embracing Defeat*, 27–28.

101. Dudden, *Troubled Apologies*, 36.

102. According to Akira Yamada, when the Japanese minister of foreign affairs told the emperor about media reports on the atrocities committed in Nanking in 1937, the emperor expressed concern regarding foreign coverage. In response to the emperor's request to find ways to "restore the 'honor of Japan' and stop the condemnation by the international press," Japanese ministers, counselors, and military chiefs suggested that the Military Code be reformed and that "comfort stations" be systematically created and extended (Argibay, "Sexual Slavery," 376). As historians have documented, the "comfort system" became more widespread and systematic after the "Rape of Nanking." Yamada asserts that the emperor would have known about the establishment of the "comfort system." See Women's Tribunal (KC), DVD #4, December 9, 2000.

103. Argibay, "Sexual Slavery," 383.

104. Ibid., 387–88.

105. Women's Tribunal (KC), DVD #2, December 8, 2000.

106. According to Alexis Dudden, the Women's Tribunal's approach was "based on recent developments in human rights law, in particular on the formula of South Africa's Truth and Reconciliation Commission" ("'We Came to Tell the Truth,'" 600 n. 7).

107. The team from Malaysia did not bring a witness because few women have come forward; instead, they showed video footage of testimony by Rosalind Saw (*Breaking the History of Silence*).

108. Dudden, "'We Came to Tell the Truth,'" 592.

109. Sakamoto, "Women's International War Crimes Tribunal," 54.

110. Dudden, "'We Came to Tell the Truth,'" 594.

111. Rumi Sakamoto also notes this point in her description of how the "predominantly legal discourse and procedure of the Tribunal sometimes seemed unable to contain the witnesses' experience, bodies, and voices within that framework" ("Women's International War Crimes Tribunal," 58). However, she offers few details.

112. Hyunah Yang writes that attention to affect led to the awareness of the "variety and richness" of verbal and nonverbal expressions in testimonies of survivors ("Finding the 'Map of Memory,'" 90). Her essay on the process of collecting the testimonies of survivors and situating testimonies within survivors' frames for remembering is excellent.

113. Cole, *Performing South Africa's Truth Commission*, 89.

114. Women's Tribunal (KC), DVD #2, December 8, 2000; and Women's Tribunal (WAM), Video #30132, December 8, 2000.

115. Women's Tribunal (WAM), Video #30132, December 8, 2000.

116. Ibid.

117. Rosen, *Dignity*, 58.

118. Women's Tribunal (KC), DVD #4, December 9, 2000; and Women's Tribunal (WAM), Video #30135, December 9, 2000.

119. Felman, *Juridical Unconscious*, 164.

120. Women's Tribunal (KC), DVD #5, December 9, 2000; and Women's Tribunal (WAM), Video #30136, December 9, 2000.

121. Dudden, "'We Came to Tell the Truth,'" 593.

122. Women's Tribunal (KC), DVD #8, December 9, 2000; and Women's Tribunal (WAM), Video #30140, December 9, 2000.

123. According to Puja Kim, these men were members of a group of former soldiers who were detained as war criminals in China after World War II. After they were repatriated, they formed a network to share their wartime experiences ("Global Civil Society," 619 n. 14).

124. Women's Tribunal (KC), DVD #9, December 10, 2000.

125. Women's Tribunal, "Concluding Speeches by Co-Chief Prosecutors," transcript, December 10, 2000, lines 1783–86, document housed at the Korean Council.

126. Women's Tribunal (WAM), Video #30131, December 8, 2000.

127. Stephen, *We Are the Face*, 9.

128. VAWW-NET Japan, "Charter."

129. Women's Tribunal (KC), DVD #2, December 8, 2000; and Women's Tribunal (WAM), Video #30132, December 8, 2000.

130. Johnson, *Appropriating Blackness*, 127, 128.

131. Taylor, *Archive and the Repertoire*, 18–21.

132. Ibid., 178, 185.

133. Ibid., 185.

134. Women's Tribunal (KC), DVD #2, December 8, 2000; and Women's Tribunal (WAM), Video #30132, December 8, 2000.

135. Walter Rundle, "Jap 'Comfort Girls,'" *C.B.I. Roundup*, November 30, 1944, accessed August 4, 2016, http://www.cbi-theater.com/roundup/roundup113044.html. *C.B.I. Roundup* was a free newspaper published by and for men in the US military serving in the China-Burma-India theater of World War II. For more on *C.B.I. Roundup*, see E. Gartley Jaco, "At Long Last, Roundup's Own Story," accessed August 4, 2016, http://www.cbi-theater.com/roundup/roundup-story.html

136. Prosecutors also showed photographs of scarred bodies. During the Korean presentation, the team presented slide after slide of photographs of scarred bodies as material evidence of the system's violence. The most common image was of scars on the abdomen. The most unusual image showed purple-stained "scars of humiliation," or tattoos, carved onto Chun Ok Sun's chest, gums, lips, and tongue by soldiers. See Women's Tribunal (KC), DVD #2, December 8, 2000; and Women's Tribunal (WAM), Video #30132, December 8, 2000.

137. VAWW-NET Japan, "Public Hearing."

138. The Women's Caucus for Gender Justice was formed in 1997 to ensure the presence of a gender perspective at the International Criminal Court (ICC). For more on the work of the Women's Caucus for Gender Justice in shaping the ICC, see Spees, "Women's Advocacy."

139. "My Vagina Was My Village" is told from the perspective of a Bosnian woman who survived rape. According to Charlotte Bunch, this monologue speaks to the horrible violence that women still face today. See Public Hearing on Crimes against Women in Recent Wars and Conflicts (WAM), Video #30173, December 11, 2000.

140. Public Hearing on Crimes against Women in Recent Wars and Conflicts (WAM), Video #30169, December 11, 2000.

141. Women's Caucus for Gender Justice, "About the Public Hearing."

142. Women's Caucus for Gender Justice, "Public Hearing on Crimes against Women in Recent Wars and Conflicts: A Compilation of Testimonies," WAM 1-13 02266, December 11, 2000, 62.

143. Public Hearing on Crimes against Women in Recent Wars and Conflicts (WAM), Video #30169, December 11, 2000.

144. Ibid.

145. Ibid.

146. Okinawa has a long history of US military presence and militarized sexual violence against women. Okinawa was a US protectorate from the end of World War II until 1972. The 1995 rape of a local girl by three US soldiers prompted a public outcry. Okinawan women connected with activists in South Korea and the Philippines to deal with the issue of military sex work. See Mackie, *Feminism in Modern Japan*, 216–17.

147. Eric Talmadge, "GIs Frequented Japan's 'Comfort Women,'" *Washington Post*, April 25, 2007, accessed August 4, 2016, http://www.washingtonpost.com/wp-dyn/content/article/2007/04/25/AR2007042501801.html

148. Tanaka, *Japan's Comfort Women*, 133–66; and Koikari, *Pedagogy of Democracy*, 163–65.

149. Tanaka, *Japan's Comfort Women*, 147.

150. Soh, *Comfort Women*, 207.

151. Moon, *Sex Among Allies*, 127.

152. Dudden makes a similar point ("'We Came to Tell the Truth,'" 597). During the Women's Tribunal when a prosecutor presented on Japanese "comfort women," she did show a map of Okinawa that suggested that the US military was involved in continuing forms of sexual exploitation of Japanese women during the occupation, but she did not directly implicate the US military or go into detail about the afterlife of the "comfort system" on the island. See Women's Tribunal (KC), DVD #9, December 10, 2000; and Women's Tribunal (WAM), Video #30149, December 10, 2000.

153. Public Hearing on Crimes against Women in Recent Wars and Conflicts (WAM), Video #30169, December 11, 2000; Video #30170, December 11, 2000.

154. Quoted in Matsui, "Women's International War Crimes Tribunal," 126.

155. Women's Tribunal (KC), DVD #1, December 8, 2000.

156. Chinkin, "Women's International Tribunal," 339; and *Prosecutors and the Peoples of the Asia-Pacific Region*, 15.

157. For a transcript of the final judgment delivered in The Hague, see Women's Caucus for Gender Justice, "Transcript."

158. "NGO Shadow Report," 9. Many thanks to Mina Watanabe, secretary-general of the Women's Active Museum on War and Peace, for sharing this document with me.

159. Felman, *Juridical Unconscious*, 162.

160. Mee Hyang Yoon, interview.

161. For more on reasons for the underreporting of sexual abuse in human rights investigations and reports, see Hayner, *Unspeakable Truths*, 86–88.

162. Walker, "Gender and Violence," 18.

163. Ibid.

164. Crosby and Lykes, "Mayan Women Survivors Speak," 461, 464.

165. "Four Special Exhibitions 2005–2006."

166. "Herstory," Women's Active Museum brochure, 2010, in author's possession.

167. Mina Watanabe, interview.

168. Ibid.

169. WAM has two paid staff workers and many volunteers who lead museum tours, work on publicity and exhibits, and collect research material. In addition, volunteers and members of the WAM steering committee have actively supported survivors and advocated for state redress from the Japanese government.

170. Mina Watanabe, interview.

171. Tomasa Salinog was the inspiration for *The Story of Lola Masing* (2008), a Japanese community-based musical about a Filipina "comfort woman." Salinog testified at the Women's Tribunal and attended the opening ceremony of the Women's Active Museum.

Chapter 3

1. The Korean/Canadian Hanuree Drama Club in Toronto hosted the Nabi Theatre Company for a performance at the Evergreen Cultural Centre on November 20–22, 2008. See Yeon-yong An, "Wianbu Halmonishilhua Yeunguk 'Nabi'" [The True Story of Comfort Women Grandmothers in the Play "Nabi"], *Hankook Ilbo* [Korea Times], November 19, 2008, accessed February 21, 2011, http://www.koreatimes.com/article/487414

2. For exemplary work on the restorative power of theater that addresses histories of violence, see, for example, Patraka, *Spectacular Suffering*; Rokem, *Performing History*; Harry J. Elam Jr., *Taking It to the Streets*; Harry J. Elam Jr. and Michele Elam, "Blood Debt"; Harvey Young, *Embodying Black Experience*; Colbert, *African American Theatrical Body*; Chambers-Letson, *Race So Different*; and Breed, *Performing the Nation*.

3. Branislav Jakovljević's point about the possibilities of theater as a mechanism or a site of anger and retribution that can foster a critical consciousness helped me see how redressive theater about the "comfort women" history can cultivate a social consciousness. See Jakovljević, "Look Ahead in Anger: Theatre and Politics of Passion," paper presented at the American Society for Theatre Research Conference, Portland, Oregon, November 7, 2015. Freddie Rokem and Damon Krometis, for example, discuss the potential for witnessing in the space of what Rokem calls "both inside and outside the fictional frame" and in the movement between what Krometis describes as "in and above the play's action." While my definition of *extrospection* resonates with their conceptions of "outside" and "above," my invocation of *introspection* focuses more on the audience members' self-reflection and scrutiny of their relation to the staged subject matter.

See Rokem, *Performing History*, 37; and Krometis, "Dissonant Witnessing," 322. For more on witnessing in the theater, see, for example, Taylor, *Disappearing Acts*; Wake, "Accident and the Account"; and Solga, *Violence Against Women*.

4. Chungmi Kim, *Comfort Women*, 91. *Comfort Women*, directed by Frances Hill, premiered at Urban Stages on October 23–November 28, 2004. Urban Stages is an award-winning not-for-profit Off-Broadway theater company founded in 1984 by current artistic director Frances Hill ("About Us").

5. *Hanako, Comfort Women*, and *Nabi* join a flourishing body of theatrical work on the history of "comfort women." Some theatrical representations include Doo-rae Han, *Sorieomneun Manga* [A Silent Dirge] (Korea, 1993); Gil-cha Hur, *Noeure Waseo Noeure Gada* [Coming and Going at Sundown] (Korea and Galway, 1995, 1997); Miyagi Satoshi, *Medea* (Japan, 1999); Shi-Zheng Chen, *Forgiveness* (United States, 2000); Jeany Park, *Falling Flowers* (United States, 2003); Eve Ensler, "Say It, for the 'Comfort Women,'" in *The Vagina Monologues* (part of the V-Day Global Campaign for "Comfort Women") (United States, 2006); Aida Karic, *The Trojan Women: An Asian Story* (Austria, United States, and Korea, 2007); Haerry Kim, *Face* (United States and Korea, 2009, 2011); Hae-sung Lee, *Ppalganshi* [Red Poem] (Korea, 2011); and Jung-mo Yoon, *Bongseonhwa* [Garden Balsam] (Korea and United States, 2013, 2014). These stage productions join a robust body of artistic representations of the history of "comfort women" in literature, visual arts, music, and dance.

6. *The Comfort Women* won the Grand Prize at the University of Southern California (USC) One-Act Play Festival in 1995. It was completed with the Jerome Lawrence Playwright Award from the USC Professional Writing Program and was also a finalist of the O'Neill Playwrights Conference. See Chungmi Kim, *Comfort Women*, 52, 54.

7. Ibid., 54; and Diane Haithman, "Baring the Scars of Shame," *Los Angeles Times*, April 4, 1999, accessed April 23, 2015, http://articles.latimes.com/1999/apr/04/entertainment/ca-23914

8. Chungmi Kim, *Comfort Women*, 54.

9. Ibid.

10. *Hanako* premiered at East West Players on April 7, 1999, as part of the company's thirty-third season, which was titled "The Sound of a Voice." See also Chungmi Kim, *Comfort Women*, 54.

11. Diane Haithman, "Baring the Scars of Shame," *Los Angeles Times*, April 4, 1999, accessed April 23, 2015, http://articles.latimes.com/1999/apr/04/entertainment/ca-23914

12. See Esther Kim Lee, introduction, xvi, xvii; and "Production History & Archive," *East West Players*, accessed June 12, 2015, http://www.eastwestplayers.org/about/production-history-archive/

13. Esther Kim Lee, introduction, xvi.

14. Esther Kim Lee notes a few exceptions (ibid., xvii).

15. Diane Haithman writes, "East West Players artistic director Tim Dang says he already was interested in the story of comfort women when Kim sent her script to the theater for consideration. And the play fit, too, because the theater had been looking for ways to reach out to Los Angeles' fast-growing Korean community" ("Baring the Scars of Shame," *Los Angeles Times*, April 4, 1999, accessed April 23, 2015, http://articles.latimes.com/1999/apr/04/entertainment/ca-23914). Dang stepped down in June 2016 and was replaced by Snehal Desai.

16. Quoted in Lin, "Tragedy Retold."

17. Ibid.

18. Frances Hill, e-mail to author, October 2, 2016. Urban Stages, which Hill founded, aims to "champion new works by artists of diverse cultural backgrounds and to make these works available to all" ("About Us"). As artistic director, Hill is also interested in plays that bring "out the cross-cultures in New York, where we live," so the company develops and produces plays by "multiethnic playwrights that speak to the whole of society." See Onofri, "Women Who Run the Show."

19. Frances Hill, e-mail to author, October 2, 2016.

20. The low attendance among Koreans and Korean Americans might have been related to the distance between the theater in Manhattan and Queens, where most first-generation Koreans live, and the absence of a theatergoing culture among Korean Americans. Frances Hill does note that the "play toured through the Queen's Asian communities and the other boroughs of New York" as part of the On Tour series, an outreach program organized by Urban Stages. See Hill, e-mail to author, October 2, 2016.

21. Wilson, "Comfort Women."

22. Sandman, "*CurtainUp* Review."

23. Bacalzo, "Reviews: *Comfort Women.*"

24. On April 28, 2004, the now-infamous Abu Ghraib photos of prisoner abuse hit the Internet. Preliminary hearings in the trial of Saddam Hussein began in the summer of that year, and US forces launched a major assault in Fallujah in November.

25. Hesford, "Staging Terror," 35.

26. Edward Rothstein, "Onstage, the War Never Ends as Playwrights Pose Questions of Responsibility and Guilt," *New York Times*, November 8, 2004, accessed September 28, 2016, http://www.nytimes.com/2004/11/08/theater/reviews/onstage-the-war-never-ends-as-playwrights-pose-questions-of.html

27. Ibid.

28. The five permanent members are China, France, the Russian Federation, the United Kingdom, and the United States. The protests failed, and Japan served as a nonpermanent member in 2005–6, one of eleven two-year terms to which the country has been elected. See UN Security Council, "Countries Elected Members"; "Japan Elected for Record 11th Time to U.N. Security Council Nonpermanent Seat," *Japan Times*, October 16, 2015, ac-

cessed October 27, 2016, http://www.japantimes.co.jp/news/2015/10/16/
national/politics-diplomacy/japan-elected-record-11th-time-nonpermanent-
unsc-member-ukraine-also-gets-seat/#.WBIrI3eZO-o

29. Don Shirley, "A Grim Past Lives with Them Still: 'Hanako' Struggles to Capture the Soul-Searing Experiences of WWII 'Comfort Women,'" *Los Angeles Times*, April 9, 1999, accessed October 19, 2010, http://articles.la times.com/1999/apr/09/entertainment/ca-25560

30. It is rare to hear of former military sex slaves who have immigrated to the United States outside fictional works such as this play and Keller's novel, *Comfort Woman*.

31. The grandmother is not completely forthright with her granddaughter, telling her only that her great-uncle was "drafted into the Japanese Army and got killed during World War II." The grandmother provides the full details only to the other survivors. See Chungmi Kim, *Comfort Women*, 61, 69.

32. Kang, "Conjuring 'Comfort Women,'" 27, 36.

33. Chungmi Kim, *Comfort Women*, 64.

34. Ibid., 77.

35. Edward Rothstein, "Onstage, the War Never Ends as Playwrights Pose Questions of Responsibility and Guilt," *New York Times*, November 8, 2004, accessed September 28, 2016, http://www.nytimes.com/2004/11/08/theater/reviews/onstage-the-war-never-ends-as-playwrights-pose-questions-of.html

36. The Korean Council for the Women Drafted for Military Sexual Slavery by Japan advocated that the South Korean government provide support for survivors. In 1993, the South Korean National Assembly passed the Iljeha Ilbongun Wianbu Pihaeja Saenghwaranjeongjiwonbeop [Daily Life Stability Support Act for Women Drafted for Military Sexual Slavery by Japan]; it provides survivors with "housing, living expenses, and free medical services." See Hanguk Jeongsindae Munje Daechaek Yeobuihoe, *Jiulsu Eomneun Yeoksa*, 40; and Mee-hyang Kim and Ji-hoon Kim, "Government Begins Cash Payments to Former Comfort Women," *Hankyoreh*, October 15, 2016, accessed October 20, 2016, http://english.hani.co.kr/arti/english_edition/e_international/765828.html

37. Mee-hyang Kim and Ji-hoon Kim, "Government Begins Cash Payments to Former Comfort Women," *Hankyoreh*, October 15, 2016, accessed October 20, 2016, http://english.hani.co.kr/arti/english_edition/e_international/765828.html

38. In her analysis of Gil-cha Hur's play *Noeure Waseo Noeure Gada* [Coming and Going at Sundown] (1997), Jung-Soon Shim writes about the play's depiction of the "double oppression" endured by "comfort women" survivors such as the play's protagonist who are unable to return to their families because of a "sense of shame" and "fear of social ostracism" ("Coming and Going at Sundown").

39. Chungmi Kim, *Comfort Women*, 64, 63, 75.

40. Ibid., 75.

41. Ibid., 67. In 1996, Radhika Coomaraswamy, the UN special rapporteur on violence against women, submitted a report on the "comfort women" issue that has become known as the Coomaraswamy Report. See Soh, *Comfort Women*, 48; and Coomaraswamy, "Report.

42. A typical script for testimony includes information about where the woman was born, the circumstances under which she entered sexual slavery, her experiences during captivity, her return home, and her involvement in the social movement for redress.

43. Chungmi Kim, *Comfort Women*, 74, 75.

44. Ibid., 91.

45. Herman, *Trauma and Recovery*, 37.

46. Caruth, *Unclaimed Experience*, 58; and Caruth, "Violence and Time," 25.

47. Chungmi Kim, *Comfort Women*, 92.

48. Ibid., 93.

49. Eunmi Bang, interview.

50. Chungmi Kim, *Comfort Women*, 99.

51. Ibid., 99–100.

52. Yoon-young Lee, "Yeunchulgawa Gwangaek Oohlleen Yeunguk 'Nabi'" [Tears of the Producers and Audience for "Nabi"], *Yeonhap Nyuseu* [Yonhap News], May 6, 2005, accessed March 9, 2011, http://news.naver.com/main/read.nhn?mode=LSD&mid=sec&sid1=104&oid=001&aid=0000995377

53. Eunmi Bang's Arirang Theatre Company first produced the play. It later changed its name to the Nabi Theatre Company. For a review of the production at the Evergreen Cultural Centre in Vancouver, see Yeonyong An, "Wianbu Halmeoni Silhwa Yeongeuk Nabi" [The True Story of Comfort Women Grandmothers in the Drama Nabi], *Hankook Ilbo* [Korea Times], November 19, 2008, accessed April 23, 2015, http://www.koreatimes.com/article/487414

54. *Nabi* means "butterfly" in Korean. Activists use butterflies as a kind of mascot for the survivors, symbolizing their coming out about their past and their liberation as survivors. Eunmi Bang, the play's director, explains that Jina's grandmother is like a butterfly: when she represses her past, she is trapped in the "caterpillar stage," and when she accepts her past, she emerges as a butterfly. Bang adds that she hopes that the story of survivors as told through her productions will "spread far with the butterfly effect." Finally, the audience transitions from a "caterpillar" state of ignorance about the past to "butterflies" who know the "truth and follow through with action" (Eunmi Bang, interview).

55. Ibid. An unnamed friend of Bang's translated the script. The playwright also offered suggestions regarding the translation and restructuring and attended rehearsals to provide feedback.

56. Ibid.

57. Lisa Kocian, "Ban Book from Class, Panel Says: Wartime Memoir Called Too Explicit for 6th Grade," *Boston Globe*, November 12, 2006, accessed December 4, 2010, http://www.boston.com/news/local/articles/2006/11/12/ban_book_from_class_panel_says/

58. Lisa Kocian, "Author Defends 'Bamboo Grove' Memoir," *Boston Globe*, February 15, 2007, accessed December 4, 2010, http://archive.boston.com/bostonglobe/regional_editions/globe_west/west/2007/02/author_defends.html

59. Carter Eckert, "A Matter of Context," *Boston Globe*, December 16, 2006, accessed December 6, 2010, http://www.boston.com/news/globe/editorial_opinion/oped/articles/2006/12/16/a_matter_of_context/?rss_id=Boston

60. Aruna Lee, "Korean Americans Protest Inclusion of Controversial Novel in Schools," *New America Media*, February 14, 2007, accessed July 18, 2017, https://web.archive.org/web/20080306111924/http:/news.newamericamedia.org/news/view_article.html?article_id=71df52682d036af6b43d421187b37cb1

61. Ibid.

62. Grace M. Cho, *Haunting the Korean Diaspora*, 7.

63. Eunmi Bang, interview.

64. Ibid.

65. Ibid.

66. "Arirang" conveys longing, separation, and resilience; it can be sung in an upbeat way or a slower, more elegiac manner. There are many regionally specific variations. See Dunbar, "Arirang."

67. Eunmi Bang, interview.

68. Ibid. For more on other productions of *Nabi* in Seoul schools, see Sangdon Pak, "Yeongeung 'Nabi' Seoul 6 Gae Hakgyoseo Gongyeon" [Performances of the Play "Nabi" at 6 Schools in Seoul], *Yeonhap Nyuseu* [Yonhap News], May 8, 2007, accessed August 12, 2015, http://news.naver.com/main/read.nhn?mode=LSD&mid=sec&sid1=103&oid=001&aid=0001629972

69. Eunmi Bang, interview.

70. Quoted in Il-man Heo, "Jonggun Wianbuui Apeumeul Geurin Yeongeuk 'Nabi' Hakgyoro Gada" ["Nabi" Depicting Pains of Comfort Women Visits School], *Seoulgyoyuksosikji* [Seoul Education News], August 1, 2007, 9.

71. I saw *The Trojan Women: An Asian Story* at the Alexander Kasser Theater in Montclair, NJ, on October 20, 2007. It was a coproduction of Schauspielhaus Wien, Wiener Festwochen, Wuturi Players, Seoul Arts Center, and Peak Performances @ Montclair State University.

72. Aida Karic arrived in Vienna in 1992 as a war refugee. In 2000, she was in residence at the Schauspielhaus Wien, a progressive theater in Vienna, as director, author, and dramaturg. For more on mass rape during the Bosnian war, see Radio Free Europe/Radio Liberty, "Amnesty Urges Justice."

73. Quoted in Soyeon Kim, "Teuroi Yeoindeurui Bigeuk Wianbuui Hangwa Jeommoksikyeotjyo" [The Han of Comfort Women Is Grafted onto the Tragedy of the Trojan Women], *Hankook Ilbo* [Korea Times], November 13, 2007, A30.

74. The original title was *Les Orchidées Rouges de Shanghai* (2001).

75. Hall, introduction, xvi–xvii; and Clay, introduction, 7.

76. Barbara Petsch, "Vom Sterben im Leben. 'Die Troerinnen' im Schauspielhaus. Grosspartig und Erschutternd" [Of Dying in Living: "The Trojan Women" at the Schauspielhaus. Brilliant and Shocking], *Die Presse* [The Press], May 5, 2007, accessed October 30, 2015, http://diepresse.com/home/kultur/news/302244/Vom-Sterben-im-Leben

77. Edwidge Danticat writes that people often depended upon the arts—reading, writing, adapting and staging the classics—during the repressive regime of Francois Duvalier as modes of survival and resistance. "Because those writers who were still in Haiti, not yet exiled or killed, could not freely perform or print their own words outright," she writes, "many of them turned, or returned, to the Greeks" (*Create Dangerously*, 9).

78. Petra Rathmanner, "Missbrauch, jahrtausendelang" [Thousand-Year-Long Abuses], *Wiener Zeitung* [Vienna News], May 6, 2007, accessed November 19, 2015, http://www.wienerzeitung.at/nachrichten/kultur/buehne/273205_Missbrauch-jahrtausendelang.html

79. Barbara Petsch, "Vom Sterben im Leben. 'Die Troerinnen' im Schauspielhaus. Grosspartig und Erschutternd" [Of Dying in Living. "The Trojan Women" at the Schauspielhaus. Brilliant and Shocking], *Die Presse* [The Press], May 5, 2007, accessed October 30, 2015, http://diepresse.com/home/kultur/news/302244/Vom-Sterben-im-Leben

80. Even though the "comfort women" topic had received extensive newspaper attention before the play had its US premiere (H.R. 121 was passed three months before the production at the Kasser Theater), the choice of venue likely limited the American audience for *The Trojan Women*. For a short review of the American production, see Peter Filichia, "Play about War's Savagery Links Ancient Troy to WWII Japan," *Star-Ledger*, October 19, 2007, accessed November 20, 2007, http://www.nj.com/entertainment/arts/index.ssf/2007/10/play_about_wars_savagery_links.html

81. Hyeon Noh, "Geuriseu Bigeukgwa Mannan Wianbudeul" [The Comfort Women Meet Greek Tragedy], *Maeilgyeongje* [Maeil Business News], October 22, 2007, A35; and Yoon Kyung Hyun, "Teuroi Yeoindeul Yeonchul Karichi" [Karic, Director of The Trojan Women]," *Yeonhap Nyuseu* [Yonhap News], November 12, 2007, accessed October 30, 2015, http://news.naver.com/main/read.nhn?mode=LSD&mid=sec&sid1=103&oid=001&aid=0001817823

82. Sunsook Kang, the *pansori* singer in *The Trojan Women*, is a re-

nowned artist. *Pansori* is ranked as Korea's national treasure No. 5 in the category of nonvisual arts (Alexander Kasser Theater 2007) and was designated an Intangible Cultural Asset by the Korean Ministry of Culture in 1964 and a Masterpiece of Oral and Intangible Heritage of Humanity by UNESCO in 2003. *Pansori* is performed by a solo vocalist who tells a dramatic narrative through *sori* [song], *aniri* [dialogue and narration], and *pallim* [gestures] to the accompaniment of a drummer. Originating in the seventeenth century in the ritual songs of shamans, *pansori* had evolved from a form of outdoor folk entertainment to indoor entertainment for the elite by the mid-nineteenth century. See Kasser Theater, playbill for *The Trojan Women: An Asian Story*, October 18-21, 2007; Um, "New *P'ansori*," 24–25; Oh-Kon Cho, "Korea," 188; and Willoughby, "Sound of *Han*," 20.

83. "Pansori Epic Chant," *UNESCO Intangible Cultural Heritage*, accessed September 29, 2014, http://www.unesco.org/culture/ich/en/RL/pansori-epic-chant-00070

84. Yoon Kyung Hyun, "Teuroi Yeoindeul Yeonchul Karichi" [Karic, Director of The Trojan Women]," *Yeonhap Nyuseu* [Yonhap News], November 12, 2007, accessed October 30, 2015, http://news.naver.com/main/read.nhn?mode=LSD&mid=sec&sid1=103&oid=001&aid=0001817823

85. See, for example, Knowles, *Theatre and Interculturalism*; Lei, "Interruption, Intervention, Interculturalism"; Lo and Gilbert, "Toward a Topography"; and Holledge and Tompkins, *Women's Intercultural Performance*.

86. Lo and Gilbert, "Toward a Topography," 44.

87. Claire Sung, interview.

88. Aida Karic, "Director's Note," program for *The Trojan Women: An Asian Story*, Seoul Arts Center, 7.

89. Lei, "Interruption, Intervention, Interculturalism," 574.

90. Ibid., 571, 574.

91. Sam-Jin Kim, interview.

92. I did not have an opportunity to interview the *pansori* singer or the composer. It would have been interesting to see if they agreed with the Wuturi Players' frustrations.

93. Aida Karic, "The Trojan Women: An Asian Story," script, 2, in author's possession.

94. Ibid., 3.

95. Ibid., 4.

96. Rokem, *Performing History*, xii.

97. Rokem makes a similar point. The actor-witness, he writes, "draw[s] his or her authority from some kind of direct experience of the Shoah, in spite of the problematic status of such first-person narratives" (ibid., 33).

98. Aida Karic, "The Trojan Women: An Asian Story," script, 3, in author's possession.

99. Ibid., 4.

100. Ibid.

101. Ibid, 3.

102. Ibid.

103. Chuh, "Discomforting Knowledge," 10.

104. Aida Karic, "The Trojan Women: An Asian Story," script, 4, in author's possession.

105. Ibid.

106. Ibid., 5.

107. Peter Filichia, "Play about War's Savagery Links Ancient Troy to WWII Japan," *Star-Ledger*, October 19, 2007, accessed November 20, 2007, http://www.nj.com/entertainment/arts/index.ssf/2007/10/play_about_wars_savagery_links.html

108. Rokem, *Performing History*, 36.

109. Literary scholar Elaine Scarry discusses how physical pain is unshareable and resistant to language (*Body in Pain*, 4). For more on the performance of pain in the production, see Son, "Korean Trojan Women," 379-382.

110. When asked whether she ever hesitated in choreographing these scenes of violence, choreographer Sam-Jin Kim gave a surprising response. "I should have expressed [the violence] even more." She wished that the scene with blood had been more dramatic with additional lighting and sound: "I don't think we were able to make it as spectacular as it could have been" (Sam-Jin Kim, interview).

111. Korea has various regional shamanic rituals with distinct sets of roles for participants, narratives and chants, costumes, food offerings, songs, musical accompaniment, dance, and other physical movement. See Huhm, *Kut*. For more on the rituals conducted by members of the Association for the Preservation of Hwanghae-do Shamanic Ritual for "comfort women" survivors, see David Kim, "Critical Mediations."

112. Sam-Jin Kim interview.

113. For more on the limitations of the "reconciliation narrative" in theatrical productions about apartheid in South Africa, see Cole, "Blanket of Reconciliation."

114. Kasser Theater, playbill for *The Trojan Women: An Asian Story*, October 18–21, 2007.

115. *Josen* is the Japanese word for *Korea*, and *ppi* is the English letter *P*, for *prostitute*. See "Stage Play 'Bongseonhwa.'"

116. Quoted in "Stage Play 'Bongseonhwa.'"

117. Quoted in Hiroko Tabuchi, "Women Sent to Brothels Aided Japan, Mayor Says," *New York Times*, May 14, 2013, A7.

118. Ibid.

119. Quoted in Hongju Yang and Sangsun Shin, "Yeongeugiran Jangneuman Danji Billyeowasseul Ppuntt . . . Wianbuui Silje, Dakyue Gakkapge Jeondal Noryeok" [The Medium of Theater Is Only Borrowed . . . I Strove to

Portray the Reality of Comfort Women, Almost Like a Documentary], *Hankook Ilbo* [Korea Times], November 20, 2013, accessed January 15, 2016, http://news.zum.com/articles/10048694?cm=popular

120. Quoted in "Stage Play 'Bongseonhwa.'"

121. Jung-mo Yoon, "Bongseonhwa," script, 12, in author's possession.

122. *KAN-WIN*.

123. Jung-mo Yoon, "Bongseonhwa," script, 21, in author's possession.

124. Ibid., 22–23.

125. Namjin Kim, Yoongyu Seong, and Seonah Lee, "Gwangaegui Nun: Seoulsigeukdan Bongseonhwareul Bogo" [Audience's Viewpoint: Reviewing Seoul Metropolitan Theater's Bongseonhwa], *Mun Hwa Gong Gan* [Culture Center], June 2014, accessed January 6, 2016, http://navercast.naver.com/magazine_contents.nhn?rid=1526&contents_id=57024

126. Jung-mo Yoon, "Bongseonhwa," script, 25, 27, in author's possession.

127. Ibid., 29.

128. Hye Ryun Kim, "Welcoming Words," program for *Bongseonhwa*, 4, performed at the North Shore Center for the Performing Arts, Skokie, IL, August 2, 2014.

129. Janice C. H. Kim, *To Live to Work*, 130; and Hanguk Jeongsindae Munje Daechaek Yeobuihoe, *Jiulsu Eomneun Yeoksa*, 10.

130. Jung-mo Yoon, "Bongseonhwa," script, 17–18, 49, in author's possession.

131. Jung-mo Yoon, "Bongseonhwa," script, 11, in author's possession.

132. Jongum Im, "Jeonguk Ilbongun 'Wianbu' Chumo Chohyungmul Hyunhwanggwa Owichi" [Nationwide Status and Location of Tribute Sculptures for Japanese Military "Comfort Women"], *Kyungnamdomin Ilbo* [Kyungnam Domin News], September 22, 2015, accessed September 16, 2016, http://m.idomin.com/?mod=news&act=articleView&idxno=490454

133. Jung-mo Yoon, "Bongseonhwa," script, 19, in author's possession.

134. Ibid., 31.

135. "Stage Play 'Bongseonhwa.'"

136. Ibid.

137. Jung-mo Yoon, "Bongseonhwa," script, 33, in author's possession.

138. Hongju Yang and Sangsun Shin, "Yeongeugiran Jangneuman Danji Billyeowasseul Ppuntt . . . Wianbuui Silje, Dakyue Gakkapge Jeondal Noryeok" [The Medium of Theater Is Only Borrowed . . . I Strove to Portray the Reality of Comfort Women, Almost Like a Documentary], *Hankook Ilbo* [Korea Times], November 20, 2013, accessed January 15, 2016, http://news.zum.com/articles/10048694?cm=popular

139. Martin, "Bodies of Evidence," 10.

140. Tae Hyung Song, "Mudae Eoneoro Chiyuhan Wianbu Sangcheowa Seulpeum" [Healing the Wounds and Sadness of the Comfort Women through Stage Language], *Hangukgyeongje* [Korea Economic Daily], November 25,

2013, accessed January 6, 2016, http://www.hankyung.com/news/app/news-view.php?aid=2013112481011

141. Ji Eun Yeom, "Seoulsigeukdan 'Bongseonhwa' Haegyeolhago Gayahal Yeoksajeok Gwaje Gagin" [Seoul Metropolitan Theater's "Bongseonhwa": Historical Burden to Resolve], *Painaensyeol Nyuseu* [Financial News], December 1, 2013, accessed January 6, 2016, http://www.fnnews.com/news/201312011134420528?t=y

142. Iseul Gang, "Wianbu Yeongeuk 'Bongseonhwa,' Bulpyeonhan Eokji Gamdong·Seulpeum" [Comfort Women Play "Bongseonhwa," Unnaturally Forcing Affect and Sadness], *Nyuseutudei* [News2Day], November 19, 2013, accessed January 6, 2016, http://www.news2day.co.kr/n_news/news/view.html?no=38690Negative%20review.%20Criticizes%20that%20it%20was%20overly%20emotional

143. Brittany Levine, "Former 'Comfort Women' Visit Statue," *Los Angeles Times*, July 24, 2014, accessed March 20, 2015, http://www.latimes.com/tn-gnp-former-comfort-women-visit-statue-20140724-story.html

144. "Former Comfort Women Visit L.A. to Support Glendale Statue," *Korea Times*, July 23, 2014, accessed August 29, 2014, http://www.koreatimesus.com/former-comfort-women-visit-l-a-to-support-glendale-statue/

145. Hyung-jae Kim, "Visiting Former Comfort Women Boycott Glendale Statue's 1-Year Anniversary Event," *Korea Times*, July 29, 2014, accessed August 29, 2014, http://www.koreatimesus.com/visiting-former-comfort-women-boycott-glendale-statues-1-year-anniversary-event/

146. Quoted in "Former Comfort Women Accuse Play of Distortion," *Korea Times*, August 4, 2014, accessed November 4, 2015, http://www.koreatimesus.com/former-comfort-women-accuse-play-of-distortion/

Chapter 4

1. Haye-ah Lee, "Former 'Comfort Women' Hold 1,000th Weekly Rally against Japan," *Yonhap News*, December 14, 2011, accessed September 24, 2016, http://english.yonhapnews.co.kr/national/2011/12/14/44/0301000000AEN20111214008800315F.HTML

2. Quoted in Huiseon Kim, "20nyeon Heullin Halmeonideurui Nunmul . . . 'Wianbu' Munje Josoki Haegyeoreul" [Tears Shed for 20 Years by the Grandmothers . . . Immediately Resolve the "Comfort Women" Issue], *Yeoseongsinmun* [Women's News], December 14, 2011, accessed September 24, 2016, http://womennews.co.kr/news/51719. For more about Bok Dong Kim, see Ji-soo Kim, "Kim Bok-dong Still Fighting for Sex Slave Victims," *Korea Times*, August 17, 2016, accessed July 21, 2017, http://www.koreatimes.co.kr/www/news/people/2016/08/178_212108.html

3. Activists, artists, and journalists refer to these objects as memorials or

monuments. In Korea, they are called *ginyeombi* [monument or memorial]. I
refer to them as memorials because the term includes a greater variety of me-
morial objects. Marita Sturken points out a useful distinction between the two
nouns: "Whereas a monument most often signifies victory, a memorial refers to
the life or lives sacrificed for a particular set of values" (*Tangled Memories*, 47).
Erika Doss notes "a major shift in American commemorative practices from
the monument to the memorial, from 'official' national narratives to the subjec-
tive symbolic expressions of multiple American publics" (*Memorial Mania*,
47). Drawing on Rebecca Schneider's "theory of monumentality," D. J. Hopkins
and Shelley Orr write, "To put our position in Schneider's terms: a memorial is
constructed with this 'mutually constitutive relationship' in mind; a monu-
ment is constructed in denial of any relationship between the official structure
and the pedestrian visitor (Schneider's 'passerby')" ("Memory/Memorial/Perfor-
mance," 47; and Schneider, "Patricide and the Passerby," 56).

4. Boram Park, "Girl Statue Should Remain to Conjure Up Japan's War-
time Atrocities: Creator," *Yonhap News*, September 1, 2016, accessed Sep-
tember 24, 2016, http://english.yonhapnews.co.kr/news/2016/09/01/26/020
0000000AEN20160901000251315F.html

5. The artists have collaborated with civic organizations and students to
make variations of the bronze girl statue. Woo-young Lee, "'Comfort Women'
Statues Resonate with Koreans," *Korea Herald*, March 3, 2016, accessed Oc-
tober 3, 2016, http://www.koreaherald.com/view.php?ud=20160303000844.
See also Sang-Hun Choe, "Statue Deepens Dispute over Wartime Sexual
Slavery," *New York Times*, December 15, 2011, accessed October 4, 2016,
http://www.nytimes.com/2011/12/16/world/asia/statute-in-seoul-becomes-
focal-point-of-dispute-between-south-korea-and-japan.html

6. Doss, *Memorial Mania*, 2.

7. Sturken, *Tangled Memories*, 2.

8. Schlund-Vials, *War, Genocide, and Justice*, 20.

9. James E. Young, *Texture of Memory*, xii. Memorials create the possi-
bility for what Dassia Posner calls "material performance." In writing about
puppetry, she defines "material performance" as "performance that assumes
that inanimate matter contains agency not simply to mimic or mirror, but
also to shape and create" (Introduction, 5).

10. See, for example, Kirshenblatt-Gimblett, *Destination Culture*; Glazer,
Radical Nostalgia; Hopkins, Orr, and Solga, *Performance and the City*; Har-
vey Young, *Embodying Black Experience*; and Schneider, *Performing Re-
mains*.

11. Quoted in Doss, *Memorial Mania*, 13; and Cvetkovich, *Archive of
Feelings*, 7.

12. Bernstein, *Racial Innocence*, 12–13.

13. The word *care* has roots in the Germanic word *karôjan*, which means
"to mourn, sorrow, have trouble, or trouble oneself." According to the *Oxford
English Dictionary*, *care* means "to sorrow or grieve; to be troubled, uneasy, or

anxious; to take thought for, provide for, look after, take care of; to have a regard or liking for" (*Oxford English Dictionary*, accessed October 7, 2016, http://www.oed.com/view/Entry/27902?rskey=D9nY5x&result=4#eid).

14. Sang-Hun Choe, "Statue Deepens Dispute over Wartime Sexual Slavery," *New York Times*, December 15, 2011, accessed September 29, 2016, http://www.nytimes.com/2011/12/16/world/asia/statute-in-seoul-becomes-focal-point-of-dispute-between-south-korea-and-japan.html?_r=0

15. Quoted in Sun-min Lee, "Statue Planned for Another Type of Victim," *Korea JoongAng Daily*, January 19, 2016, accessed September 24, 2016, http://koreajoongangdaily.joins.com/news/article/Article.aspx?aid=3014083

16. Eun Sung Kim and Seo Kyung Kim, interview.

17. Sun-min Lee, "Statue Planned for Another Type of Victim," *Korea JoongAng Daily*, January 19, 2016, accessed September 24, 2016, http://koreajoongangdaily.joins.com/news/article/Article.aspx?aid=3014083

18. Eun Sung Kim and Seo Kyung Kim, interview; and Boram Park, "Girl Statue Should Remain to Conjure Up Japan's Wartime Atrocities: Creator," *Yonhap News*, September 1, 2016, accessed September 24, 2016, http://english.yonhapnews.co.kr/news/2016/09/01/26/0200000000AEN20160901000251315F.html

19. Sang-Hun Choe, "Statue Deepens Dispute over Wartime Sexual Slavery," *New York Times*, December 15, 2011, accessed September 29, 2016, http://www.nytimes.com/2011/12/16/world/asia/statute-in-seoul-becomes-focal-point-of-dispute-between-south-korea-and-japan.html?_r=0

20. Eun Sung Kim and Seo Kyung Kim, interview.

21. Sorgenfrei, "Guilt, Nostalgia, and Victimhood," 185.

22. Quoted in Yun-hyung Gil, "Japanese Ambassador Says Comfort Woman Statue Is 'Not Helping,'" *Hankyoreh*, April 18, 2013, accessed April 18, 2013, http://english.hani.co.kr/arti/english_edition/e_international/583456.html

23. The practice of dressing Jizo statues is related to "accruing merit for the afterlife, a common theme in Buddhism" (Amy Chavez, "A Guide to Jizo, Guardian of Travelers and the Weak," *Japan Times*, March 31, 2012, accessed May 8, 2013, http://www.japantimes.co.jp/community/2012/03/31/our-lives/a-guide-to-jizo-guardian-of-travelers-and-the-weak/#.UYqlHILhjUU). For more on the ritual object of the Jizo statue, see also Law, "Puppet Think," 158–59.

24. Eun Sung Kim and Seo Kyung Kim, interview. There is no explicit connection between the bronze girl statue in Seoul and the Hiroshima Peace Memorial.

25. Quoted in Jeong-bong Lee, "The 'Comfort Women' Sculptors Aren't Done," *Korea JoongAng Daily*, December 29, 2012, accessed September 30, 2016, http://koreajoongangdaily.joins.com/news/article/Article.aspx?aid=2964622

26. Quoted in Hyo-jin Kim, "Heartfelt Memorials Resonate for Peace: Kim Eun-sung and Kim Seo-kyung, Sculptors Standing by Victims of War,"

Yonsei Annals, April 10, 2016, accessed September 27, 2016, http://annals.yonsei.ac.kr/news/articleView.html?idxno=1615

27. The House of Sharing has a similar statue of a young girl shadowed by an elderly woman. The statue of the young girl is also dressed in a *hanbok*. This statue is a replica of a painting by a survivor. Nearby is a statue of the torso of an elderly woman coming out of the earth. See Pilzer, *Hearts of Pine*, 23–24.

28. Eun Sung Kim and Seo Kyung Kim, *Jageun Sonyeosang*, 10.

29. See Pilzer, "'My Heart, the Number One,'" 36; and Pilzer, *Hearts of Pine*, 24, 94.

30. For this observation, I thank Jodi Kim and the other participants at the Histories of Violence Symposium, Northwestern University, May 10, 2013, who provided useful feedback on an earlier version of this section. Pilzer makes a similar point: "As the 'comfort women' survivors have become symbols of the national wound, the public expression of sexuality has become incompatible with the image of the archetypal 'comfort women grandmother'" (*Hearts of Pine*, 52). See also Soh, *Comfort Women*, 75.

31. Eun Sung Kim and Seo Kyung Kim, interview.

32. Suk-Young Kim, *Illusive Utopia*, 233.

33. Jung-yoon Choi, "South Korean Protesters Care for 'Comfort Woman' Statue," *Los Angeles Times*, January 11, 2012, accessed October 4, 2012, http://latimesblogs.latimes.com/world_now/2012/01/japanese-occupation-of-korea-comfort-women-protests-.html

34. Quoted in ibid.

35. Se Hwan Park, interview.

36. Eun Sung Kim and Seo Kyung Kim, interview.

37. Facebook post by Meang Suk Lee, April 25, 2016, accessed October 3, 2016.

38. Eun Sung Kim and Seo Kyung Kim, *Jageun Sonyeosang*, 11.

39. Rayner, *Ghosts*, 112.

40. Sturken, *Tangled Memories*, 46–47. For more on the names on the Vietnam Veterans Memorial, see *Tangled Memories*, 58–63.

41. In-jin Choi, "'Ugly Japanese' Insults Comfort Women Victim Again," *Kyunghyang Shinmun*, May 20, 2015, accessed October 4, 2016, http://english.khan.co.kr/khan_art_view.html?artid=201505201855487&code=710100

42. Quoted in Eun-joo Lee and Ki-hwan Kim, "Japanese Activist Stokes Netizen Ire with Video Stunt," *Korea JoongAng Daily*, June 23, 2012, accessed October 4, 2016, http://koreajoongangdaily.joins.com/news/article/article.aspx?aid=2954952

43. "Desecrating a Statue Honoring Korea's 'Comfort Women,'" *KBS World*, July 11, 2012, accessed October 5, 2012, http://world.kbs.co.kr/english/news/news_zoom_detail.htm?No=6795

44. "Angry Old Man Rams His Truck into Japanese Embassy," *Hankyo-*

reh, July 10, 2012, accessed October 5, 2012, http://www.hani.co.kr/arti/english_edition/e_international/541848.html

45. Roach, *Cities of the Dead*, 36, 2.

46. Quoted in Monsy Alvarado, "Uncomfortable Silence: At Palisades Park Memorial, Korean Women Tell of WWII Abuse," *Bergen County Record*, December 16, 2011, L1, L6.

47. A few days earlier, on December 13, 2011, in conjunction with the one thousandth Wednesday Demonstration, the Korean and Jewish women had shared their World War II experiences at an event, "Comfort Women and Holocaust Survivors Calling for Justice Together," at the Kupferberg Holocaust Resource Center. See KACE, "Press Conference."

48. KACE promotes civic participation in Korean American communities through activities such as voter registration campaigns, voter education events, youth internship programs on voter registration and Japanese war crimes during World War II, grassroots activist training programs, and memorial projects. See Korean American Civic Empowerment, accessed January 19, 2015, http://us.kace.org

49. Monsy Alvarado, "Uncomfortable Silence: At Palisades Park Memorial, Korean Women Tell of WWII Abuse," *Bergen County Record*, December 16, 2011, L1, L6.

50. In addition to coordinating events together, KACE and the Kupferberg Holocaust Center cosponsor the Northeast Asian History Internships. See KACE, "Education Program."

51. For more on Korean American populations, see Jie Zong and Jeanne Batalova, "Korean Immigrants in the United States," *Migration Policy Institute*, December 3, 2014, accessed October 29, 2016, http://www.migrationpolicy.org/article/korean-immigrants-united-states#Distribution

52. On March 8, 2013, a "comfort women" memorial joined the ring of memorials outside the Hackensack courthouse. See Monsy Alvarado, "Memorial Dedicated to Women Forced into Sexual Slavery during WWII," *Bergen County Record*, March 8, 2013, accessed October 29, 2016, http://www.northjersey.com/news/memorial-dedicated-to-women-forced-into-sexual-slavery-during-wwii-1.553020

53. Chejin Park, interview.

54. Korean American Civic Empowerment, "Korean American Civic Empowerment: Introduction to House of Representatives Japanese Military 'Comfort Women' Resolution and Memorial," information sheet, 6–7, in author's possession.

55. Tiron, "Korean-Americans Seek Resolution." For an excellent analysis of the "Americanization of Japanese war crimes," see Yoneyama, *Cold War Ruins*, 147–76.

56. In addition to Mike Honda, the resolution's two biggest supporters were Representative Tom Lantos and House Speaker Nancy Pelosi, both of

whom have large Korean American populations among their constituents. See Tiron, "'Comfort Women' Resolution."

57. Collet and Lien, "Transnational Politics," 1–2; and Tokudome, "Passage of H. Res. 121."

58. Tiron, "'Comfort Women' Resolution"; and Tokudome, "Passage of H. Res. 121."

59. Chejin Park, interview.

60. Ibid.

61. Korean American Civic Empowerment, "Korean American Civic Empowerment: Introduction to House of Representatives Japanese Military "Comfort Women" Resolution and Memorial," information sheet, 6–8, in author's possession.

62. Quoted in Schmertz, 'Comfort Women Memorial.'

63. Steven Cavallo, interview.

64. Ibid. Although it is possible to read the circle as a symbol for Imperial Japan, Steven Cavallo explains that he wanted a way to tie the whole image together and did not necessarily mean to depict the sun on the Japanese flag.

65. The Palisades Park memorial faced minimal local opposition. The mayor held open meetings with local residents to discuss the progress of the memorial. Two Jewish American sisters objected to comparisons with the Holocaust and said that the memorial does not belong in Palisades Park. Another man of Italian descent threatened to rip out plants installed by landscaper Young H. Paek.

66. Tae-ho Kwon and Nam-ku Jeong, "Japan Struggles against US Statue to Comfort Women," *Hankyoreh*, May 23, 2012, accessed January 27, 2015, http://english.hani.co.kr/arti/english_edition/e-international/534214.html

67. Steven Cavallo, interview.

68. "'Comfort Women' Memorial Set Up in New York State," *Chosun Ilbo*, June 18, 2012, accessed February 5, 2013, http://english.chosun.com/site/data/html_dir/2012/06/18/2012061800584.html

69. Kirk Semple, "In New Jersey, a War Memorial for 'Comfort Women' Deepens Old Animosity," *New York Times*, May 19, 2012, A17. David Lee, president of the Korean American Public Affairs Committee, was so upset that he decided to spearhead his own "comfort women" memorial project in Westbury, NY. See "'Comfort Women' Memorial Set Up in New York State," *Chosun Ilbo*, June 18, 2012, accessed February 5, 2013, http://english.chosun.com/site/data/html_dir/2012/06/18/2012061800584.html

70. Rebecca D. O'Brien, "Sign of Conflict at Korean Memorial as Fight over Tiny Island Echoes in Palisades Park," *Bergen County Record*, October 27, 2012, accessed September 30, 2016, http://www.northjersey.com/news/sign-of-conflict-at-korean-memorial-as-fight-over-tiny-island-echoes-in-palisades-park-1.493587

71. Eun-joo Lee, "Japanese Activist Admits to 2 Dokdo Stakes in U.S.," *Korea JoongAng Daily*, October 31, 2012, accessed October 7, 2016, http://

koreajoongangdaily.joins.com/news/article/article.aspx?aid=2961572 &ref=mobile; and S. P. Sullivan, "Korean American Group Says 'Comfort Women' Memorial Defaced in Palisades Park," *NJ.com*, October 26, 2012, accessed July 21, 2017, http://www.nj.com/bergen/index.ssf/2012/10/ korean_american_group_says_comfort_women_memorial_defaced_in_pali sades_park.html

72. Steven Cavallo, interview.

73. Quoted in Hanseo Seo, "Paelpak Girimbi Jikimi Yun Gumjongssi . . . 'Wianbu Halmeonideulkke Jageun Wiro Dwaesseumyeon'" [Palisades Park Memorial Keeper Gumjong Yoon . . . "Hope for Small Consolation for Comfort Women Grandmothers"], *JoongAng Ilbo* [Korea Daily], November 26, 2012, accessed October 1, 2016, http://www.koreadaily.com/news/read.asp?art_id=1534575. For an English translation and summary of this article and two other articles on the memorials, see Somi Park, trans., "Helping Hands and New Monument for Comfort Women," *Voices of NY*, December 28, 2012, accessed October 1, 2016, https://voicesofny.org/2012/12/helping-hands-and-new-monu ment-for-comfort-women/

74. Kyoung-tae Koh and Mi-hyang Yoon, "Vietnamese War Victims Speak of Sexual Violence by S. Korean Troops for the First Time," *Hankyoreh*, April 25, 2015, accessed October 7, 2016, http://english.hani.co.kr/arti/english_ edition/e_international/688435.html

75. Young H. Paek, interview.

76. Seo Hanseo, "'Wianbu Sonyeo,' HyungSang Boonjae Shimgi Oon-Dong" [Campaign to Plant Bonsais Representing 'Comfort Women' Girls," *JoongAng Ilbo* [Korea Daily], November 29, 2012, accessed April 25, 2013, http://www.koreadaily.com/news/read.asp?art_id=1537304. For a translation, see also Somi Park, trans., "Helping Hands and New Monument for Comfort Women," *Voices of NY*, December 28, 2012, accessed October 1, 2016, https://voicesofny.org/2012/12/helping-hands-and-new-monument-for-comfort-women/. Park does not correctly translate the landscaper's name; I use his preferred spelling.

77. Young H. Paek, interview.

78. Ibid.

79. Quoted in Seo, "'Wianbu Sonyeo.'"

80. Changhyeon Noh, "Mi Wianbugirimbie 'Gyeouldamyo' Deopgi Hwaje" [Covering American Comfort Women Memorial with "Winter Blanket" Attracts People's Attention], *Nyusiseu* [*Newsis*], February 9, 2014, accessed October 4, 2016, http://www.newsis.com/ar_detail/view.html?ar_id= NISX20140209_0012709093&cID=10104&pID=10100

81. An earlier West Coast "comfort women" memorial was installed on private property in front of a shopping center in Garden Grove, CA. See "Monument Built in US to Commemorate Suffering of 'Comfort Women,'" *Korea Times*, December 2, 2012, accessed October 29, 2016, http://www.ko reatimes.co.kr/www/news/nation/2016/08/116_125990.html

82. Korean American Forum, "About Us."

83. Eun Sung Kim and Seo Kyung Kim, interview.

84. Brittany Levine, "Glendale Approves Korean 'Comfort Woman' Statue Despite Protest," *Los Angeles Times*, July 9, 2013, accessed October 1, 2016, http://www.latimes.com/tn-gnp-me-glendale-approves-comfort-woman-statue-despite-japanese-protest-20130709-story.html

85. Frank Quintero, interview.

86. Brittany Levine, "Japanese Councilman Opposes Glendale's Comfort Women Memorial," *Los Angeles Times*, November 18, 2013, accessed October 4, 2016, http://articles.latimes.com/2013/nov/18/local/la-me-ln-japanese-councilman-comfort-women-20131118

87. Brittany Levine, "Federal Judge Upholds 'Comfort Women' Statue in Glendale Park," *Los Angeles Times*, August 11, 2014, accessed March 20, 2015, http://www.latimes.com/local/la-me-comfort-women-20140812-story.html

88. "Appeals Court Rules in Favor of Glendale's 'Comfort Women' Statue," *Rafu Shimpo*, August 14, 2016, accessed October 1, 2016, http://www.rafu.com/2016/08/appeals-court-rules-in-favor-of-glendales-comfort-women-statue/

89. For a brief overview of "Japanese 'comfort women' revisionism" in the United States that includes opposition to memorials and textbooks that mention Japanese military sexual slavery, see Koyama, "U.S. as 'Major Battleground.'"

90. Comments made at the installation of the "Comfort Women" Statue, Glendale, CA, July 30, 2013.

91. Ibid.

92. Yoneyama, *Cold War Ruins*, 172.

93. Comments made at the installation of the "Comfort Women" Statue, Glendale, CA, July 30, 2013.

94. Stephen Oh, interview.

95. Joseph Oh, interview.

96. Susan Valot, "Cultural Battle over 'Comfort Women' Statue Heads to Court," *California Report*, June 6, 2014, accessed June 21, 2014, http://www.californiareport.org/archive/R201406061630/d

97. Quoted in Amy Lieu, "Wounds of War for Japan, Korea Re-Open with Comfort Women Statue," *NBC News*, June 30, 2014, accessed July 21, 2014, http://www.nbcnews.com/news/asian-america/wounds-war-japan-korea-re-open-comfort-women-statue-n139481

98. For a funeral ritual honoring a deceased survivor, see Arin Mikailian, "South Korean Students Pay Respects in Glendale before Cross Country Trek Spreading Awareness of Comfort Women," *Los Angeles Times*, June 26, 2015, accessed October 1, 2016, http://www.latimes.com/tn-gnp-south-korean-students-pay-respects-in-glendale-before-cross-country-trek-spreading-awareness-of-comf-20150626-story.html

99. Quoted in Arin Mikailian, "Former Comfort Woman Visits Bronze Memorial," *Los Angeles Times*, May 6, 2015, accessed October 1, 2016, http://www.latimes.com/tn-gnp-former-comfort-woman-visits-bronze-me morial-20150506-story.html; and Changhyeon Noh, "Yiyongsuhalmeoni, Geullendeil Wianbusonyeosange Bunhongbitseukapeu Maejwo" [Grand-mother Lee Yong Soo Wraps a Pink Scarf around the Comfort Woman Girl Statue], *JoongAng Ilbo* [Korea Daily], May 7, 2015, accessed October 4, 2016, http://news.joins.com/article/17751136

100. Kwon Hoon, "Gimbokdong Halmeoni, 'Pyeonghwaui Sonyeosang Jal Jikyeodalla'" [Kim Bokdong Grandmother, "Please Watch over the Peace Statue Girl"], *Yeonhap Nyuseu* [Yonhap News], July 31, 2013, accessed October 3, 2016, http://www.yonhapnews.co.kr/international/2013/07/31/06011 10100AKR20130731048200075.HTML

Epilogue

1. Women's Tribunal (KC), DVD #2, December 8, 2000; and Women's Tribunal (WAM), Video #30132, December 8, 2000.

2. For more on Mun Pil Gi's personal history and a discussion of singing in her life, see Pilzer, *Hearts of Pine*, 67–104.

3. Ok-seon Yi, interview.

4. "Students Protest to Protect Comfort Woman Statue in Seoul," *Dong-A Ilbo*, January 5, 2016, accessed October 1, 2016, http://english.donga.com/List/3/04/26/520548/1

5. Hyun-ju Ock, "Student Sit-in Shields 'Comfort Woman' Statue," *Korea Herald*, January 27, 2016, accessed October 3, 2016, http://www.korea herald.com/view.php?ud=20160127000938

6. Quoted in Woo-young Lee, "'Comfort Women' Statues Resonate with Koreans," *Korea Herald*, March 3, 2016, accessed October 3, 2016, http://www.koreaherald.com/view.php?ud=20160303000844

7. Soyeong Park, "Sonyeosang Jikimideul 'Uriga Sonyeosangida. Ije Kaempeoseuro'" [Girl Statue Keepers. "We Are the Girl Statue. Now to Campus"], *Minjunguisori* [Voice of the People], March 1, 2016, accessed October 3, 2016, http://www.vop.co.kr/A00000998352.html

8. Boryeong Geum, "'Sonyeosang Jikimi' 300il Majihaneun Daehak-saengdeul" ["Girl Statue Keeper" University Students Mark 300 Days], *Asia-gyeongje* [Asian Economic News], October 23, 2016, accessed October 29, 2016, http://view.asiae.co.kr/news/view.htm?idxno=2016102318370205204; and "Japan Recalls South Korea Envoy over 'Comfort Women,'" *Al Jazeera*, January 6, 2017, accessed June 10, 2017, http://www.aljazeera.com/news/2017/01/japan-recalls-south-korea-ambassador-comfort-women-170106054414090.html

9. Tae-woo Park, "Civic Group Launches Campaign to Scrap the SK-

Japan Comfort Women Settlement," *Hankyoreh*, January 15, 2016, accessed January 15, 2016, http://english.hani.co.kr/arti/english_edition/e_national/726389.html

10. Quoted in Woo-young Lee, "'Comfort Women' Statues Resonate with Koreans," *Korea Herald*, March 3, 2016, accessed October 3, 2016, http://www.koreaherald.com/view.php?ud=20160303000844

11. For a link to the fund-raising site, see "Jageun Sonyeosang."

12. During the Wednesday Demonstration on April 6, 2016, civic groups from Korea and Japan participated in a ceremony to lay copper nameplates with the names of deceased survivors at the foot of the statue. Eun Sung Kim and Seo Kyung Kim collaborated with Gunter Demnig, a German artist who has been installing commemorative brass plaques in pavement across Europe in honor of victims of National Socialism, to plan this ceremony. See Shin Choe, "Wianbupihaeja Chumo Dongpan, Eeltaesagwanap Sonyeosanggwa Naranhi" [Comfort Women Victims' Memorial Copper Plates, in Front of the Japanese Embassy Alongside the Girl Statue], *Yeonhab Nyuseu* [Yonhap News], April 6, 2016, accessed October 3, 2016, http://www.yonhapnews.co.kr/bulletin/2016/04/06/0200000000AKR20160406111600004.HTML?input=1195m. For more on Demnig's project, see "Home," accessed October 3, 2016, http://www.stolpersteine.eu/en/home/

13. Young-dong Kim, "Busan Citizens Hold Human Statue Relay in Protest of Comfort Women Settlement," *Hankyoreh*, January 13, 2016, accessed January 15, 2016, http://english.hani.co.kr/arti/english_edition/e_national/725989.html. See Boseong Lee, "Busansimin 10myeong Jung 9myeong 'Ilbonyeongsagwan Ape Sonyeosang Sewoya'" [9 out of 10 Busan Citizens Say "Install a Girl Statue in Front of the Japanese Consulate General"], *Minjunguisori* [Voice of the People], August 24, 2016, accessed October 22, 2016, http://www.vop.co.kr/A00001061699.html

14. "Ingan Sonyeosang Gyeongnyeo Swaedo" [Flood of Encouragement for the Human Girl Statue], *KNN News*, January 17, 2016, accessed October 4, 2016, https://www.youtube.com/watch?v=F2sitiaWA4Y

15. Young-dong Kim, "Busan Citizens Hold Human Statue Relay in Protest of Comfort Women Settlement," *Hankyoreh*, January 13, 2016, accessed January 15, 2016, http://english.hani.co.kr/arti/english_edition/e_national/725989.html. I do not agree with the translation of the Korean sign that appears in this article.

16. "Ingan Sonyeosang Gyeongnyeo Swaedo" [Flood of Encouragement for the Human Girl Statue], *KNN News*, January 17, 2016, accessed October 4, 2016, https://www.youtube.com/watch?v=F2sitiaWA4Y

17. The Japanese government temporarily recalled its ambassador to South Korea and its consul general in Busan "to protest what it saw as a violation of a December 2015 agreement between the two countries, meant to resolve the longstanding dispute." In June 2017, the Busan city assembly "passed an ordinance that allows the city government to protect a 'comfort

women' statue that has been installed in front of the Japanese consulate-general in the city." "The new ordinance," according to *Asahi Shimbun*, "will likely make it even more difficult for the South Korean government to remove the statue, as requested by Tokyo as a condition of implementing the bilateral agreement." See Hyon-hee Shin, "Seoul Faces Dilemma over 'Comfort Women' Statue in Busan," *Korea Herald*, January 3, 2017, accessed February 20, 2017, http://www.koreaherald.com/view.php?ud=20170103000764; Motoko Rich, "Japan Envoy, Recalled Over 'Comfort Woman' Statue, Is Returning to Seoul," *New York Times*, April 3, 2017, accessed July 27, 2017, https://www.nytimes.com/2017/04/03/world/asia/japan-ambassador-south-korea-comfort-woman.html?_r=0; and "'Comfort Women' Statue Granted Protection by Busan Assembly," *Asahi Shimbun*, June 30, 2017, accessed July 27, 2017, http://www.asahi.com/ajw/articles/AJ201706300026.html

18. Jiyeong Um and Gyeongeun Son, "Busansimingwa Hamkke Jikineun 'Pyeonghwaui Sonyeosang,'" [Busan Citizens Join Together to Protect the "Peace Girl Statue"], *iCOOP Moksori* [iCOOP Voice], February 28, 2017, accessed July 27, 2017, http://blog.naver.com/icoopkorea/220940973813

19. Quoted in Jun-ho Bang, "Comfort Women and Supporters Vow to 'Keep Fighting' at Year's Final Protest," *Hankyoreh*, December 31, 2015, accessed January 2, 2016, http://english.hani.co.kr/arti/english_edition/e_international/724276.html

Bibliography

Archival Sources

Korean Council for the Women Drafted for Military Sexual Slavery by Japan, Seoul
 Digital Image Archives
 General Collections
Women's Active Museum on War and Peace, Tokyo
 General Collections
 Women's International War Crimes Tribunal on Japan's Military Sexual Slavery Video and Print Archive

Interviews by Author

Bang, Eunmi. August 2, 2008, Seoul.
Cavallo, Steven. March 8, 2013, Palisades Park, NJ.
Gil, Won Ok. July 27, 2007, Seoul.
Kang, Ji Soo. October 30, 2013, Seoul.
Kim, Eun Sung, and Seo Kyung Kim. October 31, 2013, Seoul.
Kim, Sam-Jin. August 5, 2008, Seoul.
Lee, Mak Dal. July 27, 2007, Seoul.
Lee, Yong Soo. October 5, 2007, Los Angeles; and July 24, 2008, Seoul.
Nakahara, Michiko. May 28, 2010, Tokyo.
Oh, Joseph. July 31, 2013, Glendale, CA.
Oh, Stephen. July 31, 2013, Glendale, CA.
Paek, Young H. March 8, 2013, Hackensack, NJ.
Park, Chejin. March 7, 2013, Queens, NY.
Park, Se Hwan. November 5, 2013, Seoul.
Quintero, Frank. July 31, 2013, Glendale, CA.
Sung, Claire. July 24, 2008, Seoul.

Watanabe, Mina. May 29, 2010, Tokyo.

Yi, Ok-seon. July 21, 2007, Gwangju City, South Korea.

Yoon, Mee Hyang. August 6, 2008, Seoul.

Internet Sources

"About Us." *Urban Stages*, n.d. Accessed October 1, 2010. http://www.ur
banstages.org/about-us/

Asian Women's Fund. "Closing of the Asian Women's Fund." *Digital Museum: The Comfort Women Issue and the Asian Women's Fund*, n.d. Accessed October 21, 2016. http://www.awf.or.jp/e3/dissolu
tion.html

Asian Women's Fund. "Establishment of the AW Fund, and the Basic Nature of Its Projects." *Digital Museum: The Comfort Women Issue and the Asian Women's Fund*, n.d. Accessed October 21, 2016. http://www.awf.
or.jp/e2/foundation.html

Bacalzo, Dan. "Reviews: *Comfort Women.*" *TheaterMania*, November 2, 2004. Accessed August 13, 2015. http://www.theatermania.com/new-
york-city-theater/reviews/11-2004/comfort-women_5286.html

Center for Justice and Accountability. "The Comfort Women Case: Support-
ing the Claims of WWII-Era Victims of Sexual Violence/Hwang Geum Joo
V. Japan," n.d. Accessed August 29, 2016. http://cja.org/what-we-do/liti
gation/amicus-briefs/hwang-geum-joo-v-japan/

Cole, Catherine M. "The Blanket of Reconciliation in South Africa." *Dissi-
dences* 4, no. 8 (2012). Accessed October 16, 2015. http://digitalcom
mons.bowdoin.edu/dissidences/vol4/iss8/11

"'Comfort Women of the Empire' by Professor Park Yuha," April 30, 2016. Accessed October 21, 2016. http://scholarsinenglish.blogspot.com/
2014/10/summary-of-professor-park-yuhas-book.html

Coomaraswamy, Radhika. "Report on the Mission to the Democratic Peo-
ple's Republic of Korea, the Republic of Korea and Japan on the Issue of
Military Sexual Slavery in Wartime." United Nations Economic and So-
cial Council, January 4, 1996. Accessed October 27, 2016. http://hrli-
brary.umn.edu/commission/country52/53-add1.htm

"Desecrating a Statue Honoring Korea's 'Comfort Women.'" *KBS World*, July
11, 2012. Accessed October 5, 2012. http://world.kbs.co.kr/english/news/
news_zoom_detail.htm?No=6795

Dolan, Jill. "Critical Generosity." *Public: A Journal of Imagining America* 1,
nos. 1–2 (n.d.). Accessed November 5, 2015. http://public.imagining
america.org/blog/article/critical-generosity-2/

Dunbar, Jon. "Arirang, Korea's Unofficial Anthem." *Korea.net: Gateway to
Korea*, April 5, 2012. Accessed October 27, 2016. http://www.korea.net/
NewsFocus/Culture/view?articleId=998 13

East West Players. "Production History & Archive," n.d. Accessed June 12, 2015. http://www.eastwestplayers.org/about/production-history-archive/

Field, Norma. "The Courts, Japan's 'Military Comfort Women,' and the Conscience of Humanity: The Ruling in VAWW-Net Japan v. NHK." *Asia-Pacific Journal: Japan Focus* 5, no. 2 (2007). Accessed August 2, 2016. http://apjjf.org/-Norma-Field/2352/article.html

"Four Special Exhibitions 2005–2006: The Life and Work of Yayori Matsui." *WAM: Women's Active Museum on War and Peace* 1 (Fall 2006). Accessed October 3, 2016. http://wam-peace.org/en/wp-content/uploads/2013/05/newsletter_06_sml.pdf

Hadl, Gabriele. "Korean Protest Culture." *Kyoto Journal* 60 (June 15, 2005). Accessed August 22, 2016. http://www.kyotojournal.org/the-journal/society/korean-protest-culture/

Hibbitts, Bernard J. "De-Scribing Law: Performance in the Constitution of Legality." Paper presented at the Performance Studies Conference, Northwestern University, March 1996. Accessed July 16, 2016. http://law.pitt.edu/archive/hibbitts/describ.htm

"Ingan Sonyeosang Gyeongnyeo Swaedo" [Flood of Encouragement for the Human Girl Statue]. *KNN News*, January 17, 2016. Accessed October 4, 2016. https://www.youtube.com/watch?v=F2sitiaWA4Y

International Criminal Court. "About," n.d. Accessed July 14, 2017. https://www.icc-cpi.int/about

Iovino, Nicholas. "Judge Dismisses Comfort Women's Claim on Japan." *Courthouse News Service*, June 29, 2016. Accessed August 1, 2016. http://www.courthousenews.com/2016/06/29/judge-dismisses-comfort-womens-claim-on-japan.htm

"Jageun Sonyeosang" [Mini Girl Statue], n.d. Accessed October 1, 2016. https://www.tumblbug.com/peace

KACE. "Education Program." Accessed January 19, 2015. http://us.kace.org/programs/grassroots-internship/

KACE. "Press Conference of Comfort Women and Holocaust Survivors (The 1000th Seoul's Wednesday Protest Promotion Event)." *Korea & International Affairs News*, November 22, 2011. Accessed January 19, 2015. http://us.kace.org/2011/press-conference-of-comfort-women-and-holocaust-survivors-the-1000th-seouls-wednesday-protest-promotion-event/

KAN-WIN: Empowering Women in the Asian American Community. N.d. http://www.kanwin.org

Kim, Hyo-jin. "Heartfelt Memorials Resonate for Peace: Kim Eun-sung and Kim Seo-kyung, Sculptors Standing by Victims of War." *Yonsei Annals*, April 10, 2016. Accessed September 27, 2016. http://annals.yonsei.ac.kr/news/articleView.html?idxno=1615

Kim, Namjin, Yoongyu Seong, and Seonah Lee. "Gwangaegui Nun: Seoul-sigeukdan Bongseonhwareul Bogo" [Audience's Viewpoint: Reviewing Seoul Metropolitan Theatre's Bongseonhwa]. *Mun Hwa Gong Gan* [Cul-

ture Center], June 2014. Accessed January 6, 2016. http://navercast.naver.
com/magazine_contents.nhn?rid=1526&contents_id=57024

Korean American Forum of California. "About Us," n.d. Accessed January
20, 2015. http://kaforumca.org/about-us/

Korean Council for the Women Drafted for Military Sexual Slavery by Japan.
n.d. https://www.womenandwar.net/

Korean Council for the Women Drafted for Military Sexual Slavery by Japan.
"Objectives & Activities," n.d. Accessed October 22, 2016. https://www.
womenandwar.net/contents/general/general.asp?page_str_menu=2101

Korean Council for the Women Drafted for Military Sexual Slavery by Japan,
"Suyo Siwi," n.d. Accessed July 10, 2017. https://www.womenandwar.
net/contents/general/general.asp?page_str_menu=020101

Koyama, Emi. "The U.S. as 'Major Battleground' for 'Comfort Woman' Revi-
sionism: The Screening of Scottsboro Girls at Central Washington Uni-
versity." *Asia-Pacific Journal: Japan Focus* 13, issue 22, no. 2 (June 3,
2015). Accessed May 25, 2017. http://apjjf.org/Emi-Koyama/4324.html

Kudan Kaikan, February 20, 2011. Accessed October 31, 2016. https://web.
archive.org/web/20110220160657/http://www.kudankaikan.or.jp/index.
html.

Lee, Sangjin. "Jeongsindaemunjedaechaekyeobuihoeneun Jwapaseonghyan-
gui Danche" [The Korean Council, a Left-Wing Organization], Toron-
madang [Discussion Forum], *Chosun Ilbo*, July 4, 2015. Accessed October
21, 2016. http://forum.chosun.com/bbs.message.view.screen?message_
id=1181953&bbs_id=1010¤t_sequence=04xRM~&start_
sequence=zzzzz~&start_page=1¤t_page=5&list_ui_
type=0&search_field=1&search_word=&search_limit=all&sort_
field=0&classified_value=&cv=

Lin, Sam Chu. "A Tragedy Retold." *Asiaweek*, May 7, 1999. Accessed April 23,
2015. http://www.cnn.com/ASIANOW/asiaweek/99/0507/feat2.html

Memory and Reconciliation in the Asia-Pacific. "Korean Comfort Women v.
Japan," April 3, 1993. Accessed August 5, 2016. https://memoryrecon
ciliation.org/topics/comfort-women/comfort-women-korea/

Min, Yong Soon. "Wearing History," n.d. Accessed February 16, 2017. http://
www.yongsoonmin.com/art/wearing-history/

"An NGO Shadow Report to CEDAW, Japan: The 'Comfort Women' Issue."
44th Session of CEDAW, New York, 2009. Accessed February 14, 2017.
http://www2.ohchr.org/english/bodies/cedaw/docs/ngos/Comfort-
Women_Japan_cedaw44.pdf

Nozaki, Yoshiko. "The 'Comfort Women' Controversy· History and Testi-
mony." *Asia-Pacifio Journal: Japan Focus* 3, no. 7 (July 6, 2005). Accessed
October 24, 2016. http://apjjf.org/-Yoshiko-Nozaki/2063/article.html

Onofri, Adrienne. "Women Who Run the Show: Frances Hill of Urban
Stages." *Broadway World*, March 26, 2009. Accessed October 20, 2010.

http://offbroadway.broadwayworld.com/article/Women_Who_Run_the_
Show_Frances_Hill_of_Urban_Stages_20090326

Prosecutors and the Peoples of the Asia-Pacific Region v. Hirohito Emperor Showa, Ando Rikichi, Hata Shunroku, Itagaki Seishiro, Kobayashi Seizo, Masui Iwane, Umezu Yoshijiro, Terauchi Hisaichi, Tojo Hideki, Yamashita Tomoyuki, and the Government of Japan, Judgement, Women's International War Crimes Tribunal for the Trial of Japan's Military Sexual Slavery, Case No. PT-2000-1-T, December 4, 2001. Accessed May 25, 2017. http://www.internationalcrimesdatabase.org/Case/981/The-Prosecutors-and-the-Peoples-of-the-Asia-Pacific-Region/

Radio Free Europe/Radio Liberty. "Amnesty Urges Justice for Bosnian War Rape Victims," September 30, 2009. Accessed June 16, 2010. http://www.unhcr.org/refworld/docid/4acb41a3c.html

Sandman, Jenny. "A *CurtainUp* Review: Comfort Women." *CurtainUp,* 2004. Accessed November 12, 2015. http://www.curtainup.com/comfortwomen.html

Schmertz, Andrew. "Comfort Women Memorial Stays in Palisades Park, Despite Objection from Japanese Government." *NJ Today with Mike Schneider,* July 23, 2012. Accessed July 17, 2013. http://www.njtvonline.org/njtoday/video/comfort-women-memorial-stays-in-palisades-park-despite-objection-from-japanese-government/

Shim, Jung-soon. "*Coming and Going at Sundown*: A Korean Comfort Women Play." *Open Page* 3 (1998): 84–88. Accessed October 16, 2014. http://www.themagdalenaproject.org/en/content/open-page

Shin, Meong Jin, Stephen Westland, Edel M. Moore, and Vien Cheung. "Colour Preferences for Traditional Korean Colours." *Journal of the International Colour Association* 9 (2012): 48-59. Accessed July 25, 2017. http://jaic.jsitservices.co.uk/index.php/JAIC/article/view/126/106

"Stage Play 'Bongseonhwa.'" *KBS World Radio,* December 3, 2013. Accessed October 23, 2014. http://world.kbs.co.kr/english/program/program_trendkorea_detail.htm?lang=e&No=119757¤t_page=7

Tiron, Roxana. "'Comfort Women' Resolution to Reach Foreign Affairs Panel." *The Hill,* June 20, 2007. http://thehill.com/business-a-lobbying/3159-comfort-women-resolution-to-reach-foreign-affairs-panel

Tiron, Roxana. "Korean-Americans Seek Resolution on Sex Slavery." *The Hill,* September 27, 2006. Accessed August 16, 2013. http://thehill.com/business-a-lobbying/2375-korean-americans-seek-resolution-on-sex-slavery

Tokudome, Kinue. "Passage of H. Res. 121 on 'Comfort Women,' the US Congress and Historical Memory in Japan." *Asia-Pacific Journal: Japan Focus* 5, no. 8 (2007). Accessed March 20, 2015. http://japanfocus.org/-Kinue-TOKUDOME/2510

"Tomiyama Taeko," n.d. *Imagination without Borders.* http://imaginationwithoutborders.northwestern.edu/artists/tomiyama

UN Economic and Social Council. "Further Promotion and Encouragement of Human Rights and Fundamental Freedoms, Including the Question of the Programme and Methods of Work of the Commission: Alternative Approaches and Means within the United Nations System for Improving the Effective Enjoyment of Human Rights and Fundamental Freedoms." E/CN.4/1996/53/Add.1, January 4, 1996. Accessed October 24, 2016. http://hrlibrary.umn.edu/commission/country52/53-add1.htm

UN/International Criminal Tribunal for the Former Yugoslavia. "About the ICTY," n.d. Accessed August 2, 2016. http://www.icty.org/en/about

UN Security Council. "Countries Elected Members of the Security Council," n.d. Accessed November 14, 2014. http://www.un.org/en/sc/members/elected.asp

US House of Representatives. "H.Res. 121: A Resolution Expressing the Sense of the House of Representatives that the Government of Japan Should Formally Acknowledge, Apologize, and Accept Historical Responsibility in a Clear and Unequivocal Manner for Its Imperial Armed Forces' Coercion of Young Women into Sexual Slavery, Known to the World as 'Comfort Women,' during Its Colonial and Wartime Occupation of Asia and the Pacific Islands from the 1930s through the Duration of World War II," 2007. *Congress.gov.* Accessed October 24, 2016. https://www.congress.gov/bill/110th-congress/house-resolution/121

Valot, Susan. "Cultural Battle over 'Comfort Women' Statue Heads to Court." *California Report,* June 6, 2014. Accessed June 21, 2014. http://www.californiareport.org/archive/R201406061630/d

VAWW-NET Japan. "Programme and Schedule of Tribunal: Background and Purpose of the Tribunal," n.d. Accessed September 26, 2016. http://home.att.ne.jp/star/tribunal/

VAWW-NET Japan. "Programme and Schedule of Tribunal: Charter of the Tribunal," n.d. Accessed September 26, 2016. http://home.att.ne.jp/star/tribunal/

VAWW-NET Japan. "Programme and Schedule of Tribunal: Events Leading Up to the Women's International War Crimes Tribunal," n.d. Accessed September 26, 2016. http://home.att.ne.jp/star/tribunal/events_E.htm

VAWW-NET Japan. "Programme and Schedule of Tribunal: Message from the Convenors," n.d. Accessed September 26, 2016. http://home.att.ne.jp/star/tribunal/

VAWW-NET Japan. "Programme and Schedule of Tribunal: The Organizers," n.d. Accessed September 26, 2016. http://home.att.ne.jp/star/tribunal/

VAWW-NET Japan. "Programme and Schedule of Tribunal: Public Hearing on Crimes against Women in Recent Wars and Conflicts," n.d. Accessed September 26, 2016. http://home.att.ne.jp/star/tribunal/

Wake, Caroline. "The Accident and the Account: Towards a Taxonomy of Spectatorial Witness in Theatre and Performance Studies." *Performance*

Paradigm: A Journal of Performance and Contemporary Culture 5, no. 1 (May 2009). Accessed July 17, 2017. http://performanceparadigm.net/index.php/journal/article/view/68/69

Wilson, Lindsey. "Comfort Women." *Talkin' Broadway*, October 28, 2004. Accessed October 20, 2010. http://www.talkinbroadway.com/ob/10_28_04.html

Women's Caucus for Gender Justice. "About the Public Hearing," n.d. Accessed May 25, 2016. http://iccwomen.org/wigjdraft1/Archives/old WCGJ/tokyo/aboutph.html

Women's Caucus for Gender Justice. "Transcript of Oral Judgment, Delivered in The Hague, Netherlands, 4 December 2001." Accessed September 23, 2015. http://www.iccwomen.org/wigjdraft1/Archives/oldWCGJ/tokyo/summary.html

Yasukuni Shrine. "About Yasukuni Shrine: Worshipping," 2008. Accessed December 16, 2010. http://www.yasukuni.or.jp/english/about/worshipping.html

Films

The Apology. Dir. Tiffany Hsiung. Documentary film. Canada: National Film Board of Canada, 2016.

Breaking the History of Silence: The Women's International War Crimes Tribunal on Japan's Military Sexual Slavery for the Trial of Japanese Military Sexual Slavery. VHS cassette. Japan: Video Juku and VAWW-NET Japan, 2001.

History That Can't Be Erased: Military Sexual Slavery by Japan. VHS cassette. Seoul: Korean Council for the Women Drafted for Military Sexual Slavery by Japan, 2005.

Najeun Moksori [The Murmuring]. Dir. Young-joo Byun. Documentary film. South Korea: Docu-Factory Vista, 1995.

Najeun Moksori 2 [Habitual Sadness]. Dir. Young-joo Byun. Documentary film. South Korea: Docu-Factory Vista, 1997.

Okinawa no Harumoni [A Grandmother in Okinawa]. Dir. Tetsuo Yamatini. Documentary film. Tokyo: Bungeishunju, 1979.

Quest for Justice. Dir. Verona Fonté. Berkeley, CA: Iris Arts and Education Group, 2002.

Silence Broken: Korean Comfort Women. Dir. Dai Sil Kim-Gibson. VHS cassette. New York: Dai Sil, 1999.

Sumgyeol [My Own Breathing]. Dir. Young-joo Byun. Documentary film. South Korea: Docu-Factory Vista, 1999.

Print Sources

Anderson, Benedict. *Imagined Communities: Reflections on the Origin and Spread of Nationalism.* 1983. London: Verso, 1991.

Anderson, Patrick. *So Much Wasted: Hunger, Performance, and the Morbidity of Resistance.* Durham: Duke University Press, 2010.

Argibay, Carmen M. "Sexual Slavery and the 'Comfort Women' of World War II." *Berkeley Journal of International Law* 21, no. 2 (2003): 375–89.

Auslander, Philip. *Liveness: Performance in a Mediatized Culture.* 1999. New York: Routledge, 2008.

Austin, J. L. *How to Do Things with Words.* Cambridge: Harvard University Press, 1962.

Barthes, Roland. *Camera Lucida: Reflections on Photography.* Translated by Richard Howard. 1980. New York: Hill and Wang, 1981.

Bejarano, Cynthia L. "Las Super Madres de Latino America: Transforming Motherhood by Challenging Violence in Mexico, Argentina, and El Salvador." *Frontiers: A Journal of Women Studies* 23, no. 1 (2002): 126–50.

Benegas, Diego. "'If There's No Justice . . .': Trauma and Identity in Post-Dictatorship Argentina." *Performance Research: A Journal of the Performing Arts* 16, no. 1 (2011): 20–30.

Bernstein, Robin. *Racial Innocence: Performing American Childhood from Slavery to Civil Rights.* New York: New York University Press, 2011.

Bingham, Charles, and Gert Biesta, with Jacques Rancière. *Jacques Rancière: Education, Truth, Emancipation.* London: Continuum, 2010.

Boal, Augusto. *Theatre of the Oppressed.* Translated by Charles A. and Maria-Odilia Leal McBride. New York: Theatre Communications Group, 1979.

Borland, Elizabeth. "The Mature Resistance of Argentina's Madres de Plaza de Mayo." In *Latin American Social Movements: Globalization, Democratization, and Transnational Network,* edited by Hank Johnston and Paul Almeida, 115–30. Lanham, MD: Rowman and Littlefield, 2006.

Bosco, Fernando J. "Human Rights Politics and Scaled Performances of Memory: Conflicts among the *Madres de Plaza de Mayo* in Argentina." *Social and Cultural Geography* 5, no. 3 (2004): 381–402.

Breed, Ananda. *Performing the Nation: Genocide, Justice, Reconciliation.* London: Seagull, 2014.

Brooks, Roy L. *Atonement and Forgiveness: A New Model for Black Reparations.* Berkeley: University of California Press, 2004.

Brooks, Roy L., ed. *When Sorry Isn't Enough: The Controversy over Apologies and Reparations for Human Injustice.* New York: New York University Press, 1999.

Butler, Judith. *Bodies That Matter: On the Discursive Limits of "Sex."* New York: Routledge, 1993.

Campari, Irene. "Uncertain Boundaries in Urban Space." In *Geographic Ob-*

jects with Indeterminate Boundaries, edited by Peter A. Burrough and Andrew U. Frank, 57–69. London: Taylor and Francis, 1996.

Carlson, Marvin. *Performance: A Critical Introduction.* New York: Routledge, 2004.

Caruth, Cathy. *Unclaimed Experience: Trauma, Narrative, and History.* Baltimore: Johns Hopkins University Press, 1996.

Caruth, Cathy. "Violence and Time: Traumatic Survivals." *Assemblage* 20 (April 1993): 24–25.

Certeau, Michel de. *The Practice of Everyday Life.* Translated by Steven Rendall. Berkeley: University of California Press, 1984.

Chambers-Letson, Joshua Takano. *A Race So Different: Performance and Law in Asian America.* New York: New York University Press, 2013.

Chang, Paul Y. *Protest Dialectics: State Repression and South Korea's Democracy Movement, 1970–1979.* Stanford: Stanford University Press, 2015.

Cheung, Mong. *Political Survival and Yasukuni in Japan's Relations with China.* New York: Routledge, 2017.

Chinkin, Christine M. "Women's International Tribunal on Japanese Military Sexual Slavery." *American Journal of International Law* 95, no. 2 (2001): 335–41.

Cho, Grace M. *Haunting the Korean Diaspora: Shame, Secrecy, and the Forgotten War.* Minneapolis: University of Minnesota Press, 2008.

Cho, Oh-Kon. "Korea." In *The Cambridge Guide to Asian Theatre*, edited by James R. Brandon, 180–89. 1993. New York: Cambridge University Press, 2008.

Choi, Chungmoo, ed. "The Comfort Women: Colonialism, War, and Sex." *positions: east asia cultures critique* 5, no. 1. Durham: Duke University Press, 1997.

Choi, Chungmoo. "Nationalism and Construction of Gender in Korea." In *Dangerous Women: Gender and Korean Nationalism*, edited by Elaine H. Kim and Chungmoo Choi, 9–31. New York: Routledge, 1998.

Choi, Chungmoo. "The Politics of War Memories toward Healing." In *Perilous Memories: The Asia-Pacific War(s)*, edited by T. Fujitani, Geoffrey M. White, and Lisa Yoneyama, 395–409. Durham: Duke University Press, 2001.

Chuh, Kandice. "Discomforting Knowledge; Or, Korean 'Comfort Women' and Asian Americanist Critical Practice." *Journal of Asian American Studies* 6, no. 1 (2003): 5–23.

Chuh, Kandice. "Guest Editor's Introduction: On Korean 'Comfort Women.'" *Journal of Asian American Studies* 6, no. 1 (2003): 1–4.

Chung, Chin Sung. "Korean Women Drafted for Military Sexual Slavery by Japan." In *True Stories of the Korean Comfort Women: Testimonies Compiled by the Korean Council for Women Drafted for Military Sexual Slavery by Japan and the Research Association on the Women Drafted for Military Sexual Slavery by Japan*, translated by Young Joo Lee and edited by Keith Howard, 11–30. London: Cassell, 1995.

Clay, Diskin. Introduction to *Euripides: The Trojan Women*, 1–33. Newbury-port, MA: Focus/Pullins, 2005.

Cohen-Cruz, Jan. *Local Acts: Community-Based Performance in the United States.* New Brunswick, NJ: Rutgers University Press, 2005.

Colbert, Soyica Diggs. *The African American Theatrical Body: Reception, Performance, and the Stage.* New York: Cambridge University Press, 2011.

Cole, Catherine M. *Performing South Africa's Truth Commission: Stages of Transition.* Bloomington: Indiana University Press, 2010.

Cole, Catherine M. "Performance, Transitional Justice, and the Law: South Africa's Truth and Reconciliation Commission." *Theatre Journal* 59, no. 2 (May 2007): 167–87.

Collet, Christian, and Pei-Te Lien. "The Transnational Politics of Asian Americans: Controversies, Questions, Convergence." In *The Transnational Politics of Asian Americans,* edited by Christian Collet and Pei-Te Lien, 1–22. Philadelphia: Temple University Press, 2009.

Conquergood, Lorne Dwight. "Lethal Theatre: Performance, Punishment, and the Death Penalty." *Theatre Journal* 54, no. 3 (October 2002): 339–67.

Crosby, Alison, and M. Brinton Lykes. "Mayan Women Survivors Speak: The Gendered Relations of Truth Telling in Postwar Guatemala." *International Journal of Transitional Justice* 5 (2011): 456–76.

Cumings, Bruce. *Korea's Place in the Sun: A Modern History.* 1997. New York: Norton, 2005.

Cvetkovich, Ann. *An Archive of Feelings: Trauma, Sexuality, and Lesbian Public Cultures.* Durham: Duke University Press, 2003.

Danticat, Edwidge. *Create Dangerously: The Immigrant Artist at Work.* Princeton: Princeton University Press, 2010.

Dolan, Jill. *The Feminist Spectator as Critic.* 1988. Ann Arbor: University of Michigan Press, 2012.

Dolan, Jill. *Utopia in Performance: Finding Hope at the Theater.* Ann Arbor: University of Michigan Press, 2005.

Doss, Erika. *Memorial Mania: Public Feeling in America.* Chicago: University of Chicago Press, 2010.

Dower, John W. *Embracing Defeat: Japan in the Wake of World War II.* 1999. New York: Norton, 2000.

Dower, John W. *War without Mercy: Race and Power in the Pacific War.* 1986. New York: Pantheon, 1993.

Dudden, Alexis. *Troubled Apologies Among Japan, Korea, and the United States.* New York: Columbia University Press, 2008

Dudden, Alexis. "'We Came to Tell the Truth': Reflections On the Tokyo Women's Tribunal." *Critical Asian Studies* 33, no. 4 (2001): 591–602.

Elam, Harry J., Jr., and Michele Elam. "Blood Debt: Reparations in Langston Hughes's *Mulatto.*" *Theatre Journal* 61, no. 1 (2009): 85-103.

Elam, Harry J., Jr. *Taking It to the Streets: The Social Protest Theater of Luis Valdez & Amiri Baraka.* 1997. Ann Arbor: University of Michigan Press, 2001.

Eng, David L., and David Kazanjian, eds. *Loss: The Politics of Mourning.* Berkeley: University of California Press, 2003.

Enloe, Cynthia. *Bananas, Beaches, and Bases: Making Feminist Sense of International Politics.* 1989. Berkeley: University of California Press, 2000.

Falk, Richard. "The Rights of Peoples (In Particular Indigenous Peoples)." In *The Rights of Peoples,* edited by James Crawford, 17-37. Oxford: Clarendon Press, 1988.

Felman, Shoshana. *The Juridical Unconscious: Trials and Traumas in the Twentieth Century.* Cambridge: Harvard University Press, 2002.

Foster, Susan Leigh. "Choreographies of Protest." *Theatre Journal* 55, no. 3 (2003): 395–412.

Franko, Mark. *The Work of Dance: Labor, Movement, and Identity in the 1930s.* Middletown, CT: Wesleyan University Press, 2002.

Freeman, Michael, and Andrew D. E. Lewis, eds. *Law and Literature: Current Legal Issues 1999.* Vol. 2. Oxford: Oxford University Press, 1999.

Fuentes, Marcela. "The Politics of Casting in Federico León's *Artistic Shantytown.*" Paper for the ASTR working group Theorizing Dissensus: Neoliberalism, Performance, and the Discourse of Human Rights and International Law, 2008.

Fujitani, T., Geoffrey M. White, and Lisa Yoneyama. Introduction to *Perilous Memories: The Asia-Pacific War(s),* edited by T. Fujitani, Geoffrey M. White, and Lisa Yoneyama, 1–29. Durham: Duke University Press, 2001.

Glazer, Peter. *Radical Nostalgia: Spanish Civil War Commemoration in America.* Rochester, NY: University of Rochester Press, 2005.

Grewal, Inderpal. *Transnational America: Feminisms, Diasporas, Neoliberalisms.* Durham: Duke University Press, 2005.

Grewal, Inderpal, and Caren Kaplan. "Introduction: Transnational Feminist Practices and Questions of Postmodernity." In *Scattered Hegemonies: Postmodernity and Transnational Feminist Practices,* edited by Inderpal Grewal and Caren Kaplan, 1–33. Minneapolis: University of Minnesota Press, 1994.

Grossman, Atina. *Jews, Germans, and Allies: Close Encounters in Occupied Germany.* Princeton: Princeton University Press, 2009.

Guterman, Gad. *Performance, Identity, and Immigration Law: A Theatre of Undocumentedness.* Basingstoke: Palgrave MacMillan, 2014.

Hall, Edith. Introduction to *Hecuba, Trojan Women, Andromache.* Translated by James Morwood, ix–xlii. New York: Oxford University Press, 2000.

Hammond, Elle H. "Commemoration Controversies: The War, the Peace, and Democracy in Japan." In *Living with the Bomb: American and Japanese Cultural Conflicts in the Nuclear Age,* edited by Laura Hein and Mark Selden, 100–121. Armonk, NY: Sharpe, 1997.

Hanguk Jeongsindae Munje Daechaek Yeobuihoe [Korean Council for the Women Drafted for Military Sexual Slavery by Japan]. *Jiulsu Eomneun Yeoksa: Ilbongun "Wianbu"* [History That Can't Be Erased: Military Sexual Slavery by Japan]. Seoul: Korean Council for the Women Drafted for Military Sexual Slavery by Japan and the Ministry of Gender Equality and Family, 2005.

Hayner, Priscilla B. *Unspeakable Truths: Transitional Justice and the Challenges of Truth Commissions.* 2001. New York: Routledge, 2011.

Hein, Laura, and Mark Selden. "The Lessons of War, Global Power, and Social Change." In *Censoring History: Citizenship and Memory in Japan, Germany, and the United States,* edited by Laura Hein and Mark Selden, 3–50. Armonk, NY: Sharpe, 2000.

Henry, Nicola. "Memory of an Injustice: The 'Comfort Women' and the Legacy of the Tokyo Trial." *Asian Studies Review* 37, no. 3 (2013): 362–80.

Herman, Judith Lewis. *Trauma and Recovery: The Aftermath of Violence—From Domestic Abuse to Political Terror.* 1992. New York: Basic Books, 1997.

Hesford, Wendy S. "Staging Terror." *TDR: The Drama Review* 50, no. 3 (2006): 29–41.

Hicks, George. *The Comfort Women: Japan's Brutal Regime of Enforced Prostitution in the Second World War.* New York: Norton, 1994.

Holledge, Julie, and Joanne Tompkins. *Women's Intercultural Performance.* London: Routledge, 2000.

Hopkins, D. J., Shelley Orr, and Kim Solga, eds. *Performance and the City.* Basingstoke: Palgrave Macmillan, 2009.

Hopkins, D. J., and Shelley Orr, "Memory/Memorial/Performance: Lower Manhattan, 1776/2001." In *Performance and the City,* edited by D. J. Hopkins, Shelley Orr, and Kim Solga, 33–50. Basingstoke: Palgrave Macmillan, 2009.

Hoskins, Janet, and Viet Thanh Nguyen, eds. *Transpacific Studies: Framing an Emerging Field.* Honolulu: University of Hawai'i Press, 2014.

Howard, Keith, ed. *True Stories of the Korean Comfort Women.* London: Cassell, 1995.

Hua, Julietta. *Trafficking Women's Human Rights.* Minneapolis: University of Minnesota Press, 2011.

Huh, Dong-hwa. "History and Art in Traditional Wrapping Cloths." In *Rapt in Colour: Korean Textiles and Costumes of the Choson Dynasty,* edited by Claire Roberts and Dong-hwa Huh, 19–21. Sydney: Powerhouse, 1998.

Huhm, Halla Pai. *Kut: Korean Shamanist Rituals.* Elizabeth, NJ: Hollym, 1980.

Jackson, Shannon. *Social Works: Performing Art, Supporting Publics.* New York: Routledge, 2011.

Jakovljević, Branislav. "From Mastermind to Body Artist: Political Perfor-

mances of Slobodan Milošević." *TDR: The Drama Review* 52, no. 1 (2008): 51–74.

Jelin, Elizabeth. *State Repression and the Labors of Memory*. Translated by Judy Rein and Marcial Godoy-Anativia. Minneapolis: University of Minnesota Press, 2003.

Jin, Jong-Heon. "Demolishing Colony: The Demolition of the Old Government-General Building of Choson." In *Sitings: Critical Approaches to Korean Geography*, edited by Timothy R. Tangherlini and Sallie Yea, 39–58. Honolulu: University of Hawai'i Press, 2008.

Johnson, E. Patrick. *Appropriating Blackness: Performance and the Politics of Authenticity*. Durham: Duke University Press, 2003.

Joseph, May. *Nomadic Identities: The Performance of Citizenship*. Minneapolis: University of Minneapolis Press, 1999.

Julius, Anthony. Introduction to *Law and Literature: Current Legal Issues 1999*, edited by Michael Freeman and Andrew D. E. Lewis, 2: xi–xxv. Oxford: Oxford University Press, 1999.

Kang, Laura Hyun Yi. *Compositional Subjects: Enfiguring Asian/American Women*. Durham: Duke University Press, 2002.

Kang, Laura Hyun Yi. "Conjuring 'Comfort Women': Mediated Affiliations and Disciplined Subjects in Korean/American Transnationality." *Journal of Asian American Studies* 6, no. 1 (2003): 25–55.

Kang, Laura Hyun Yi. *Traffic in Asian Women*. Durham: Duke University Press, forthcoming.

Kaplan, Caren, Norma Alarcón, and Minoo Moallem, eds. *Between Woman and Nation: Nationalisms, Transnational Feminisms, and the State*. Durham: Duke University Press, 1999.

Karic, Aida. "The Trojan Women: An Asian Story." Unpublished script. 2007.

Keller, Nora Okja. *Comfort Woman*. New York: Penguin Books, 1997.

Kim, Chungmi. *Comfort Women*. In *New Playwrights: The Best Plays of 2005*, edited by D. L. Lepidus, 51–100. Hanover, NH: Smith and Kraus, 2006.

Kim, David J. "Critical Mediations: *Haewon Chinhon Kut*, a Shamanic Ritual for Korean 'Comfort Women.'" *positions: asia critique* 21, no. 3 (2013): 725–54.

Kim, E. Tammy. "Performing Social Reparation: 'Comfort Women' and the Path to Political Forgiveness." *Women and Performance: a journal of feminist theory* 16, no. 2 (July 2006): 221–49.

Kim, Elaine H. "Home Is Where the *Han* Is: A Korean-American Perspective on the Los Angeles Upheavals." In *Reading Rodney King/Reading Urban Uprising*, edited by Robert Gooding-Williams, 215–35. London: Routledge, 1993.

Kim, Elaine H., and Chungmoo Choi. Introduction to *Dangerous Women: Gender and Korean Nationalism*, edited by Elaine H. Kim and Chungmoo Choi, 1–8. New York: Routledge, 1998.

Kim, Eun Sung, and Seo Kyung Kim. *Jageun Sonyeosang: Pyeonghwaui So-nyeosang Hwaksan Peurojekteu* [Little Girl Statue: Proliferation Project for the Girl Statue of Peace]. Edited by Sung-min Oh. N.p., 2016.

Kim, Hyun Sook. "History and Memory: The 'Comfort Women' Contro-versy." *positions: east asia cultures critique* 5, no. 1 (Spring 1997): 73–106.

Kim, Janice C. H. *To Live to Work: Factory Women in Colonial Korea, 1910–1945*. Stanford: Stanford University Press, 2009.

Kim, Jodi. *Ends of Empire: Asian American Critique and the Cold War*. Min-neapolis: University of Minnesota Press, 2010.

Kim, Michael. "Collective Memory and Commemorative Space: Reflections on Korean Modernity and the Kyongbok Palace Reconstruction, 1865–2010." *International Area Review* 13, no. 4 (2010): 75–95.

Kim, Puja. "Global Civil Society Remakes History: 'The Women's Interna-tional War Crimes Tribunal 2000.'" *positions: east asia cultures critique* 9, no. 3 (2001): 611–20.

Kim, Pu Ja. "Looking at Sexual Slavery from a *Zainichi* Perspective." In *Voices from the Japanese Women's Movement*, edited by AMPO-Japan Asia Quarterly Review, 157–60. Armonk, NY: Sharpe, 1996.

Kim, Suk-Young. *DMZ Crossing: Performing Emotional Citizenship along the Korean Border*. New York: Columbia University Press, 2014.

Kim, Suk-Young. *Illusive Utopia: Theater, Film, and Everyday Performance in North Korea*. Ann Arbor: University of Michigan Press, 2010.

Kim-Gibson, Dai Sil. *Silence Broken: Korean Comfort Women*. Parkersburg, IA: Mid-Prairie, 1999.

Kimura, Maki. *Unfolding the "Comfort Women" Debates: Modernity, Vio-lence, Women's Voices*. Basingstoke: Palgrave Macmillan, 2016.

Kirshenblatt-Gimblett, Barbara. *Destination Culture: Tourism, Museums, and Heritage*. Berkeley: University of California Press, 1998.

Knezevic, Dubravka. "Marked with Red Ink." In *Radical Street Performance: An International Anthology*, edited by Jan Cohen-Cruz, 52–62. New York: Routledge, 1998.

Knowles, Ric. *Theatre and Interculturalism*. Basingstoke: Palgrave Macmil-lan, 2010.

Kobayashi, Hiroaki. "State and Religion in Japan: Yasukuni Shrine as a Case Study." In *Law and Religion in the 21st Century: Relations between States and Religious Communities*, edited by Silvio Ferrari and Rinaldo Cristofori, 65–78. Burlington: Ashgate, 2010.

Koikari, Mire. *Pedagogy of Democracy: Feminism and the Cold War in the U.S. Occupation of Japan*. Philadelphia: Temple University Press, 2008.

Krometis, Damon. "Dissonant Witnessing: The 'in' and 'above' of *Thou Proud Dream*." *Theatre Topics* 26, no. 3 (November 2016): 321–31.

Kuftinec, Sonja. *Staging America: Cornerstone and Community-Based The-ater*. Carbondale: Southern Illinois University Press, 2003.

Kwan, SanSan. *Kinesthetic City: Dance and Movement in Chinese Urban Spaces*. Oxford: Oxford University Press, 2013.

Larasati, Rachmi Diyah. *The Dance That Makes You Vanish: Cultural Reconstruction in Post-Genocide Indonesia*. Minneapolis: University of Minnesota Press, 2013.

Laub, Dori. "Bearing Witness or the Vicissitudes of Listening." In *Testimony: Crises of Witnessing in Literature, Psychoanalysis, and History*, edited by Shoshana Felman and Dori Laub, 57–74. New York: Routledge, 1992.

Law, Jane Marie. "Puppet Think: The Implication of Japanese Ritual Puppetry for Thinking through Puppetry Performances." In *The Routledge Companion to Puppetry and Material Performance*, edited by Dassia N. Posner, Claudia Orenstein, and John Bell, 154–63. London: Routledge, 2014.

Lee, Chang-rae. *A Gesture Life*. New York: Riverhead, 1999.

Lee, Esther Kim. Introduction to *Seven Contemporary Plays from the Korean Diaspora in the Americas*, edited by Esther Kim Lee, xi–xxviii. Durham: Duke University Press, 2012.

Lee, Namhee. *The Making of Minjung: Democracy and the Politics of Representation in South Korea*. Ithaca: Cornell University Press, 2007.

Lee, Na-Young. "The Construction of U.S. Camptown Prostitution in South Korea: Trans/formation and Resistance." PhD diss., University of Maryland, College Park, 2006.

Lee, Na-Young. "The Korean Women's Movement of Japanese Military 'Comfort Women': Navigating between Nationalism and Feminism." *Review of Korean Studies* 17, no. 1 (June 2014): 71–92.

Lee, Yong Soo. "Wontonghaeseo Motsalgetda, Nae Cheongchuneul Dollyeodao" [I Can't Bear the Resentment, Give Me Back My Youth]. In *Gangjero Kkeullyeogan Joseonin Gunwianbudeul-Jeungeonjip I* [Forcibly Dragged Korean Military Comfort Women: Collection of Testimonies I], edited by Korean Council for the Women Drafted for Military Sexual Slavery by Japan and the Korea Chongshindae's Institute, 121–32. 1993. Seoul: Hanul, 2007.

Lei, Daphne P. "Interruption, Intervention, Interculturalism: Robert Wilson's HIT Productions in Taiwan." *Theatre Journal* 63, no. 4 (2011): 571–86.

Lim, Eng-Beng. *Brown Boys and Rice Queens: Spellbinding Performance in the Asias*. New York: New York University Press, 2014.

Lionnet, Françoise, and Shu-mei Shih, eds. *Minor Transnationalism*. Durham: Duke University Press, 2005.

Lo, Jacqueline, and Helen Gilbert. "Toward a Topography of Cross-Cultural Theatre Praxis." *TDR: The Drama Review* 46, no. 3 (2002): 31–53.

Lowe, Lisa. "The International within the National: American Studies and Asian American Critique." *Cultural Critique* 40 (Autumn 1998): 29–47.

Macki Braconi, Adrienne. *Harlem's Theaters: A Staging Ground for Community, Class, and Contradiction, 1923–1939*. Evanston: Northwestern University Press, 2015.

Mackie, Vera. *Feminism in Modern Japan: Citizenship, Embodiment and Sexuality*. Cambridge: Cambridge University Press, 2003.

Madison, D. Soyini. *Acts of Activism: Human Rights as Radical Performance*. Cambridge: Cambridge University Press, 2010.

Martin, Carol. "Bodies of Evidence." *TDR: The Drama Review* 50, no. 3 (Fall 2006): 8–15.

Martinez, Monica Muñoz. "Recuperating Histories of Violence in the Americas: Vernacular History-Making on the US-Mexico Border." *American Quarterly* 66, no. 3 (2014): 661–89.

Matsui, Yayori. "Women's International War Crimes Tribunal on Japan's Military Sexual Slavery: Memory, Identity, and Society." *East Asia: An International Quarterly* 19, no. 4 (December 2001): 119–42.

McClintock, Anne. *Imperial Leather: Race, Gender and Sexuality in the Colonial Contest*. New York: Routledge, 1995.

Mendoza, Katharina R. "Freeing the 'Slaves of Destiny': The Lolas of the Filipino Comfort Women Movement." *Cultural Dynamics* 15, no. 3 (2003): 247–66.

Min, Pyong Gap. "Korean 'Comfort Women': The Intersection of Colonial Power, Gender, and Class." *Gender and Society* 17, no. 6 (December 2003): 938–57.

Mohanty, Chandra Talpade. *Feminism without Borders: Decolonizing Theory, Practicing Solidarity*. Durham: Duke University Press, 2003.

Moon, Katharine H. S. *Sex Among Allies: Military Prostitution in U.S.-Korea Relations*. New York: Columbia University Press, 1997.

Moon, Katharine H. S. "South Korean Movements against Militarized Sexual Labor." *Asian Survey* 39, no. 2 (1999): 310–27.

Morillot, Juliette. *Die Roten Orchideen von Shanghai: Das Schicksal der Sangmi Kim* [The Red Orchid of Shanghai: The Tragedy of Sangmi Kim]. Translated by Gaby Wurster. Munich: Goldmann, 2003. Originally published as *Les Orchidées Rouges de Shanghai*. Paris: Presses de la Cité, 2001.

Nguyen, Viet Thanh. *Nothing Ever Dies: Vietnam and the Memory of War*. Cambridge: Harvard University Press, 2016.

Norma, Caroline. *The Japanese Comfort Women and Sexual Slavery during the China and Pacific Wars*. London: Bloomsbury, 2016.

Nozaki, Yoshiko. "Japanese Politics and the History Textbook Controversy, 1982–2001." *International Journal of Education Research* 37, nos. 6–7 (2002): 603–22.

Oh, Bonnie B. C. "The Japanese Imperial System and the Korean 'Comfort Women' of World War II." In *Legacies of the Comfort Women of World War II*, edited by Margaret Stetz and Bonnie B. C. Oh, 3–25. Armonk: Sharpe, 2001.

Paik, A. Naomi. *Rightlessness: Testimony and Redress in U.S. Prison Camps*

since World War II. Chapel Hill: University of North Carolina Press, 2016.

Park, Soyang. "Silence, Subaltern Speech and the Intellectual in South Korea: The Politics of Emergent Speech in the Case of Former Sexual Slaves." *Journal for Cultural Research* 9, no. 2 (2005): 169–206.

Patraka, Vivian M. *Spectacular Suffering: Theatre, Fascism, and the Holocaust*. Bloomington: Indiana University Press, 1999.

Pilzer, Joshua D. *Hearts of Pine: Songs in the Lives of Three Korean Survivors of the Japanese "Comfort Women."* Oxford: Oxford University Press, 2012.

Pilzer, Joshua D. "'My Heart, the Number One': Singing in the Lives of South Korean Survivors of Japanese Military Sexual Slavery." PhD diss., University of Chicago, 2006.

Posner, Dassia N., Claudia Orenstein, and John Bell. Introduction to *The Routledge Companion to Puppetry and Material Performance*, edited by Dassia N. Posner, Claudia Orenstein, and John Bell, 1–12. London: Routledge, 2014.

Qiu, Peipei, with Su Zhiliang and Chen Lifei, eds. *Chinese Comfort Women: Testimonies from Imperial Japan's Sex Slaves*. 2013. Oxford: Oxford University Press, 2014.

Rancière, Jacques. "Who Is the Subject of the Rights of Man?" *South Atlantic Quarterly* 103, nos. 2–3 (Spring–Summer 2004): 297–310.

Rayner, Alice. *Ghosts: Death's Double and the Phenomena of Theatre*. Minneapolis: University of Minnesota Press, 2006.

Real, J. R. Robert G. "Continuing the Quest for Justice after the Philippine Supreme Court's Decision on the Japanese Military Sex Slaves." *Michigan International Lawyer* 26, no. 3 (2014): 13–16.

Richards, Sandra L. "What Is to Be Remembered?: Tourism to Ghana's Slave Castle-Dungeons." In *Critical Theory and Performance*, rev. and enl. ed., edited by Janelle G. Reinelt and Joseph R. Roach, 85–107. Ann Arbor: University of Michigan Press, 2007.

Roach, Joseph. *Cities of the Dead: Circum-Atlantic Performance*. New York: Columbia University Press, 1996.

Roberts, Mary Louise. *What Soldiers Do: Sex and the American GI in World War II France*. Chicago: University of Chicago, 2013.

Robinson, Martin. *Lonely Planet: Seoul*. Melbourne: Lonely Planet, 2006.

Roht-Arriaza, Naomi. "The New Landscape of Transitional Justice." In *Transitional Justice in the Twenty-First Century*, edited by Naomi Roht-Arriaza and Javier Mariezcurrena, 1–16. Cambridge: Cambridge University Press, 2006.

Roht-Arriaza, Naomi, and Javier Mariezcurrena, eds. *Transnational Justice in the Twenty-First Century: Beyond Truth versus Justice*. Cambridge: Cambridge University Press, 2006.

Rokem, Freddie. *Performing History: Theatrical Representations of the Past in Contemporary Theatre*. Iowa City: University of Iowa Press, 2000.

Román, David. *Acts of Intervention: Performance, Gay Culture, and AIDS*. Bloomington: Indiana University Press, 1998.

Rosen, Michael. *Dignity: Its History and Meaning*. Cambridge: Harvard University Press, 2012.

Sakamoto, Rumi. "The Women's International War Crimes Tribunal on Japan's Military Sexual Slavery: A Legal and Feminist Approach to the 'Comfort Women' Issue." *New Zealand Journal of Asian Studies* 3, no. 1 (2001): 49–58.

Sarat, Austin. "Editorial." *Law, Culture, and the Humanities* 4, no. 2 (2008): 137–38.

Scarry, Elaine. *The Body in Pain: The Making and Unmaking of the World*. New York: Oxford University Press, 1985.

Schechner, Richard. *Between Theater and Anthropology*. Philadelphia: University of Pennsylvania Press, 1985.

Schlund-Vials, Cathy J. *War, Genocide, and Justice: Cambodian American Memory Work*. Minneapolis: University of Minnesota Press, 2012.

Schneider, Rebecca. *Performing Remains: Art and War in Times of Theatrical Reenactment*. London: Routledge, 2011.

Schneider, Rebecca. "Patricide and the Passerby." In *Performance and the City*, edited by D. J. Hopkins, Shelley Orr, and Kim Solga, 51–67. Basingstoke: Palgrave Macmillan, 2009.

Sharp, Gene. *The Politics of Nonviolent Action*. Boston: Porter Sargent Publisher, 1973.

Shigematsu, Setsu, and Keith L. Camacho. "Introduction: Militarized Currents, Decolonizing Futures." In *Militarized Currents: Towards a Decolonized Future in the Asia and the Pacific*, edited by Setsu Shigematsu and Keith L. Camacho, xv–xlviii. Minneapolis: University of Minnesota Press, 2010.

Shim, Jung-Soon. "Female Trance in Han Tae-Sook's Production of *Lady Macbeth*." *New Theatre Quarterly* 25, no. 1 (2009): 63–71.

Shim, Jung-Soon. "The Shaman and the Epic Theatre: The Nature of Han in the Korean Theatre." *New Theatre Quarterly* 20, no. 3 (2004): 216–24.

Shin, Gi-Wook. *Peasant Protest and Social Change in Colonial Korea*. Seattle: University of Washington Press, 1996.

Snyder-Young, Dani. *Theatre of Good Intentions: Challenges and Hopes for Theatre and Social Change*. Basingstoke: Palgrave Macmillan, 2013.

Soh, Chunghee Sarah. *The Comfort Women: Sexual Violence and Postcolonial Memory in Korea and Japan*. Chicago: University of Chicago Press, 2008.

Soh, Chunghee Sarah. "The Korean 'Comfort Women': Movement for Redress." *Asian Survey* 36, no. 12 (1996): 1226–40.

Solga, Kim. *Violence Against Women in Early Modern Performance: Invisible Acts*. 2009. Basingstoke: Palgrave Macmillan, 2013.

Son, Elizabeth W. "Korean Trojan Women: Performing Wartime Sexual Violence." *Asian Theatre Journal* 33, no. 2 (Fall 2016): 369–94.

Son, Elizabeth W. "Transpacific Acts of Memory: The Afterlives of *Hanako*." *Theatre Survey* 57, no. 2 (May 2016): 264–74.

Son, Elizabeth W., and Joshua Takano Chambers-Letson. "Performed Otherwise: The Political and Social Possibilities of Asian/American Performance." *Theatre Survey* 54, no. 1 (January 2013): 131–39.

Sorgenfrei, Carol Fisher. "Guilt, Nostalgia, and Victimhood: Korea in the Japanese Theatrical Imagination." *New Theatre Quarterly* 29, no. 2 (2013): 185–200.

Spees, Pam. "Women's Advocacy in the Creation of the International Criminal Court: Changing the Landscapes of Justice and Power." *Signs: Journal of Women in Culture and Society* 28, no. 4 (2003): 1233–54.

Stephen, Lynn. *We Are the Face of Oaxaca: Testimony and Social Movements*. Durham: Duke University Press, 2013.

Stetz, Margaret, and Bonnie B. C. Oh, eds. *Legacies of the Comfort Women of World War II*. Armonk, NY: Sharpe, 2001.

Sturken, Marita. *Tangled Memories: The Vietnam War, the AIDS Epidemic, and the Politics of Remembering*. Berkeley: University of California Press, 1997.

Suzuki, Shogo. "The Competition to Attain Justice for Past Wrongs: The 'Comfort Women' Issue in Taiwan." *Pacific Affairs* 84, no. 2 (2011): 223–44.

Suzuki, Shogo. "Overcoming Past Wrongs Committed by States: Can Non-state Actors Facilitate Reconciliation?" *Social and Legal Studies* 21, no. 2 (2012): 201–13.

Tanaka, Yuki. *Japan's Comfort Women: Sexual Slavery and Prostitution During World War II and the US Occupation*. New York: Routledge, 2002.

Tarrow, Sidney G. *Power in Movement: Social Movements and Contentious Politics*. 1994. Cambridge: Cambridge University Press, 2011.

Taylor, Diana. *The Archive and the Repertoire: Performing Cultural Memory in the Americas*. Durham: Duke University Press, 2003.

Taylor, Diana. *Disappearing Acts: Spectacles of Gender and Nationalism in Argentina's "Dirty War."* Durham: Duke University Press, 1997.

Thiong'o, Ngũgĩ wa. *Penpoints, Gunpoints, and Dreams: Towards a Critical Theory of the Arts and the State in Africa*. Oxford: Clarendon, 1998.

Thompson, James. *Humanitarian Performance: From Disaster Tragedies to Spectacles of War*. London: Seagull, 2014.

Thompson, James. *Performance Affects: Applied Theatre and the End of Effect*. Basingstoke: Palgrave Macmillan, 2009.

Torell, David. "Remember the Russell Tribunal?" In *Cultural Memories of Nonviolent Struggles: Powerful Times*, edited by Anna Reading and Tamar Katriel, 111–27. Basingstoke: Palgrave Macmillan, 2015.

Totani, Yuma. *The Tokyo War Crimes Trial: The Pursuit of Justice in the Wake of World War II*. Cambridge: Harvard University Asia Center, 2008.

Tran, Quan Tue. "Remembering the Boat People Exodus: A Tale of Two Memorials." *Journal of Vietnamese Studies* 7, no. 3 (2012): 80–121.

Turner, Victor. *Dramas, Fields, and Metaphors: Symbolic Action in Human Society*. Ithaca: Cornell University Press, 1974.

Um, Hae-kyung. "New *P'ansori* in Twenty-first-century Korea, Creative Dialectics of Tradition and Modernity." *Asian Theatre Journal* 25, no. 1 (Spring 2008): 24–57.

US House of Representatives, Committee on Foreign Affairs, Subcommittee on Asia, the Pacific, and the Global Environment. *Protecting the Human Rights of Comfort Women: Hearing before the Subcommittee on Asia, the Pacific, and the Global Environment of the Committee on Foreign Affairs House of Representatives, One Hundred Tenth Congress, First Session, February 15, 2007*. Serial No. 110-16. Washington, DC: U.S. Government Printing Office, 2007.

Volpp, Leti. "Talking Culture: Gender, Race, Nation, and the Politics of Multiculturalism." *Columbia Law Review* 96 (1996): 1573–1617.

Walker, Margaret Urban. "Gender and Violence in Focus: A Background for Gender Justice in Reparations." In *The Gender of Reparations: Unsettling Sexual Hierarchies While Redressing Human Rights Violations*, edited by Ruth Rubio-Marín, 18–62. Cambridge: Cambridge University Press, 2009.

Watanabe, Mina. "NGO Briefing to Ms. Navanethem Pillay, UN High Commissioner for Human Rights." May 13, 2010. In author's possession.

Watkins, Yoko Kawashima. *So Far from the Bamboo Grove*. New York: Lothrop, Lee, and Shepard, 1986.

Willoughby, Heather. "The Sound of *Han*: *P'ansori*, Timbre, and a Korean Ethos of Pain and Suffering." *Yearbook for Traditional Music* 32 (2000): 17–30.

Wonhaeng, Monk, ed. *The Painting Edition of Japanese Military Sexual Slaves*. Gwangju City: Nanumui Jip/Museum of Japanese Military Sexual Slavery, 2004.

Yang, Hyunah. "Finding the 'Map of Memory': Testimony of the Japanese Military Sexual Slavery Survivors." *positions: east asia cultures critique* 16, no. 1 (2008): 79–107.

Yang, Hyunah. "Re-Membering the Korean Military Comfort Women: Nationalism, Sexuality, and Silencing." In *Dangerous Women: Gender and Korean Nationalism*, edited by Elaine H. Kim and Chungmoo Choi, 123–39. New York: Routledge, 1998.

Yang, Sunny. *Hanbok: The Art of Korean Clothing*. Elizabeth, NJ: Hollym, 1997.

Yeo, Andrew. *Activists, Alliances, and Anti-U.S. Base Protests*. Cambridge: Cambridge University Press, 2011.

Yi, Yongsu. "Return My Youth to Me." In *True Stories of the Korean Comfort Women: Testimonies Compiled by the Korean Council for Women Drafted for Military Sexual Slavery by Japan and the Research Association on the Women Drafted for Military Sexual Slavery by Japan*, translated by Young Joo Lee and edited by Keith Howard, 88–94. London: Cassell, 1995.

Yoneyama, Lisa. *Cold War Ruins: Transpacific Critique of American Justice and Japanese War Crimes*. Durham: Duke University Press, 2016.

Yoneyama, Lisa. "Traveling Memories, Contagious Justice: Americanization of Japanese War Crimes at the End of the Post–Cold War." *Journal of Asian American Studies* 6, no. 1 (2003): 57–93.

Yoneyama, Lisa. *Hiroshima Traces: Time, Space, and the Dialectics of Memory*. Berkeley: University of California Press, 1999.

Yoon, Jung-mo. "Bongseonhwa." Translated by Yoon-suhg Yahng. Unpublished script. 2013.

Yoon, Mee Hyang. *25nyeonganui Suyoil* [25 Years of Wednesday]. Paju: Sai Planet, 2016.

Yoshimi, Yoshiaki. *Comfort Women: Sexual Slavery in the Japanese Military During World War II*. New York: Columbia University Press, 1995.

Young, Harvey. *Embodying Black Experience: Stillness, Critical Memory, and the Black Body*. Ann Arbor: University of Michigan Press, 2010.

Young, James E. *The Texture of Memory: Holocaust Memorials and Meaning*. New Haven: Yale University Press, 1993.

Yuh, Ji-Yeon. *Beyond the Shadow of Camptown: Korean Military Brides in America*. New York: New York University Press, 2002.

Index

Page numbers in italics refer to illustrations.

Abe, Shinzo, 1, 2, 13, 17, 81, 137, 174, 200n63
aging and activism, 14–15, 41–42, 63–64, 65, 66, 88, 204n118. *See also* bodies
Ahn, Bok Sung, 86
Ahn, Jeom-Soon, 127–30
Anderson, Benedict, 50
apology: from Japanese government, 1–2, 11, 13, 165, 189n55; physical expression of, 31; rhetoric of, 10
Argibay, Carmen, 78, 84
"Arirang" (folk song), 60, 119, 220n66
Asian Centre for Women's Human Rights, 75, 95
Asia Policy Point, 163
Asian Solidarity Conference, 77
Asian Women's Fund, 13, 189nn55–56
Association of Korean Victims, 73–74
"atonement model," 10
audience expectations and participation, 18, 20, 34, 64
Austin, J. L., 205n9

Bacalzo, Dan, 109
Bae, Bong-gi, 188n42
Bae, Chun-hui, 29

Bae, So-yeong, 182
Bang, Eunmi, 116–17, 118–20, 219n54
Barthes, Roland, 46
Bernstein, Robin, 149
Bessho, Koro, 153
Boal, Augusto, 64
bodies: as archives, 92–93; as "crucible of experience and an expressive instrument," 19; interplay between young and old, 11, 14–15, 42, 44, 62–63, 115, 154–55, 182, 199n59; at protests, 48–50, 61–62; scarred, xvii, 15, 70, 87, 91–92, 213n136
Bongseonhwa (Yoon Jung-mo), 22, 24, 103–4, 134–45, *136*, 155; controversial scene in, 143–44; novel version of, 134, 142
Bore, Marta Abu, 65, 66, 68, 132
Borland, Elizabeth, 204n118
bronze girl statue ("Peace Monument"), 1–2, 10, 25, 142, 147, 149–60, *151*, *156*, 165, 172, 180–82, *183*; clothing on, 150, 152, 155; creation of, 150; empty chair significance, 157–58; Little Girl Statue project, 181; live performances of, 181–83; names for, 153–54; vandalizing of, 159, 166

Brooks, Roy, 10
Bunch, Charlotte, 95, 96, 213n139
Butler, Judith, 205n9
Butterfly Fund (Nabigigeum), 18, 167
butterfly symbolism, 192n84, 219n54

Camacho, Keith L., 20
Campari, Irene, 197n29
camptown sex work. See prostitution, militarized
Caruth, Cathy, 115
Cavallo, Steven, 162, 164, 166, 230n64
Certeau, Michel de, 33
Chambers-Letson, Joshua Takano, 206n22
Chinkin, Christine M., 98
Cho, Elizabeth, 12
Cho, Grace M., 118
Choe, Sang-hun, 150
Choi, Chungmoo, 14, 32
Choi, Jung-yoon, 155
Choi, Kimberly, 173
Chrysanthemum Taboo, 83
Chuh, Kandice, 129
Chu Lin, Sam, 108
Chun, Ok Sun, 213n136
Clinton, Hillary, 17
Cole, Catherine, 14–15, 69–70, 85, 205n10
"comfort stations," xvii–xviii, 5–6, 27, 187nn24–25
"comfort system," 6, 7–8, 10, 200n71; beginnings of, 187n16, 187n21, 211n102; distinction from militarized prostitution, 43, 199n63; justification for, 136–37; postwar silence on, 7, 28, 34–35; US soldiers and, 97; Women's Tribunal and, 72, 83, 84. See also Japanese military sexual slavery

"comfort women": backgrounds of, xvii, xix, 6, 65, 197n36; exclusion from Japanese history textbooks, 10, 13, 43–44, 60, 110, 120, 190n58; moral innocence of, 36, 42–47, 63, 113–15, 142; nomenclature for, 16–17; number of, xvii, 185n2; registration with government by, 8, 113, 188n43, 201n77; scholarship on, 11, 16, 191n73; theatrical representations of. See specific titles
Comfort Women (Chungmi Kim). See Nabi/Comfort Women
Committee on Measures for Compensation to the Former Comfort Women for Japanese Army and Pacific War Victims, 77
communities of remembrance, 18, 21, 23, 51, 63, 67, 103, 105, 175
community building, 3, 31, 50, 64
Coomaraswamy, Radhika, 7, 95, 219n41
Conquergood, Lorne Dwight, 193n87
crime against humanity, sexual slavery as, 71–72, 78, 82, 83, 96, 98, 96, 98–99, 161, 165
Cvetkovich, Ann, 193n94

Dang, Tim, 108, 217n15
Danticat, Edwidge, 221n77
D.C. Circuit Court of Appeals hearing (2005), 59, 74, 203n203
dignity, loss and restoration of, 4, 11, 37, 47, 52; in bronze girl statue, 150; in Nabi, 119; at Women's Tribunal, 85, 87–88, 89
dissensus, performativity of, 66 67, 76, 85, 205n9
Dokdo Islets protests, 59–60, 157, 159, 197n31, 203n109
Dolan, Jill, 22
Dolgopal, Ustinia, 82, 90, 98

domestic violence, 135, 137–38, 143, 145
Doss, Erika, 148–49, 226n3
Dower, John W., 73
Dudden, Alexis, 83, 85, 89, 212n106

East West Players (EWP), 107–8, 217n15
Eckert, Carter, 117–18
embodiment, 14, 62; defined, 85, 203n113. *See also under* performance; Women's International War Crimes Tribunal on Japan's Military Sexual Slavery
Euripides, xviii, 121–22, 124–25, 132

Felman, Shoshana, 75–76, 88–89, 98–99
Field, Norma, 81
Filichia, Peter, 131
Foster, Susan Leigh, 48, 49
Franco, Mark, 19
Fujimura, Osamu, 150

Gang, Iseul, 143
Gilbert, Helen, 126
Gil, Won Ok, xviii, 1, 4–5, 9, 10–11, 12, 18, 29, 31, 55, 57, 115, 172, 182, 192n84
Global Alliance for Historical Truth–US Corporation, 169–70
grandmotherhood, 14, 42–43, 47, 63. See also *halmeoni*
Grewal, Inderpal, 41
Guanzon, Rowena, 81–82
gut (shamanic ritual), 122, *123*, 132–33
Gwanghwamun Square, 32, 196n24

Haithman, Diane, 106, 108, 217n15
Hall, Edith, 124
halmeoni (pl. *halmeonidul*), xx, 17, 36, 42, 51–52, 54–56, 61, 63–64, 86–87, 140; presence in bronze girl

statue, 150, 154; terminology of, 185n7, 201n88
han feelings, 11, 27–28, 128, 132–33, 167, 189n51
hanbok (Korean traditional dress), 125, 142, 150, 152, 155, 172
Ha, Sang Suk, 86–87, 92
Hashimoto, Toru, 136–37
Herman, Judith, 115
Hill, Frances, 108, 217n18
Hirohito, 66, 73, 81, 82–83, 98, 211n102
Hiroki, Shigeyuki, 165
Hiroko, Tabuchi, 137
Honda, Mike, 163
Hopkins, D. J., 226n3
House of Sharing (Nanumaejip), 22, 29, 144, 164, 177–80, 192n84, 199n58, 228n27; in *Bongseonhwa*, 135, 141, 142; history of, 195n13
H.R. 121. *See under* United States
Hua, Julietta, 41
Hur, Gil-cha, 218n38
husondeul designation, 55
Indonesian Women's Coalition for Justice and Democracy, 77
institutionalized sexual violence, xix, 16
International Criminal Court (ICC), 99, 206n13
International Criminal Tribunal for Rwanda (ICTR), 78, 99
International Criminal Tribunal for the Former Yugoslavia (ICTY), 78, 99
introspection and extrospection, 104, 215n3
Jakovljević, Branislav, 76, 215n3
Jang, Jeom Dol, 9
Japanese Embassy (Seoul), 1–2, 23, 27, 30, 31–34, 35, 37, 44, 48–51, 54; bronze girl statue and, 152–53, 155, 158; employees of, 49–50, 153, 201n82; photographs of, *38*, *53*, *58*; renovations of, 196n26

Japanese imperialism and colonialism, 32, 73, 76–77
Japanese military sexual slavery, xvii–xviii, 45, 65, 67, 70, 82, 84, 90–91, 95, 129, 187nn24–25, 187n25; as "forced prostitution," 72, 170; government denials and evasion of, xviii, 2–3, 4, 6–7, 8, 11, 13, 15–18, 43–44, 65, 81, 85, 96–97, 110, 118, 137, 165–66, 169; historical conditions of, 4–6, 187n16; legal dismissals of, 72–75, 98, 208n42
Jelin, Elizabeth, 21
jeongsindae term, 140, 198n45
Jeon, Sol, 54–55
Jizo statues, 153, 227n23
Johnson, E. Patrick, 92
Joseph, May, 50
Justice and Memory Foundation for the Imperial Japanese Army's Comfort Women, 181

Kaneko, Yasuji, 90
Kang, Laura Hyun Yi, 41, 111–12
Kang, Duk-Kyung, 42, 44–45, 46, 155, 199n58; in *The Trojan Women*, 127–30
Kang, Il-chul, 59, 60–61, 143
Kang, Ji Soo, 55
Kang, Sunsook, 121, 125, 221n82
KAN-WIN, 138
Karic, Aida. See *The Trojan Women*
Kim, Chungmi. See *Nabi*
Kim, E. Tammy, 19
Kim, Elaine H., 32, 189n51
Kim, Jodi, 228n30
Kim, Phyllis, 173–74
Kim, Puja, 76, 77, 210n90, 212n123
Kim, Suk-Young, 15, 155
Kim, Bok Dong, xviii, 2, 18, 85, 147, 182, 192n84; at Glendale memorial, *171*, 171–72, 175

Kim, Eun Sung, 150, 155, 157–58, 169, *171*, 181, 234n12
Kim, Hak-soon, 8, 28
Kim, Hye Ryun, 140
Kim, Ji-hae, 181–82
Kim, Kwang-Lim, 126
Kim, Sam-Jin, 121, 126, 131, 223n110
Kim, Seo Kyung, 150, 154, 157–58, 169, *171*, 181, 234n12
Kim, Soon Duk, 200n69
Kim, Yong Sook, 86, 87, 91–93
Kim, Yun-shim, 54
Kocian, Lisa, 117
Koikari, Mire, 72
Koizumi, Junichiro, 165
Kono, Yohei, 11, 13, 165
Koo, Tae-Hwan, 134
Korean American Civic Empowerment (KACE), 160–66, 168–69, 229n48
Korean American Forum of California (KAFC), 168–69
Korean Council for the Women Drafted for Military Sexual Slavery by Japan (Hanguk Jeongsindae Munje Daechaek Hyeobuihoe), 2, 7, 8, 10, 17, 18, 22, 43–44, 47, 58–59, 163, 167, 175, 181, 218n36; Asian Women's Fund and, 13, 189n56; bronze girl statue and, 150; criticism of, 13; personnel of, 195n15; Wednesday Demonstrations and, 29–31, 34–35, 37, 40, 42; on the Women's Tribunal, 71
Korean military sexual violence in Vietnam, 18, 167
Kotler, Mindy, 163
Krometis, Damon, 215n3
Kwan, SanSan, 48–49

landscaping activism, 166–68, 173–74
Lantos, Tom, 163, 229n56

Laub, Dori, 52
League of Filipino Grandmothers, 8
Lee, Chang Y., 169
Lee, Esther Kim, 108
Lee, Mak Dal, xvii–xx, 6, 7, 9, 29, 182
Lee, Myung-bak, 118
Lee, Na-Young, 18, 192n84
Lee, Seonah, 139
Lee, Soon-duk, 9, 29, 199n54
Lee, Yong Soo, xviii, 1, 9, 16–17, 27–28, 44, 52–56, 64, 115, 159, 172, 182, *183*, 184; at Glendale memorial, 174; at Palisades Park memorial, 160, *161*; Wednesday Demonstration performances by, 35–36, 37–38, *53*, 152; at Women's Tribunal, 85
legal proceedings and embodiment. *See under* performance
Lei, Daphne P., 126
Levine, Brittany, 169
"Like a Rock" (protest song), 30, 49, 195n18
Lin, Shen-chung (Iyang-Apay), 89–90
Lionnet, Françoise, 20
Lo, Jacqueline, 126
loss, defined, 196n19
Lowe, Lisa, 15

Ma, Tzi, 108
Martin, Carol, 142
Masaoka, Kathy, 170–71, 175
Matsui, Yayori, 73, 74–75, 77, 100
McClintock, Anne, 50
McDonald, Gabrielle Kirk, 66, 78, 81–82, 86, 88–89, 94, 98
memorial building, 25, 147–75; in *Bongseonhwa*, 140–41; in Glendale (CA), 25, 140, 143, 147, 148, 168–74, *171*, *173*); in Palisades Park (NJ), 25, 147, 148, 160–68, *161*, 230nn64–65. *See also* bronze girl statue

memorialization, 3, 21, 37, 100, 148, 226n9; nomenclature for, 225n3
memory: "counter-memories," 21; cross-legal, 75–81, 98; culture and, 148; "dialectics of remembering," 194n100; "epochal," 21; politics of, 15, 16, 117, 162; public embodiment of, 21, 63; space and, 33
Milošević, Slobodan, 76
Miyazowa, Kiichi, 28
Min, Pyong Gap, 187n21
Mladjenovic, Lepa, 84
Mohanty, Chandra Talpade, 77
Moon, Katharine H. S., 97
Mori, Yoshiro, 65
Morillot, Juliette, 122
Mun, Pil Gi, 86, 91, 177–78, *179*
Mutunga, Willy, 201n74

Nabi/Comfort Women (Chungmi Kim), 22, 24, 103–4, 144–45, 219nn53–55; English version (*Comfort Women*), 105–16, *107*, 119, 139; Korean version (*Nabi*), 116–21, *120*; original version (*Hanako*), 105, 106–8
Naina, Vaheeta, 95–96
Nakahara, Michiko, 79
National Diet (Japan), 9, 13, 79
Nguyen, Viet Thanh, 21
North Korea, 5, 13, 155
Nuremberg Trials, 71, 72

Ock, Hyun-ju, 180
Oh, Soon-tek, 108
Oh family, 172, *173*, 175
Oh, Seung-Ah, 121
O'Herne, Jan Ruff, 77
Omoto, Mary, 108
121 Coalition, 163
Onishi, Norimitsu, 74, 200n63
Orr, Shelley, 226n3
Our House (Urijip), 22, 29, 195n13

Paek, Young H., 167–68, 174–75, 230n65
pansori music, 121, 125–27, 132, 222n82
Park, Annabel, 163
Park, Chejin, 161, 162, 163
Park, Elly, 12
Park, Ok-sun, 9, 29
Park, Se Hwan, 157
Park, Yong Shim, 93–94
Patraka, Vivian M., 193n94
Pelosi, Nancy, 229n56
performance: categories of, 17; as "embodied forms of expression," xviii–xix, 3–4, 14–15, 66, 85; legal proceedings and, 68–70; memorial objects and, 149, 226n9; repetition and, 19, 193n94; of sexual enslavement onstage, 131–32, 142–43, 223n110. *See also* age; redressive acts; testimony; Wednesday Demonstrations; Women's International War Crimes Tribunal on Japan's Military Sexual Slavery
"performances of care," 149, 154, 157–58, 166, 167, 173, 175; etymology of *care*, 226n13
Petsch, Barbara, 124
Pilzer, Joshua D., 16, 42, 154, 185n4, 192n82, 193n92, 197n37, 199nn59–60, 228n30
Plaza de Mayo (Buenos Aires) protests, 14, 63–64, 92–93, 204n115, 204nn118–19
Posner, Dassia, 226n9
prostitution, militarized forms of, 43, 77, 96–97, 114, 200n64
Public Hearing on Crimes against Women in Recent Wars and Conflicts, 66, 94, 97, 129
pungmullori performances, 46, 56

Quintero, Frank, 169, 171

Rancière, Jacques, 66–67, 205n9
Rathmanner, Petra, 124–25
Rayner, Alice, 158
"reckoning," defined, 14
Recreation and Amusement Association, 97
redress: activist demands for, xviii, 1–3, 8, 9–11, 17–18, 37, 74; *baesang* term, 11; broader definitions of, xix, 3–4, 17, 22–23; growth of social movement for, 7–9; Japanese government's gesture of (2015) (*see* South Korea–Japan Agreement); limitations of political and legal, 4; transpacific framework of, 20
redressive acts: defined, 3, 193n92; incompleteness of, 19, 64; need for multiple reckonings of, 100, 183; performance of, 19, 34, 193n87
Rhyne, Mary, 92
Richards, Sandra L., 62, 203n111
Rno, Sung, 108
Roach, Joseph, 21, 33, 75, 160, 209n62
Roh, Tae-woo, 7
Rokem, Freddie, 127, 131, 211n92, 215n3, 222n97
Román, David, 22, 54, 62
Rosen, Michael, 87–88
Rothstein, Edward, 112
Rotundo, James, 162, 164, 165–66

Sajor, Indai, 74–75, 77
Sakamoto, Rumi, 85, 212n111
Salinog, Tomasa, 215n171
Sandman, Jenny, 109
San Francisco Peace Treaty, 73
Sarat, Austin, 69
Scarry, Elaine, 223n109
scars. *See under* bodies
Schechner, Richard, 19
Schlund-Vials, Cathy J., 15, 16, 148, 191n72

Schneider, Rebecca, 47, 226n3
sex tourism, 7, 188n36, 209n69
sex trafficking, 96, 133–34, 170–71, 175
shame, national sense of, 34, 43, 113
Shanghai Research Center on Comfort Women, 77
Sharp, Gene, 50
Shigematsu, Setsu, 20
Shih, Shu-mei, 20
Shim, Jung-Soon, 189n51, 218n38
Shirley, Don, 110
Sinanyan, Zareh, 170, 171
sobok (mourning dress), 38
social movement, defined, 188n35
Soh, C. Sarah, 7, 35
Song, Joon-yong, 120–21
Song, Tae Hyung, 143
Sorgenfrei, Carol Fisher, 152
South Korea–Japan Agreement on "comfort women," 1–2, 175, 180–82, 234n17
Stephen, Lynn, 91
Sturken, Marita, 148, 158, 194n100, 226n3
Sung, Claire, 126
"survivor" term, 17
Suzuki, Nobuyuki, 159, 166, 174
Suzuki, Yoshio, 90
Suzuyo, Takazato, 95

Taipei Women's Rescue Foundation, 8, 77
Talmadge, Eric, 97
Tanaka, Yuki, 77, 187n25, 208n42
Taylor, Diana, 14, 64, 92–93, 204n119
testimony as performance, xvii, 15, 57, 115; in The Trojan Women, 122, 127–28; at the Women's Tribunal, 70, 85
Thiong'o, Ngũgĩ wa, 31, 33
Tokyo War Crimes Trials (International Military Tribunal for the Far East), 7, 15, 71–73, 76–79, 82–84, 99, 207n31
Totani, Yuma, 71–72, 79, 207n37
transnational activism, 8, 20, 70, 112, 149; Korean prominence in, 211n99
transpacific affinity, 111–12, 162; protests as, 58–61, 117
transpacific community, 71; of remembrance, 94, 99
trauma, xviii, 4, 14, 21, 43, 52, 65, 88, 91, 193n94; in Comfort Women/Nabi, 105, 110–11, 115; posttraumatic stress disorder, 84, 115
Treaty on Basic Relations between Japan and the Republic of Korea, 13, 190n59, 208n49
Tribunal of Conscience for Women Survivors of Sexual Violence during the Armed Conflict in Guatemala, 100
Trojan Women: An Asian Story, The (Aida Karic), xviii, 22, 24, 103–4, 121–34, 123, 142–43, 144–45
Truth and Reconciliation Commission (TRC, South Africa), 69, 99, 205n11, 212n106
truth commissions, 65, 68–69, 84–85, 91, 99, 205n10
Tsugo, Imamura, 205n4
Turner, Victor, 19

Um, Hae-kyung, 125
United Nations, 78, 114, 205n13; Japanese bid for Security Council seat at, 59–60, 110, 217n28
United States: Japanese colonialism and, 32–33, 73; militarized prostitution and sexual violence, 15–16, 43, 73, 83, 96–97, 171, 214n146, 214n152; postwar occupation and prosecution of Japan, 72–73, 83, 208n46; 2007 House of Representatives resolution on survivors

United States (*continued*)
(H.R. 121), 97, 110, 162–63, 168–
69, 229n56
Urban Stages, 108–9, 217n18

Vagina Monologues, The (Eve Ensler), 95, 213n139
victimization (victimhood, victimology): *huisaeng* vs. *pihaeja* terminology, 37; individual, 17–18,
30, 36, 38, 43, 52, 63, 154, 192n82;
national, 34–35, 38–39, 41, 42–43,
110, 192n82, 197n37
Vietnam War, 18, 167, 207n25
Violence against Women in War
Network (VAWW-NET Japan), 75,
77, 80–81, 95
Viseur-Sellers, Patricia, 78, 82
Volpp, Leti, 41

Walker, Margaret Urban, 99
Wan, Ai-hua, 88–89
War and Women's Human Rights
Museum, 8, 10
Watanabe, Mina, 100
Watkins, Yoko Kawashima, *So Far
from the Bamboo Grove*, 117–
18
Wednesday Demonstrations, 1, 2, 5,
9, 22, 23, 25, 27–64, 85, 101, 115,
118, 140, 180; accoutrements at,
28, 29, 35, 36–39, 42, 47; banners
at, 36, 40, 42–47, 93, 94, 200n66;
bronze girl statue and, 147, 149–
50, 152, 159–60, 165; color
schemes at, 28, 36–37, 39, 157,
198n49, 198n53; criticism of,
199n55; effectiveness of, 64,
204n119; history of, 1, 28–31; Japanese citizens at, 57, 58, 234n112;
location of, 1, 27, 29, 31–33, 35,
37, 48; *Lonely Planet* listing for,
202n103; music at, 46, 56–57;
name significance, 194n8; as performances, 29, 33–34, 35–38, 56–
57, 62, 152–53; photographs of, 9,
38; repertoire of rallies at, 48–61,
63
Wickstrom, Maurya, 205n6
Wilson, Lindsey, 109
Wilson, Monique, 95
Women's Active Museum on War
and Peace (WAM), 22, 100–101,
215n169
Women's Caucus for Gender Justice,
66, 95, 213n138
women's human rights, 29, 34, 41,
67, 78
Women's International War Crimes
Tribunal on Japan's Military Sexual Slavery, 10, 15, 23–24, 39, 65–
101, 69, 129, 177, 182, 211n99;
charter of, 209n60; embodied
(physical) evidence admitted at,
91–94; genealogy of, 71–75; locations of, 79–81,80, 98, 210n90;
oath-taking at, 86–87; objectives
of, 75; performative strategies at,
66–67, 70–71, 75–76, 82–83, 85–
86, 92, 98–99, 101; televised version of, 80–81; verdict of, 98–99.
See also Public Hearing on
Crimes against Women in Recent
Wars and Conflicts
wound symbolism, 9, 19, 38–39,
143, 167, 170; "woundedness ideology," 192n82, 193n92
Wuturi Players, 121, 126

Yamada, Akira, 83, 211n102
Yang, Hyunah, 34–35, 197n35,
212n112
Yang, Ming-zhen, 88
Yasukuni Shrine, 10, 13, 79–80, 110,
157, 210n84
Yeom, Ji Eun, 143
Yi, Ok-seon, xviii, 29, 57, 143, 160,
161, 178, 180, 182

Yoneyama, Lisa, 15, 21, 60, 171,
189n56, 191n69
Yoon, Gumjong, 166–67
Yoon, Jeong-Ok, 7, 74–75, 77
Yoon, Jung-mo. *See Bongseonhwa*
Yoon, Mee Hyang, *12*, 37, 39, 40,
47–48, 99

Yoshimi, Yoshiaki, 11, 187n25,
189n55
Youn, Joachim, 169
Young, Harvey, 185n6
Young, James E., 148
Yuan, Zhu-lin, 88